THINKING ABOUT THE FUTURE
A Critique of *THE LIMITS TO GROWTH*

THINKING ABOUT THE FUTURE

A Critique of

THE LIMITS TO GROWTH

Edited for The Science Policy Research Unit
of Sussex University by

H. S. D. COLE · CHRISTOPHER FREEMAN
MARIE JAHODA · K. L. R. PAVITT

CHATTO & WINDUS

FOR

SUSSEX UNIVERSITY PRESS

1974

Published for
Sussex University Press
by
Chatto & Windus Ltd
40 William IV Street
London WC2N 4DF

*

Clarke, Irwin & Co Ltd
Toronto

First published May 1973
Second Impression December 1973
Third Impression October 1974

Hardback ISBN 0 85621 018 8
Paperback ISBN 0 85021 020 X

© Science Policy Research Unit 1973

Printed and bound in Great Britain by
REDWOOD BURN LIMITED
Trowbridge & Esher

Preface by
ASA BRIGGS

Vice-Chancellor, University of Sussex

This book speaks for itself. Thirteen essayists associated with the Science Policy Research Unit at the University of Sussex set out to examine the influential and provocative approach to the forecasting of the future followed in Jay W. Forrester's *World Dynamics* and later in Dennis L. Meadows's *The Limits to Growth*. Each essayist has been free to pursue his own line of argument, but the volume as a whole has been carefully planned. Part I deals with the models and seeks to analyse their constituent relationships: Part II attempts to place in perspective both the models and the approaches which they represent.

Thinking about the future has become fashionable in recent years, with particular emphasis on 'doom watching'. Yet such thinking is not without precedent. Reacting sharply against 18th-century theories of human and social perfectability. Malthus stimulated a controversy which he did not begin, and forced contemporaries to think about issues which some of them would have been only too willing to ignore. The 'dismal' elements in his population theories certainly carried with them a sense of doom strengthened by reason of the apparent 'aura of relentless objectivity'. He introduced numbers and the relationships between numbers, though, of course, he not only had no computers at his disposal but would probably not have been prepared to use them had they been available. As this volume shows, there is more in common between the Malthusian controversy – which went through many twists and turns – and the current controversies about people and resources, quickened but not started by MIT forecasters, than there is between most current and earlier debates about the future of society.

The essayists in this volume are critical not because they wish to score points but because they wish to clarify complex issues. They are concerned both with assumptions – for example, about resources – and with methodologies. They do not wish the debate in which they are engaged tó parallel some of the noisy debates of the 19th century, some of which also were concerned in a very different setting with first and last things, when more heat was generated than light. They recognise that there is no room for complacency in contemplating the future and the way that we can shape it. They know, too, that the model-builders will produce as many revisions and qualifications as Malthus did. The Director of the Science Policy Research Unit at Sussex, Professor Freeman, sets the scene in this volume, and his colleagues then take over. The last chapter on social change is written neither by a sociologist nor a historian but by a psychologist. Malthus lived at a time before the different social sciences had separated out from each other. This volume, though it criticises Malthus as much as it criticises too facile dependence on computers, attempts to link different branches of specialised knowledge in an effort to get answers to identifiable problems. Whatever else Malthus might have thought of the book, he would have approved of that.

I feel sure that this contribution to what is already a lively international debate will stimulate controversy in the best sense. It will not comfort readers in their prejudices but will rather invite them to think critically and constructively.

Acknowledgements

This project was carried out at the Science Policy Research Unit of the University of Sussex by members of the Unit who are working on a programme of research on social and technological forecasting. The programme is supported by grants from the Social Science Research Council, the Leverhulme Foundation, ICI and BP. We are grateful to them for their support.

Individual members of the Unit and two visiting Research Fellows from Canada (Simmons and Julien) are named as authors of the 14 chapters, but most of the research was the result of team-work. Many other members of the Unit and of the University contributed to the preparation and criticism of the papers presented here, under the overall guidance of Professor Marie Jahoda. She made it possible for a diverse and sometimes unruly group to cooperate fruitfully.

Since the papers went through several drafts this imposed a great burden on the secretaries concerned. We are particularly grateful to Charlotte Huggett and Hazel Groundsell for much patient work and putting up with a great deal of inconvenience. Pamela Newick made a special contribution by her work on the graphs and diagrams. Our thanks to them all.

We are greatly indebted to the DTI/UKAEA Programmes Analysis Unit for making possible the use by Cole and Curnow of the Harwell IBM 360/165 computer. We would also like to thank members of the Harwell Computing Centre for the assistance given to us throughout the project.

Finally, we should like to pay tribute to the courtesy, patience and thoroughness of Dennis and Donella Meadows in answering numerous questions and criticisms from our Sussex team, when they visited us in July 1972, and also for presenting us with an early version of the Technical Report of *The Limits to Growth*. Although we differed on many questions we had a valuable and constructive discussion. From this encounter we are convinced that they would prefer frank and professional criticism to flattery, and it is in this spirit that we have prepared these papers for publication.

The Editors

Contents

The Project Team

CHRISTOPHER FREEMAN, B.Sc. · Economist
R. M. Phillips Professor of Science Policy and Director, Science Policy
Research Unit, University of Sussex

MARIE JAHODA, D.Phil.
Professor of Social Psychology, University of Sussex; Chairman of the Project
Team

H. S. D. COLE, B.Sc., D.Phil., A.R.C.S. · Mathematical physicist
Research Fellow in SPRU

A. J. BROMLEY, B.Sc. · Economist
Visiting Fellow at SPRU (1972–73) on BP Fellowship

C. M. COOPER, B.Sc., B.A. · Economist/physicist
Senior Research Fellow at SPRU

R. C. CURNOW, B.Sc., A.R.C.S. · Mathematician/statistician
Senior Research Fellow at SPRU

P-A. JULIEN, B.A., B.Sc. Comm., Lic. Sc.Econ., Doc.Sc. Econ. ·
Economist
Visiting Fellow at SPRU in 1972 from University of Quebec

PAULINE K. MARSTRAND, M.Sc., M.I.Biol. · Biologist
Research Fellow at SPRU

R. W. PAGE, B.A. · Social psychologist
Research Fellow at SPRU

K. L. R. PAVITT, M.A. · Engineer/economist
Senior Research Fellow at SPRU

H. G. SIMMONS, B.A., M.A., Ph.D. · Political scientist
Visiting Fellow at SPRU in 1972 from York University, Ontario, Canada

T. C. SINCLAIR, B.Sc., F.Inst.P., M.Inst.Env.Sci. · Physicist
Senior Research Fellow at SPRU

A. J. SURREY, B.Sc. Economist
Senior Research Fellow at SPRU

Part I: The world models and their sub-systems

Part I: *The world models and their sub-systems*

1. MALTHUS WITH A COMPUTER

Christopher Freeman

Take for instance Malthus' book on Population. *In its first edition it was nothing but a sensational pamphlet and plagiarism from beginning to end into the bargain. And yet what a stimulus was produced by this libel on the human race!*—(Karl Marx, in The Poverty of Philosophy).

THE MIT *World Dynamics* and *The Limits to Growth* models* represent the most ambitious attempt so far to bring together forecasts of population growth, resource depletion, food supply, capital investment and pollution into one general model of the future of the world. In view of the wide interest this MIT work has attracted and the importance of the issues it raises, it deserves thorough and constructive criticism. That is the purpose of this publication. Since the criticism is extensive, and sometimes severe, it is essential to make several points quite clear at the outset.

First, although the authors of the essays disagree strongly with much of the MIT analysis and also disagree with each other about some of the issues raised, we are in complete agreement with the MIT authors and their sponsors, the

* *World Dynamics*, by Jay W. Forrester, was published in 1971 (Cambridge, Massachussetts, Wright-Allen Press). It contains the first description of the world model, called World 2, as well as commentaries on the various runs of the model. *The Limits to Growth*, by Donella H. Meadows, Dennis L. Meadows, Jørgen Randers and William W. Behrens III, was published in 1972 (New York, Universe Books, and London, Earth Island). It outlines a more elaborate world model, called World 3, built under the direction of Dennis Meadows and based on Forrester's original. The detailed description of this model is contained in a separate Technical Report. This Technical Report has gone through several (mimeographed) editions. The final revised version will be published in the spring of 1973 under the title, *The Dynamics of Growth in a Finite World* (Wright-Allen Press). The papers published here are concerned with *World Dynamics*, *The Limits to Growth* and the early versions of the Technical Report, which are the most relevant in considering the arguments advanced in *The Limits to Growth* and the computer runs presented in that book.

The following papers are concerned with all these publications. When the comments and criticisms pertain to all of them, the publications are referred to either as the MIT model (or models), or as the work of Forrester and Meadows. Otherwise, reference is made to the specific publications and/or their authors. The use of MIT as an adjective is purely a matter of convenience, to indicate the geographical origin of the research team. It does not of course imply any institutional responsibility for the models. We are well aware that many members of that institution do not share the views expressed in these publications.

Club of Rome, about the urgency of many of the social problems with which they are concerned.

Our critique must not be taken in any way as justifying complacency about such issues as population growth rates in some areas of the world, the development of satisfactory national and international mechanisms for the monitoring and prevention of pollution hazards, or conservation of amenity. We *do* believe that these issues are extremely important for the future of the world and that they are urgent and of global concern.

Secondly, as the paper by Cole makes clear, our critique should not be taken as an attack on the use of mathematical model-building in the social sciences. On the contrary, we agree with Gabor[1] that the social sciences can benefit from the use of computer model-building techniques and specifically from system dynamics. As will be explained, however, we also believe that such models have serious limitations and dangers of misuse.

Thirdly, we do not underestimate the positive importance of the MIT work as a courageous and pioneering attempt to make a computer model of the future of the world. As a result of reading *The Limits to Growth* many people are now thinking anew about long-term problems and discussing them much more seriously. In particular, they are discussing once again whether or not the world is likely to run up against physical limits. This is a very important achievement.

Moreover, we do not accept the precious and self-centred view that systems analysts and natural scientists have no business to trespass in the exclusive realm of the social sciences. On the contrary, we think that the MIT work has done a great deal of good in compelling social scientists to re-examine some of their assumptions and in exposing the limitations both of data and of satisfactory explanatory theories for some of the most important social mechanisms.

Since the days of Malthus and Ricardo, economists have tended to neglect problems of resource depletion; they have been slow to develop the economics of pollution; and it is good for them to be reminded that their explanations of long-term growth and technical progress are still in an unsatisfactory state. Neither economists, nor sociologists, nor political scientists have satisfactory theories of social change and it is unlikely that they will develop them unless they overcome their fragmentation into separate jealously guarded kingdoms and learn to cooperate with each other and with natural scientists, looking at the kind of fundamental long-term problems which are at the heart of the MIT work.

Consequently, we do not reproach the MIT group with being over-ambitious in attempting to bring together expertise from many different disciplines, although we are critical in many respects of the way in which they have done it. If anything, we might reproach them for not being inter-disciplinary enough. Our own essays were prepared by an equally mixed team: Cole is a mathematical physicist, Sinclair a health physicist and nuclear engineer, Pavitt an engineer and an economist, Page a social psychologist, Surrey and Bromley are economists specialising in energy, Curnow is a statistician, Julien and Cooper are economists, Marstrand an applied biologist, and Simmons a political scientist. The whole team was co-ordinated by Marie Jahoda, Professor of Social Psychology at Sussex, and Chairman of the forecasting research

group. In addition we had the benefit of valuable comments on our drafts from demographers, geologists, sociologists, geographers, ecologists, agricultural economists, control engineers and systems analysts.

The first part of the critique examines in some detail the structure and assumptions of the MIT models. After a general introduction to the models by Cole a chapter is devoted to each of the principal sub-systems: resources, population, agriculture, capital and pollution (chapters 3 to 7). Although energy is treated in the MIT models as part of "non-renewable resources", we believed it to be sufficiently important to warrant separate treatment (chapter 8). For each sub-system the assumptions are critically analysed in relation to available data. With the exception of the population sector they are generally found to be unsatisfactory. After this review of the separate sub-systems Cole and Curnow return in chapter 9 to a discussion of the model as a whole, and its sensitivity to a few key assumptions. All of these are highly debatable and in our view difficult to justify.

The question which we ask in relation to each sub-system and the model as a whole is: how far do the assumptions made correspond to what is known about the real world before 1970, and to what might be plausibly assumed about the world's probable future development from then onwards? Admittedly this is a severe test for any model to satisfy since the real world is extremely complex and diverse and it is very difficult to make simplifying assumptions which are realistic and mutually consistent. Some may doubt whether it is feasible to satisfy this requirement for world model-building at all. However, this is the test which is actually prescribed by the MIT team for their own work.[2]

They rightly believe that ideally each relationship in the model should be an accurate representation of a real world phenomenon and that model behaviour must be in reasonable agreement with real world behaviour. This implies the need to assemble time series data on the variables in the real world from 1900 to 1970.

Our examination suggests that the MIT models do not on the whole satisfy these requirements. This is partly a problem of data and partly a question of assumptions about relationships. The MIT team cannot be blamed for the lack of data, although they may be criticised for trying to erect such an elaborate theoretical structure and such sweeping conclusions on so precarious a data base. The MIT team are, however, responsible for the choice of assumptions and for the relative neglect of economics and sociology.

The nature of their assumptions is not a purely technical problem. It is essential to look at the political bias and the values implicitly or explicitly present in any study of social systems. The apparent detached neutrality of a computer model is as illusory as it is persuasive. Any model of any social system necessarily involves assumptions about the workings of that system, and these assumptions are necessarily coloured by the attitudes and values of the individual or groups concerned. For this reason too Cole and Curnow conclude that computer models should be regarded as an integral part of political debate, just because they may hide possible sources of bias. The model is the message.

This is particularly important in relation to forecasting models. Subjective values and attitudes do influence forecasts, however much the individual may

strive for objectivity. It does matter in considering forecasts of the future patterns of world energy demand and their implications for pollution whether the forecasters are working in the oil industry, the nuclear power industry or the coal industry. This does not mean that all forecasters are paid hacks or manipulate their data in a dishonest way but only that the environment in which a forecaster works influences his theoretical assumptions. His sources of data necessarily influence (often unconsciously) the form and presentation of a complex argument in which values are inevitably and inextricably involved.

The MIT system dynamics group is no exception to this rule. As we shall see, they place great emphasis on "computer models" versus "mental models". They argue that in understanding the behaviour of complex systems, computer models have great advantages. This view is unexceptionable if we are considering the number of variables, complex interactions and speed of calculation. But it can easily and dangerously be exaggerated into what is best described as computer fetishism. The computer fetishist endows the computer model with a validity and an independent power which altogether transcends the mental models which are its essential basis. Because of the prevalence of this computer fetishism it cannot be repeated too often that the validity of any computer calculation depends entirely on the quality of the data and the assumptions (mental models) which are fed into it. Computer models cannot replace theory.

The healthy reaction to computer fetishism is exemplified by the terse aphorism "Garbage in, garbage out". What has gone into the *The Limits to Growth* model is not garbage. On the contrary a great deal of effort has been made to find data, to develop reasonable assumptions about the real world and to test the model. But Meadows has himself emphasised that only about 0·1% of the data on the variables required to construct a satisfactory world model is now available. Moreover, as will be shown in these essays, little is known about the forces which determined past relationships between some of the variables; still less about their future relationships.

This inevitably means that the modellers are required to make assumptions about relationships and to make estimates about data. There are many possible assumptions about such a complex system as the future of the human race. Consequently, the MIT team has had to choose between alternative assumptions. Moreover, since the world is so complex they (or anyone else attempting a world model) had to omit what they consider to be irrelevant. These decisions are matters of judgement, not of fact or mathematics. (Meadows calls them "Hazards of Omission".) For example, the MIT team tried to concentrate on physical limits to growth and omit changes in values, yet these changes may be the most important dynamic element in the whole system.

The assumptions and judgements made by the computer modellers depend no less than those of other social scientists on their mental models—on their information, their bias, their experience, their capacity and their values. Consequently, although it would be quite wrong to talk of "garbage" in the MIT model, there is a real point in the description: "Malthus in, Malthus out". In fact, as we shall see, the MIT model is not strictly Malthusian. Many assumptions are made which have little to do with that country parson. But the expression: "Malthus in, Malthus out" does bring out the essential point that

what is on the computer print-out depends on the assumptions which are made about real-world relationships, and these assumptions in turn are heavily influenced by those contemporary social theories and values to which the computer modellers are exposed.

Therefore, the critique of a computer model is not just a question of looking at the structure, or conducting mathematical tests. Far more important is the examination of the underlying assumptions. That is the reason for this chapter's title. It is also the reason for devoting the second part of the critique to a discussion of the ideological background to the distinctive MIT approach to world forecasting. This may reasonably and precisely be described as a neo-Malthusian approach.

The MIT work is the most numerate, influential and clearly formulated statement of this position. Because of the prestige of the computer and of MIT, it is also frequently cited in other doomsday literature as an authoritative source for views which otherwise might be rather difficult to justify. Thus, for example, the *Ecologist* "Blueprint for Survival" cites Forrester's work as justification for the view that economic growth in Britain must cease and the population decline to 30 million. [3]

This resurgence of Malthusian ideas is combined in the MIT approach with a strong, almost Messianic faith in the more modern system dynamics, and a strong pre-occupation with environmental issues characteristic of contemporary American thought. It is the convergence of these various strands which gives the MIT work its peculiar flavour, conveyed in the title to this chapter. In the second part of the critique we trace briefly the development of economic thought in relation to the problems raised by Malthus (chapter 10), and review the experience of population forecasting (chapter 11). Historically, it is difficult to find any similar body of theory or quantitative forecasting experience in relation to environmental problems, but we nevertheless believed it would be useful also to review, partly from purely literary sources, some aspects of the development of environmental concern (chapter 12). These chapters and, even more so, Simmons' polemical critique of Forrester's techno-cratic tendencies (chapter 13) are necessarily more sketchy, subjective, speculative and overtly political than the detailed critical analysis of the MIT model itself.

It was suggested to us that, because of their more speculative and controversial character, these chapters ought to be omitted. We, however, did not accept this view, believing that discussion of the ideological background of the MIT work is just as important as the technical aspects and indeed, for reasons which have already been discussed, the two are intimately related. We would, nevertheless, certainly accept that the views advanced in these essays reflect our own political biases and subjective limitations. Our value judgements and intellectual assumptions are as much a part of the debate as those of MIT. As we shall see, there are obviously some big differences in the approach of Forrester on the one hand and Meadows on the other, and no doubt there were many other differences of opinion between the various members of the MIT team, as there certainly were in ours. It is similarly difficult to generalise about the bias of our group. It included people of very diverse political views ranging across the whole spectrum from Conservative to Marxist, and some of no

identifiable political complexion. It included members from many different disciplines, and we were not united, as were the MIT group, by a common faith in system dynamics. But we were, and are, agreed on the urgency of many of the social and political problems raised by *The Limits to Growth*, and the belief that satisfactory solutions can only emerge as a result of a continuing process of research, political debate, and social experiment.

It is for this reason that I personally believe that the open public debate surrounding the MIT work is their most important achievement. To remove any possible misconception, I am not suggesting through my choice of quotation at the beginning of this introduction that the MIT work is a piece of plagiarism. On the contrary, it is one of the most original and ambitious constructions in the history of the social sciences. The parallel which is implied between the work of Malthus and that of MIT lies purely in the stimulus which they have both given to an extremely important debate. Because our team at Sussex is agreed that science and social policy can only advance by continuous critical debate and discussion, we see our own contribution as only one stage in this continuing process. Therefore it may be useful in this introduction to focus on three of the essential differences between our views and those of MIT.

First, we put much greater emphasis on the political and social limits to growth than on the purely physical limits. Our reasons for scepticism and disagreement about many of the MIT physical estimates are explained in detail here. Since we believe that brute poverty is still a major problem for most people in the world, and since in general we do not believe that the physical constraints are quite so pressing as the MIT team suggest, we do not accept their enthusiastic endorsement of zero growth as the ideal for the world. We do agree with them, however, on the need to develop new technologies which do not damage the environment and which contribute to the conservation of finite resources. In our view the Growth versus No Growth debate has become a rather sterile one of the Tweedledum/Tweedledee variety, because it tends to ignore the really important issues of the *composition* of growth in output, and the *distribution* of the fruits of growth. Some types of growth are quite consistent not merely with conservation of the environment, but with its enhancement. The problem, in our view, is a socio-political one of stimulating this type of growth and of more equitable distribution, both between countries and within them.

Secondly, technical change is at the heart of our differences. We believe that, like Malthus, the MIT group is underestimating the possibilities of continuous technical progress. "Progress" is used here in the economic sense of greater output from the same inputs or reduced inputs, or the introduction of new products and processes. It does not necessarily imply a value judgement on the desirability of a particular set of technical changes. As Cole and Curnow demonstrate in chapter 9 (and as other critics have also shown), the inclusion of technical progress in the MIT model in sectors from which it is omitted has the effect of indefinitely postponing the catastrophes which the model otherwise predicts.

When we are making forecasts for 130 years ahead, as in the MIT models, it is extremely important to make realistic judgements about technical progress. As Surrey and Bromley point out in chapter 8, a forecast made in 1870 would

have omitted the principal source of energy in 1970 (oil) and the fastest growing new source (nuclear power). It would probably have excluded not only all the synthetic materials, fibres and rubbers, but probably aluminium and sundry other metals. As Page points out in chapter 3, the concept of "reserves" in most resource forecasting is techno-economic rather than geo-physical and the world reserves of most known materials would probably have been underestimated by orders of magnitude. The technologies of resource exploration, extraction and re-cycling have changed the picture out of all recognition. We should not fall into the error of some of the more pessimistic ecologists: failure to consider the tremendous potential of changing technology in relation to human social systems.

This does not mean, of course, that continuous technical progress will inevitably occur. The fact that it has occurred between 1870 and 1970 does not necessarily mean that it will continue to 2070. There are two perfectly respectable grounds for pessimism. It could be maintained on purely technical grounds that the world has now encountered or is about to encounter technical problems of such difficulty and magnitude that discontinuities may reasonably be expected. Or, it could be maintained that, although technically feasible, progress cannot be sustained for institutional reasons. It is apparently for some combination of these reasons that Meadows is particularly harsh in his attack on "technological optimism". While we do not believe that the model itself validates these arguments, they may nevertheless be true and certainly deserve serious consideration and debate.

The resources now devoted to organised research and development are many times greater than they were in 1870. At that time the social invention of the industrial research laboratory had only just been made. Today these laboratories are characteristic institutions in industry as well as in government and universities. In addition the resources now devoted to dissemination of knowledge are huge and still growing. On these grounds it might reasonably be supposed that the rate of technical change could be expected to accelerate rather than to diminish, and this is indeed the supposition of many environmentalists as well as economists. But there are several grounds for doubt. First, there is some evidence of diminishing returns to investment in research and development and education. This might be expected as scientists and engineers approach extreme limits of temperature, pressure and size as well as for other reasons. The very high cost of some types of research equipment is one reflection of these problems although there is the counter argument of the revolutionary breakthrough, such as the transistor in communications equipment.

Secondly, there is much stronger evidence of serious mal-distribution of the large resources which are now devoted to R and D. These problems are at the heart of our own interest in Sussex as a Research Unit concerned with policy for science and technology. As members of our team have shown in detail elsewhere,[4] there are very disquieting features in the pattern of deployment of the world's scientific and technical resources. About half the total is devoted to military and prestige objectives and less than 2% of the world's R and D effort is devoted to the urgent agricultural, environmental and industrial problems of the developing countries. Although there has been a welcome impetus to the development of new techniques from recent environmental

legislation in the richer countries, the scale of effort remains very small. Unless this imbalance is rectified, there must be continuing cause for concern about the possibility of sustained technical progress in food supply, energy and environmental improvement. This is at the heart of the political and social changes we believe to be necessary.

The MIT work rightly points to the importance of the delays in response mechanisms, which may make remedial or avoiding action too little and too late. Nowhere is this more true than in relation to investment in R and D. The quality of life for future generations depends in large measure on a wise deployment of scientific resources today. From this standpoint, a high priority for much long-term R and D can be justified, including for example, both research on solar energy and on fusion power. World R and D is in the nature of a global insurance policy.

Moreover, we agree with the MIT group that the problem of unwelcome secondary effects of technical change is a very serious one. In retrospect, the decision of the United States Congress to set up an Office of Technology Assessment may appear as a political turning point, since it marks the recognition that a policy of "laissez-innover" is as undesirable as "laissez-faire" in relation to social and economic policy. We would agree with the MIT group that social institutions for anticipating and coping with the manifold problems of technical change are embryonic and still inadequate. But we have perhaps greater faith than they have in the adaptive response of human beings to these problems. This in turn is related to our differing views of social change which Marie Jahoda discusses in chapter 14.

Finally, we are not wholly convinced that world models based on system dynamics can develop into satisfactory tools of forecasting and policy-making. We regard this as still a question for experiment and discussion, whereas the MIT team are prepared to base a prescription for the world on the results of their model. Although we believe that mathematical modelling and system dynamics can make an important contribution to the social sciences, we also believe that there are serious dangers in the way that these models are often used or misused. One of our colleagues in the University, Dr R. Golub, a physicist, has argued strongly that the MIT approach is inherently dangerous, since it encourages self-delusion in five ways:

● By giving the spurious appearance of precise knowledge of quantities and relationships which are unknown and in many cases unknowable.
● By encouraging the neglect of factors which are difficult to quantify such as policy changes or value changes.
● By stimulating gross over-simplification, because of the problem of aggregation and the comparative simplicity of our computers and mathematical techniques.
● By encouraging the tendency to treat some features of the model as rigid and immutable.
● By making it extremely difficult for the non-numerate or those who do not have access to computers to rebut what are essentially tendentious and rather naive political assumptions.

In short, Golub believes that the method is an attempt to substitute mathe-

matics for knowledge and computation for understanding. We agree with him that these dangers are present in the world models, and often in other models too. Some members of our team would agree with Golub that these arguments constitute reason for rejecting altogether the system dynamics approach to the world. Harvey Simmons too argues in chapter 13 that there are strong simplistic technocratic tendencies inherent in Forrester's approach. Ida Hoos has given a similar warning about the uncritical application of systems research techniques to social problems.[5] Moreover, the experience of systems model-building in ecology and meteorology lends considerable weight to the view that our attempts to model complex systems are still at a very primitive level.

However, most members of our team, among them myself, while agreeing with Golub and Simmons about all the dangers which they point to, nevertheless believe that the attempt to develop satisfactory mathematical models is worthwhile and can be a valuable aid to systematic thought for the reasons advanced by Cole in chapter 2. It may prove difficult for a long time to overcome the justifiable objections which can be raised and we would certainly all approach social systems models with great scepticism. Any attempt to represent future tendencies in the world, whether in words or in numbers, is attended by great difficulties. We nevertheless believe such attempts to be of great importance, whether in the arts or the sciences. Even if our judgement on this particular MIT model is largely negative, we may nevertheless see some point in the quotation with which this chapter begins, in the sense of its being a stimulus for an extremely fundamental debate.

References

1. D. Gabor, "The new responsibilities of science", *Science Policy*, Vol. 1, No. 3, May–June, 1972
2. Technical Report and *The Limits to Growth*
3. E. Goldsmith, ed, "Blueprint for survival", *Ecologist*, Vol. 2, No. 1, January, 1972
4. C. Freeman *et al.*, "The goals of R & D in the 1970s", *Science Studies*, Vol. 1, pages 357–406, 1971
5. I. Hoos, *Systems Analysis and Social Policy* (London, Institute for Economic Affairs, 1969)

2. THE STRUCTURE OF THE WORLD MODELS

H. S. D. Cole

The world models of *World Dynamics* and *The Limits of Growth* and the claims of their respective authors are described. In examining the overall structure of the models, the method of calculation and the data base, features are noted which could cause the results to be in error and might cast doubt on the conclusions that have been drawn from them.

World 2

THE world will encounter one of several possible alternative futures depending on whether population growth is eventually suppressed by shortage of natural resources, by pollution, by crowding and consequent social strife, or by insufficient food. Malthus dealt only with the latter, but it is possible for civilisation to fall victim to other pressures before food shortages occur.

This statement is made by Forrester in the introduction to *World Dynamics*. The basis for his prediction is, he explains, "that population, capital investment, pollution, food consumption and standard of living have been growing exponentially throughout recorded history" and that these "rising forces cannot be resolved by the historical solutions of migration, expansion, economic growth and technology".

While the human mind is a powerful tool for identifying the main features of complex problems such as the world's future, Forrester says, it is poor at estimating the dynamic consequences of the way the parts of a system will interact. He argues however that by translating the mental picture (or model) into a computer model the dynamic consequences can be determined correctly through the computer's ability to manipulate information without error. Consequently, to examine these rising forces in the world and the alternative futures they promise, Forrester has built a computer model of the world. He calls this World 2 and describes it as: "A dynamic model of world scope—a model which inter-relates population, capital investment, geographical space, natural resources, pollution and food production."

To examine the problems correctly Forrester implies that it is necessary to consider the world system as a whole, and none of the sectors can be considered in isolation. His model, therefore, contains many mechanisms which link the

sectors together and upon which he places much importance. The actual computer model consists of a set of programmed equations, but it can also be represented in formal system dynamics[1] notation as in Figure 1.

Forrester has "run" (tested) the model and adjusted its parameters to ensure that it generates trends for world population, capital investment and so on which exhibit plausible agreement with world trends during the period 1900 to 1970. On the strength of this he argues that he is entitled to use the model to project these trends forward to the year 2100. This he has done and the results of the exercise, the "standard run" for World 2, are shown in Figure 2.

Population rises to a peak in the year 2020 and thereafter declines. This decline in population is caused in this figure by falling natural resources. The falling natural resources lower the material standard of living enough to reduce population . . . the supply of natural resources was assumed (in section 3.8 of *World Dynamics*) sufficient to last for 250 years at the 1970 rate of usage . . . The effect of rising demand and falling supply is to create the dynamic consequences of change, not 250 years in the future, but only 30 to 50 years hence (Section 4.2, *World Dynamics*).

He explains that this result is typical of a system in which exponential growth is colliding with a finite limit. In the same way he uses his model to show that even if the efficiency of use of resources is improved by a factor of four from 1970 onwards (thereby avoiding the resource crisis) population decline still occurs as a consequence of rising pollution levels. In fact Forrester suggests that as one barrier to growth is removed another will take its place. His conclusions are qualified but forceful.

Within the next century, man may face choices from a four-pronged dilemma— suppression of modern industrial society by a natural resource shortage; decline of world population from changes wrought by pollution; population limitation by food shortage; or population collapse from war, disease, and social stress caused by physical and psychological crowding (Section 1.3, *World Dynamics*).

He suggests that catastrophe can only be avoided by implementing combined and rather drastic policies with respect to the control of population, capital investment and pollution which would lead to a state of world equilibrium. This equilibrium would be characterised by stationary levels of population and standards of living and a steady depletion of natural resources.

Forrester is careful to point out that his model is not sufficiently precise to show the actual form of collapse which would follow from a continuation of present world trends. Even so, as he explains in the preface to his book, Forrester does consider it a sufficient basis for recommending policy actions, particularly in view of the inherent advantages of computer models over mental models.

World 3

Using Forrester's model as his prototype, Meadows has constructed a more elaborate world model, with which to examine in more detail the factors limiting growth and which are potentially responsible for catastrophe. This model, World 3—described in *The Limits to Growth*—has the same basic structure and underlying assumptions as World 2, but it contains about three times as many mathematical equations and many of the numerical relationships are

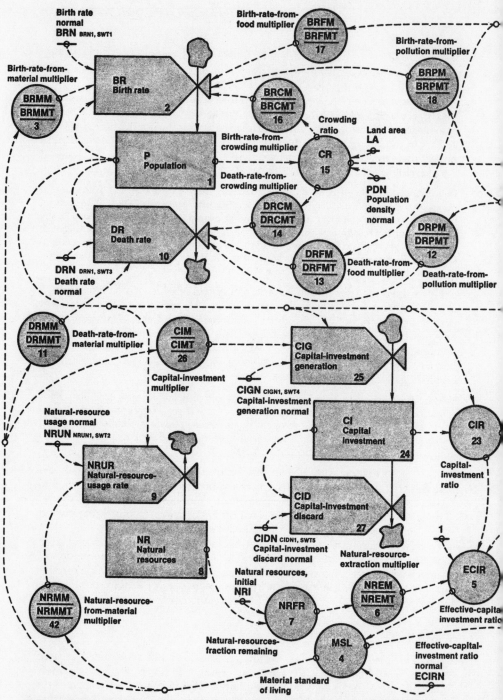

Figure 1. The complete World 2 model (*World Dynamics* by J. W. Forrester, © 1971, Wright-Allen Press, Cambridge, Massachusetts 02142). The World 2 model is represented here by a flow diagram in formal system dynamics style. The names and acronyms of each variable are shown in the diagram. Physical quantities (termed levels) that can be measured directly are drawn as boxes ▭, rates that influence those levels are drawn as valves ◁, and auxiliary variables that influence the

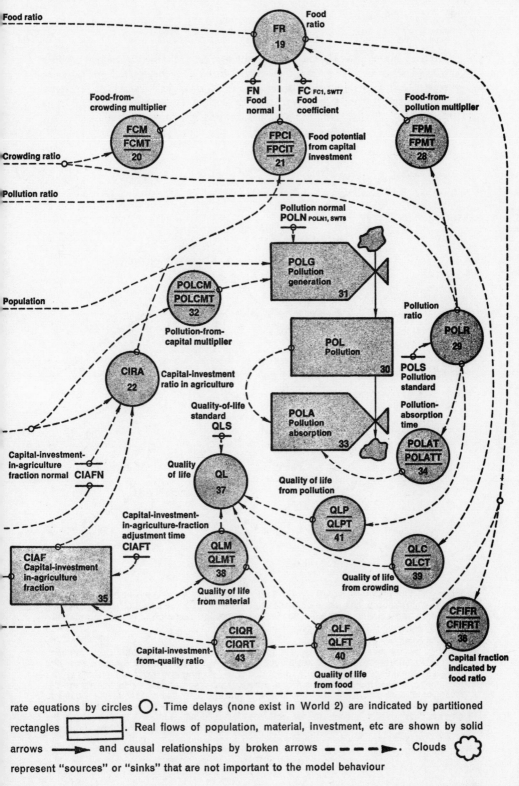

Food ratio

FR 19 — Food ratio

Food-from-crowding multiplier

FCM / FCMT 20

Crowding ratio

FN — Food normal
FC FC1, SWT7 — Food coefficient

FPCI / FPCIT 21 — Food potential from capital investment

Food-from-pollution multiplier

FPM / FPMT 28

Pollution ratio

Pollution normal
POLN POLN1, SWT6

POLG — Pollution generation **31**

POLCM / POLCMT 32 — Pollution-from-capital multiplier

Population

POL — Pollution **30**

POLR 29 — Pollution ratio

POLS — Pollution standard

CIRA 22 — Capital-investment ratio in agriculture

Quality-of-life standard
QLS

POLA — Pollution absorption **33**

Pollution-absorption time

POLAT / POLATT 34

Capital-investment-in-agriculture fraction normal CIAFN

Quality of life

QL 37

Quality of life from pollution

QLP / QLPT 41

Capital-investment-in-agriculture-fraction adjustment time CIAFT

QLM / QLMT 38

Quality of life from crowding

QLC / QLCT 39

CIAF — Capital-investment-in-agriculture fraction **35**

Quality of life from material

CIQR / CIQRT 43 — Capital-investment-from-quality ratio

QLF / QLFT 40

Quality of life from food

CFIFR / CFIFRT 36

Capital fraction indicated by food ratio

rate equations by circles ○. Time delays (none exist in World 2) are indicated by partitioned rectangles ▭. Real flows of population, material, investment, etc are shown by solid arrows ——➤ and causal relationships by broken arrows – – – –➤. Clouds ☁ represent "sources" or "sinks" that are not important to the model behaviour

B

estimated from empirical data. The complete model is shown in Figure 3[2]. The futures generated by the Meadows' model differ only in detail from those of Forrester. Figure 4 shows the "standard run" for World 3. As with Forrester's model, the results have fair agreement with world average growth patterns from 1900 to 1970. As with Forrester's model, growth is followed by collapse.

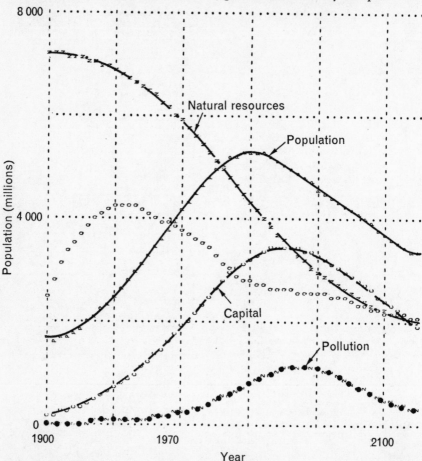

Figure 2. The standard run of World 2—a projection of current world trends. Steadily increasing resource costs inhibit industrial growth. This has the effect of lowering standards and causing population to decline. Although pollution is increasing steadily, it plays no part in this particular catastrophe

How to read the graphs
The figures are drawn over graphical computer output. The horizontal scale is in years. For each parameter the vertical scale is automatically adjusted so that the computer plot makes the best use of the graphs. Consequently the scaling and range of each parameter may vary between graphs. Where this occurs it is pointed out. Numerical values are not given for all parameters since what is important for the discussion is the levels relative to the 1970 values or relative to the "standard run" and this can be judged directly from the curves. The graphs shown in this collection have been produced by re-running the MIT program. In some cases the scales differ slightly from the corresponding figures in *World Dynamics* and *The Limits to Growth*.

In this run the collapse occurs because of non-renewable resource depletion. The industrial capital stock grows to a level that requires enormous input of resources. In the very process of growth it depletes a large fraction of the reserves available. As resource prices rise and mines are depleted, more and more capital must be used for obtaining resources, leaving less to be invested for future growth. Finally investment cannot keep up with depreciation, and the industrial base collapses, taking with it the service and agricultural systems, which have become dependent on industrial inputs (such as fertilisers, pesticides, hospital laboratories, computers and especially energy for mechanisation). For a short time the situation is especially serious because population, with the delays inherent in the age structure and the process of social adjustment, keeps rising. Population finally decreases when the death rate is driven upward by lack of food and health services (*The Limits to Growth*, page 125).

This run is the result of assuming "that there will be in the future no great changes in human values nor in the functioning of the global population-capital system as it has operated for the last one hundred years".

As with Forrester, Meadows points out that because of simplifications in the model "the exact timing of the event is not meaningful" but he says, it is significant that growth is stopped well before 2100. For the standard run Meadows assumed the same world stock of non-renewable natural resources as Forrester. He considers that 250 years supply at 1970 usage rates is "optimistic" but tests this model assumption by doubling the resource reserves in 1900. The results are still catastrophic but the collapse occurs for different reasons.

Now industrialisation can reach a higher level since resources are not so quickly depleted. The larger industrial plant releases pollution at such a rate, however, that the environmental pollution absorption mechanisms become saturated. Pollution rises very rapidly, causing an immediate increase in the death rate and a decline in food production. At the end of the run resources are severely depleted in spite of the doubled amount initially available (*The Limits to Growth*, page 127).

Meadows goes on to consider other futures which would be brought about by successive optimistic changes to his original assumptions. He looks finally at the combined effect of improving resource usage by a factor of four, reducing pollution generation by one fourth of its 1970 rate, doubling agricultural land yields, together with a reduction in birth rate. The result is still an end to growth before the year 2100.

In the light of his results Meadows, like Forrester, then goes on to examine the sort of changes needed to establish a state of global equilibrium. In addition to the fixed improvements in the various technologies already included in the model, equilibrium would necessitate further restriction of population growth (for example limiting families to two children only), fixing world average industrial output *per capita* at its 1975 levels, shifting the economic preferences of society towards services such as education and away from material consumption as well as increasing the durability of goods. Meadows shows that if these changes are not implemented until the year 2000, even the equilibrium state would no longer be achievable. "Population and industrial capital reach levels high enough to create food and resource shortages before the year 2100."

Meadows has some confidence in his model and he is far more positive than Forrester. In the introduction to *The Limits to Growth* he says:

KEY

1. IC. Industrial Capital
2. ICDR. Industrial Capital Depreciation Rate
3. ALIC. Average Lifetime of Industrial Capital
4. ICUF. Industrial Capital Utilisation Fraction
5. IO. Industrial Output
6. ICOR. Industrial Capital Output Ratio
7. ICIR. Industrial Capital Investment Rate
9. FIOAC. Fraction of Industrial Output Allocated to Consumption
11. IOPC. Industrial Output *Per Capita*
12. ISOPC. Indicated Service Output *Per Capita*
15. FIOAS. Fraction of Industrial Output Allocated to Services
18. SCIR. Service Capital Investment Rate
19. SC. Service Capital
20. SCDR. Service Capital Depreciation Rate
21. ALSC. Average Lifetime of Service Capital
22. SO. Service Output
23. SCOR. Service Capital Output Ratio
24. SOPC. Service Output *Per Capita*
25. F. Food
25.1. LFH. Land Fraction Harvested
25.2. PL. Processing Loss
26. PAL. Potentially Arable Land
27. AL. Arable Land
28. LFC. Land Fraction Cultivated
28.1. PALT. Potentially Arable Land Total
29. DCPH. Development Cost per Hectare
30. LDR. Land Development Rate
31. IFPC. Indicated Food *Per Capita*
34. TAI. Total Agricultural Investment
35. FIOAA. Fraction of Industrial Output Allocated to Agriculture
38. FPC. Food *Per Capita*
39. LY. Land Yield
40. LYF. Land Yield Factor
41. AIPH. Agricultural Inputs Per Hectare
42. LYMC. Land Yield Multiplier from Capital
43. CAI. Current Agricultural Inputs
44. AI. Agricultural Inputs
46. FIALD. Fraction of Investment Allocated to Land Development
47. MPLD. Marginal Productivity of Land Development

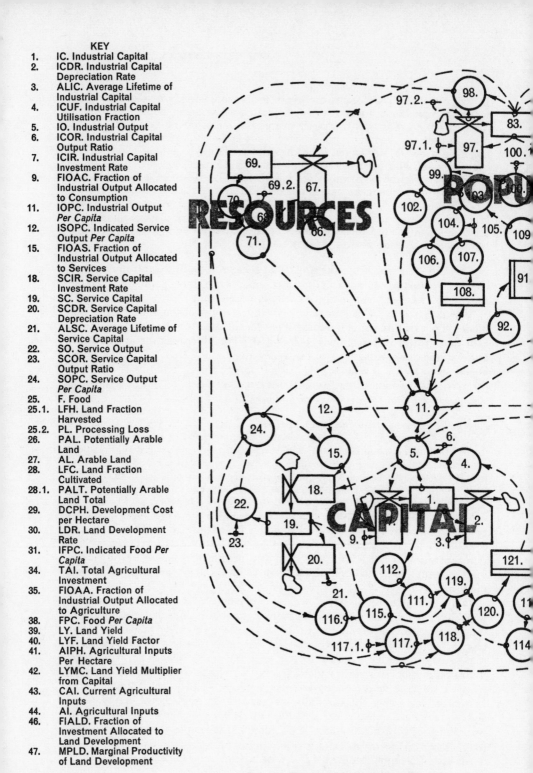

Figure 3. The complete World 3 model.

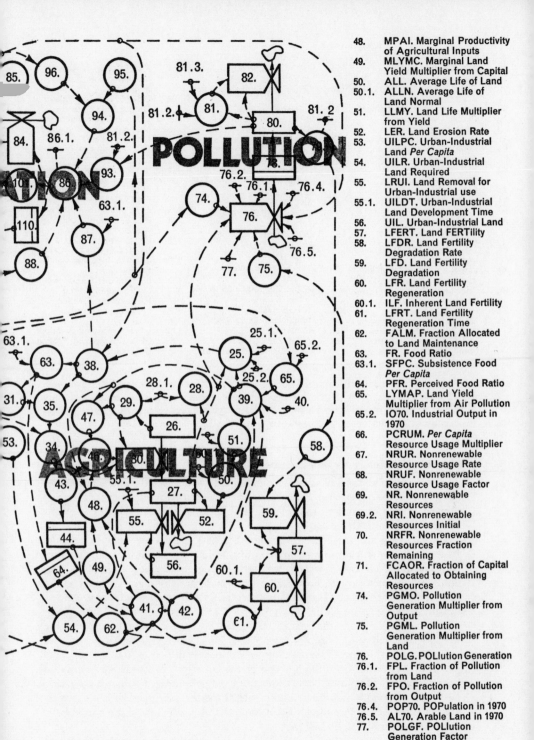

48. MPAI. Marginal Productivity of Agricultural Inputs
49. MLYMC. Marginal Land Yield Multiplier from Capital
50. ALL. Average Life of Land
50.1. ALLN. Average Life of Land Normal
51. LLMY. Land Life Multiplier from Yield
52. LER. Land Erosion Rate
53. UILPC. Urban-Industrial Land *Per Capita*
54. UILR. Urban-Industrial Land Required
55. LRUI. Land Removal for Urban-Industrial use
55.1. UILDT. Urban-Industrial Land Development Time
56. UIL. Urban-Industrial Land
57. LFERT. Land FERTility
58. LFDR. Land Fertility Degradation Rate
59. LFD. Land Fertility Degradation
60. LFR. Land Fertility Regeneration
60.1. ILF. Inherent Land Fertility
61. LFRT. Land Fertility Regeneration Time
62. FALM. Fraction Allocated to Land Maintenance
63. FR. Food Ratio
63.1. SFPC. Subsistence Food *Per Capita*
64. PFR. Perceived Food Ratio
65. LYMAP. Land Yield Multiplier from Air Pollution
65.2. IO70. Industrial Output in 1970
66. PCRUM. *Per Capita* Resource Usage Multiplier
67. NRUR. Nonrenewable Resource Usage Rate
68. NRUF. Nonrenewable Resource Usage Factor
69. NR. Nonrenewable Resources
69.2. NRI. Nonrenewable Resources Initial
70. NRFR. Nonrenewable Resources Fraction Remaining
71. FCAOR. Fraction of Capital Allocated to Obtaining Resources
74. PGMO. Pollution Generation Multiplier from Output
75. PGML. Pollution Generation Multiplier from Land
76. POLG. POLlution Generation
76.1. FPL. Fraction of Pollution from Land
76.2. FPO. Fraction of Pollution from Output
76.4. POP70. POPulation in 1970
76.5. AL70. Arable Land in 1970
77. POLGF. POLlution Generation Factor

78.	POLAR. POLlution Appearance Rate	
79.	POLX. Persistent POLlution relative to 1970	
80.	POL. persistent POLlution	
81.	POLAT. POLlution Absorption Time	
81.2.	POL70. POLlution in 1970	
81.3.	POAT70. POLlution Absorption Time in 1970	
82.	POLA. POLlution Absorption rate	
83.	POP. POPulation	
84.	D. Deaths per year	
85.	CDR. Crude Death Rate	
86.	LE. Life Expectancy	
86.1.	LEN. Life Expectancy Normal	
87.	LMF. Lifetime Multiplier from Food	
88.	LMHS. Lifetime Multiplier from Health Services	
91.	EHS. Effective Health Services	
92.	HS. Health Services	
93.	LMP. Lifetime Multiplier from persistent Pollution	
94.	LMC. Lifetime Multiplier from Crowding	
95.	CMI. Crowding Multiplier from Industrialisation	
96.	FPU. Fraction of Population Urban	
97.	B. Births per year	
97.1.	FFW. Fraction of Fertile Women	
97.2.	RLT. Reproduction Life-Time	
98.	CBR. Crude Birth Rate	
99.	TF. Total Fertility	
100.	MBTF. Maximum Biological Total Fertility	
100.1.	MBTFN. Maximum Biological Total Fertility Normal	
101.	FM. Fecundity Multiplier	
102.	BCE. Birth Control Effectiveness	
103.	DTF. Desired Total Fertility	
104.	DCFS. Desired Completed Family Size	
105.	DCFSN. Desired Completed Family Size Normal	
106.	FNMR. Family Norm Multiplier from Resources	
107.	FNMSS. Family Norm Multiplier from Social Structure	
108.	DIOPC. Delayed Industrial Output Per Capita	
109.	CMPLE. Compensatory Multiplier from Perceived Life Expectancy	
110.	PLE. Perceived Life Expectancy	
111.	PJIS. Potential Jobs in Industrial Sector	
112.	JPICU. Jobs Per Industrial Capital Unit	
113.	JPH. Jobs Per Hectare	
114.	PJAS. Potential Jobs in Agricultural Sector	
115.	PJSS. Potential Jobs in Service Sector	
116.	JPSCU. Jobs Per Service Capital Unit	
117.	LFF. Labour Force Fraction	
117.1.	LFPF. Labour Force Participation Fraction	
118.	LF. Labour Force	
119.	J. Jobs	
120.	UF. Unemployed Fraction	
121.	UFD. Unemployed Fraction Delayed	

We feel that the model described here is already sufficiently developed to be of some use to decision makers. Furthermore, the basic behaviour modes we have already observed in this model appear to be so fundamental and general that we do not expect our broad conclusions to be substantially altered by further revisions (*The Limits to Growth*, page 22).

How the models will be examined

The social implications of the future indicated by the world models are extensive, to say the least, and have received wide publicity. However, forecasts derived from a computer are no less fallible than any others and so the results must receive careful scrutiny.

In one sense at least Forrester's and Meadows' results are incontrovertible. Exponential growth of population and industrialisation on a finite planet cannot continue indefinitely. However, they are saying much more than just this; firstly, the present growth must end within the lifetime of a large proportion of the world's present population, and secondly, and more frightening, unless drastic steps are taken global disaster will occur. Their results have been given added weight because they derive from the computer, even though on the strength of their basic premise alone it is clear that exponentially growing resource use, depleting 250 years' supply of resources at present usage rates, must end rather quickly. So although one could go a long way towards verifying Forrester's and Meadows' conclusions simply by checking the main underlying assumptions upon which their mathematical models are based, it is also necessary to examine the actual models in some detail. Criticisms of the model have to be computerised to be believed.

Models can have many forms; the only categories distinguished here are mental and mathematical models in order to point out their complementary natures. Mental modelling is the process of simplification in order to achieve

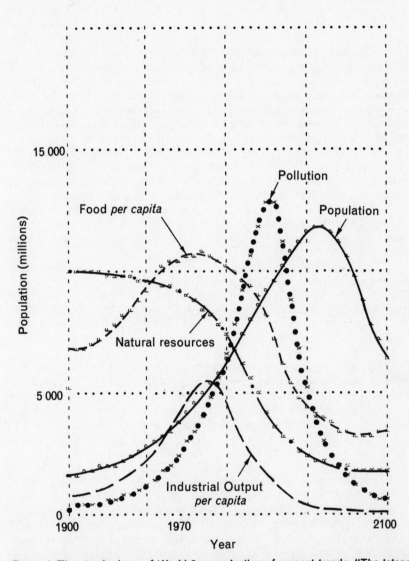

Figure 4. The standard run of World 3—a projection of present trends. "The 'standard' model run assumes no major change in the physical, economic or social relationships which have historically governed the development of the world system. All variables plotted here follow historical values from 1900 to 1970. Food, industrial output and population grow exponentially until the rapidly diminishing resource base forces a slowdown in industrial growth. Because of natural delays in the system, both population and pollution continue to increase for some time after the peak of industrialisation. Population growth is finally halted by a rise in death rate due to decreased food and medical services." (*The Limits to Growth*, page 124)

conceptual clarification and understanding. In the process, details are ignored and often forgotten but generality may be gained. Patterns and relationships are uncovered and more and more processes can be drawn into the same mental picture. Mathematical modelling can be used to supplement mental modelling. The consequences of assumptions derived from a mental model can be more exactly determined using the corresponding mathematical model, although invariably in translating a mental model into a mathematical one more details and nuances are lost. Further, even if the equations in a model are to be manipulated using a computer, there are still severe constraints on the amount of detail that can be considered. Often the question arises as to whether the degree of simplification needed to achieve a model that can be manipulated renders the approach worthless except as an interesting exercise. However, the act of quantification, the need to formalise the relationships, and the results themselves can all contribute to additional qualitative insights, and these in turn may be introduced into both the mental picture and the mathematical model itself. Even if little is known for sure about the system being modelled (so the results of the mathematical model cannot be considered reliable), its function as a playground for ideas can be valuable for developing understanding.

A mathematical model of a process is nothing more than a set of equations which one would like to generate trends similar to those observed for the real world. The model is considered to be a good simulation if it does in fact reflect the real world. However the situation is in practice not as clear cut as this. Many models can generate similar trends or the same model may give different results with different methods of calculation, but what constitutes the "real world" is a matter for debate.

This applies to all mathematical model building, not just to Forrester's and Meadows'. Because the degree to which such factors operate in a model is unknowable, the extent to which one uses mathematical models to supplement one's mental picture becomes, in practice, almost a matter of faith. Forrester and Meadows claim to have confidence in their models and, with the Club of Rome, they have given the results an unusual level of publicity. In view of the general difficulty of building mathematical models their assurance is surprising. Nevertheless, whether or not their results deserve such publicity, recognition is certainly due to them for their pioneering work in the field of global modelling.

Just as modelling itself has many pitfalls, so does the testing of a model, especially someone else's. Consequently the approach adopted here for examining the world models is first to look at aspects of the models that could cause their results to be in error, while, at the same time, noting some of the possible snares in attempting to correct them. For the discussion it is useful to make the distinction between structure, data and method of calculation even though these areas are not strictly independent. The term "structure" is taken to include not only general aspects such as the choice of main parameters and interactions and the degree of aggregation but also details such as the construction of the equations.

The data and assumptions used in the World 2 and 3 models will be considered in this chapter in broad terms, looking at the approach used by Forrester and Meadows rather than at specific details. Each of the sub-systems of World 3 will be discussed separately in chapters 3 to 7. Energy resources are considered

separately in chapter 8. In chapter 9, some shortcomings of the models will be described.

The nature of the models

The most important general features of the world models are:

- the description of the world as a closed system with no external influences;
- the choice of the major parameters;
- the major interactions and the feedback loops;
- the use of world averages for all parameters;
- the amount of detail (the number of relationships);
- the non-probabilistic nature of its predictions.

The description of the world as a closed system. In the world models, which are made up of several sub-systems (or sectors), all factors external to each sub-system are contained within the models (in the other sub-systems). Apart from the world system, few other phenomena can be so reasonably modelled as isolated systems. Usually long-term forecasts are rendered less accurate because not all external influences can be taken into account, so clearly there is a tremendous advantage in modelling the world system as a whole.

The choice of the major parameters. The main variables of both world models are population, capital investment, geographic space, natural resources, pollution and food production. With the exception of pollution, these were the parameters used by the early classical economists such as Ricardo and Smith. In the world models, all these parameters are not equally significant; for example, geographic limitations have not played an important role in any of the collapse modes described, whereas all the other sectors have done. World 2 contains another parameter, which is called "Quality of Life". It represents an attempt by Forrester to combine together several welfare indicators into a single variable. Although it does not affect the workings of his model—Meadows has omitted it entirely from World 3—it is an important variable and will be discussed together with other important omissions after the feedback mechanisms of the models have been described.

The major interactions and feedback processes in the models. Figure 5 is a simplified diagram of the world models. The boxes represent the main sub-systems of the model (for example, the box labelled Population represents all the parameters in the models concerned with population). The arrows represent the causal links between them. Thus, for example, the production of pollution affects agricultural output and also the rate at which population grows; changes in capital investment lead to changes in living standards. However, changes in living standards (via a different mechanism) also affect the rate of capital investment. This is called a feedback process (ie, one in which the effects of a change in one part of a system are eventually felt again in the same part of the system). The world models contain a set of such processes. Each of the loops in Figure 5 represents a feedback process which may be traced in detail on Figures 1 and 3 of the complete models. For example, going back to the loop noted above, it can be seen that for World 2 the loop from Capital Investment through Material

Standard of Living back to Capital Investment actually contains interactions between Capital Investment (CI) and Capital Investment Ratio (CIR), between CIR and Effective Capital Investment Ratio (ECIR), between ECIR and Material Standard of Living (MSL), between MSL and the Capital Investment Multiplier (CIM), between CIM and Capital Investment Generation (CIG) and finally between CIG and CI. This loop represents the process assumed by Forrester whereby as the level of capital investment rises so does Material Standard of Living, and as material standards rise so does the amount of surplus capital available for re-investment and the generation of new capital. It is an example of positive feedback (ie, the increase in a level increases the rate of increase in that level, and so amplifies growth). An example of negative feedback (ie, the increase in a level reducing the rate of increase of that level,

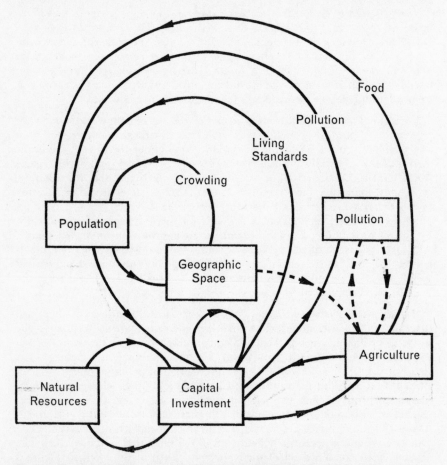

Figure 5. The main feedback loops of the world models. The boxes represent the main subsystems of the world system. The arrows show the assumed causal links between them. Each of the feedback loops may be traced in detail on the diagrams of the complete world models (Figures 1 and 3). The broken arrows show links included only in World 3

thus damping growth) is the interaction of population with finite geographical space. As population grows, crowding increases and is assumed to cause birth rates to decline and death rates to increase.

Since in the real world no processes take place instantaneously, time delays must be built into the models. Usually this is done implicitly through the growth rates (eg, birth rate, death rate, investment rate) but in some cases in World 3 the time lags between cause and effect are made explicit. For example, there is a delay between extra expenditure on services and the assumed resultant lowering of death rate, and also between the production of pollution and its deleterious effect on agricultural productivity. The effect of a delay in a loop is to reduce the strength of the feedback mechanism and so slow down the rate at which a growth mechanism responds to constraints upon it. Consequently it is possible for growth to continue beyond its "natural limits". This may have the effect of reducing the limits to below their original levels and so the system has after-wards to relax back much further and faster in order to adjust to the new constraints. This would happen, for example, if excessive pollution had much reduced land yields. This behaviour, called "overshoot and collapse", is charac-teristic of the standard runs of the world models shown in Figures 2 and 4.

One of the main arguments of Forrester and Meadows for not including certain technological and social feedback mechanisms in their models is that they believe the delays in adopting new technologies or adapting to new constraints may be very long and therefore do not warrant explicit inclusion in the model. Consequently there may be several obvious and related types of feedback mechanism which are not adequately included in either model and could be important for the results. In the first place there are the processes which comprise both education and research and development. These are important feedbacks which in the past have led to continuous social and technological change. The latter is, in effect, an expansion of the carrying capacity of the earth as defined in the models. Other mechanisms are those which in the real world attempt to balance social, political and economic factors in order to avoid just those catastrophes which Forrester and Meadows foresee.

Although both models contain, for example, mechanisms to trade off invest-ment in material wealth against investment in agriculture, they do not contain similar social control mechanisms for balancing material wealth against pollution[3] or against other factors which might lead to increases in death rate. In this sense the models are unrealistically deterministic. Furthermore, social responses are programmed into the model as fixed whereas in reality they do adjust to changes in circumstances. A control mechanism included in the model to balance the different components of some Quality of Life parameter (though not necessarily Forrester's), in order to maximise it, would give a better reflection of the social process.[4]

The use of world averages for all parameters. The models use world average figures for the parameters and the relationships between them. So, for example, when the term Material Standard of Living is used it refers to the *per capita* world average. In constructing the relationships between variables, Forrester and Meadows argue that they are taking some account of the world distribution about these averages. However one does this, without dividing up the model into,

for instance, different geographical areas, it is impossible not to make rigid and unrealistic assumptions about the structure of distributions within the world system. Consequently it may be impossible to make sensible forecasts with such a highly aggregated model. In the real world there are local problems which generate serious local crises (eg, famines) as well as widespread problems (eg, potential shortages of particular minerals) which generate less serious local crises. What Forrester and Meadows are in effect arguing in their books is that such crises will become both more widespread and more serious in the future. Their models would only truly reflect their arguments if the use of world averages does actually capture the net effect of local events.

The amount of detail (the number of relationships). The main structural difference between the two models is that World 3 contains about three times as many equations as does World 2, so that, for example, the single link between Material Standards of Living to Birth Rate in Forrester's model is replaced in Meadows' model by a complex system of links between industrial and service investment levels and Desired Completed Family Size, Birth Control Effectiveness and the Effect of Health Services. At first sight it would seem that because Meadows' model is more comprehensive it is also a better forecasting device. However, this need not necessarily be so. Most of the real world processes described in both models are little understood and one reason for this is that few data are available. Little is gained from the point of view of accuracy of forecasting by attempting to construct a more exact model than the available data allow. Conceptual simplicity of a model is desirable in practice. It helps both the modeller and those wishing to use the model, to appreciate the validity of the results. Again practically speaking, simplicity reduces computation. Many of the extra relationships used by Meadows are not important for any of his results and therefore are redundant; the linking of urban and agricultural land needs in World 3 is a case in point. On the other hand the links between the agricultural and the pollution sub-systems determine a collapse mode of this model. The presence of redundant details makes it more difficult to identify the important mechanisms in the model.

The optimum level of detail depends very much on the purpose of the model. If the model is to be used to make predictions on which to base policies, less error is acceptable than if the model is to be used simply to gain an understanding of particular processes.

The non-probabilistic nature of the predictions. Processes in the real world are subject to unforeseeable fluctuations. This makes it impossible to establish precise relationships between variables. The use of inexact relationships and the impossibility of accounting exactly for these fluctuations precludes the possibility of making precise predictions with complete certainty. Consequently any prediction can only be attributed limited probability.

The results of the world models are non-probabilistic, that is, for any particular set of inputs the model gives a single "most likely" prediction rather than a range of predictions with different probabilities. It is impossible to estimate from a single run just how probable the most likely prediction is. Some idea of the uncertainty in the predictions can be gained by feeding into the models the possible errors in each of the inputs and relationships. By re-running the models

with the new parameter values the sensitivity of the predictions to such changes is seen. This is called sensitivity analysis. As seen earlier from the brief description of the models, Forrester and Meadows have carried out sensitivity tests (for example, changing the assumed level of natural resource supplies and usage rates, and rates of pollution production). They conclude that the general nature of their results is not sensitive even to what they consider to be optimistic changes in the inputs. In chapter 9 this conclusion is contradicted in the light of further analysis.

Detailed structure

Figures 1 and 3 showed the detailed structure of the world models in formal system dynamics notation. These diagrams correspond to a set of algebraic equations and some features of these will now be considered.

The construction of the equations. The diagrams levels (drawn as boxes) represent the total amount of a physically measurable quantity (eg, population). Rates (drawn as valves) influence the levels and cause their value to change over time (eg, death rate). For example, in World 2 population at time K is calculated from population at time J and the Birth Rate (BR) and Death Rate (DR) in the intervening period JK which is of length DT.

The equation for this is written:

$$P.K = P.J + (DT)(BR.JK - DR.JK) \tag{1}$$

The rates themselves are determined from other levels in the system. So, for example, the Death Rate in the time interval JK is calculated by multiplying the Normal Death Rate (that is, its magnitude in 1970) by factors, called "Multipliers" (drawn as circles in the diagrams). These take account of the way that rates are assumed to vary as levels of material standard of living, food, pollution and crowding change. The equation for death rate is written:

$$DR.JK = (DRN)(DRMM.K)(DRFM.K)(DRPM.K)(DRCM.K) \tag{2}$$

Here, DRMM means Death Rate from Material Multiplier, DRFM means Death Rate from Food Multiplier and so on. The value of each multiplier is usually defined to be unity when material standards of living, etc, have their 1970 levels.

Look-up tables. Figure 6 shows the assumed relationship for the Death Rate from Material Multiplier used in World 2. World 3 contains a corresponding set

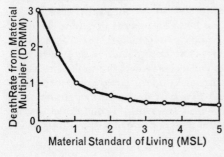

Figure 6. Death Rate from Material Multiplier (DRMM) versus Material Standard of Living (MSL); "look-up table" (*World Dynamics*, page 40)

of multipliers. The graphical representations of the multipliers are called look-up tables. The use of these look-up tables (and their computer programme representation) is a convenient method for introducing non-linear relationships into the workings of the models without having to use an explicit algebraic form for this.

The method of calculation

Modelling dynamic systems. A major problem in modelling dynamic systems as it affects the world models is that of instability, which arises when one or more positive (or negative) feedback loops dominate the behaviour of the model. Usually in a dynamic system some kind of equilibrium is maintained by the compensating action of negative (or positive) feedback mechanisms.

Whether a system exhibits exponential growth, an asymptotic approach to some fixed or expanding limit or "overshoot and collapse" depends on the degree of balance (including the effect of delays) between the various feedback mechanisms. If, when modelling a dynamic system, the relative strength of the compensating mechanisms are wrongly estimated by even a small amount, the dynamic balance of a model will be destroyed because errors of this kind rapidly accumulate during the stepwise calculation. This is why the absence of the feedback processes discussed earlier may be very important.

System dynamics. System dynamics is a technique originally conceived by Forrester for programming fairly simple dynamic problems. Although easy to use it is rather inflexible and contains approximations which can lead to errors in some circumstances. The first of these comes from the way the dynamic calculation is performed. The calculation proceeds in a series of steps. The initial values of the levels are set (at 1900 in the case of the world models) and the rates corresponding to these are calculated (see Equations 1 and 2). From these rates new values for every level are calculated for the next time interval and so on for successive intervals of length (DT) until the year 2100. In the calculation DT must be set sufficiently small so that no significant change in the results would occur if it was further reduced. However, at each step in the calculation, "rounding errors" occur which are accumulative and may sometimes influence the results if sensitive feedback loops are present in the system. System dynamics uses the most simple linear (Euler) approximations throughout and so rounding errors would tend to be large compared with other methods.

Another possible source of error arises through the same kind of approximation. The values actually taken by the multipliers in the calculation are approximations even to the assumed relationships between pairs of variables, since the computer programmes perform only straight interpolation between selected points on the assumed curves. The form of the approximation can be seen in Figure 6. Discontinuities in the results will occur when the multiplier value crosses one of the "corners" of a look-up table. Again this could give rise to errors which are amplified in sensitive feedback loops. In the world models attention has been paid to this, and some look-up tables in World 3 contain very many points (up to 25 in some cases). This is usually indicative of relationships which the modellers have found to be sensitive.

Data used in the models

World 2. The only real data which appear to have been used in Forrester's model are the world population figures for 1900 and 1970. For the most part the model is based on his vision of how the real world operates. What he has done is to guess the values for parameters and then ensure by adjusting these that the model gives a plausible history from 1900 to 1970. Clearly there are dangers in this approach although they are not exclusive to it. Effects explicitly included in the model may be weighted wrongly with serious consequences when the model is used to extrapolate trends outside the 1900 to 1970 interval (see later). Also, factors which operate in the real world but which are omitted from the model will be subsumed into other relationships in an indeterminate manner and to an unknowable extent. For example, since there is no explicit inclusion of improvements of agricultural productivity, improvements which actually did take place over the historical period 1900 to 1970 are included through the unrealistically rapid increase in the proportion of capital invested in agriculture. Both these problems would apply even if the data had not been guessed.

World 3. There is a more substantial body of data behind the relationships in World 3. Look-up table relationships in the World 3 sub-systems have in the main been separately matched to graphical data before each sub-system was assembled. The sub-systems were adjusted to show reasonable behaviour and the complete model was then assembled. Although few "guessed" data are used the quality of much of the rest (as chapters 3 to 8 will show) is extremely poor.

Many of the relationships were estimated indirectly by comparison with other variables which are expected to change in the same manner. For example, fecundity is taken to be a function of life expectancy which is used as an indicator of health standards (see chapter 5); national accounts depreciation data are used to estimate physical lifetime of equipment (chapter 7). This is made necessary either by the absence of data or because the appropriate parameter is not used elsewhere in the model but leads to inaccuracies. These add to others which arise simply because much of the data that are available has been collected for different purposes, by different methods, over different time periods in different countries. Many of the relationships used to show how parameters are expected to vary over time are actually based on cross-section analysis at a single time (for instance, the increasing proportion of total investment directed into services as a function of rising income *per capita*—see chapter 7). To treat historical and cross-sectional data as equivalent is evidently a dubious approximation.

Only in a few cases (for example, parts of the agricultural sub-system) has use been made of the results of statistical techniques (such as regression analysis) which are available for fitting data. In general, this in itself is not too important as large errors in the data will cause correspondingly large errors in the parameters whatever the method of fitting used. The cases where statistical fitting techniques might have helped are those where a parameter is assumed to depend on several others and the partial dependence has to be measured. Many parameters used in the models have to date all varied simultaneously and monotonically in the real world. This makes it very difficult to separate, for example, the effects of changes in food, wealth, crowding and pollution on birth and

death rates and to establish the best figures to use in the world models. There is, of course, no general foolproof solution to this problem, since historical events which are non-recurrent usually interfere with the collection of controlled data. In any situation where the data base is poor and open to wide interpretation, there arises the possibility of bias. The effects of this, although small for individual relationships, can be large when applied systematically in a model.

Finally there is a problem of extrapolation. During the computer runs, some parameters take values outside those so far experienced in the world. This means that several look-up tables have to be extrapolated well beyond the range of the data available (this is especially true of the pollution and agricultural subsystems). Serious errors of extrapolation are more likely to occur when relationships are assumed to be multiplicative rather than additive, especially if the errors are all biased in the same direction. Furthermore, the fact that a model appears to fit historical data within a certain range is not a guarantee of the model's validity within that range, let alone an indication that it may be used to extrapolate outside it. Many different combinations of mechanisms can give rise to the same pattern for a few major variables. Errors in the mechanisms may compensate for each other within the fitted range (if the parameter values are adjusted suitably), but they may not continue to do so outside it.

This chapter has described the world models of Forrester and Meadows and explained some of the features of the models which could cause their results to be in error. Not all these factors are equally important for the world models but they have been enumerated to show just how wide-ranging are the possible deficiencies in such models. The features of the models' structure which appear to be unrealistic in a way likely to affect the results are the absence of technical, economic and social feedback processes and the use of world averages for all variables. Added to this is the possibility of a bias of many of the relationships arising in part from the lack of good empirical information and in part from errors of extrapolation. In chapter 9 a few general exercises on World 2 are used to show that structural changes in the models can indeed produce substantially different projections of current trends from those put forward by Forrester and Meadows as being invariant to revisions in the model. Chapters 3 to 8 describe the essential details of each of the major sub-systems of World 3. They also examine the quality of the relationships and data used in relation to relevant theory and empirical evidence. In addition to commenting on data and relationships, each chapter makes suggestions as to how the World 3 model might be improved. Several of these suggestions are then used in chapter 9 to confirm that the changes in the results brought about by the alterations to World 2 really do apply to the same extent to World 3. Taken together with the discussion in preceding chapters it is possible to assess the reliability of the models and the conclusions that Forrester and Meadows draw from their results.

References
1. Jay W. Forrester, *Principles of Systems* (Cambridge, Wright-Allen Press, 1968)
2. The diagram is based on that in the 1st edition of the Technical Report—April 1972
3. T. W. Oerlemans, M. M. J. Tellings, H. de Vries, "World Dynamics—Social feedback offers hope for the future", *Nature*, Vol. 238, No. 5362, page 251, August 1972
4. P. van der Grinten and P. de Jong, "Werelddynamica", *Chemish Weekblad*, March, May 1972. These authors have outlined a model containing a dynamic optimising mechanism

3. THE NON-RENEWABLE RESOURCES SUB-SYSTEM

William Page

Natural resource exhaustion combined with increasing extraction costs are a major assumption in the World 3 model and play an important role in many of the collapse modes. This sub-system is described and the strengths and weaknesses of its assumptions are assessed in the light of a more optimistic attitude towards technological improvement and the effects of economic and social pressures.

Outline of the sub-system

THE two key assumptions made in the World 3 model are that, on aggregate, the world has 250 years' supply of minerals (at current consumption rates) and that the economic cost of exploiting the remaining deposits will increase significantly. The former assumption is based largely upon US Bureau of Mines estimates for the world; the latter, upon the hypothesis that the technological advances which have allowed mineral prices to stay down (despite lower grade ores being exploited) are unlikely to be maintained in the future.

The figure of 250 years' supply is referred to as the "current reserve life index", and the conceptual advantage of this measure is that it neatly evades the problem of reserves for different minerals being expressed in different conventional units—iron in tons, rarer metals in troy ounces, oil in barrels, etc. Also, it is much easier to imagine, say, 100 years' supply of a mineral than a quantity such as a billion tons. In the figure of 250 years' supply, perfect substitutability is assumed; as one mineral becomes unavailable, another can take its place. In the model, these reserves are labelled NRI—Non-renewable Resources, Initial.

Consumption rates are derived by multiplying a *per capita* rate (the *Per Capita* Resource Usage Multiplier, PCRUM) by the population size at that date. *Per capita* consumption is taken as being a function of only Industrial Output *Per Capita* (IOPC). The relationship used is shown in Figure 1.

Usage (PCRU) increases as industrial output (IOPC) increases, but at a diminishing rate. The rate is measured by taking the aggregate 1970 level as unity; thus a value of seven, for instance, means a global *per capita* rate seven times higher than the 1970 rate. This relationship is derived from both historical time series (comparing US steel and copper consumption *per capita* with industrial output *per capita* between 1890 and 1968) and a cross-sectional comparison of different countries in 1969. Thus, a measure of industrialisation determines *Per Capita* Resource Usage Rate and this in turn, with population size, determines the Non-renewable Resource Usage Rate, NRUR. Subtracting the

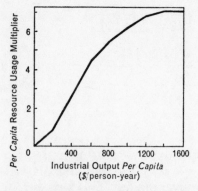

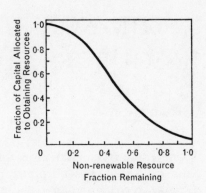

Figure 1. Relationship between Industrial Output *Per Capita* and *Per Capita* Resource Usage (as assumed in World 3)

Figure 2. Capital versus depletion

accumulated consumption from the initial level, NRI, leads to a new variable, the Non-renewable Resource Fraction Remaining, NRFR.

NRFR can vary between 1 and zero, being the fraction of what there is left to exploit to what there was initially. A value of one would represent the (historical) situation in which nothing had been exploited, and zero, in which there was nothing left. The main use of this variable in the model relates to the cost of obtaining minerals: as deposits are depleted, it is assumed that the cost of obtaining each additional unit of material increases. "Cost" is measured in terms of the Fraction of the world's total Capital which must be Allocated to Obtaining Resources (FCAOR). As resources are depleted, this fraction will increase, thus leaving less capital over for use in other sectors such as agriculture and industry. As NRFR (resource fraction remaining) approaches zero, FCAOR (required capital fraction) approaches one. The assumed form of the relationship (the look-up table) is shown in Figure 2.

There are two key assumptions underlying this relationship. According to the Technical Report, they are:

Assumption 1: The capital costs of locating, extracting, processing and distributing, ie, obtaining virgin natural resources, will rise as the resources are depleted.
Assumption 2: The progress of technology will not be sufficient to counteract the effect of Assumption 1 as the fraction of resources remaining approaches zero.

Evidence produced to support the first assumption—rising capital costs—includes the way in which the most accessible ores have been located and exploited first, implying that more effort (and therefore capital) must go into finding and exploiting the less accessible.

Although Assumption 1 is expressed in terms of capital costs, the model operates using the fraction of the capital in the economy which is allocated to resource extraction and, as mentioned, this is related to resource depletion and not to the tonnage extracted *per se*. A summary chart showing the fraction of America's capital allocated to the "extraction" industries (prepared by

Resources for the Future, Washington, DC) is presented in the Technical Report and reproduced in Figure 3. It shows that something has been happening during this century to counteract the upward trend.

This "something" certainly includes technological advance. However, in World 3 it is postulated that technological advance "cannot be expected to hold costs down in the face of continued exponentially increasing resource exhaustion". The effects of assuming technological advances in bringing minerals to the marketplace and in reducing usage rates of virgin material (such as recycling) are discussed in the report.

The structure of this sub-system is given in Figure 4. In the standard run of the model the depletion of resources draws capital away from industrial output as FCAOR increases, causing "free" capital (and so Industrial Output) to plummet. If one doubles NRI (available reserves) to 500 years, at current rates, the capital peak occurs only 20 years later. This point simply shows the power of exponential growth rates. Again, if one assumes that technology will keep the costs of minerals down, the same basic pattern is followed; all that happens is that the depletion problem is "hidden" until virtually all resources are exhausted, thus permitting a higher peak for industrial output—but also a very rapid collapse when it comes. Increased levels of recycling, it is argued, have a similar effect.

This sub-system covers much ground, though not in great detail. Perfect substitutability of minerals is assumed throughout; the consequences of recycling are considered; the possibility of the reserve life index being too low has been looked

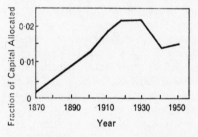

Figure 3. **Fraction of USA capital allocated to the USA extractive industries.** *Source:* Barnett and Morse, *Scarcity and Growth,* quoted in the Technical Report.

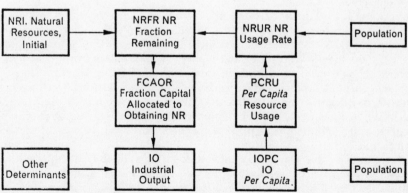

Figure 4. World 3 non-renewable resources sector

at; technological advance, which stabilises prices, has been allowed. Despite all these, we still have a collapse. Are these conclusions correct? If not, where are they wrong? In the following sections, we shall briefly review the geological, technological and economic aspects of the sub-system's assumptions.

The planet's mineral deposits

The model assumes that, at current usage rates, the earth contains around 250 years' supply of minerals and, as a concession to optimists, takes double and ten times that figure in a sensitivity test. Five hundred years' supply at current rates will not avert a collapse while 2 500 years' will—at least up the year 2100 which is the horizon for the MIT forecasts. It is also argued that these quantitative figures are not as important as the qualitative principle of the deposits being finite over periods of centuries.

Nobody could argue that the planet's deposits are literally infinite; clearly, there is a limit. The question is how near are we to it; is 250 years the best figure, or is it more like 2 500 years? There are two unanswerable components to this question: what is in the earth (and where); and how much of it will prove exploitable over the period of concern?

The earth's crust varies in thickness from around 25 to 40 miles, tending to be thicker under land masses than under sea and oceans. The depth of present-day mines is measured in hundreds and, very occasionally, in thousands of feet; oil wells are among the deepest holes being drilled, and the deepest are generally around six or seven miles. What lies below this, in terms of potentially useful minerals is unknown. In the past it was believed that the deeper one went, the more deposits there were; there are now reasons for suspecting the opposite to be true. However, completely ignoring exploitation problems, deposits are virtually certain to be measurable in terms of thousands of years at least. Any doubt fades if we consider inner sections of the planet; the iron-nickel core contains perhaps around 10^{20} metric tons of deposit, with a static life index of 10^{11} years, give or take a few orders of magnitude[1]. By no means should this be taken as implying that the core is necessarily exploitable—for the foreseeable future exploitation is quite inconceivable; the point is that the ultimate limits are not the contents of the planet *per se*.

Seawater has been estimated to contain 1 000 million years' supply of sodium chloride, magnesium and bromine; 100 million years' of sulphur, borax and potassium chloride; more than 1 million of molybdenum, uranium, tin and cobalt; more than 1 000 of nickel and copper[2]. A cubic mile of seawater contains around 47 tons each of aluminium, iron and zinc[3]; given around 330–350 million cubic miles of such water, we are talking of around 16 000 million tons each. Such estimates tend to exclude special concentrations such as the Red Sea brines and sediments; these alone contain perhaps $2 000 million worth of zinc, copper, silver and gold, and perhaps ten times this level, at current market prices.[4]

It seems likely that manganese nodules, to be found on the seabed, contain a wealth of minerals; these may be 10^{12} tons in the Pacific alone[5], containing around 0·25 to 0·30% cobalt, 0·20 to 0·75% copper, 0·42 to 1% nickel, and 16 to 25% manganese[6,7,8]. There may also be vast quantities of iron, aluminium and

zinc, to take only the industrially important minerals. Thus 1/50th of 1% of the ocean seabed could, in this sense, meet a year's demand on aggregate, at current consumption rates[9].

The most pressing of the limits to growth in resource usage are not geological: Mother Nature has put on and in the planet ample for perhaps tens of thousands of years, but certainly sufficient for the world models' time period of up to the year 2100. The above figures may be horribly in error, but it is inconceivable that the principal qualitative point is entirely erroneous. What limits there may be come from man's economic and technological ability to exploit these resources.

What has been said so far makes it necessary to define more carefully what exactly is meant by such terms as NRI (the initial reserves) and NRFR (the fraction remaining). Given that the figures used cannot be referring to the absolute levels, we have to conclude that some cut-off point, induced through human extractive abilities, is being implied. Otherwise, an NRI as low as 250 years (or even 500) could not be argued. The model's assumptions put us much nearer the point of resource exhaustion (NRFR = 0) than is geologically the case, and this is a main reason for the stubborn tendency of the World 3 model to collapse.

Technological improvement

Exploration technology. The old prospector with his mule and pick is not simply a romantic notion. "The old-timers who spent their lives playing a game with chance and against very heavy odds built up a large body of useful empirical knowledge and discovered many of the great mineral deposits of the world"[10]. There are very few examples of exploration exercises which have revealed what is below a few hundred feet, and they are mainly searching for oil.

Current exploratory techniques include measuring variations in gravity (indicating the presence of relatively dense matter), in magnetic fields (revealing nickel-iron deposits), in electric fields (limiting what is there to conductors, and suggesting the deposit's size) and the use of surface seismology (also giving information on physical structures). Analysis of the minerals in local vegetation can lead to other deposits. Aerial photography—or aerial mounting of some of the equipment used for some of these techniques—can also produce much information rapidly[11]. Such techniques often only suggest favourable locations for drilling for core samples. The average depth of such drill holes is around 100 feet[12], and the technique is relatively cumbersome and slow—drilling speeds often being a few feet an hour. There are still other imperfections; it is possible to drill through a coal seam without realising it, for instance.

Thus conventional exploration is none too developed. Geology is currently undergoing a revolution in its theory: the theory of tectonic plates may be comparable to relativity in physics. New drilling hardware is being developed, employing (for instance) gas-burning jets to assist the drilling. Since our time horizon is at least a century, one can also envisage dramatic developments in underwater exploration, which currently is almost entirely dependent upon remote sampling and coring devices, and an oft-shifting geological theory. Sea-bed vehicles are being developed[13] as (currently on a larger scale) are small, exploratory submarines[14]. Again, drilling in a hundred feet or so of water was

pushing the technology to its limits only a decade ago, whereas depths deeper by an order of magnitude are now being contemplated.

In many cases, known deposits have increased over the years. In 1908, President Roosevelt called a meeting of State Governors in Washington, to discuss what to do about the apparent run-down of many mineral reserves. A large-scale survey of the USA was launched as a result and sufficient new deposits were found to alleviate concern. There have been a number of similar surveys conducted since then. Had a 1944 review[15] been correct, the Americans would by now have totally exhausted their reserves of about 21 of the 41 commodities examined. Tin, nickel, zinc, lead and manganese were on this short list. But more has been found; more deposits (in terms of tons) were found in the USA during the 1950's than during the previous 25 years[16]. Or take aluminium: between 1941 and 1953, known world bauxite reserves grew by 50 million tons a year on average, while between 1950 and 1958 the average annual increase was about 250 million tons[17]. Thus one can be at least suspicious of the static index figures used in *The Limits to Growth*.

A large portion of the earth's land mass has hardly been looked at in any detail. One would imagine the USA to be among the best explored, but even there one has examples such as the great 1950's uranium hunt[18]. Somehow, the hunt for the metal became a national craze. The Atomic Energy Commission, very worried about the reserves (which were a classified secret), had offered to buy all the uranium produced after 1962; before 1962 arrived, around 80 million tons had been discovered and fears of over-production helped to cause cancellation of the offer. It is undeniable that a widely expanded application of current technologies in at least Asia, Africa, Australia and South America would produce major finds. "Just look at the world's resources as we entered the decade of the sixties compared with today. The thousands of millions of tons of Western Australian iron ore were then unknown, so was the copper of Papua, New Guinea, Canada and elsewhere. The vast bauxite deposits of Brazil and the nickel deposits in Australia have all been discovered in the past ten years"[19].

The optimistic tone of the above paragraphs should be rounded off with an explicit acknowledgement of possible shortages of some materials, including helium and mercury. Such shortages, however, are unlikely to be of any importance at the aggregated global levels considered in the models, and would hardly be responsible for a major global catastrophe of the kind found there.

Mining technology. What is the current state-of-the-art in extracting minerals from the planet, and what are the long-term prospects for improvements? The technology of underground mining has been changing fairly rapidly over the last decade, especially in contrast to the relative stagnation of the last few centuries. The traditional tunnelling process involved drilling holes in the tunnel face, inserting and detonating an explosive, then transporting the lumps to the mine entrance. Different pieces of machinery were usually required for each part of this cycle, and moving them in and out of a working area was not easy.

One solution to this problem is to use a continuous process, whereby one piece of machinery is capable of drilling, blasting and moving the rock at least to the tunnel transport system, while perhaps also carrying out other operations such as shoring, and water extraction. Such equipment is currently being developed and becoming available, and one particular line of research is in drilling

techniques. As well as improvements in conventional drill heads (thus increasing their life), new concepts are being explored, such as softening rock through chemical or vibrational techniques, or the use of induction heating or hydraulic jets. Such equipment has been capable of tunnelling a few hundred feet an hour, meaning that the limiting factors may become the back-up operations, like shoring and water removal.

Open-pit mining is generally much easier. The space available permits the use of large machines, and allows simultaneous access to many areas of the mine. It is currently cheaper to open-mine unless there is more than 50 to 100 feet of overcover to remove; on average, American mines remove around 2 tons of overcover to 1 of ore[19]—and around 80% of the virgin resources mined there come from open-pits[20].

Related to the problem of extraction is that of transporting ores. Benefication (improving ore grades by removing debris) has helped reduce transport costs per ton of metal content, and this is still a very active field in terms of improvements[21].

The cost of transporting ores has, if anything, been reduced, largely because of improvements in the efficiency of fuel use and the advantages of larger and larger bulk carriers. Costs could increase in the future (as, for instance, the maximum feasible capacities for carriers is reached), but the effect would probably be small.

Processing technology. Veins of gold used to be worked in the USA by gravity separation, and the waste put on one side. Then a new technology, mercury amalgam, was introduced which was economically capable of removing yet more gold; thus the waste became an ore again, was processed, and went back to being a waste. And then yet another technology, the cyanide process, and, once more, the waste became an ore[22].

This illustrates the way in which lower and lower grade ores have become amenable to use. In 1880, the lowest grade of copper ore which could be economically handled was around 3%; it has slowly gone down—by 1906 it was 2·1%—and is now almost 0·4%[23]. The immense taconite reserves in America are now seen as a source of iron, as they can be concentrated up to 60% iron[24]; they were previously ignored. For 1930 aluminium extraction, bauxite had to contain at least 60% alumina; by 1950 the figure was 50% and is still lower now[25, 26]. The maximum silica content tolerable was less than 8% in the early 1940's, and up to 15% two decades later[27].

Another possible fear relates to the auxiliary materials needed in processing—cryolite for aluminium, coking coal for iron and steel, or even water for the Frasch extraction of sulphur. Current technologies, as used in the plants, are dependent upon such materials. However, new routes to the end product are being found: the aluminium industry is finding ways of eliminating cryolite, electric arcs can eliminate the need for coking coal[28]. This does not guarantee a safe future, but it does give grounds for optimism.

There are no visible natural-law barriers lying just ahead; such barriers as the speed of light or absolute zero are not relevant. One possible exception could concern energy, on which processing technology increasingly depends. Energy is the theme of chapter 8.

The critical limits for examination therefore, are not so much technological, but more economic and social.

The economic aspects

The question has now ceased to involve geological reserves or even the potential of technology to exploit those reserves. It has become that of man's ability to develop such technologies, given what can be subsumed under the label "economic and social constraints". It is conceivable that the economic and social costs involved will prove unacceptable. The model assumes major increases in these costs.

Historically, real costs of minerals in the market place have not generally gone up but have tended to stay roughly constant. This point is not under debate, nor is the argument that the stability is the result of two counteracting trends: one towards lower prices (technological improvements) and one towards price increases (the use of less convenient deposits). What is under debate is the likely cost of minerals in the future; the economic and social costs of identifying, researching, developing and applying the technology needed.

The only hard data which can be brought to bear on this issue are, as usual, historical data; there is no possible way of proving the correctness of a postulated future. The MIT assumptions may be right or wrong; but are there equally good cases to be made out for alternatives? If so, are the sensitivity tests reported by the MIT team a sufficient representation of them?

The arguments put forward to support the claim of future price increases come from Ayres and Kneese[29]. Their arguments, and this author's comments upon them, are as follows:

● *Lower quality ores in some important materials do not necessarily exist in exploitable quantities.* This argument is central to the whole doomsday approach to resources. We have argued that it is not very convincing. That it could well be true, for say, helium or mercury, does not validate the generalisation.

● *There are few new geographic areas left to explore, except for seabeds.* This point was answered if not disproved above, by reference to the level of detail of the exploration of so-called explored regions (explored countries are still producing surprises), and to the issue of depth of exploration. Also, the seabeds are not an insignificant qualification to this point.

● *Social costs will probably be reflected in future mineral prices, and could rise disproportionately as output increases.* Chapters 8 and 12 argue that this need not necessarily be the case. Protests from industrialists notwithstanding, the acceptance by the resource industry of social costs has not, and probably will not, cause big cost increases.

● *... The effort and investment required to achieve further productivity gains in the future will probably be much greater than has been true in the past.* This is ascribed to the necessary ending of one historical trend which has helped keep prices down: increased mechanisation. The barrier of 100% will soon be reached. If there were to be no improvements within mechanisation itself, one might have a convincing argument. As it is, machinery has not only been keeping prices down by replacing expensive labour—but also by replacing older and more expensive machinery and saving on capital costs as well as labour costs. Secondly, one cannot argue that we are yet close to the all-mechanised end of the machines-versus-labour continuum: globally, there is still ample scope for replacing labour, especially in mining operations. It is also worth noting that

Ayres and Kneese back up their conclusion partly from electricity generating history: the forty-fold increase in efficiency over 200 years (from around 1% to 40%) clearly cannot be repeated, given an absolute limit of 100%. But the analogy between energy production and resource extraction is not justified. There are no physical limits in resource extraction equivalent to 100% thermal efficiency in energy production.

It is not unlikely that raw material exporters (upon whom rich countries are becoming dependent) will increasingly band together to multiply their bargaining power and increase their revenues This point, being entirely political, is not relevant to physical limits. It would lead to a redistribution of costs and benefits between the rich and the poor countries, none of which would be discerned in the MIT models, which are concerned only with world totals.

The Technical Report calls Ayres' and Kneese's arguments "convincing"; should we make it quite explicit that this is a subjective view, not a fact? The counter-arguments may not be convincing either—but are they so grossly inferior that they justify ignoring alternatives to the assumptions employed in World 3?

Conclusions

The behaviour of the resources sub-system is critical to the overall behaviour of World 3. One of its main modes of "collapse" is resource depletion. The main reason for this is the assumption of fixed economically-available resources, and of diminishing returns in resource technology. Neither of these assumptions is historically valid. The relative cost of minerals has remained roughly constant, and has not increased over the past eighty years as a consequence of diminishing returns. And new economically exploitable reserves are being discovered all the time.

There is little reason to think that this historical trend is bound to change in future. That technological change will slow down because of the diminishing opportunities for labour-saving innovations is a highly debatable assumption because technological change has historically been capital-saving as well as labour-saving; and there appear to be no physical limits likely in future to slow down productivity increases and innovations in the industries producing capital goods for mining, exploration, and processing.

However, Meadows looked at this sort of possibility and found that collapse still happens because available resources are fixed. We have argued that they are finite (not fixed), but that what is available in the earth's crust is (almost) infinitely greater than what is in fact assumed in World 3. Furthermore, whether what is geologically available becomes economically exploitable reserves depends on market conditions and on the state of resource technology. One important relationship (or feedback loop) missing from the World 3 sub-system is the effect that market conditions have on the rate and direction of both resource technology and available reserves.

Thus, instead of assuming a static reserve index, one could equally well assume that it is in fact expanding continuously, even at an exponential rate. We have already seen that by increasing the static reserve index by a factor of 10, the resource mode of collapse is put off beyond the time horizons of the model. Now

an increase of a factor of 10 over 100 years is equivalent to a sustained annual rate of increase of 2·3%. Thus, if one also includes the possibilities of improvements in recycling, and of further economy in the use of resources in industry, then we can conclude the following: if the sum of the annual rates of increase of resource discovery, of recycling, and of economy of use in industry add up to more than around 2%, then the resource mode of collapse in World 3 will be avoided and there will not be any net drain on "available" reserves. Whether such a rate of increase is plausible depends on more detailed research. It is of an order of magnitude that seems socially and technologically feasible.

References

1. Calculated from geological data given in M. H. P. Bott, *The Interior of the Earth* (London, Edward Arnold, 1971), and from usage rates data in US Bureau of the Mines, *Minerals Yearbook, 1970* (Washington, DC, USGPO, 1970)
2. John L. Mero, "Oceanic mineral resources", *Futures*, Vol. 1, No. 2, December 1968, pages 125–141
3. *Ibid*
4. E. T. Degens and D. A. Ross, "The Red Sea hot brines", *Scientific American*, Vol. 222, No. 4, April 1970, pages 32–42
5. E. L. LaQue, "Deep ocean mining: prospects and anticipated short-term benefits", in *Pacem in Maribus: Ocean Enterprise*, Occasional Paper 11 (4), (Santa Barbara, Center for the Study of Democratic Institutions, 1970)
6. *Ibid*
7. J. S. Tooms, "Potentially exploitable marine minerals", *Endeavour*, Vol. 31, No. 114, September 1970
8. Mero, *op cit*
9. LaQue, *op cit*
10. C. C. Furnas, "Discovering, recovering and concentrating the minerals", in S. Rapport and H. Wright, eds, *Engineering* (New York, Washington Square Press, 1964)
11. R. N. Colwell, "Remote sensing of natural resources", *Scientific American*, Vol. 218, No. 1, January 1968, pages 54–69
12. *Larousse Earth Encyclopedia*, page 437
13. Tony Loftas, "Sealbeaver—failure by default? *New Scientist*, Vol. 55, No. 804, 13 July 1972, pages 75–78
14. H. A. Arnold, "Manned submersibles for research", *Science*, Vol. 158, No. 3797, 6 October 1967, pages 84–95
15. E. W. Pehrson, "The mineral position of the United States and the outlook for the future", *Mining and Metallurgy Journal*, No. 26, 1945, pages 204–214
16. J. Boyd, "The pulse of exploration", in H. Jarrett, ed, *Science and Resources* (Baltimore, The Johns Hopkins Press, 1959)
17. Private communication from an aluminium company
18. J. A. S. Adams, "New ways of finding minerals", in H. Jarrett, *op cit*
19. W. R. Hibbard, "Mineral resources: challenge or threat?", *Science*, No. 160, 1968, pages 143–150
20. *Ibid*
21. M. M. Fine, "The benefication of iron ores", *Scientific American*, Vol. 218, No. 1, January 1968, pages 28–35
22. Furnas, *op cit*
23. H. H. Landsberg, L. L. Fischman and J. L. Fisher, *Resources in America's Future* (Baltimore, The Johns Hopkins Press, 1963)
24. Fine, *op cit*
25. Landsberg, *op cit*
26. Private communication from an aluminium company
27. Landsberg, *op cit*
28. F. Cartwright, "Challenge to the blast furnace", *New Scientist*, Vol. 54, No. 794, 4 May 1972, pages 252–255
29. R. U. Ayres and A. V. Kneese, "Economic and ecological effects of a stationary economy", *Annual Review of Ecology and Systematics*, No. 11, 1971

4. THE POPULATION SUB-SYSTEM

William Page

The overall behaviour of the World 3 model is not highly sensitive to the behaviour of the population sub-system. This is divided into two parts, fertility and mortality, and each are examined here as being important in their own right, although the fact that many of the relationships could be subject to policy decisions is noted as a major problem in building the model.

Fertility

DESPITE the number of variables employed, the fertility side of the sub-system is conceptually straightforward. The number of births per year in the world will be influenced by the total population size (P), which in turn is increased by births. (See Row 1 in Figure 1.) Births are derived from Total Fertility, which is expressed in terms of births per woman per reproductive life. To convert Total Fertility to births, then, it must be multiplied by the number of fertile women in the population (Fraction of Fertile Women times P) and divided by their average reproductive life time. Row 2 shows the three assumed determinants of Total Fertility and Row 3 shows those of Row 2. The Maximum Total Fertility is the number of children each woman would have working at her biological limits (fecundity); Desired Total Fertility is the number each would like; and Birth Control Effectiveness is the means by which the maximum can be reduced to the desired. Combining these three will give the Total Fertility.

Fecundity is assumed to be influenced by the general healthiness of the population (including health services, nutrition, etc), and, as shown in Figure 1, this is measured by way of life expectancy. The Fecundity Multiplier converts life expectancy values into fecundities, the normal value (the base on which the multiplier operates) being 12 children, corresponding to a life expectancy of 60 years. Birth Control Effectiveness is a broad concept, encompassing all the means a community has to control its fertility; it includes marriage age, abortion and celibacy as well as contraception. It is assumed to be positively associated with the *per capita* output of service industries (which includes health and education).

Desired Total Fertility is derived from the Desired Completed Family Size (DCFS). It is determined by the *per capita* industrial output (IOPC) via two routes. In one, IOPC determines Income Expectations (and thus the physical

ability to support children); in the other, increasing **IOPC**—increasing levels of industrialisation—produces social changes which influence desired family sizes. The former route employs the Family Norm Multiplier from Income Expectation, and the latter from Social Structure.

The fertility sub-system is apparently comprehensive but important considerations may be missing. The variables in Rows 1 and 2 of the flow-chart are hardly debatable: they are either requisite mathematical manipulations or, in the case of the second row, they are a set of classifications that are sufficiently comprehensive to include all the possible "second order" variables. There are, however, a number of defects and problems in the modelling. Problems include considerations of policy decisions that influence the postulated relationships between variables, of what actually goes on in the real world (of identifying what processes one is trying to model) and consistency in the detail of the modelling.

As far as policy decisions are concerned there is nothing that mankind can do to change some of the relationships. No possible decision, for instance, could

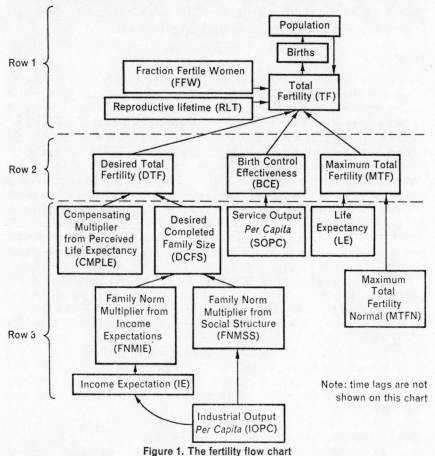

Figure 1. The fertility flow chart

change the way in which fecundity is altered by, say, a given diet. Women will starve given no food. On the other hand, take the relationship between Birth Control Effectiveness and Service Output *Per Capita*, which currently operates through explicit health service functions. One can draw a graph plotting calculated BCE against estimated SOPC for a number of countries, and a fairly good curve emerges. However, this proves little about the future: there is nothing "God-given" and therefore unchangeable about the proportion of the service output of an economy which can be devoted to those factors influencing the means of controlling births. The Chinese provide an illustration: despite a relatively low service industry output, in dollar terms, it seems that population control has become a high priority and there are, for instance, strong pressures to late marriage age. Again, take the Family Norm Multipliers, FNMIE and FNMSS: it could well be that Income Expectation and Social Structures have been the predominant determinants of desired family size in the past. This does not rule out the very strong possibility that other influences may start to play a part—influences such as family planning propaganda which emphasises the need for smaller families. The changes which could thus be introduced into the assumed relationships could be such as to invert them.

In the model, there is virtually no operational consideration of such possibilities; they are discussed in the Technical Report and their impact can be explored by changing the appropriate parts of the model, such as some of the look-up tables. The only change which has been explicitly catered for is that of changing net population growth rates; however, this is not done to explore population dynamics *per se*, but rather the effects on other growth rates in the remainder of the model (natural resource usage, etc).

The most understandable reason for not incorporating such possible policy changes in the original model is the difficulty involved in modelling the determinants of such changes. Given the present structure, one would be forced to postulate the conditions which would result in policy changes; the MIT team were apprehensive about attempting such an exercise, it seems. Nonetheless, omitting them does mean that their results will only be valid if present policies continue. They are not so much forecasts of the future as projections of history into the future.

The second set of problems concerned identification of the processes occurring in the real world; unless this is done satisfactorily, the model is almost certainly doomed to be invalid. This applies to both hard data and to understanding population dynamics.

The basic data in demography are unsatisfactory—even if better than those found in other fields. Many of the figures one would like to see are either not available, or else contain important errors. Even in a country like Britain, there is an error of around $\frac{3}{4}$ of 1% in the basic census head-count, and greater errors may be expected in breakdowns. This example is indicative of the kind of problems encountered: errors of 10% or more are far from uncommon in many parts of the world. Historical data are very scant and unreliable for most developing countries. At a crude operational level, as in the world models, this defect is not too important, except in so far as the hypotheses extracted from the demographic literature are based upon such data.

The model employs two routes from Industrial Output *Per Capita* to Desired

Total Fertility, one via the Family Norm Multiplier from Income Expectation (FNMIE), the other, FNMSS (from Social Structure). This construction has been introduced to explain a real world phenomenon: fertility at low income levels tends to be high but decreases as income goes up. However, there is a turning point beyond which further income increases give rise to a now-increasing fertility, presumably reflecting a predominance of the ability-to-support-children factor. FNMIE and FNMSS have been adjusted so as to reflect this. But is this in fact a real world phenomenon? The data which support it come from two sources: one, that the American IOPC is the world's highest and American fertility is above that of most of the other developed countries; and secondly, on a national basis, the richest people in an advanced country often have large families. Thus the hypothesis is tenable but not necessarily correct; the data are too scant to permit such a definite statement of a real world process, let alone that IOPC is its major (or, in the model, sole) determinant. The results of simulation runs are quite sensitive to changes in the Family Norm Multipliers, which is why this point is important.

Other examples could include the relationship between fecundity and those measures subsumed under life expectancy. It is impossible to measure fecundity directly. There are no documented cases of societies rejecting all forms of population control for any appreciable length of time; if little else, marriage age is usually at least a few years after puberty. Thus any attempt at determining the relationship between this and other factors must be derived from other evidence. That the maximum total fertility is around 12 to 13 children per woman (over a population) is not particularly controversial; what is, is the extent to which the figure is reduced by a less-than-perfect physical and social environment. The Fertility Multiplier look-up table, relating fecundity to life expectancy, is largely speculative.

Related to this issue is that of the trade-off between the needs of modelling techniques and the needs of representing reality. DCFSN is, in real world terms, meaningless; Desired Completed Family Size Normal is the number operated upon by some multipliers, and its value is four children per fertile woman. This implies an innate desire for four children—innate in that it is a behaviour unchanged by other things. As such, it is psychologically a nonsense. Mathematically it is useful.

The next point, again related to what is actually in the model, concerns the relative detail of the different parts of the system. The Fraction of Fertile Women (FFW) in the population and the Reproductive Life Time (RLT) are both constants (22% and 30 years respectively). Clearly these can vary in the real world, and in the variations of the sub-system employing several age levels, FFW does change. At this crude level of modelling, taking these as constant is sufficiently accurate; real world deviations tend to be only a few per cent. However, fecundity has not been treated in the same way, although there is perhaps as much justification for taking it as constant as there is for the other two. The reproductive life time is for instance from 15 to 44. If one is to assume extreme conditions (as is done in the Fecundity Multiplier look-up table), then reproductive life time might possibly vary from, say, 10 years of age to 50 at one extreme, and from 20 to 40 at the other; thus the reproductive life-time might be anything from 20 to 40 years' duration. This possible variation cannot

be documented any more soundly than can the fecundity variation. Nonetheless, this suggests that if fecundity (MTF) is to be variable, then RLT should be too: and, if RLT is to be constant, then the other should be also. The latter could be achieved by fixing fecundity at (say) 12 children per woman; the former, perhaps, by having it determined by life expectancy, that being a measure of general health levels in the community.

Lastly, there is the issue of what should be in the model but has been omitted. The key gap on the fertility side is the way in which desired family size may be influenced not only by economic factors (subsumed under IOPC), but also by autonomous decision processes, as reflected in (for instance) government or individual decisions to limit families for some social reason not directly related to IOPC-type considerations. China was quoted as an illustration; other countries could have been added—India, Taiwan, or Japan. This may have been left out because it counted as policy.

The same escape route cannot be used for another omission: the model currently assumes no link between desired fertility (DTF—the goal) and the effort put into achieving birth control (BCE—the means). One can hypothesise that, as desired fertility deviates from the maximum fecundity, then more effort will go into finding means to improve Birth Control Effectiveness: the need has become greater. BCE is determined by Services Output *Per Capita* and DTF (indirectly) by Industrial Output *Per Capita*. As these two determinants are related to each other, so birth control and desired fertility are indirectly related to each other. At times—as in the standard World 3 run— birth control increases as desired fertility decreases, thus showing that the model's mechanisms provide this relationship—and again, while the former declines, the latter is increasing (showing consistency in the relationship). All the same, the introduction of a more explicit and direct relationship would seem not unreasonable.

Mortality

In a manner analogous to the top of the fertility flow chart, deaths change population size which, in turn, influences the number of deaths (Figure 2). Death rates are derived from Life Expectancy (LE), which is affected by four variables: pollution, crowding, health services and food.

Pollution in this context means global pollutants, which include the heavy metals and perhaps some pesticides. Although there is some empirical and plausible medical evidence available to justify the assumption of an association between such pollution and death rates, there is very little known about the details of the association: what are the concentrations of the various pollutants, their effects upon human (and other) bodies, their lifetimes, absorption rates, etc. If pollution effects are to be included in this population sub-system, it makes sense to have the relationship negative—high pollution leading to lower life expectancy. The relationship actually employed has only a minor effect initially: life expectancy drops only 10% for a global pollution level 40 times that of 1970, and a 50% drop (ie, the so-called Lifetime Multiplier from Pollution equals 0·50) at 80 times the level. We do not have the empirical evidence to gauge whether these figures are too optimistic or otherwise.

Similar data-base problems are encountered when assessing the impact of crowding upon life expectancy—the Lifetime Multiplier from Crowding. The MIT work sometimes suggests that the term "crowding" also means "urbanisation", although this is not in fact strictly the case—either in their texts or in the real world. Four possible mechanisms for the impact of crowding (or urbanisation) are suggested, and these will now be briefly reviewed.

Animal populations under both laboratory and natural conditions often stabilise on reaching a certain size. This is often explained through the "increased competition for a decreased share of resources". As far as the human analogy is concerned "resources" is not defined here, nor is "decreased" justified. As implicitly admitted, this mechanism is none too important, if indeed plausible. Does it make more sense if expressed in terms of urbanisation? Is urbanisation associated with competition to a greater extent than the rural life—and associated in such a way as to influence life expectancy? The concepts here are all very vague; what is "urbanisation", what is "competition", and how can they be measured?

Infectious diseases can spread among a crowded population more easily, although historically the preventive factors have often been sufficient to cut down the dangers. A problem in modelling this is that health services already feature in the system, so there are two alternative courses which could be followed: both include positive and negative components (ie, crowding leads to disease, and health services/food lead to prevention), or alternatively include just the first component here, and let the contribution of health and food be

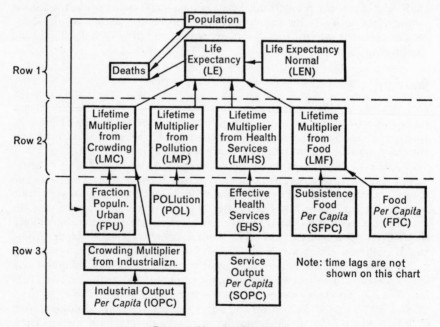

Figure 2. Mortality flow chart

accounted for under their own headings. The latter approach is more in keeping with the principle of this methodology—but it seems to be the former which has been used. As it is, the impact is again assumed to be small, because in practice health services in urban areas have more than compensated the crowding effects.

Pollution now re-appears, this time local rather than global; this means mainly atmospheric pollution. The purpose of this distinction is that crowding/ urbanisation can be used as an indicator of the proportion of the population which is "at risk" from local pollution (everybody being equally "at risk" to global pollution). Local pollution comes from industry, and that tends to be where people are. It seems undeniable that high levels can influence death rates.

The final crowding/life expectancy mechanism postulated involves the stress of living in crowded (or urbanised) areas. Yet again much of the alleged evidence here is controversial. That high population densities in animals (especially laboratory rats) can cause abnormal behaviour is well documented; the analogy with humans is not. That many social and medical indicators reflect urban/rural differences is also well documented; that crowding *per se* is relevant is not. The Technical Report makes the controversial but plausible suggestion that stress lowers resistance to disease and so can serve to lower life expectancy.

We have now briefly discussed two of the four determinants of life expectancy in the model—pollution and crowding—which leaves health services and food (LMHS and LMF). Although they are more important than crowding, urbanisation and pollution, it is difficult to unravel their respective weights.

Any single positive answers must be controversial. Take the ever-popular example of Ceylon: between 1940–44 and 1959, the crude death rate fell from 19·7 to 9·1 per 1 000. This drop is generally attributed to the massive, anti-malaria DDT spraying campaign, a classic example of a relatively cheap and easy public health effort paying high dividends. However, further research has recently suggested that the decline is much more closely associated with changes in other indicators, especially nutritional levels. To say that well-fed people better resist disease and are easier to cure may, in general, be true, but it is also true that deaths from malaria have started to increase again despite no change in food levels. Theory is in a state of flux.

The relative weights given to food and health services in the model can vary; there is no simple ratio used. Life Expectancy Normal (LEN) would be the value of LE given subsistence food levels and no medical/health service; it is taken as 28 years. Food *per capita* is measured in kilograms of vegetable and vegetable-equivalent, and the Subsistence Food *Per Capita* is assumed to be 180 kilos of vegetable (-equivalent) per year or 2 200 calories per day. Double the subsistence level of food (4·4 kcal) increases LE by 20%, to nearly 34 years; trebling, by 28% to 36 years); quadrupling, 32% (to 37 years). The curve then levels out, so that the maximum impact of food alone can be an LE of around 38 years, a 35% increase. Health services, on the other hand, can increase LE by a maximum of over 100%, to 60 years. One hundred dollars per year *per capita* is the expenditure deemed necessary for this effect; $55 will buy an 80% increase, $30 gives 60%, and the 50% increase comes with under $20. In the model, the combined effects of food and health upon life expectancy are obtained

by multiplying the "normal" LE by the Lifetime Multipliers from Food and Health Services (LMF and LMHS); if, for instance, LMF is 1·20 at a point in time (a 20% increase in LE), and LMHS is 1·40, then LE = 28 × 1·20 × 1·40, or 47 years. The other multipliers operate in the same manner.

This means that the potential of health services to improve LE is considerably greater than that of food—the increase in LE can be up to around three times greater. (This does not mean that they are necessarily weighted three-to-one in the simulations; that will depend upon the levels of health service and food supply at any time.) Is this potential weight plausible? The key problem is that, in the real world, the effects of the two are not independent. To imply that LE of 60 years could be associated with minimal food (health service expenditure being around $100 *pa, per capita*) is controversial (even if that situation does not actually occur in the simulation runs). Its impossibility cannot be definitively shown, as there are no real world data for such a situation. On the other hand, the other extreme—ample food, no health services, LE of 38 years—is more plausible, even if it cannot be definitively checked either. In the actual standard simulation run, health services are given far greater importance than food (see Figure 3).

In overall terms, the evidence relating to the relative importance of food and health services is contradictory, although it seems impossible to deny that the two are related to each other—a relationship which is non-existent in the model. Thus two suggestions can be made: that there should be some form of food/health service relation added if a significantly more realistic representation of the real world is sought and secondly, alternative levels of relative importance of the two should be explicitly explored.

Behaviour of the sub-system

In the standard run of the model, world population starts at 1 610 million people, and increases exponentially. Table 1 compares the World 3 figures for 1900 to 1970 with UN estimates.

The agreement, although not perfect, is not unsatisfactory: the maximum divergence is 9%. Although the model's estimates are higher than those of the

TABLE 1. COMPARISON OF WORLD 3 AND ACTUAL POPULATION, 1900–1970

Year	Population size — World 3 standard run (millions)	UN estimate of actual (millions)	Ratio World 3 : UN (per cent)	Decennial growth rates — World 3 (per cent)	UN (per cent)
1900	1610	1610	100	9	—
1910	1760	—	—	9	—
1920	1910	1860	103	9	—
1930	2080	2070	100	9	11
1940	2380	2300	103	14	11
1950	2740	2520	109	15	10
1960	3210	3000	107	17	19
1970	3790	3660	104	18	22

UN, the death rates in the model for the 1960's and 1970's are higher than those of the UN, meaning that the model's net growth rate for the present day is on the low side. The maximum population size reached in this standard run is 12 000 million people, in about 2070.

To take mortality first: Figure 3 shows the values of life expectancy and its four first-order determinants at various times. The contribution of pollution (LMP) is virtually non-existent in this, the standard run: its lowest value is 0·995 (ie, it is then reducing life expectancy to 0·995 of what it would be otherwise—these are multipliers). Crowding is marginally more important, ranging (in the pre-collapse days) between 0·933 and 1·012. During the collapse period itself (not that the model is claimed to be valid for that period) it does become more significant, reaching 0·764 by 2050 for instance. However, the two major influences are food and, above all, health services. Up to 1930, food is the more important: both are below 1·025 in 1900, but by 1930 the food multiplier has climbed to 1·075, and the health multiplier (LMHS) to 1·039. Then the LMHS clip comes into action, pushing the curve up: the 1940 value is 1·235. (A clip switches the model from using one set of quantitative values in a look-up table to using another set.) The operation of this clip is caused solely by the date (1930).

Perhaps the easiest way to show why the clip is included is by showing what would happen if it were not. In the real world, there was a major decline in world-wide mortality in the years just before and since the last war. This could be modelled by playing around with the various (single, fixed) look-up tables in such a way as to reduce mortality then. This would be a very difficult thing to do, and so it is easiest to assume that one or more of the first-order determinants of life expectancy did something then. One could assume that food levels suddenly increased in a quite spontaneous manner (ie, not as a result of changes in the other variables); it would be difficult to justify this— food production in the real world did *not* suddenly increase then. An alternative is to assume a sudden increase in the effectiveness of health services: that research into public health and medical matters started to pay large dividends and, especially, the research findings were applied. This is modelled by the clip function which operated in 1930. This is another instance of the trade-off between reality and ease of modelling (as was the "normal" aspect of the completed family size). The clip is also a one-way process: if Service Output *Per Capita* later on drops to below the 1930 level, it is assumed that we still have the post-1930 knowledge, and so the post-1930 health effectiveness will still apply.

By 1940, therefore, the health multiplier is at 1·235, while that of food is still slowly increasing and has reached 1·088.

Health then becomes by far the most important factor in determining Life Expectancy. The peak Life Expectancy is 51·5 years; as always it comes from multiplying LEN (LE Normal—28 years) by the four Lifetime Multipliers; at this time, the health service multiplier is 1·63, food multiplier 1·115. It is the food position which induces the drop in LE: food *per capita* is the first to decline, this starting 30 years before the maximum LE is achieved. Crowding starts to have an adverse effect again 20 years before this LE peak, and health services decline 10 years after it.

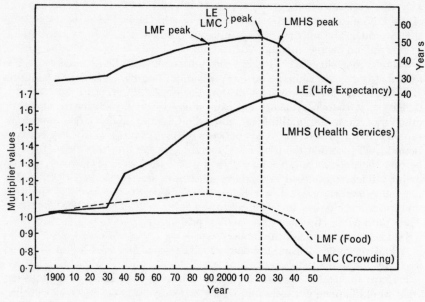

Figure 3. Mortality

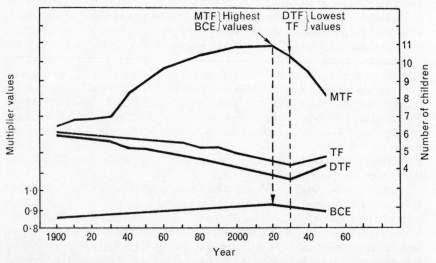

Figure 4. Fertility; MTF = Fecundity (children per fertile women); TF = Total Fertility (children per fertile woman); DTF = Desired Total Fertility (children per fertile woman); BCE = Birth control.

On the fertility side (Figure 4) we find Total Fertility declining slowly from 6·1 children per fertile woman in 1900, corresponding to a crude birth rate of 44 per thousand; the 1970 values are 5·5 children, or 40 per thousand; the minimum values reached (2030) are 4·43 and 32. This reduction is partly the result of an improvement in Birth Control Effectiveness (from 0·86 in 1900 to 0·90 in 2030). It was determined by the broadly-defined Service Output *Per Capita*. The other cause is the decline in Desired Total Fertility (from 5·98 children to 3·74); this was determined by the Industrial Output *Per Capita*, routed by way of the Family Norm Multipliers from Social Structure and from Income Expectation.

The Social Structure multiplier is by far the more influential initially: for the first few decades of this century its value is around 1·8 as against 0·8 for the income multiplier. By 1970, the former is near to 1, while the latter has not changed significantly; in other words, the changes in social structure which come with industrialisation are, initially, more important than those in income expectation. The relative importance changes at higher levels of industrialisation, as was described earlier.

Desired Fertility and Birth Control trends have had to offset a third factor: an increase in fecundity (from 6·5 children per woman in 1900 to 11·0 in 2020); this increase comes from the general improvement in health, as reflected in the changes in life expectancy. Come the period of increasing fertility—2030 onwards—the reverse pattern appears: desired fertility increases and Birth Control Effectiveness falls, offsetting the lower fecundity levels.

As mentioned elsewhere, it is claimed that the model's assumptions are valid only during the pre-collapse days. The need for this disclaimer is reflected here: an increase in desired family size during a collapse seems somewhat improbable. Another possible anomaly concerns the gap between achieved and desired family sizes (Total Fertility, and Desired Total): the gap after 1930 is greater than that before then. This is because the improvements in birth control are not sufficient to compensate completely for the marked increase in fecundity.

So much for the actual basic run of the model; we now turn to considering how sensitive these results are to the assumptions employed. But firstly, a note on the sensitivity of the model as a whole to its population sub-system. In Chapter 9, it will be shown that changes in the rate of population growth had a minimal effect upon the overall behaviour of the world models: although the numbers changed, the qualitative results were very similar. This means that, when looking at the "internal" sensitivity of this sub-system, any changes in assumptions which lead to changes in the population growth rate do not have to be considered in the context of the model as a whole—unless the induced changes are considerably larger than those described in Chapter 9.

Only a few of the many sensitivity runs conducted by *The Limits to Growth* team are reported in the Technical Report. These involve changing the assumptions relating to the following so as to increase the population growth rate. Only one is changed at a time: the effects of food, of health services and of crowding upon life expectancy (LMF, LMHS and LMC); fecundity (MTF—set constant at 12 children), the Family Norm Multiplier from Income Expectation (FNMIE—eliminated), the multiplier compensating for infant mortality

(CMPLE), and Birth Control Effectiveness. BCE and the Social Structure Multiplier (FNMSS) were also changed so as to reduce the population growth rate. Thus eight variables are taken, and twelve runs reported—the eight being out of a possible twenty-eight. In general, the changes make but little difference to the emerging results; fixing fecundity at 12 children, for instance, increases the birth rate and so population sizes, but the difference is small. Not even changing the food and health service assumptions causes noteworthy changes. There are also two variations on the sub-system described, one introducing four age breakdowns, and the other fifteen. Again, any differences in the results are only marginal.

There are, however, two multipliers which form exceptions: the two Family Norm Multipliers (FNMSS and FNMIE), that from Social Structure and that from Income Expectation. (Both concern the impact of increasing levels of industrialisation upon desired family size; FNMSS reflects social structure changes, leads to a reduced desired size, while the FNMIE reflects an increased physical ability to support children and thus an increase in desired size.) The tests shown in the Technical Report suggest a marked sensitivity of the birth rate to changes, especially in the Social Structure Multiplier. The runs in the Technical Report involve only the population sub-model, set values being assumed for inputs from other sectors (such as industrial output having been 7×10^{10} dollars, growing at $3 \cdot 7\%$ annually). In the base run for this situation, the crude birth rate drops from 44 per thousand to a minimum around 18 over a 120-year period. The Social Structure Multiplier, it will be remembered, is intended to handle the way social changes, induced by industrialisation, reduce the size of the desired family; the effect of the multiplier upon births is thus routed through desired total fertility (as is also that of income expectation). In the standard World 3 run, the multiplier (in itself) moves desired family size between 3 and 5 children. If this range is changed to 2 to 4, the birth rate is around 10 per thousand after 120 years, and still dropping. If fixed at 3 children, the corresponding figure is 12 per thousand and the population is stable. Eliminating the income expectation multiplier keeps the birth rate above 30 per thousand throughout the run. As mentioned, all these figures are in comparison to the 18 per thousand of the sub-system's own "standard run".

Thus changes to these two multipliers cause significant fluctuations in the sub-model changes which are in the perfectly plausible range of between 2 and 5 children per fertile woman. It was mentioned earlier that, although the structure of this part of the sub-model is plausible, there is insufficient evidence relating to the real world process to justify this structure in comparison to possible, equally plausible, alternatives. Thus it is unfortunate that the sub-system is sensitive to this particular pair of variables.

We can also note that the exact quantitative form of all the relationships could be changed, and these changes could be equally arbitrary. The "normal" life expectancy, for instance, could be taken as 24 or 32, say, as well as the 28 years used; the Desired Completed Family Size Normal could be taken as, say, 2 or 10—as well as 4; maximum possible fecundity may be as high as 15 children per woman rather than 12; and so on, with all the others. However the overall behaviour of the world model is relatively insensitive to changes in the output of the population sub-system.

Conclusions

The two key problems for the population sub-model relate to the paucity of real world knowledge of population dynamics, and the extent to which population growth is determined by matters of a policy nature as well as a physical nature.

The problems of knowledge have appeared at many points. How do food and health services influence life expectancy, and what are their relative contributions? What are the possible impacts of crowding and pollution upon life expectancy, and what is the relationship between industrial output *per capita* (as reflected in income expectation) and desired family size? What variations can be expected in fecundity as health levels change? Such questions convey an idea of the challenge the sub-system model-builders undertook, and it is therefore not surprising that their conclusions are controversial.

Regardless of choice, a given set of physical conditions (food supply, pollution levels, etc) will have a given physical effect upon people. This is a matter of knowledge in the life sciences. The second problem concerns the choice between those possible given conditions; what levels of food supply and health services will be chosen (from within the "naturally constrained" range), how will those levels be constituted (animal or vegetable matter, for instance), and how will they be distributed over the population?

The historical record of population forecasting is not too impressive. Showing the consequences of present trends continuing may be a relatively straight-forward arithmetic operation or, as in the World 3 sub-model, a complex modelling operation, whereas estimating the most likely future population must explicitly acknowledge the possibilities of changes in the trends. Which leads to the question of what set of conditions are meant by the continuation of present trends. As has been shown, the present model does not assume any changes to the policy-determined relationships it uses.

As regards population, the model is not really forecasting the most likely world population sizes. Rather, the population sub-system is a means of generating plausible population figures to use as input for the other sub-systems—and, as such, could have been made much simpler.

5. THE AGRICULTURAL SUB-SYSTEM

Pauline K. Marstrand and K. L. R. Pavitt

The assumptions about the physical limits of the critical variables in the agricultural sub-system of World 3 are pessimistic. By making more optimistic but, on the basis of available information, equally plausible assumptions about them, any physical limits to agricultural production recede beyond the time horizon of the model. The major problems of feeding the less developed world are seen to lie in political rather than in physical limits.

THE key assumptions of the agricultural sub-system of World 3 are as follows:
- Food is produced from arable land and agricultural inputs (like fertiliser, seed, pesticides).
- Food output increases when the arable land area, land fertility, or the amount of agricultural inputs are increased.
- There are decreasing returns to the use of agricultural inputs.
- The amount of potentially arable land is finite and development costs (for clearing, roads, irrigation, dams) increase as the most attractive land is used first.
- Newly developed land enters at the current average land fertility.
- Arable land erodes irreversibly on a time scale of centuries when subject to intense cultivation.
- Arable land disappears when built upon, a process occurring more rapidly as the wealth increases.
- Capital-intensive use of land potentially leads to persistent pollution of the land (pesticide addiction, salinity, heavy metal poisoning).
- Land fertility decreases on a timescale of decades when affected by persistent pollutants.
- Land fertility regenerates itself over decades and the process can be speeded up by proper land maintenance. . . .
- Land yield is reduced by air pollution.[1]

Structure

The basic structure of the agricultural sub-system is shown in Figure 1. Demand for food stimulates agricultural investment, either in land development or in

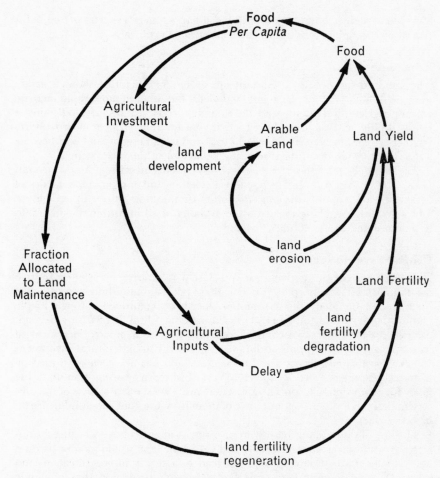

Figure 1. The main structure of the agricultural sub-system

agricultural inputs into land already under cultivation, depending on relative marginal productivities. The amount available for agricultural investment is drawn from the total investible resources available for industry, services, resources and agriculture, and it adjusts automatically to the level of demand for food. This level of demand for food is itself a function of population and income *per capita*, consumers tending to devote a relatively smaller proportion of their total income to food as they become richer.

There are diminishing returns to investment in both agricultural inputs and the development of new land. Furthermore, increasing agricultural inputs (ie, fertiliser, pesticides, mechanisation) cause land erosion and the reduction of land fertility (ie, the inherent capability of the arable land to produce crops). Land erosion is irreversible and leads to the loss of available arable land but only after

a very long period. Loss of land fertility can happen over a shorter period but is reversible through regeneration, either natural or artificial..

Behaviour

The standard run of the agricultural sub-system for the future shows a steady increase in both food *per capita* and land yields but an even more rapid increase in both agricultural inputs and development costs per hectare, reflecting a steady decline of the marginal productivity of capital investment in agriculture. Neither erosion, nor fertility, nor industrial and urban uses of land ever become a dominant or important feature of the behaviour of the sub-system.

The agricultural sub-system has a very important effect on the overall behaviour of World 3. If the resource depletion and the pollution modes of "collapse" are avoided, the combination of diminishing returns in agriculture and a growing population leads to the draining of all investible resources into agriculture and to yet another "collapse".

Critical assumptions

The behaviour of the agricultural sub-system is clearly conditioned by two assumptions. First, as people get richer, they spend a diminishing percentage of their wealth on food: this assumption has been confirmed through ample empirical observation and is in fact graced with the title of Engels' Law. Second, each increase in the production of food will require a greater increment of investment; this assumption of diminishing returns to agricultural investment was first postulated early in the 19th century and has not been confirmed by historical experience. It is, therefore, on this second assumption that the following discussion will concentrate. There are several other aspects of the sub-system that merit discussion, but none of them have the same major influence on its behaviour.

The law of diminishing returns to investment in agriculture was first formulated by Malthus, who argued that good cultivable land would soon be used up and that technical progress would not lead to a steady improvement in land yields. This assumption was critical to Ricardo's prediction that economic growth would eventually stop because it would result in growing population, and because feeding this population would drain off an ever-increasing proportion of investible resources into the agriculture sector. It is methodologically reassuring to note that World 3 makes the same prediction: as we have seen, if the natural resource and pollution modes of "collapse" are avoided, the subsequent "collapse" is due to precisely the mechanism that Ricardo described 150 years ago.

However, this "collapse" has not yet happened. At least in the developed countries, where the statistical data exist, there is no long-term tendency towards diminishing returns to investment in agriculture. Such investment accounts for a much smaller proportion of total investment than in Ricardo's time and yet produces much more. A number of factors have contributed to the relative ease with which the industrialised countries have been able to feed themselves (see chapter 10) and why Malthus' and Ricardo's prediction turned out to be wrong. Birth rates went down, living standards rose, food-producing areas of the

world were colonised and technological change—both in methods of agricultural production and in methods of transportation and storage—enabled Europe to produce more itself and to eat what was produced in the newly exploited and agriculturally rich regions of North America, South America, Russia and Australia.

However, two-thirds of the world's rapidly growing population still does not eat enough, so it is perfectly right and proper to ask whether what has proved possible for the fortunate one third of the world's population will prove physically possible for all the world. The answer given by the agricultural sub-system of World 3 is that it will not. If the resource depletion and the pollution modes of "collapse" are avoided, diminishing returns to agricultural investment will become a serious problem when the world's population reaches about 20 000 million, more than five times the present figure. Is this view of the world's future justified?

This clearly depends on how right World 3 is about the rate at which the world's population grows in future. Assuming that population does reach 20 000 million, can we expect a collapse of the sort described in the World 3 model? As we shall now see, this depends critically on the validity of the assumptions made in the model about the costs of developing arable land and about future trends in land yields.

The availability of potentially arable land

It is assumed in the agricultural sub-system of World 3 that the amount of potentially arable land is finite, and that development costs (for clearing, roads, irrigation, dams) increase as the most attractive land is used first. In the early 19th century, Malthus predicted that all the world's arable land would soon be used up—including that in the Americas. According to data presented in the Technical Report, less than 50% of the world's potentially arable land is at present under cultivation. In the densely populated continents of Europe and SE Asia, the percentage is over 80; in North America and the USSR it is between 50 and 60; and in Africa, Australasia and South America it is around 15 to 20.[2] In North America, Australasia and Argentina, land yields are low by world standards but the degree of mechanisation is high, thereby suggesting that in these regions of the world the relatively scarce factor in agriculture is labour, not land.[3] Indeed, in some of these regions, arable land is being taken out of use.

The Technical Report assumes steeply rising development costs as arable land is used up; this is represented in Figure 2 where it should be noted that the scale for development costs is logarithmic. There are two objections that can be raised to this assumption. First, the empirical data on which the curve in Figure 2 is based are sparse and not representative. Virtually no data exist for the upper, left-hand part, where very steeply rising development costs are assumed. Only a few empirically based points exist for the rest of the curve. These are not sufficient either in spread or geographical region or in number to get an accurate picture of land development costs. Nor is it certain that these points show what development costs could be like through using the most appropriate technology (eg, land development patterns suitable for tropical climates).

The second objection is that, whatever the shape of the development cost curve, the procedure of taking a world average of available arable land, and then

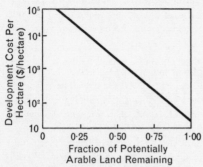

Figure 2. Development Cost Per Hectare

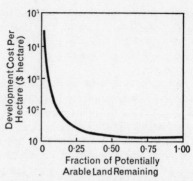

Figure 3. Development Cost Per Hectare (revised)

calculating from Figure 2 a world average of development costs for new arable land, considerably underestimates the increase in agricultural output per unit input that would be physically possible. This is because the procedure implicitly assumes that agricultural investment decisions will continue to be made by national entities, each of which will be investing in agriculture mainly within its own national boundaries. Now this may be a realistic assumption, both for the past and for the future but it has little to do with the physical limits of growth that the World 3 model sets out to identify. Moreover, it is inconsistent with the implicit assumption in the capital sub-system of perfect mobility of capital and labour on a world scale.

The procedure for dealing with physical limits proper on a world basis would be very different from that postulated in the model. It would consist in satisfying the world's food demands by investing within a world framework, starting at the first country at the bottom right hand portion of the curve in Figure 2, and then moving from right to left along the curve: in other words, one would start by investing in the regions of the world with the lowest development costs. The extent to which this procedure would change the shape of the curve depends, of course, on whether or not there are sizeable regions of the world at the right hand, lower end of the curve in Figure 2. We have already seen that this is in fact the case, with Africa, South America and Australasia at the right hand end, and North America and Russia in the middle.

Taking into account these two criticisms, the shape of the development cost curve might just as well be as depicted in Figure 3 as in Figure 2. Since the total costs of bringing all the world's arable land under cultivation are proportional to the area between the curve and the horizontal axis (and with development costs not drawn on a logarithmic basis), it is clear that the degree to which investible capital is drained off into agriculture in order to achieve a given agricultural output depends very much on the shape of this curve.

Trends in land yields

Contrary to Malthus' predictions, land yields in the richer countries have been improving steadily for at least the past 80[4] years and there have been measured improvements for a much larger number of countries over the shorter period

since 1955.[5] These improvements in land yields are to an important extent attributable to greater inputs of fertilisers and pesticides.[6] World 3 assumes that there will be diminishing returns to these inputs of fertilisers and pesticides in terms of increased output: in other words, for each identical increase in land yields, an even greater quantity of fertiliser and pesticide will be required.

Figures 4, 5 and 6 are presented in the Technical Report as quantitative evidence of this process of diminishing returns. In Figures 4 and 5, the correlations suggest that every 1% increase in land yields requires a more than $2\frac{1}{2}$% increase in pesticide and fertiliser inputs. But these data cover relatively short periods of ten or so years, whereas the model is run forward for 150 years or more. Furthermore, the data are for only three countries and, given that the figures on the graphs cluster around each country, the validity of the correlation depends heavily on an assumption that is not spelled out in the Technical Report, namely, that other factors influencing the relationship between fertiliser and pesticide inputs and land yields in all three countries are either non-existent, or are equal, or are changing at the same rate. These other factors could include climate, scale and organisation of production, and plant and

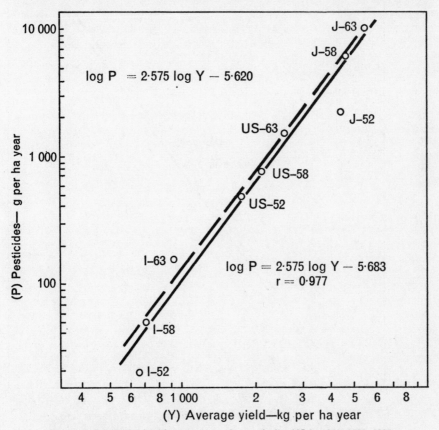

Figure 4. Pesticides/yield regression. Japan, India, USA, 1952, 1958, 1963

animal varieties, as well as the methods and degree of precision in the statistical measurement of inputs and outputs.

This is a rather shaky structure of assumptions on which to base predictions of trends in all countries in the world over a period of 150 years or more. Certainly Figure 6 includes data for many more countries on the relationship between land yields and fertiliser use, but many of the same objections hold and, although a curve indicating diminishing returns has been drawn by Meadows to "fit" the 41 points, it would have been equally justifiable to draw a straight line.

In addition to the questionable use of empirical data, there is the more fundamental point that pesticide and fertiliser inputs are not the only factors influencing the physical possibilities for changing land yields. Historically, the latter began to increase well before the large-scale introduction of the former. Improvements in plant and animal varieties and in general husbandry have contributed to higher land yields in the past and they could continue to do so in future. With such improvements, it might be possible to develop varieties with higher land yields per unit pesticide and fertiliser input, particularly in tropical

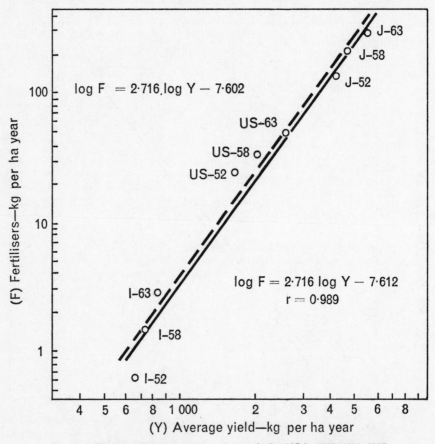

Figure 5. Fertiliser/yield regression. Japan, India, USA, 1952, 1958, 1963

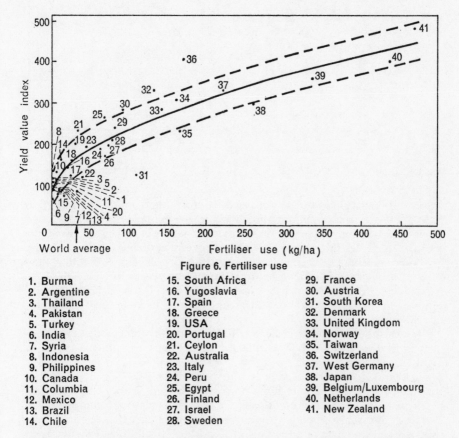

Figure 6. Fertiliser use

1. Burma	15. South Africa	29. France
2. Argentine	16. Yugoslavia	30. Austria
3. Thailand	17. Spain	31. South Korea
4. Pakistan	18. Greece	32. Denmark
5. Turkey	19. USA	33. United Kingdom
6. India	20. Portugal	34. Norway
7. Syria	21. Ceylon	35. Taiwan
8. Indonesia	22. Australia	36. Switzerland
9. Philippines	23. Italy	37. West Germany
10. Canada	24. Peru	38. Japan
11. Columbia	25. Egypt	39. Belgium/Luxembourg
12. Mexico	26. Finland	40. Netherlands
13. Brazil	27. Israel	41. New Zealand
14. Chile	28. Sweden	

and sub-tropical regions in relation to which until recently very little plant research and experimentation was done. These possibilities for technical progress are not considered in the World 3 model.

Finally, the same error in world-wide averaging has been made in the relationship between pesticide and fertiliser inputs and land yields as we have already seen in the relationship between development costs and available arable land. The calculation once again assumes that investible resources will continue to be divided among nations in much the same way as now. This is bound to lead to a sub-optimum investment on a world scale, since it would clearly be more productive to increase agricultural inputs mainly in countries at the bottom, left hand part of the curve on Figure 7, namely, North America and Australia, rather than in countries at the top right hand part, like the Netherlands and Taiwan. In other words, if the world's agricultural inputs were distributed in an optimum manner, the curve would be as in Figure 8 rather than as in Figure 7.

Conclusions

Thus for the two critical assumptions conditioning the behaviour of the agricultural sub-system in World 3, the empirical data base is weak, and the process of

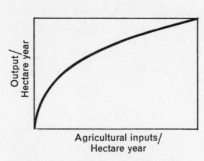

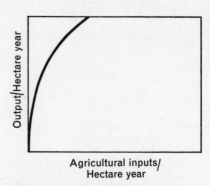

Figure 7. Land Yield Multiplier from Capital

Figure 8. Land Yield Multiplier from Capital (revised)

world-wide averaging implicitly assumes political limits rather than physical limits. If one assumes continuing technical progress in land development techniques and in plant varieties, as well as the rational use of agricultural resources on a world scale, then the relationship between available arable land and development costs per hectare could be of the form of Figure 3 rather than Figure 2, and that between agricultural inputs and outputs per hectare of the form of Figure 8 rather than Figure 7. When the model of the agricultural sub-system is re-run with these two changes, any physical limits to agricultural production recede beyond the time horizon of the model.

However, this does not mean that there are not, or will not be, any problems in feeding the world. The changed assumptions fed into the model in Figures 3 and 8 have no more empirical validity than those in Figures 2 and 7. But neither do they have less validity, and the purpose of this sensitivity analysis is to show that the behaviour of the sub-system depends greatly on parameters about which empirical information is insufficient, and where the process of averaging and aggregation is wrong. The only conclusion that one can draw with any certainty is that in its present form the agricultural sub-system is an unsatisfactory tool for forecasting the future and that the assumptions fed into it are pessimistic.

For any satisfactory model exploring the world's physical limits in producing food, improvements will be required in a number of directions, of which the following are important:

● There is the need for the collection of more thorough and representative data on land development costs, and of historical trends in both land yields and agricultural inputs, in order to improve the empirical basis of the model.
● It is necessary to examine the possibilities of technical progress that are not included in the model in its present form.

This is particularly important for the agricultural sub-system since, even with the pessimistic assumptions fed into it, the World 3 model still gives us about 100 years of grace before an agricultural "collapse". This should give ample opportunity for very radical changes, not only in plant and animal varieties, and in general husbandry, but also in the development of biological pest control, of direct methods of nitrogen fixation, of synthetic foods, of ocean farming and of food production on what is at present not considered to be arable land.

- There needs to be a clearer distinction between the physical limits and the political and economic limits to the production and distribution of the world's food. One aspect of the present model's lack of clarity on this distinction has already been discussed. There is the additional shortcoming that the economic mechanisms whereby food supply responds to food needs, agricultural investment decisions are made and agricultural produce is distributed, are not made explicit in the model. In this sense, it is inferior to the model of Ricardo, developed in the 19th century.
- The model would be improved through disaggregation, either between the advanced and the underdeveloped countries of the world, or between those where land is plentiful and those where it is scarce.

Our own opinion is that, although there must clearly be physical limits to the world's capacity to produce food, the combination of technical progress and the rational use of the world's food-producing resources could put off these physical limits well beyond the time horizon of the World 3 model. However, we see the major problem of feeding the world elsewhere, in politics rather than in physical limits.

There is the geopolitics of the world's arable land. On a world basis, it would clearly be most efficient to expand food production in North America, Australia, Russia and Latin America, where there is plenty of good, spare land and where land yields are still relatively low. This is how densely populated Europe helped feed itself in the 19th century, until new techniques helped it become relatively more self-sufficient. But in certain poor parts of the world today the population pressures are greater than they were in 19th century Europe, and these poor countries cannot sell products in exchange for their food, nor emigrate to the more land-abundant countries, with quite the same ease as the European people could in the 19th century. So the food producing potential of the agriculturally rich areas remains untapped, and physical limits might well be approached in certain densely populated regions of, say, SE Asia.

Another political problem is the political economy of investment in land. The fertility and long-term productivity of land depends on the time horizon over which agricultural investment is made. Investments aimed solely at short-term pay-offs can lead to erosion, pollution and loss of fertility of the soil. All these problems can be avoided if the time horizons for investment decisions are long enough. Thus the political, economic and social factors which determine the length of these time horizons are crucial to the productivity of the land over the long term.

The World 3 Technical Report recognises this problem and discusses it. It says nothing about the first and potentially more explosive problem of the distribution of the world's arable land. But, as we have seen, its pessimistic conclusions do reflect these political limits rather than any physical ones, even if its authors do not appear to be aware of the fact.

References
1. Technical Report
2. *Ibid*
3. Y. Hayami and V. Ruttan, *Agricultural Development* (Baltimore, The Johns Hopkins Press, 1971), pages 71–72
4. *Ibid*, Appendix B
5. *Ibid*, page 73
6. *Ibid*, pages 71–72

6. THE CAPITAL AND INDUSTRIAL OUTPUT SUB-SYSTEM

P -A. Julien and Christopher Freeman
with an appendix by C. M. Cooper

The World 3 model has an acknowledged sensitivity to the capital sector. It predicts catastrophe. But the great weakness of the capital sub-system is that it assumes inflexible relationships and constants throughout which make overshoot and collapse typical modes of behaviour of the model. It excludes the possibility of adaptive flexible response to changing circumstances—one of the main characteristics of real world behaviour of the economy.

THE "capital sector" has a very precise meaning in the model. Capital includes only the physical, produced inputs of the production process. It is the accumulation of past material output which was not consumed (within one year) by the population. As we shall see, the model-builders do not always quite succeed in adhering to this strictly physical definition but this is their aim.

In *The Limits to Growth* Meadows says that "the basic behaviour mode of the world system is exponential growth of population and capital followed by collapse".[1] For this collapse, the world models are much more sensitive to the behaviour of the capital sector than to population. This sensitivity is due to the nature of the feed-back loops incorporated and the other rather rigid relationships which are assumed to govern the system. Figure 1 illustrates the "causal loops" of the capital sector.

From this it may be seen that, so long as the Industrial Capital Investment Rate (ICIR) exceeds the Industrial Capital Depreciation Rate (ICDR), the positive feedback leads to the accumulation of capital and growth of Industrial Output (IO) over time. This tends to bring about the collapse of the world economy because of the assumptions made that associate rising output with depletion of non-renewable resources and the Fraction of Capital Allocated to Obtaining Resources (FCAOR) as described in chapter 3. Alternatively, if this mode of collapse is averted, the rising scale of pollution assumed to follow

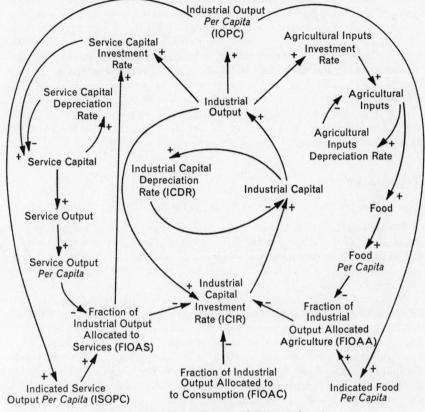

Figure 1. Causal loop diagram of the capital sector.

from the accumulation of capital will bring about catastrophe (chapter 7). If this too is averted then the diversion of capital to agriculture will cause collapse (chapter 5).

The greater the net investment (gross investment minus depreciation), the higher the growth rate of the world economy and the sooner the collapse. But the effect of assuming a longer life of capital goods is greatly to accelerate catastrophe, since the rather rigid assumption is made that if depreciation is less, net investment is correspondingly increased and the accumulation of capital accelerated.

When, however, investment (ICIR) falls below depreciation (ICDR), the other rigid relationships assumed have the opposite effect and negative feedback leads to a downward spiral of both output and capital stock. This downward collapse is first induced by the growing fraction of output and capital which is claimed by extraction of natural resources and by agriculture. That part of total industrial output which is re-invested in industry and goes to increase the stock of capital (ICIR) is so defined that it is essentially a residual after the needs

of agriculture (Fraction of Industrial Output Allocated to Agriculture: FIOAA), services (FIOAS), and consumption (FIOAC) have been met. The assumed tendency for diminishing returns to investment in mining and resource extraction (chapter 3) and in agriculture (chapter 5) combined with the assumption that consumption is a constant fraction of output must inevitably lead to a situation where ICDR exceeds ICIR and a downward spiral sets in. In other words, both the positive and negative feedbacks are so designed that, if the assumed relationships correctly describe the system, the collapse of the world economy is quite inevitable if growth continues. Steady growth or a gradual approach to limits is ruled out. But are the assumptions plausible and do they correspond to what is known of behaviour in the real world?

The assumptions

The critical assumptions made in the capital sector are the following:

● *The Average Life of Industrial Capital (ALIC) now and for an indefinite period is assumed to be 14 years (ie, a constant).* The Average Life of Service Capital (ALSC) is also assumed to be constant at 18 years. Service capital is assumed to last a little longer because it includes a higher proportion of buildings in relation to machinery.

● *The Industrial Capital/Output Ratio (ICOR) is assumed to be a constant* with a value of 3, and the Service Capital/Output Ratio (SCOR) a constant with a value of 1. The specification of the model with regard to labour is by no means clear, and there appear to be serious anomalies and inconsistencies. These follow from the desire of the model-builders to exclude labour as an unnecessary complication and from the choice of a Harrod-Domar production function. Although labour is generally not considered, there is a crude labour sector in the model which only comes into play if population declines faster than the capital base ie, not at all during growth. During growth the assumption is made that the accumulation of capital and the generation of output can be adequately described without the explicit inclusion of labour. These assumptions imply that industrial output increases (or decreases) strictly in proportion with the growth (or decline) of capital stock. The serious theoretical problems involved in the MIT treatment of the production function are described briefly in an appendix to this chapter.

● *According to the MIT view, the assumption of a capital/output ratio which is constant itself implies another important assumption: that diminishing returns will not affect investment in this sector* (Figure 2). The authors comment in the Technical Report that this is an optimistic assumption about future developments in productive technology. It is also at variance with the assumption of diminishing returns to capital in the other sectors (agriculture and resources).

● The model is usually divided into three sub-sectors—agriculture, industry and services. This is the standard economic classification into primary, secondary and tertiary production sectors. But there are anomalies which are far from clear in the MIT treatment of mining and utilities (electricity, gas and water). Sometimes they appear to be treated as a fourth sector, corresponding to "non-renewable" mineral resources; elsewhere as part of the primary sector.

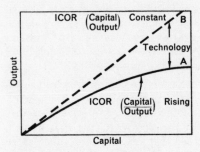

Figure 2. The capital/output ratio in the world model

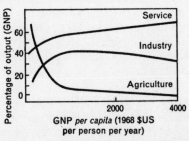

Figure 3. Development patterns: Sectorial shares of GNP and GNP *per capita*. Data for the graphs came from 54 countries, but none were from the Socialist bloc. That *their* development pattern is more appropriate or likely for developing countries is not considered

Leaving aside these anomalies the critical assumption is made that the past and future shares of each sector in total output can be determined by reference to the average world per capita income. Furthermore it is assumed that the changes in this relationship over time have in the past and will in the future correspond to the pattern which emerges from the "cross-country" picture as shown in Figure 3 for 1968. Thus, with average world *per capita* income estimated at $200 in 1900 and $660 in 1970, it is assumed that the sectoral shares of output in 1900 and 1970 corresponded to the 1968 sectoral pattern of those countries which in 1968 had *per capita* incomes of approximately $200 or $660 (Table 1).

If world *per capita* income grows to $1 000 or $2 000 in the future then the appropriate sectoral pattern is derived from the relationships shown in Figure 3. The "Indicated Services Output *Per Capita*" and the "Indicated Food *Per Capita*" (see Figure 1) are derived from look-up tables based on sector shares. The precise derivation of the sectoral shares and the detailed reconciliation of the MIT classification with the international accounts data is not clear. Chenery's work on growth patterns and sectoral shares of output [3] is used to

TABLE 1. GNP, IOPC and SOPC (CONSTANT 1968: US DOLLARS)

	1900	1968–70
Gross World Product (GWP) *per capita*	200	660
Industrial Output *Per Capita* (IOPC)*	40	240
Services Output *Per Capita* (SOPC)*	90	330

* Economists who are accustomed to *per capita* productivity measures which relate output to employment in a particular sector should remember that IOPC and SOPC are used in quite a different sense in the MIT model. The *per capita* refers to the entire world population in each case.

justify the use of cross-sectional 1968 patterns to derive time series for 1900 to 2100.

However, on the MIT standard runs world *per capita* income never in fact reaches the higher levels ($4 000 in USA mid 1968) so that the left-hand side of Figure 3 is the only part which is relevant in practice.

• All capital for all sectors of the economy is defined as coming from industrial output. The greater part of Industrial Output is capital goods in the MIT model, but there is also another fraction of industrial output which is allocated to consumption. *The assumption is made that this fraction (FIOAC) is constant at 43% of total industrial output.* It must be remembered that FIOAC has a much more restricted meaning than "consumption" in most econometric models. It excludes the outputs of the service and agricultural sectors altogether. It consists of such items as textiles, household goods, toys and paper which are consumed by private households (but *not* consumer durables). It apparently also includes government military expenditures.

• *Finally, the model makes the assumption that the economic values of the World 3 population are constant:* ie, the marginal utility of food and services as a fraction of industrial output does not change over time.

Further, there is no mechanism in the model to represent a spontaneous shift in values from those incorporated in the two table functions of indicated service and agricultural output.

Since the table functions are derived from 1968 data, this means that at each world income level in the future, the values will be assumed to be those of that part of the "free world" which was living at that *per capita* income level in 1968.

However implausible this may seem, it is in line with the general structure of the model in excluding values as an independent variable (although of course they are included implicitly in many of the other relationships).

Validity of the assumptions

Do the six assumptions described above correspond to what is known about the real world before 1970, and what may be plausibly assumed about its probable future development from now onwards?

One must first of all express considerable sympathy with the MIT team in trying to make sense of the very fragmentary and inadequate time series which do exist. Economic historians and econometricians have yet to produce satisfactory statistics for many of the variables in which the MIT group are interested. It is to be hoped that one of the beneficial effects of the MIT model-building will be to stimulate data collection and historical research on such a scale that far more adequate and global measures will become available on such variables as capital/output ratios and life of capital. The MIT team cannot be reproached with a failure to collect raw data or with failure to conduct historical research. These tasks were obviously beyond the possibility of a project such as world dynamics. The lack of sufficient empirical time series means that, if a model is to be constructed at all, much depends on an adequate theoretical structure and on making sense of the limited data which are available. The absence of empirical supporting evidence inevitably weakens the credibility of any model and means

that the logical structure and plausibility must be correspondingly stronger if the model is to carry conviction as a simulation of the real world. Therefore, we are obliged to examine both the theoretical structure and the extent to which there is empirical support for the assumptions.

Taking first the assumptions on life of capital: there is no empirical basis from historical time series for the assumption that ALIC and ALSC are constants. Nor is there any empirical evidence that the physical life of the capital assets is 14 and 18 years respectively. The model-builders have fallen into the trap of using 1967 national accounts depreciation data as a surrogate for *physical* life data. But industrial assets are scrapped on the average after 14 years or so, not because of physical exhaustion but because of technological competition, tax systems, and other *economic* advantages of replacement. These economic factors which today determine the average life of capital would obviously change over time, and they would change especially in the sort of situation envisaged in the MIT model—imminent collapse of the economy brought about by shortage of capital. In these circumstances obviously the *physical* life of assets would become more important, and all the empirical evidence indicates that in any case this is, on the average, far more than 14–18 years. In a situation of acute capital shortage obviously the balance of economic advantage in any foreseeable system, capitalist or socialist, would change towards designing and maintaining durable physical assets. Thus at the very first step the MIT model has departed from its own declared aim of making a model of physical capital. It has done so in such a way as to make an extremely implausible assumption about life of capital, based on national accounts data for one year only.

The empirical data on capital/output ratios are inadequate and economists are by no means agreed on their interpretation. However, even though adequate empirical data for estimating world ICOR accurately do not exist, the available data do show for various countries during the period 1900 to 1970 values for the ratio between 2 and 8. [4] There appears to be only a slender justification therefore for assuming a constant of 3 for the whole world, and no justification for a model structure which permits variations between 2 and 4 to make all the difference between complete stagnation and explosive growth. The choice of the constant 3 is based on Samuelson's estimates for the US economy and even here there is a problem of the different coverage of the MIT concept of "industry". But there seems little justification for taking the relative stability of the *US* ratio as a basis for assuming a constant ratio for the *world*. All through the period from 1900 to 1970 the USA was a highly industrialised, technically advanced economy. But when we are considering the world economy, most parts of it are starting from a totally different structure. It is highly improbable that they would have the same capital/output ratio and the (admittedly inadequate) empirical evidence does not support this assumption. Even allowing for the substantial weight of the USA in the world economy, the use of Samuelson's US estimates seems indefensible.

Taking the third assumption of a constant rate of technical progress which is supposedly implied by the choice of a constant capital/output ratio, it is notable that this is completely at variance with the assumptions made about technical progress in the other sub-systems. In relation to agriculture and resources, a

major feature of each sub-system is the assumption of diminishing returns to capital investment. This implies the denial of the possibility of that continuous technical progress which is (probably correctly) taken for granted in the capital sector. Similarly in relation to pollution, the possibility of steady improvement in anti-pollution technology is excluded. Moreover, widespread and heavy capital investment in anti-pollution technologies in industry would in the model perversely lead to an increase in pollution and an acceleration of growth with constant ICOR. In the real world it would lead to a reduction in pollution, and probably a slowdown of growth and a rise in the capital/output ratio. All of these possibilities are excluded by the combination of rigid assumptions which govern the behaviour of the capital sector in the model. The choice of a rising (or a higher) ICOR in the capital sector would have the effect of dampening down the explosive growth process.

The fourth assumption is based on the view that Chenery's work on development patterns justifies the use of cross-sectional data for 1968 to derive a time series for 1900 to 2100. This claim is dubious. Those countries in 1968 with very low *per capita* incomes, of less than $250, were generally net importers of capital goods and net exporters of primary products, whereas the reverse is true of countries with *per capita* incomes greater than $1 000. Consequently a derivation of sectoral shares which ignores the international trade and investment flows would almost certainly give an unsatisfactory result. Moreover, it is inherently extremely unlikely that countries which are developing between 1970 and 2070 will follow a pattern of development which corresponds precisely to the experience of countries industrialising between 1870 and 1970. The very existence of the rich highly industrialised countries and a pattern of world interdependence virtually rules this out. One must also have some reservations about the derivation of the sectoral shares from a sample of countries which excludes all the Communist countries, and about the reconciliation of the Chenery and UN definitions with the MIT sectors.

The rigidity of the fourth assumption can only be sustained by the equally rigid sixth assumption—that values do not change except as indicated implicitly by the changes in sectoral shares as incomes rise (or fall). This assumption cannot be justified either empirically or theoretically but it is perhaps necessary as a modelling device, because of the extreme difficulty of isolating and measuring value changes.

Finally, the fifth assumption of a constant Fraction (43%) of Industrial Output Allocated to Consumption (FIOAC) is based neither on empirical data nor on plausible logical arguments. It is based on a simple average of 1968 data for a number of countries, for which there is an enormous spread of country values, largely unrelated to income levels. The effect of this assumption is simply to increase the rigidity of the whole structure and to ensure the minimum of adaptation by the socio-economic system to changing circumstances and values.

Thus to sum up, of the six critical assumptions for the capital sector, three (life of capital, consumption and values) are based only on 1968 data for part of the world and the assumptions are in any case wrong. The fourth assumption, although also based only on 1968 figures for part of the world, is justified by the argument that there is correspondence between the cross-country and time

series data from 1900 to 1970. This is a highly debatable assumption. The remaining two assumptions (constant capital/output ratios and implied technical progress) are based on a time series, but for only one country (the USA) which is assumed without supporting evidence to be representative of world trends.

Perhaps the most significant feature of the assumptions is that 5 out of 6 are the choice of *constants* for the whole period from 1900 to 2100. This choice can perhaps be defended in terms of the complexity of alternative assumptions and the lack of available data on which to base them. But if the model is defended in this way, then no great claims can be made for its value as a forecasting model, and even less as a guide to policy. The consequence of assuming constants and rigid inflexible relationships is to exclude the possibility of adaptive flexible response to changing circumstances which is one of the main characteristics of real world behaviour of the economy.

The combined effect of all the assumptions is perhaps more important than the validity of each one taken singly. The combined outcome of the assumptions is to set up a rigid framework within which social collapse is unavoidable. If, for example, the Average Life of Industrial Capital (ALIC) constant is extended from 14 to 21 years from 1900, the MIT team found that this had such a great effect that explosive growth of the world economy followed by collapse would have occurred *before* 1970. If the Industrial Capital/Output Ratio (ICOR) is set at 2 instead of 3, collapse would have occurred by 1940. If it is set at 4, no growth would occur at all. Similar tests for variations in the fraction of capital allocated to obtaining resources or to agriculture (FCAOR and FIOAA) before 1970 show very great effect from relatively small changes in the values of the individual variables. The MIT team conclude rightly that these three parameters are critical to the growth mode of the model. The results of these tests did not however apparently lead them to query the plausibility of the assumptions for their "standard run", or the unrealistic rigidity of the structure which they were postulating. Yet this is the obvious conclusion, from the tests which they made themselves for 1900 to 1970 and which we made for the period 1970 to 2100.

Conclusions

The main weakness of the modelling of the capital sector is its rigidity. One does not have to be a believer in the infallible equilibrating mechanism of the invisible hand to recognise that price is a function of demand and supply, and to recognise that if supply decreases because of scarcity, relative price tends to increase and substitution effects come into play. The price mechanism does mean that automatic substitution and replacement tendencies tend to operate in the long run. For a long time economists have been building models which take into account the price effects of relative scarcity. The main effect of assuming rigidity and constants throughout the model is to make overshoot and collapse the typical modes of behaviour of the model, whereas more flexible assumptions would mean that when "limits" exist they would be approached more gradually. The substitution of cheaper inputs and of new and cheaper combinations of factors of production for older combinations is the stock-in-trade of all economic theory and applied economics. Increasingly too,

economics has taken into account the role of industrial R and D in generating new products and processes. While the autonomous price and market mechanisms play a lesser part in most socialist economies, planning and decision-making mechanisms exist which induce a similar degree of adaptability.

Consequently, it is difficult to understand the reluctance of the MIT modellers to allow for adaptability, except in terms of their prior commitment to the beliefs and values discussed in Part 2 of this collection. In particular, some of the more pessimistic ecologists use absolute (and not relative) scarcity of all goods in the long run, and tend to view both physical capital and natural resources in very rigid terms ignoring social controls. This can probably be attributed to an impermissible transfer of ecological concepts to economic problems. Changing technology and social adaptability are the main characteristics which mean that human populations cannot be treated in quite the same way as animal populations. Ecological systems are of course also characterised by great flexibility and elasticity and seldom by the "stability" often assumed in the "anti-growth" literature.

The deliberate exclusion of intangible investment in research and education, and the exclusion of labour from most parts of the model accentuate the tendency to disregard the adaptive response of the economy to changing conditions of supply. It is a tenacious myth adopted by MIT that only capital and the manufacturing sector represent the motor of growth. The French physiocrats regarded both manufacturing and services as parasitic on agriculture. An alternative view is that the knowledge generated by research and education in the service sector is the main dynamic factor, and that the physical capital merely embodies temporarily the technological know-how of society.

The idea that there is a fixed relationship between the relative size of the service, manufacturing and agricultural sectors is unacceptable. There are many factors which could lead to a change in the patterns derived from Chenery's data. For example, since prices increase at different rates on different goods, if we assumed scarcity of natural resources, it is quite possible that the prices of FIOAC goods and durable commodities would grow faster than service and art and leisure goods, especially if the trend of productivity of the manufacturing sector reached its highest point before the rising trends of productivity in the agricultural and service sectors (Figure 4). It is quite possible, too, that rising educational standards would stimulate the demand for cheaper output from the service sector.

Of course there are many constraints to this "invisible hand" of the system. Some come from the rigidity of production in monopolistic competition or

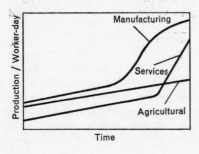

Figure 4. Possible trends in sector productivity

failures in planning. For example, multi-national corporations might escape drastic laws for the protection of the environment by increasing their investments in more "liberal" countries. Bad distribution between people or between countries can increase frustration and diminish quality of life. Adaptability depends on political and social change even more than on the price mechanism and because the system changes very fast, many bottlenecks can arise. Consequently, people want more responsibilities to be taken on by government *and* greater participation in decision-making. A much stronger argument can probably be made for pessimism in terms of a political model, than in the terms of physical capital chosen by the MIT team. We ourselves are not pessimists, but we do accept the view of the MIT group that there are some important rigidities in the system, which are a source of long-term danger for society. These are not the rigidities assumed in the capital sector which we believe are entirely the product of false modelling assumptions and not features of the real world.

Appendix. A note on the assumptions about the production function in World 3

This technical note is intended primarily for economists. The main argument is that the assumptions which are made about the production function in World 3 are unclear, often logically contradictory and also in contradiction with empirical evidence. It is not always clear whether a more systematic set of assumptions would predict "catastrophe" sooner or later. However, given these contradictions, the poverty of empirical data (and the acknowledged sensitivity of World 3 to the "capital sector"), the probability that the overall results of the predictions are correct must be very low.

The capital sector plays a particularly important part in the World 3 model as a whole. In spite of this, the authors have been satisfied with an ambiguous account of its underlying assumptions.

An examination of the Technical Report reveals:

● A confusion about the assumptions regarding the industrial production function. We are told it has fixed coefficients *ex ante*, but it is sometimes discussed in terms which suggest variable coefficients *ex post*.
● A failure to consider the implications of different assumptions about the aggregate production function. For example, if a variable coefficient function were used, (*ex ante* or *ex post*) it would almost certainly lead to different conclusions about the model as a whole from those the authors have reached.
● Extreme implicit assumptions, of which the most notable is an assumption that there is perfect mobility of factors of production (labour and capital) internationally.
● A confusion about the empirical evidence on the production function.

The capital sector model inevitably gives rise to a number of conceptual problems about the measurement of capital and about the validity of "assuming that there is an aggregate production function". However, in this respect, we shall accept the model on its own terms and assume that there are no problems of this kind.

In the only explicit statement about the production function we are told that "... *in general* ... in World 3 there can be no substitution between capital and labour. The actual production function used in the service and industry sector is *usually* a production function with zero elasticity of substitution between the production factors". This production function is described in the Technical Report as "of the Walras–Leontief–Harrod–Domar type"—which presumably invests it with all the authority one could wish, short of actual empirical verification—and is specified as

$$Q = \min\left\{\frac{\text{capital}}{\text{capital/output ratio}}, \ \frac{\text{labour}}{\text{labour/output ratio}}\right\}$$

This is familiar as a production function with technically fixed coefficients. In other words, at any given state of technology, capital and labour can be efficiently combined in only one proportion (K/L) regardless of relative factor prices. It is intended apparently that this rule should apply *ex ante* (to new investments) as well as *ex post* (to capital stock).

The ambiguities come in because the production function does not *always* have technically fixed coefficients—only sometimes.

We may deduce that the fixed coefficients assumption is used to analyse situations where there is an excess supply of labour. It might be more correct to say that the assumption is used—at least implicitly—to explain how the situation of excess labour can arise. At all events, when there is excess labour, there is a production function with capital and the capital/output ratio alone, for the world economy. The use of this pı ,duction function is justified on the grounds that "... globally there has been a large surplus of labour, and economic development was never significantly constrained by a (global) shortage of labour".

On the other hand the fixed coefficients assumption is dropped (apparently) for those special cases where the population declines faster than the capital base.

A first and rather obvious point is about the assertion that "globally there has been a large surplus of labour, and economic development was never significantly constrained by a (global) shortage of labour". This is not very convincing. Even though it is true that there has never been a global shortage of labour in the world economy, it certainly does not follow from this alone that the development of the world economy has never been constrained by shortage of labour. A necessary condition for the second assertion to *follow* from the first (and the authors apparently intend that it should) is that there is perfect mobility of factors of production across national frontiers. This is an heroic assumption. Furthermore, it is at least doubtful whether the second assertion, standing alone, is true as a matter of fact. Economic historians have frequently called upon national shortages of labour *relative* to capital in order to explain the facts of development in various economies (the USA for example).

This leads to a second objection, which is simply that the same assumption (ie, perfect factor mobility internationally) is required to justify the use of a production function of capital and the capital/output ratio alone for those cases of the model where there is a (world) excess supply of labour. Without the assumption it is always possible (if there are fixed coefficients), that labour

shortage will constrain the growth of the major part of the world economy, while there is a massive excess labour force in the rest of it. In other words, there is an implicit assumption of perfect factor mobility underlying the whole analysis.

A third problem is that the authors make different assumptions about the production function for different values of the parameters in the model. An obvious reaction to this is that the shape of the production function is an empirical matter, so that there is no justification for alternative assumptions about it. It seems hardly justifiable to assume that since there is no empirical justification for one particular world production function, one assumption is as good as another.

The scientific response to this state of affairs (if there is one) is to run the model with various assumptions about production functions, to test whether its results are sensitive to these assumptions. The authors have not done this—they have chosen one kind of production function for one set of parametric values, and a second kind for alternative parametric values, instead of testing out the influence of various types of production function for *all* values of their parameters. This latter procedure would be defensible. What they have actually done is not. The problem is all the more serious because we know that the World 3 model is highly sensitive to the assumptions that are made about the capital sector.

It is true, of course, that their actual procedures could be defended if the choice of a fixed coefficient production function rather than, say, a more conventional neo-classical or Cobb-Douglas production function made no difference to the behaviour of the model. But it is most improbable that one would get the same results with a neo-classical production function as with a fixed coefficient assumption. In fact, the use of a neo-classical production function in the case where there is perfect international mobility of factors and a massive abundance of labour relative to capital (conditions which are assumed implicitly in those cases where a fixed coefficients assumption is used in the model) leads to all sorts of difficulties.

To illustrate, assume in addition that there are constant returns to technical change at all points along the production function, and that the rate of growth of the labour force is so great relative to the rate of growth of capital that we may assume a constant real wage rate at the subsistence level. (This is highly improbable but it is a natural outcome of the equally improbable perfect factor mobility assumption, supplemented by an assumption of perfect competition in factor markets.)

In this case, we would get different behaviour with a neo-classical production function compared with a fixed coefficients one. Because of the constant real wage rate, the marginal product of capital (and the rate of profit) would increase with technical change, the K/L ratio would fall and the capital/output ratio would also fall. The simple relationship between the rate of growth of output and the rate of growth of capital stock which one gets with the fixed coefficient model would break down. With continuous technical change output would grow more rapidly than would capital stock. Given that many of the evil things to which the world economy is heir are supposed to follow from capital accumulation—the economy could presumably go on growing for much longer

without falling apart, even if we admit the World 3 assumptions about pollution and resources.

Now precisely because these results seem empirically improbable, it may be argued that they constitute sufficient grounds for rejecting the validity of a neo-classical production function at world economy level. After all, economic growth in industrialised countries has been accompanied by *increases* in K/L and it is said that the K/Y ratio has been more or less *constant* (at least it has not fallen steadily).

The point is, however, that the empirical observations apply to a number of more or less fully employed economies in a world where there is international factor *immobility* in varying degrees, and in these economies the wage-profit ratio is determined, *inter alia*, by a relative scarcity of labour compared to capital. A neo-classical production *function* with constant returns to scale can be used to explain the observed constancy in capital/output ratios. The tendency for the marginal returns to capital to decline with increases in K/L, must be precisely offset by technical change: the rate of profit remains constant and the wage rate rises. We have Harrod-neutral technical change. Alternatively, the constant K/Y ratio may be explained by (Harrodian) labour-saving bias in technical change, combined with appropriate movements in relative factor prices. But the critical point is that any variable coefficients production function which "explains" what has happened to the K/Y ratio in the advanced economies is bound to give different results, if it is applied to a world economy in which there is a large abundance of labour and perfect mobility of factors. The observed behaviour of capital/labour and capital/output ratios in a few advanced economies cannot be used as a basis for rejecting the predictions that arise, when we apply a neo-classical type of production function to the world economy as a whole. And if we get peculiar predictions out of the world aggregate production function, it is because we have to make peculiar assumptions in order to use it.

The upshot is that the World 3 model would almost certainly behave differently if one used a smooth well-behaved production function instead of fixed coefficients. The authors give no reasons for choosing one rather than the other (or at least the reasons they give are insufficient). Moreover they apparently allow factor substitution to occur for some values of their para-meters—so like the rest of us, they are uncertain about the shape of the world production function. In this case, there is an obligation upon them to examine the effect of a variable coefficients production at all values of their parameters and not just some. They fail to do so. Variable coefficients would complicate the model considerably. Labour could no longer be left out of the picture. The assumption of a constant world capital/output ratio would have to go, unless one *assumes* constancy in the world capital/output ratio because of very heavy labour-saving bias in technical change (a strange assumption in a world economy with a relative abundance of labour). But in this case the production function would, in fact, be in contradiction with the observed constancy of the capital/output ratio in the advanced economies, and the observed constancy of the ratio in the advanced countries could not be used as an empirical justification for the assumption.

The problems are compounded in the discussion of technical change and the

capital/output ratio in the Technical Report. In spite of the assumption of fixed coefficients, this whole discussion is conducted in terms of a production function with variable coefficients. The whole question of what is being assumed is confused. We are explicitly told that the constant capital/output ratio in industry comes about because technical change offsets the tendency for the marginal product of capital to diminish as K/L increases. But if there are fixed coefficients (and only two factors), this analysis must be wrong. Fixed coefficients exclude any possibility of diminishing returns. With fixed coefficients the K/Y ratio is normally constant even if there is no growth or technical change; indeed if constancy is to be preserved when there *is* technical change, we have to make very restrictive (and on the face of it improbable) assumptions about the *direction* of technical change. But there can be no question of technical change off-setting a tendency to diminishing returns to capital. At this point one is inclined to give up. We have flatly contradictory assertions about the production function and no way of choosing between them. Perhaps we should assume that the discussion of technical change and the capital/output ratio is simply a mistake—so that we can rely on the explicit statement that there is "usually a production function with zero elasticity of substitution". This, however, can only be an assumption on our part.

Apart from these problems, there appears to be a contradiction in the way the authors have handled the empirical evidence on the constancy of the capital/output ratio. Their main justification for assuming that the industrial capital/output ratio will remain constant for a century to come, is that the macro-economic capital/output ratio in the USA has been (more or less) constant for a long time. However, the World 3 model also contains the assumption that the capital/output ratio in agriculture will increase steadily in the future. This means in fact that the model assumes that the macro-economic capital/output ratio will rise in the future, which is in contradiction with the assertion about historical constancy of the macro-economic K/Y ratio. Far from supporting the assumption in the model, the empirical evidence contradicts it.

There are a number of other puzzles in the Technical Report. For example, it looks as if there will be a steady decline in the rate of profit on capital in the agricultural sector and a constant or even increasing rate of profit in industry and services. Eventually the rate of return in agriculture must fall below that in industry. There is no indication of how this state of affairs can be made consistent with increasing net investment in agriculture. But there is not much point in further exploration of this kind of paradox while we are uncertain about fundamental assumptions on the production function itself. There are just too many ifs and buts, and too many possible ways of interpreting the model for us to say very much more.

References

1. *The Limits to Growth*, page 142
2. Technical Report, Capital Sector
3. H. B. Chenery and L. Taylor, "Development patterns among countries and over time", *Review of Economics and Statistics*, November 1968
4. S. Kuznets, *Modern Economic Growth* (Yale, 1966)

7. THE POLLUTION SUB-SYSTEM

Pauline K. Marstrand and T. C. Sinclair

In dealing with the assumptions and behaviour of the World 3 pollution sub-system, what is "physically measurable" is described and assessed. Thus there is a contrast between this and much of the actual discussion of disamenities in *The Limits to Growth*. What are avoided in this sub-system are the difficulties that are encountered in the modelling of social conditions and responses.

THE assumptions of the pollution sub-system are listed in the Technical Report as follows:

- The generation of persistent pollution is the result of industrial and agricultural activities.
- The amount of accumulated pollution is determined by the integration of the difference between past rates of pollution appearance and pollution absorption.
- There exists a delay between the time a persistent pollutant is generated and the time it appears as a harmful substance in the ecosphere.
- The amount of pollution absorbed per time period is a function of both the total amount of pollution and the time required to absorb each unit of pollution.
- The pollution absorption time, or the time required to absorb a unit of pollution, increases as the total level of pollution increases.

In chapter 12 types of catastrophes and their effects are classified on a scale of increasing severity. The lower end of the scale (Class 1) is concerned with localised or low level effects, such as might arise from contamination of small regions or from wider spread pollution at low concentrations. The scale ascends through progressively more serious impacts to arrive at (Class 4) truly catastrophic events possibly resulting in the extinction of the human species. It will be seen that the catastrophic events related to pollutants of World 3 are fairly well confined to the Class 2 region defined in that chapter, though the effects on the fertility of the soil will fall into Classes 3 and 4. The overall outcome is a catastrophe of Class 4 dimensions.

The structure of the environment sub-system model is shown in Figure 1. Pollution is generated by the industrial and agricultural sub-systems, and in time appears in the biosphere. This is the area of the model where pollution

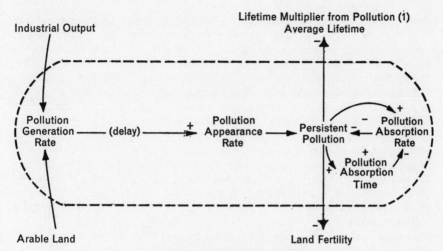

Figure 1. The pollution sub-system

can affect either average lifetime or land fertility. The impacts are made directly without recourse to any ecological model. Two opposing mechanisms influence the rate at which pollution is absorbed and so render the pollution ineffective on life or soil fertility. In the first mechanism, the higher the level of pollution, the greater is the rate at which it is absorbed, other things being equal. However, a second mechanism is postulated so that they are not equal, since rising pollution levels lengthen the pollution absorption time, which in turn depresses the pollution absorption rate. Consequently the rise in pollution is enhanced rather than diminished through time. The model is based therefore on the idea that as the pollutant level rises neither the natural system nor any social action can adjust to cope with the increasing rate. Indeed the ability to absorb, ie, neutralise, the pollution is decreased.

As industrial and agricultural output grows, so pollution grows at the same rate, since all rises in output are coupled, *pro rata*, with rises in pollution. If the resource depletion mode of "collapse" is avoided in World 3, it is the high levels of pollution, acting to depress both life expectancy and land fertility and thus food output, which then cause overall "collapse". In other words, pollution is like resources and agriculture in being one of the sources of the World 3 "catastrophes".

Limitations

Since pollution has rightly acquired significance as something to be feared and fought, this sector of the model has probably attracted a degree of attention out of all proportion to its relative strength within the model as a whole. Further, as the data base for this sector is weaker than that for any other, there is a danger that very wrong conclusions will be reached and will be given wide publicity. Virtually no statistical data are available for more than ten to twenty

years. Even within this period the data are sparse. This reliance on the trends of a few years could result in misuse of the speculations based on the model either to frighten people into taking hasty action, as in the case of substituting NTA for phosphate in detergents, or to discredit the study and, by implication, the legitimate concern for resources and the environment which it expresses.

In any area where firm information is scarce, an operational or predictive model is bound to be more than usually biased by subjective pre-conceptions. The present authors' views are that the way in which resources are at present being exploited could lead to disaster (although not necessarily on a world scale); that this is by no means a necessary outcome of the growth in the use of technology; and, in addition, that there is no possibility of adequately supporting the existing, let alone projected, population of the world without industrial development in countries which do not yet have it. Having said this, the pollution sub-system in World 3 appears to us to have the following strengths and weaknesses.

The basic tenet that the amount of persistent pollution which can be absorbed each year has a finite limit is unexceptionable though the magnitude of the limit is open to conjecture. However, the assumptions underlying the dynamic behaviour of the pollutants are ill-founded and therefore likely to lead to wrong assessments. The negative feed-back loop which tends to diminish pollution generation depends on a direct linear relationship between rate of absorption and amount of pollution. This is not valid for all pollutants, for example not for DDT or oil. The positive loop, which tends to increase pollution levels, is posited because rising pollution levels are held to increase pollution absorption time, but neither is this true of all pollutants. There has been widespread discussion of the rising CO_2 levels in the world's atmosphere which is recognised as an important potential long-term hazard. There is no evidence, however, from what is known of the interaction of oceans and atmosphere to suggest that the assumption that absorption time is increasing is valid.[1]

Furthermore it is not clear on what basis or on what data it is assumed that pollution generation and absorption were in equilibrium in 1900. To take a mundane example it is clear from historical evidence that in 1900, just before the advent of the private motor car, large British cities had reached beyond their abilities to absorb horse manure, with consequent public health implications.[2]

Since no empirical values have ever been obtained for pollution absorption time the use in the model of a constant value of three years prior to 1970 is equally arbitrary.

Another unjustified assumption seems to be that the maximum upper limit of pollution absorption will occur when the pollution level reaches 25 times that of 1970. This has been partly compensated for by performing simulation runs assuming higher levels, but the values used in these are apparently based on similar arbitrary assumptions.

The definition of persistent pollutants also has severe limitations. Since they can originate only in industry and agriculture, it automatically excludes those originating in consumer activity, such as lead and other pollutants in the atmosphere resulting from the use of private motor cars. Further, it also automatically discounts even the limited successes of current environmental

programmes as social control mechanisms. Even according to the criterion used in the Technical Report (namely, that a persistent pollutant is one which requires more than a year for half of it to be degraded to harmless by-products—ie, absorbed—and having an appearance time of more than a year), many of the forms of pollution listed in the Technical Report as persistent do not qualify. In any case, a delay between generation and appearance is not characteristic of all persistent pollutants. Since neither the upper bound for pollution absorption capacity nor the level of pollution at which it would be reached is known for any pollutant, there is no means at all of checking the suggested limits against the real state of affairs.

The particle concept of pollution absorption describes only one possible mechanism and a simplistic one at that, and should not be used as a model for all pollutants. (The pollutant is considered as an evenly spread particulate distribution. A similarly distributed supply of "absorbent" particulates acts as a "sink" for the pollutant "source".) It is highly unrealistic, too, to assume universal distribution of pollution and absorbing particles, since this could never be achieved in the real world. It is difficult to decide whether such an approach in this case leads to overall pessimism or optimism. Localised areas of very intense pollution, such as exist in the real world, would have more rapid effects but allow action to prevent spread and to abate the observed effects. The mechanism in World 3 is more characteristic of the spread of an insidious and largely unidentified menace.

It is also said that the pollutants with appearance delay times and absorption times of less than a year have short-term, local effects and are dealt with elsewhere in the model. The implication is that the chosen long-term pollutants have other than local characteristics and that these are known. On the contrary for the listed pollutants, incorporated finally in one term, the majority of data are local and highly dependent on local conditions. Thus toxicities vary widely in hard and soft waters and the effects of air and water currents on dispersion, uptake and absorption are large. The existence of DDT residues has been noted in numbers of animals and flora but no data exist which show lethal effects on man.[3] The short circuiting of long ecological chains to arrive at an effect on man's life span is an act of heroic extrapolation. In drawing other examples from an area mentioned in *The Limits to Growth*, nuclear power production, it should just be noted that the work cited[4] is entirely polemical and carries little original or indeed relevant data. The acknowledged hazards associated with such energy sources are extremely difficult to fit to the model assumed by Meadows. For example, the rupture of the containment shell of a nuclear reactor in the most disastrous case would have a high, immediate and lethal impact at a local level followed by serious long-term effects. These latter would arise principally from a radioactive nuclide having a half life of a few days but whose deleterious physical manifestation, in the locally exposed population, would not appear for around twenty years on average. The more insidious of the threats to life from reliance on a major programme of power production are also concealed by the model. The genetic effects of the low level irradiation of small localised groups of nuclear engineers from daily doses of radiation, for example, do not depend upon the release of radioactive material. The hazards of a large scale programme also include possible leakage from the

underground storage of highly concentrated waste products. The specificity of this risk, recognised by nuclear power protagonists as a problem, is ignored in the methodology of World 3, though the problem is mentioned in *The Limits to Growth*.

The aggregation of pollutants is also a questionable procedure. For if the level of pollution in 1970 is assumed to be unity, then it is not valid to determine the fractional level existing in 1900 by calculating on a *pro rata* basis for the population, industrial output *per capita*, and agricultural inputs known for that time. The consumption pattern was then completely different, especially for energy, and the effects of agriculture quite different. The use of pesticides, fertilizers and intensive methods acknowledged to be the most severe contributory causes of agricultural pollution, did not start to expand rapidly until the 1950's; and even now the damage effects are localised.

The complexities of even a single technique of intensive farming such as the use of antibiotics in animal feedstuffs and its effect on human health are many. The effects on human morbidity and mortality patterns cannot be shown unequivocally to result from this technology.[5] The chain of causation which would establish such a connection depends upon technological and institutional interactions which are only sketchily known. The risks cannot be represented in the pollution model. To return to the simplistic model, however, the pollution mix of the industrialised countries in 1900, with, for example, virtually no petrochemical industry, must have been completely different from the 1970's and making a *pro rata* comparison will be invalid.

Furthermore, as the authors of the Technical Report admit: "a changing mix of persistent pollutants . . . would change the parameters of the model relationships". This is bound to happen if only because of the changes in pollution coming from external changes in the composition of industry and agriculture, as suggested above. In addition, however, since absorption rates will differ, the mix of pollutants *must* surely change with time. This seems to imply that the upper bound of absorption should be variable, and that there cannot be "a weighted average of individual absorption limits", even if these were known. The authors themselves expect a wide variance of parameters in the persistent pollution sector, perhaps too wide to justify the use of a sector so fragile in its data base and assumptions.

A further objection can be made to a constant mix of pollutants which is then characterised in a single term "pollution" having representative or average parameters. Assuming these were ascertainable, the global nature of this mix seems a dubious proposal and this makes statements about it difficult to assess. The overall impact of such an item could be reduced by technical change induced by social choice, and the composition changes would certainly alter the upper limits for aggregate absorption time or delay between generation and absorption.

The delay in pollution appearance is a valid concept, but there will be confusion between the delays in appearance (eg, oil), delays in action (eg, death or damage), and delays in the appreciation of the link between cause and effect. The first two of these would be less subject to variations due to human error, and had they been used in the model would have probably been more useful than the third, which was selected. For example, the effects of mercury

poisoning in the region of Minamata Bay, Japan, began to be apparent after less than three years. The effects on man were noticed but not understood after three years, and the whole association was uncovered in ten years.[6] Similarly radiation damage was noticed within a year or two of the discovery of X-rays in 1896, and the "several decades" after this saw more acknowledged victims of radiation-induced illnesses. Why was ten years then selected as the pollution appearance delay time? If this is considered as being based on the ability of people to understand what is happening, then there must be a sliding delay in pollution appearance varying according to the level of sophistication of the community affected. A better definition would be the appearance of the first recognisable effects, even if these were not correctly attributed at the time.

In any event, the time taken to travel through the ecosystem is not a useful way to determine the delay. For one thing, not every pollutant does travel through the ecosystem (eg, SO_2 and dust), and of those which do, most exert effects at the first level as well as later (eg, by selectively stimulating or destroying bacteria, algae, fungi—perhaps even viruses) in ways not yet understood. By choosing to consider only pollutants with an appearance delay of more than one year, many of the pollutants which have been identified as causing damage to health, crops, etc, have been excluded, such as sulphur dioxide and organophosphor pesticides.

Critical factors in the sub-system

There remain the assumptions in the pollution sub-system which cause a "collapse" in World 3, all of which are highly questionable. Hardly anything is known about how "aggregate" pollution might (or might not) affect death rates and land fertility. Some scattered information is available. Statistical correlations have been established in one study[7] for air pollution levels and various morbidity and mortality rates for USA cities. Effects on crops of particular air pollutants are also recorded in specific instances.[8,9] In none of the cases could the data be said to be even remotely suitable for wide extrapolation. The numbers used in the Lifetime Multiplier from Pollution (LMP) and the Land Fertility Degradation Rate (LFDR) could be wrong by literally orders of magnitude.

Furthermore, the assumption of a linear relationship between agricultural and industrial output, on the one hand, and pollution output on the other, is highly questionable, and the data presented to substantiate it are very weak indeed. In the absence of any global data, the authors have been forced to work with patchy information from scattered sources gathered at various times. A very limited and haphazard selection of available information has been made, and it is not clear against what criteria. Exponential increase in lead concentrations in the Greenland icecap is taken as evidence that the general increase in pollution is exponential, although methods of measuring lead have changed and this may have affected the figures. The rate of increase in concentrations of various salts discharged into rivers used for the section are assumed to be equivalent to pollution, but are not necessarily so. The reported evidence refers to pollution by particular substances in particular localities and is very limited;

it is therefore not realistic to represent possible global effects by aggregating them.

Some of the important factors relating to the effect of atmospheric pollutants upon living materials are:

- physical and chemical properties of the pollutant
- its concentration
- duration of exposure
- environmental conditions
- susceptibility of the organism
- locus and mode of uptake
- metabolism and rate of elimination.

Other pollution areas eg, water, may have additional complicating factors. It seems an oversimplification to assume that, for all the many foreign substances in the modern environment, average figures can be adduced to characterise a single concept "pollution".

However, a trend in aggregate pollution is estimated from the trends in the non-communist world's *production* of oil, cadmium and mercury; its *consumption* of nickel, lead and energy; and urban refuse in the USA. Apart from the fact that energy is said to be related to thermal release and particle production from fossil fuels, nothing is said about how any of these might relate to pollution. Thermal release may be the basis of a disruption of local environmental conditions in some cirumstances but cannot be said to be so in all. Neither can it be claimed that solutions could not be found leading to its economic use.[10] This coupling of the two "pollution" sources from energy in the argument appears to have been done so that no escape is allowed—if nuclear power is substituted for fossil fuel to escape particle production then the lower efficiency of the former can be said to result in more "thermal" pollution. One would expect a relationship, but not necessarily constant, not universally applicable, and not necessarily linear nor even increasing. Energy consumption is not always a pollution-increasing factor. Many pollution-reducing processes consume energy. Some methods of producing and consuming energy are less polluting than others, and the same can be said for the production and consumption of all materials cited above. In addition to this, the USA urban refuse *per capita* is recognised to be the highest in the world. There is no attempt to estimate global waste, which is probably very low, and it is assumed that everyone follows the USA behaviour pattern. Urban refuse, perhaps, is more reasonably a resource and amenity problem than a health problem.

It is even possible to find data which support quite the opposite assumption to that made, namely that pollution can go down with increasing production. In chapter 12, Sinclair argues that, in general, England was a far messier place a hundred or two hundred years ago than it is today, in spite of the presently far higher levels of production. He also shows that the introduction of anti-pollution legislation has had valuable effects in reducing the apparent absolute levels of pollution, while permitting increased production, and society's ability to impose social controls to reduce industrial externalities (including pollution) has improved, though perhaps unevenly, since the 19th century.

Others argue that, in the process industries, technology already exists to allow a modification from production at lowest cost to production modified for environmental conservation. As one example, a Swedish manufacturer's intention was to dump the mercury contaminated gypsum end product of his new plant in the Straits of Oeresund. Public opinion forced the utilisation of this waste for the production of half a million tons of building boards *per annum*. The extra cost of the plant involved three million pounds representing a 30% increase in project cost. Other examples could be drawn from the metallurgical industry.

More generally, recent costings have indicated that, in the USA, currently envisaged abatement expenditures should make considerable impact on the levels of the ills. Studies have been made in fourteen industrial sectors of likely pollution levels (neglecting solid wastes).[10] Summarising the financial effects of combating these over the 1972–76 period, 1 to 4% total employment in the sector studied would be lost ($\sim 0.05\%$ of the total labour force). This would arise from closure of the presently only marginally profitable factories. The consequent annual slowing of the growth rate of USA GNP from this source would be 0·3 percentage points over 1972–76 and 0·1% over the decade.

In these studies the calculated economic effects (except those for labour) were linear with the pollution control costs. These economic effects of increased capital investment in pollution control would be, briefly, that the cost of capital per unit of output would rise, and capital and consumer goods would suffer price increases. Price increases by 1976 would range from 1 to 2% in leather tanning and petroleum refining to 10% in electric power production and pulp and paper. Even in aluminium smelting, where environmental impacts are high, the increases are expected to lie in the range 5–8%. Analogous figures are available for certain OECD countries. In these, pollution costs as a burden to the economy (in annual percentages of GNP for investment and operation over 1971–75) are given as 1·6 (USA) 1·8 (Germany), 0·6 (Italy) and 0·5 (Netherlands).[11]

One difficulty in assessing these figures is to ascertain the physical levels or standards it is claimed will be obtained by the expenditures. A very topical example of this is contained in the recent report of the USA Environmental Protection Agency which shows that the earlier costings for improvement were underestimated by a factor of two.[12] This may have been due as much to a raising of the environmental levels as to an increase in abatement costs. At any given level of technology, there are bound to be diminishing returns to abatement expenditures. The level of environment quality attained will depend upon the willingness and ability of society to pay for it, and on the state of abatement technology. The OECD report may be quoted in relation to the cost of pollution abatement: the "costs during the first half of this decade will have only a relatively modest effect on the ability of a nation to satisfy any other urgent needs of a society. The expected pollution control costs are, in general, considerably lower than some other welfare oriented expenditures".[11]

In the World 3 model, it is important to note that the effect of increased expenditure on anti-pollution equipment is to raise the capital use and so to increase pollution. Since the model is especially sensitive to marginal increases in capital investment this is particularly anomalous; and all the more so because

it is clearly recognised among environmentalists themselves that "the technology required for pollution controls, unlike ordinary technology, does not add to the value of saleable goods. Hence the extensive technological reform of agricultural and industrial production that is now demanded by the environmental crisis cannot contribute to the growth of productivity—to the continued expansion of the GNP".[13]

All this suggests that it would be equally plausible to change the relationship in World 3 between pollution and industrial output (PGMO) from one which is linear to one with a diminishing marginal increase of pollution with increasing industrial output *per capita*, or to one with a constant or diminishing level of pollution above a certain level of income *per capita*.

The likely future trend in the relationship between pollution and agricultural production is more difficult to represent. As we have already pointed out, pollution from agricultural sources is a problem which has emerged only in the past 25 years, apart perhaps from the production of dust clouds, and it is only now that the needed anti-pollution technologies are being developed. It is therefore not yet possible in this area to appeal to past trends. However, it has already been argued in chapter 5, that the method of calculating the agricultural inputs necessary to feed the world's population has been considerably exaggerated through a faulty procedure which does not allocate agricultural inputs in the most efficient manner on a world basis. Reductions in the required level of these inputs will obviously reduce the pollution originating in the agricultural sector.

Conclusion

The real problem with the sub-system is that most disasters caused by material pollutants are likely to be local, like mercury in Minamata Bay, or to be caused by one pollutant or class of pollutants, such as the effects that pesticides may have on non-target components of the ecosystem. By aggregating all pollutants, and assuming that they behave in some composite way, attention is drawn away from what are urgent, and still soluble problems, and diverted into speculation upon an imaginary race against time between "Life" and "Global asphyxiation".

In the foreseeable future, certain dangers can be predicted and avoided. Action on these will probably improve the long-term position. Computer-aided speculation about the long-term position on the basis of existing information will not tell us much that we do not know without reference to a model or access to a computer. The World 3 sub-system advances neither our understanding of pollution, nor of its interaction with other aspects of world behaviour. Furthermore by concentrating attention upon contrived physical crisis situations it diverts, or can be used to divert, attention from other social costs of economic growth such as work injuries, inadequate housing conditions and uncompensated adaptations to structural changes and the like which arise in contemporary industrial societies. It goes without saying that such impacts are unevenly distributed in society and that the model has no way of accommodating this fact.

Gertrude Stein has remarked upon the "final simplicity of unnecessary complexity"; the modelling of the pollution sector in *The Limits to Growth* has achieved, on the contrary, a final simplicity by ignoring all complexity.

References

1. SCEP, *Man's Impact on the Global Environment* (Cambridge, MIT Press, 1970) page 88
2. F. M. L. Thompson, *Victorian England: the Horse Drawn Society*, Inaugural Professorial Lecture, Bedford College, University of London, 22 October 1970
3. W. J. Hayes, *et al*, "Evidence of safety of long term, high oral doses of DDT for man", *Archives of Environmental Health*, Vol. 22, January 1971, pages 119–135
4. S. Novick, *The Careless Atom* (Boston, Houghton Mifflin, 1969)
5. C. Smart and P. K. Marstrand, "Antibiotics in UK agriculture", *Research Policy*, Vol. 1, No. 4, 1972
6. K. Irukayama, "The pollution of Minamata Bay and Minamata disease", *Advances in Water Pollution Research*, Vol. 3, 1967
7. L. B. Lave and E. P. Seskin, "Air pollution and human health", *Science*, Vol. 169, No. 3947, 1970, pages 723–733
8. American Association for Advancement of Science, *Agriculture and the Quality of our Environment*, Publication No. 85, 1967, Symposium of 133rd Meeting, 1966
9. D. Purves, "Consequences of trace element contamination of soils", *Environmental Pollution*, Vol. 3, No. 1, pages 17–25
10. US Government Printing Office, *The Economic Impact of Pollution Control*, Report No. 1972–0–458–471 (Washington DC, USGPO, 1972)
11. OECD, *Collection and Analysis of Pollution Control Cost Data*, Environmental Report AEU/ENV/72.4, March 1972
12. US Environmental Protection Agency, *Annual Report*, 1971 (Washington DC, USGPO)
13. B. Commoner, *The Closing Circle* (New York, Knopf, 1971, and London, Cape, 1972) page 270

8. ENERGY RESOURCES

A. J. Surrey and A. J. Bromley

The dual assumptions, that abundant supplies of energy are necessary for economic growth and that energy demand grows exponentially while resources are finite, imply that energy, in addition to population and food supplies, is crucial to neo-Malthusian arguments. In recognition of the central importance of energy, this chapter examines estimates of world energy reserves in the context of continued exponential growth in consumption. It is concerned with the question of whether there will be a world fuel "crisis" in the foreseeable future, and if so, what its nature is likely to be.

SEVERAL problems are involved in discussing world energy requirements and resources. Taking the widest possible canvas, the total resources of the planet include the stored-up energy contained in minerals in the earth's crust, including those below ocean beds and within the oceans themselves which cover approximately 71% of the earth's surface. They also include the flow of energy from the sun (less the losses from the earth's atmosphere), the energy which might be harnessed from the motion of tides, rivers and winds and from geothermal sources. While some scientists are rightly concerned with this wider canvas and related questions such as the thermal balance of the earth,[1] the current debate revolves around the more practical question of energy as a possible constraint upon economic growth and living standards: will reserves of fossil fuels and uranium be sufficient for foreseeable needs? It is this question with which this chapter is concerned.

At the outset it is necessary to point to several common omissions or misconceptions when energy is discussed. The first is that various novel as well as traditional forms of energy are frequently ignored owing to a preoccupation with conventional fossil fuels, particularly liquid hydrocarbons. Whether future energy supplies will meet future needs requires consideration of new sources of fuel and new energy technologies which are only now at the stage of research or pilot development. Whether recent trends in the demand for fossil fuels will continue requires consideration of how far these trends have been influenced by such factors as the substitution of liquid hydrocarbons for solid fuels in the industrialised countries and the substitution of mechanical power in the developing countries for human and animal power (and for traditional energy such as peat, wood, dung and hay). The rapid increase in world consumption of fossil fuels, especially oil and natural gas, is at least partly due to

the transition to cheaper, more convenient or more efficient forms of energy.

Because the discussion is usually conducted at a high level of aggregation and abstraction, it frequently ignores the question of changing fuel efficiencies involved in the substitution of secondary or processed forms of energy for primary fuels. The implicit assumption that energy is a homogeneous commodity obscures the problems of substitution arising from differences in prices, convenience in use, and technical limitations. Energy efficiencies, both in conversion from primary fuels to secondary forms of energy and in a variety of final uses, are improving because of technical progress, consumer preferences and government regulation. However, the potential reduction in the level of long-term energy consumption from plausible improvements in energy efficiencies appear small when compared with that from a sustained reduction in the growth rate of energy demand.

Another point commonly ignored is that the price of energy, especially oil, is distorted by various kinds of transfer payments to producers and governments. The final price therefore bears little relation to the real cost. The large increase in the cost of crude oil in Western Europe in recent years has been caused by producer governments, through the Organisation of Petroleum Exporting Countries, exerting their bargaining power rather than by increases in real production and transport costs.

Finally the popular discussion of world energy supplies ignores important ambiguities and qualifications in the published estimates of fuel reserves. The calculation of published reserves usually relates to known reserves (ie, proven reserves plus those thought to exist with a high degree of probability), estimated by reference to existing price levels and techniques. To a large extent they ignore any deposits which might be discovered and developed not only in the different economic, technical and political circumstances of the future, but also in the large areas yet to be fully explored. Even within their own definition, however, the published figures of reserves cannot always be trusted, because some countries do not have the expertise to conduct comprehensive geological surveys and different standards of calculation are sometimes used. In some cases, eg, uranium, the published estimates exclude the potentially large reserves of the communist countries. For commercial and strategic reasons, energy reserves tend to be estimated and interpreted to the advantage of particular interest groups.

The growth of energy demand

Individual countries have sometimes been concerned with the adequacy of their indigenous sources of energy,[2] but until recently there has been no widespread concern about world energy resources. This new concern has arisen because the post-war expansion of world energy consumption has been at high exponential rates and because the absolute increments are now very large. From 2 700 mtce (million tons of coal equivalent) in 1950 world energy consumption has grown approximately 5% a year—ie, doubling every 15 years—and reached 6 000 mtce in 1968. At this rate of growth world energy consumption would be 19 000 mtce in 1990 and 36 500 mtce in the year 2000.[3]

World consumption of oil and natural gas has grown at an average rate of

7·8% a year since 1950 (doubling every decade), and has risen from just over one-third of total energy consumption in 1950 to nearly two-thirds of the much larger total 20 years later. Over the same period petroleum has constituted virtually all of the massive expansion of world trade in primary fuels. These high growth rates for oil and gas, coupled with increasing dependence upon foreign supplies, explain much of the current concern of the industrialised nations about the long-term availability of energy.

Nearly all long-term energy demand forecasts have been based upon statistical extrapolation, rather than upon a consideration of the possibilities for economic, social, technical and political change. These extrapolations have assumed that past statistical relationships between energy requirements and indicative variables such as gross domestic product will continue unchanged into the long-term future. They have also been based on limited historical data, because time-series for energy consumption and economic growth were rarely published in a suitable form before 1950. Because energy forecasting methods have been highly aggregated, forecasts of total national energy requirements have usually been more accurate than forecasts for individual primary fuels. As a rule little account has been taken of factors such as price-elasticities and longterm substitution possibilities, and there have been very few attempts to forecast world requirements as distinct from national energy requirements.

The view that exponential growth in energy consumption will continue is frequently supported by reference to international comparisons. Figure 1 shows the energy consumption levels of 35 countries against their corresponding levels of gross domestic product. Note that the scales are logarithmic rather than linear. Fitting the straight line, 1, through the scatter of points, tends to confirm the view that the USA is the "front-runner" in world energy development and that other countries will reach similar levels when they attain the current US stage of economic development. This statistical relationship based upon logarithmic scales not only compresses the apparent distance between the exceptionally high energy requirements of North America and other countries (see inset in Figure 1) but it also implies that all other countries are on the same path in their economic development as North America. It thus ignores the fact that the relative price of energy to other factor prices, industrial structures, and relative efficiencies in energy use, all differ between countries.

Numerous curves can be fitted through the same scatter of points in Figure 1. The choice of any one curve is therefore arbitrary. For example, it could be assumed that different groups of countries at comparable stages of economic growth and with comparable economic structures warrant separate curves. It is not necessary to consider all the permutations. By way of illustration we have fitted a second curve, 2, in Figure 1, which implies that as countries become richer their incremental energy consumption will diminish, eg, as a higher proportion of resources goes into less energy-intensive service industries. Curve 2, included on Figure 1, which is no less arbitrary than curve 1, implies that other countries will require less energy per head than North America when they reach comparable levels of economic development. The point is simply that without a thorough examination of the possibilities for long-term economic, social and other changes, a reasoned choice between alternative curve-fitting techniques cannot be made. It is worth noting, however, that because of their

different industrial structures and rates of economic growth, different industrial-
ised countries have had different energy-elasticities over the past two decades,
and that currently in the USA consideration is being given to the possibility
of improving the efficient use of fuel.[4] (Energy elasticities are the ratios of
growth in energy consumption to growth in Gross Domestic Product in a given
period.)

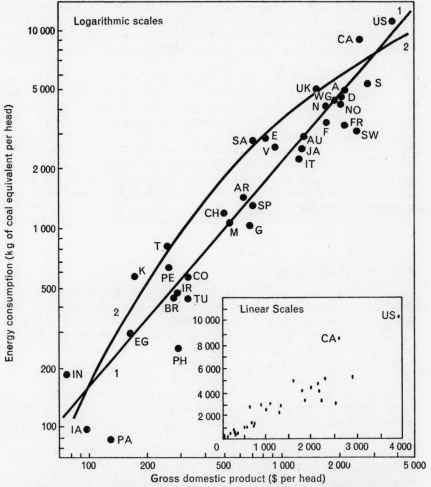

Figure 1. International energy comparisons: alternative interpretations of the
relationship between gross domestic product and energy consumption (1968 figures)

Key:

A = Australia	D = Denmark	IN = India	NO = Norway	SW = Switzerland
AR = Argentina	E = Eire	IR = Iran	PA = Pakistan	T = Taiwan
AU = Austria	EG = Egypt	IT = Italy	PE = Peru	TU = Turkey
BR = Brazil	F = Finland	JA = Japan	PH = Philippines	UK = United Kingdom
CA = Canada	FR = France	K = S. Korea	S = Sweden	US = United States
CH = Chile	G = Greece	M = Mexico	SA = South Africa	V = Venezuela
CO = Colombia	IA = Indonesia	N = Netherlands	SP = Spain	WG = W. Germany

Sources: United Nations Statistical Series J, World Energy Supplies, and United Nations Statistical Year Book

Whether existing industrialised societies will actually require the huge absolute increments of energy postulated in exponential long-term projections is an open question. Without specifying major social and other changes it is difficult to conceive for example that freight and passenger mileages or consumption by heavy industries such as iron and steel, aluminium and cement will increase at the rates implied by projections which assume that total energy consumption will quadruple over the next quarter-century. In the longer term the rapidly growing requirements of the developing countries could represent a large potential increase in world consumption, but at least until the end of the century the industrialised countries will still account for the bulk of it. (In 1968 ten industrialised countries accounted for 75% of world energy consumption).

Energy has been cheap in the post-war period. In Western Europe, despite high taxes on oil products, the expansion of low-cost oil supplies has necessitated the closure of many relatively high-cost coal mines. In North America retail prices of oil and natural gas have traditionally been low, although the situation is now changing. However, if the projected high rates of growth of potential demand for oil and gas are correct, their prices are likely to rise substantially. Whether this is due to the greater bargaining strength of oil producers, or the need to finance capital requirements or to other factors, is irrelevant in this context. Price elasticities have generally been ignored in energy forecasts (or assumed to be very low). In an era of higher oil prices, the growth of demand could well become sensitive to price, leading to improved fuel efficiency and the substitution of other fuels.

Crude oil and natural gas

Compared with coal, petroleum reserves are more difficult to locate and develop because they occur not as continuous beds but are trapped in underground rock reservoirs whose depth and geological complexity are often such that only approximate assessments of the reserves and the proportion ultimately recoverable are possible. Of the many potential petroleum-bearing structures examined by geophysical methods and drilling, few contain oil or gas in commercially-recoverable quantities.

Published estimates of reserves usually relate to *proven* quantities recoverable under existing economic and operating conditions. As more information becomes available the estimates for a particular reservoir are revised. In the past, a significant increase in reserves has occurred as initial estimates have been revised upwards. In addition to the geological uncertainties, conservatism in reporting initial discoveries has often been reinforced by commercial considerations.

World proven reserves of oil and gas at the end of 1971 are summarised in Table 1. As an indication of the expansion of the world-wide search for oil, total proven reserves of crude oil at the end of 1971—estimated at 570×10^9 (570 000 million) barrels—were 5·7 times larger than 20 years earlier.[5] (There are approximately $7\frac{1}{2}$ barrels per metric ton of oil, depending upon its specific gravity.) By far the biggest additions to world reserves were those in the Middle East, which increased more than sixfold from 52×10^9 to 347×10^9

TABLE 1. ESTIMATED PROVED WORLD RESERVES OF CRUDE OIL AND
NATURAL GAS AS AT 31 DECEMBER 1971

Area	Crude oil reserves (barrels $\times 10^9$)	Per cent of total crude oil reserves	Natural gas reserves (cubic feet $\times 10^{12}$)
North America	49·2	8·6	345·3
of which USA	*38·1*		
South America	25·2	4·4	55·6
of which Venezuela	*13·7*		
Western Europe	6·8	1·2	161·1
of which UK	*3·0*		
Norway	*2·0*		
Eastern Europe	62·1	10·9	653·4
of which USSR	*60·0*		
Africa	50·9	8·9	197·6
of which Libya	*28·0*		
Nigeria	*10·0*		
Middle East	346·8	60·9	286·0
of which Saudi Arabia	*137·0*		
Kuwait	*75·0*		
Iran	*60·5*		
Iraq	*33·1*		
Far East	13·4	2·4	23·1
of which China	*12·5*		
Oceania	13·4	2·4	26·2
of which Indonesia	*10·7*		
Other Areas	1·7	0·3	4·9
World	569·5	100	1753·2

Source: *World Oil* 15 August 1972

barrels in the last two decades. The Middle East now contains 61% of world proven crude oil reserves and is the biggest production area.

Petroleum geologists have become increasingly concerned with estimating ultimately-recoverable crude oil reserves. The earliest estimates of total reserves appear to be those of Pratt and of Levorsen, in 1950, whose estimates were 600×10^9 and $1\,500 \times 10^9$ barrels respectively. During the 1960's new estimates appeared which varied between 1 800 (Shell, 1968; and Moody 1970), 2 200 (Weeks, 1969), and $2\,480 \times 10^9$ barrels (Hendricks, 1968)[6]. In 1969, King Hubbert[7] estimated a range of 1 350 to $2\,100 \times 10^9$ barrels, and in 1971 Warman[8] expressed his belief that the total lies in the range 1 200 to $2\,000 \times 10^9$ barrels.

Great uncertainties surround all these estimates which have been calculated in the framework of existing exploration and production techniques and current price trends. They include allowances for unforeseen or chance discoveries, speculative deep-water reserves beyond the continental shelf whose recovery would require entirely new techniques, and cumulative past production. If 1 700 to $1\,900 \times 10^9$ barrels is taken as a consensus among the estimates made by petroleum geologists, and if past production and possible deep-water reserves are discounted, the remaining reserves of crude oil recoverable with existing techniques would appear to be nearer the lower estimates of King Hubbert and Warman—ie, 1 200 to $1\,300 \times 10^9$ barrels (compared with 455×10^9 estimated for known reserves by Meadows).

Since oil companies normally regard their estimates of the geographical distribution of additional reserves as commercial secrets, it is impossible to

give more than a broad indication of where new discoveries are likely to occur. Opinion among petroleum geologists appears to be that three-quarters of the reserves yet to be found will be in a few areas—the USSR and China (over a third), the Middle East (about one-seventh), North America including Alaska (about a fifth), and Latin America (about a tenth). Probable future discoveries in the large land mass of the Soviet Union appear to exceed its published proven reserves by a factor of three to four. If this is correct the USSR could become a much bigger source of world oil over the coming decades, given sufficient development effort. Additional discoveries in the Middle East—although large relative to the rest of the non-Communist world—are likely to be of a lower order of magnitude than those of the last 20 years. Provided that policies do not change radically the Middle East will remain the largest centre of world oil production, but its reserves to production ratio will probably decline.

Hitherto oil exploration has concentrated on the search for the biggest, most accessible and easily-recoverable reserves. This is reflected in the fact that oil fields with reserves of more than 300 million barrels constitute 75% of cumulative discoveries to date.[9] Because of favourable geological conditions and the large size of the reservoirs, additions to Middle East oil reserves in the 1960's were obtained at an average cost of 1·5 US cents a ton.[10] As an oil-bearing area the Middle East is unique. Geologists have stressed that there is no chance of finding oil in such vast quantities in other regions and that the huge increases in Middle East reserves since the early-1950's cannot be repeated on the same scale. New reserves will no doubt continue to be found. But it is reasonable to expect that additional discoveries will tend to be smaller than past discoveries and that, because evaluation techniques have improved, subsequent additions to reserves from underestimating past discoveries will diminish.

The search for oil has moved in recent years to areas previously ignored, such as Alaska, the North Sea and the Arctic, which have required the development of new skills and techniques. Although only sketchy published information exists, finding costs are likely to rise appreciably as greater technical difficulties are encountered in new areas and if the average size of individual finds declines. In the past, the annual discovery rate and the average size of annual discoveries have fluctuated widely, and it is impossible to calculate a trend.[11] Warman has pointed out that, while it may reasonably be inferred that the annual discovery rate is falling in the USA where so much exploration has already been done, it is unsafe to generalise that this is also the case for other areas where the discovery rate could be maintained or even increased, if the necessary exploration funds were made available. It is, however, probable that, even allowing for progress in exploration techniques, the marginal productivity of exploration effort will diminish as the search has to shift towards the discovery of smaller oilfields.

How long world crude oil reserves will last depends upon the future growth of demand as well as the size of reserves and recovery factors. If world oil demand continues to grow at $7\frac{1}{2}\%$ a year then the ratio of *proved* reserves to annual production would fall to 10 by 1978[12] (10 years being the average time to find and develop new oil fields), and by the year 2000 some $1\,100 \times 10^9$ barrels of new reserves would have to be found to prevent the ratio falling

below 10. In other words, over the next 30 years or so a large proportion of the total additional reserves will have to be found if world consumption grows at its post-war rate. In the subsequent three decades world oil production would decline rapidly as reserves become depleted. This conclusion is far more sensitive to the assumption about the rate of demand growth than to plausible changes in assumptions about the ultimate level of reserves and recovery factors. The latter have improved, and while they vary from field to field, they are typically between 30% and 40%. The widespread application of more costly recovery methods (which will depend upon oil prices), raising recovery factors by perhaps 10%, would increase recoverable reserves by the same proportion. But with demand growing at $7\frac{1}{2}\%$ this would not affect the conclusion significantly. King Hubbert has demonstrated that, if world oil reserves are $2\,100 \times 10^9$ rather than $1\,350 \times 10^9$ barrels, the ultimate decline in production would be delayed by perhaps a decade. It must be emphasised, however, that a substantial reduction in the growth rate of oil consumption *would* improve the prospects considerably.

Estimates of world reserves of natural gas are less comprehensive than those of crude oil. Large reserves of gas are known to exist in most of the petroleum producing areas of the world, but until recently only a small proportion of them had any commercial value. Price increases for other forms of energy, combined with technical advances—eg, the recent development of large diameter pipelines, bulk liquefied natural gas tankers, and underground refrigerated storage—have made it feasible to transport large quantities to distant markets. In effect, outside the USA—where it has long been developed—natural gas has only recently become a major energy resource. As oil and gas are usually found together it is reasonable to assume that, in addition to the hitherto unused gas reserves, large additional quantities will be found in association with future petroleum exploration. It is therefore impossible at present to estimate long-term demand and production levels or total reserves. The USA is in the special position of having developed a large and rapidly growing demand for natural gas whose price has hitherto been regulated at a low level.[13] Insofar as natural gas is a potential substitute for other forms of energy, the development of natural gas in the rest of the world may alleviate some of the pressure on other fuels, especially low-sulphur crude oil.

The main point emerging from this review is that the popular discussion of long-term oil prospects is heavily influenced by the critical assumption that demand will continue growing at its present rate. If this assumption is relaxed the outlook becomes considerably brighter. Three inter-related factors which may moderate the future growth of world oil consumption are rising oil prices (although this will bring other problems), the substitution of other forms of energy (including natural gas and nuclear power), and the introduction of energy conservation policies by consumer and producer governments. In any event, however, problems will arise due to the geographic location of reserves and the costs of finding additional reserves.

Over 60% of proven oil reserves are in the Middle East and a large proportion of the additional reserves are expected to be in the USSR. This will pose a problem not only for the traditional oil importing countries of Western Europe and Japan but also for the USA. If present trends and policies continue the

USA will import 10–11 million barrels of oil per day by 1980, which will represent nearly 50% of projected US oil consumption in that year.[14] The bulk of these US imports like those of Western Europe and Japan can come only from the Middle East. This additional demand for Middle East oil will doubtless affect oil prices and relative bargaining positions.

Political uncertainties are likely to become much greater than in the past when the international oil companies had little fear of losing command over their oil reserves. The problems are likely to be somewhat different as between importing from the USSR and from the Middle East. Conceivably the USSR might supply large quantities of oil and gas to the West, especially if it increases its purchases of Western technology and goods under bilateral arrangements. In addition to the political uncertainties surrounding the future of Middle Eastern oil, some of the small Arab states which are large oil producers may decide to conserve their oil reserves until prices rise, rather than accumulating large foreign exchange reserves which are subject to depreciation by inflation and currency re-alignments.

A major problem for the oil industry is to finance the exploration and development of new reserves in more remote areas on a scale sufficient to maintain an adequate discovery rate at least 10 years before the additional reserves can earn a return. Increases in exploration costs will not necessarily lead to higher oil prices. Exploration costs, except in very difficult areas such as the Arctic and the North Sea, have generally been low in relation to the final price of oil. For other reasons, however, eg, the increasing bargaining power of oil producing states, oil prices are likely to rise—perhaps sharply. This situation is likely to lead to the substitution of other fuels in certain uses and, as we discuss later, to the development of large reserves of non-conventional hydrocarbons.

Coal

World inventories of coal resources have existed since 1913, when they were put at $8\,000 \times 10^9$ metric tons.[15] Estimated total reserves have changed comparatively little in the past 60 years, although there have been changes in their composition. Compared with other fuels, estimates of coal reserves are likely to be more reliable to the extent that coal occurs in stratified sedimentary beds which are often fairly uniform over large areas. Coal reserves are therefore assessed by mapping and observation (ie, examination of surface outcrops and by test drilling). Common definitions for measuring coal reserves have emerged which take account of the different physical characteristics (ie, heat content) and the reliability of the reserve estimates. But there is no published information on the quantities of coal which would be economically recoverable at different prices, nor upon the estimated costs of proving additional reserves.

Coal reserves are commonly divided between *measured, indicated,* and *inferred.* Measured reserves are calculated from geological observation and may be regarded as known or proven reserves. The other two categories are based upon estimation. Indicated reserves are derived by projections from limited observations, while inferred reserves are based almost entirely upon knowledge of the general geological characteristics of the bed or region. The most recent and comprehensive inventory was drawn up under the auspices of the World

TABLE 2. ESTIMATED WORLD COAL RESERVES (METRIC TONS × 10⁹)

Area	Hard coal Measured	Total	Per cent of total	Soft coal Measured	Total	Per cent of total	Hard and soft coal Measured	Total	Per cent of total
North America	114·8	1164·5	17·3	21·6	430·1	20·4	136·4	1594·6	18·1
South America	3·9	26·2	0·4	0·4	10·0	0·5	4·3	36·2	0·4
Africa	41·7	85·5	1·3	—	0·1	—	41·7	85·6	1·0
Asia (excl. China)	20·2	131·6	2·0	2·6	4·7	0·2	22·8	136·3	1·5
China	—	1011·0	15·1	—	0·7	—	—	1011·7	11·5
Western Europe	88·3	96·8	1·4	64·3	67·0	3·2	152·6	163·8	1·8
Eastern Europe	39·1	60·1	0·9	27·3	89·5	4·3	66·4	149·6	1·7
USSR	145·1	4121·6	61·4	104·4	1406·4	66·8	249·5	5528·0	62·7
Oceania	3·3	16·8	0·2	48·4	96·0	4·6	51·7	112·8	1·3
World	456·4	6714·1	100	269·0	2104·5	100	725·4	8816·6	100

Source: *World Power Conference Survey of Energy Resources,* 1968

Power Conference in 1968, the boundary conditions being a maximum depth of overburden of 1 200 metres and a minimum seam thickness of 30 cm. As the estimates were supplied by local and national bodies, the information in some cases deviated from the standard definitions. A more important qualification is that by no means all the estimated coal reserves are commercially recoverable at current costs and prices.

As shown in Table 2, the 1968 Survey indicated that measured world reserves of hard coal (ie, anthracite and bituminous) are 460×10^9 metric tons and measured reserves of soft coal (ie, brown coal and lignite) are 270×10^9 metric tons. The proportion recoverable varies according to area and mining technique (100% being theoretically recoverable where open cast methods are feasible), but the authors of the 1968 Survey stated that if only half of these measured reserves could be economically extracted, they would last 100 years at present rates of consumption in the case of hard coal and 300 years in the case of soft coal. A higher recovery factor (65% is possible with modern deep mining techniques) would increase the reserves proportionally.

Indicated and inferred reserves are many times greater than measured reserves. The estimated total world reserves of hard coal are nearly 15 times the size of measured reserves, and for soft coal the total reserves are eight times the size of measured reserves.

While there are substantial coal reserves in many parts of the world, the USSR accounts for 32% of total measured hard coal reserves and 39% of measured soft coal reserves. Europe (Western and Eastern) accounts for 28% and 34% respectively; and North America accounts for 25% of measured reserves of hard coal and 8% for soft coal. If indicated and inferred reserves are included the USSR becomes an even bigger potential coal producer in relation to total world reserves. The estimates for China have not been revised since 1913, so the conclusions about the size and distribution of world coal reserves must be qualified on this account.

The most widely quoted authority on coal reserves, Averitt,[16] has attempted to estimate the total original coal resources of the world, including the additional reserves from unexplored coal deposits not covered by the World Power Conference Survey. He concluded that total original world coal reserves were 16 800 × 10⁹ short tons (15 240 × 10⁹ metric tons), compared with the 1968 Survey estimate of 8 816 × 10⁹ metric tons and with Meadows' figure of 5 000 × 10⁹ tons. Even Averitt's estimates cannot be regarded as the absolute total, for they do not include coal at depths greater than 4 000 feet and in beds of less than 12 inches; neither do they include peat.

Using Averitt's estimates King Hubbert[17] has calculated that coal could remain a major world source of energy for another 340 years. Even allowing for annual production levels to increase six and eightfold compared with their current level, he estimates that world production of coal could continue growing for another 140–200 years before being constrained by the reserves physically available.

Physical reserves of coal are therefore unlikely to represent a limit to world economic growth. The real problem with coal lies primarily in the costs of extraction and transport. For the last 30 years or so coal has increasingly suffered from competition with low-cost oil and natural gas, chiefly due to the development of Middle East oilfields, bulk transport methods, and convenience in use. From our review of long-term oil prospects it is reasonable to expect that the real price of oil and natural gas will rise substantially over the next two decades, and that in the longer term these fuels will tend to be restricted to premium uses such as transport and petrochemicals. If this occurs coal may well return as a prime fuel for bulk heating and to some extent for power generation, depending upon the growth of nuclear power and the exploitation of unconventional sources of oil. But it would be unrealistic to expect a revival of the coal industry in its traditional forms and locations.

In Western Europe, for example, the geological conditions are generally unfavourable to highly automated, large scale mining—although no doubt technical advances will continue to be made. There is unlikely to be an opening-up of high-cost deep mines with shallow beds which were closed during Western Europe's post-war retreat from coal. The principal long-term opportunities for expanding coal output are in the USSR (mainly Western Siberia), the USA (including the mid-Western and far-Western States as well as the traditional Appalachian fields), Poland, Australia, and South Africa. Whether the large coal deposits in these areas remote from the world's main industrial markets can be developed economically—allowing for rising prices of oil and natural gas—will depend upon technical progress in transportation as much as in extraction. The development of electricity transmission at voltages between 700 and 1 500 kilovolts seems likely to open the way to long-distance bulk power transfers, and hence to the exploitation of remote coal deposits for pit-head power generation. The development of high-capacity, high-speed coal trains, large-diameter coal slurry pipelines and supertankers for shipping coal may also permit the economic use of remote coal deposits for bulk heating purposes. Further research and development may also permit energy to be extracted economically from coal without conventional mining methods, eg, by underground gasification.

In considering the future of the coal industry social factors must be taken into account as well as commercial costs. Among these factors are the despoilation of the countryside (including the temporary but severe disturbances caused by opencast methods) and the undesirability of men continuing to work in deep mines which cannot be automated.

Uranium

Before the Manhattan atomic bomb project, or more accurately before the post-war interest in nuclear power generation, uranium did not count as an energy resource. In the atmosphere of the Cold War the USA, Britain and France sponsored the exploration and development of uranium in politically-friendly countries and contracted for their supplies. This strategic background set the pattern for subsequent uranium discovery. As in the case of some other minerals, only small areas of the world have been thoroughly explored for uranium and the great bulk of known reserves are "captive"—ie, available primarily for a restricted number of customers who have been anxious to acquire assured long-term supplies for their military and civil needs. Requirements for nuclear weapons programmes have significantly affected uranium prices, the rate of discovery, and hence the level of known reserves.

Government stockpiles mounted in the late 1950's. The USA and Britain spread their existing purchase commitments for uranium over a longer period. Suppliers then cut back production. Exploration virtually ceased in the late 1950's and early 1960's. Published reserves of uranium actually declined for some years until the growth of nuclear power requirements revived exploration activity after 1965.

Allowing for time lags in proving new discoveries, annual additions to published uranium reserves have moved closely with changes in exploration activity—rising sharply in the early 1950's, falling away as the demand for uranium by the nuclear power countries waned, and then reviving sharply after 1965 as exploration was stepped-up. For this relatively new and well-monitored activity the size of proven reserves are related to exploration effort, and there is no indication that diminishing returns have set in.

The extent of "captivity" of uranium supplies resulting from the desire of nuclear power states to obtain assured long-term supplies is partly reflected in the fact that only six countries—the USA, Canada, South Africa, South West Africa, Australia and France (including its former colonies of Niger, Gabon, and the Central African Republic) account for all but 5% of estimated world reserves in the non-Communist countries recoverable up to a price level of $10 per lb and all but 7% of recoverable reserves up to a price of $15 per lb.

Estimates of uranium reserves illustrate not only this geographical concentration, but also that exploration has been largely centred on low-cost reserves which are economically recoverable with existing mining and processing technology. Published estimates are usually divided between *Reasonably Assured Resources* (ie, U_3O_8 recoverable from *known* deposits with existing techniques) and *Estimated Additional Resources* (ie, surmised to occur in unexplored extensions to known deposits or in undiscovered deposits in known uranium districts). A further division is made between reserves recoverable at prices up to $10 per

TABLE 3. ESTIMATED URANIUM RESOURCES IN NON-COMMUNIST COUNTRIES, 1970

	Reasonably assured (thousand tons of U_3O_8)		Estimated additional		Total	
	a	b	a	b	a	b
USA	580	390	1040	680	1620	1070
Canada	362	232	400	230	762	462
South Africa	265	200	50	15	315	215
French Community[1]	117	95	116	81	233	176
Other[2]	106	63	119	49	225	112
New discoveries[3]	100	100	200	200	300	300
Total outside USA	950	690	885	575	1835	1265
Total	1530	1080	1925	1255	3455	2335

Note
a Recoverable at prices up to $15 per pound.
b Recoverable at prices up to $10 per pound.
[1] France, Niger, Gabon and Central African Republic.
[2] Argentina, Australia, Brazil, Italy, Japan, Mexico, Portugal and Spain.
[3] Allowance for recently reported discoveries in South West Africa and Australia, not included in the original ENEA–IAEA estimates.
Source: US Energy Outlook: An Initial Appraisal, 1971–1985, Interim Report of the US National Petroleum Council, November, 1971.

lb and those recoverable at prices between $10 and $15 per lb. Table 3 summarises estimated uranium reserves in 1970 in the non-Communist countries.

Recent exploration activity has been directed towards finding low-cost uranium. Estimates of reserves in the lower price bracket are therefore more reliable than those recoverable at prices between $10 and $15 per lb. The published estimates clearly do not represent total world uranium deposits, chiefly because they exclude the Communist countries and because so far the search has been for low-cost reserves. The published reserves also exclude: substantial stockpiles held by producers and consumers, which in total are probably equivalent to two years' supply; by-product uranium deposits—ie, where the recovery of uranium depends upon the future economic recovery of the associated main product or upon higher uranium prices; and the possibility of eventually recovering vast quantities of uranium from the sea by adsorption methods now being investigated, which might become economic if the long-term price of uranium reaches $20 per lb.

Any attempt to estimate reserves which might be recoverable at higher prices is necessarily speculative. A 1967 report by the European Nuclear Energy Agency and the International Atomic Energy Agency[18] estimated that Reasonably Assured Resources would be 2·09 million tons if the price of uranium rose to $30 per lb (compared with 1·35 million tons at prices up to $15), and that Additional Resources would be 3·48 million tons at a price of $30 (compared with 1·26 million tons at prices up to $15). It must be emphasised, however, that estimates of reserves at prices above $15 per lb are highly speculative, because there has been no economic need to search for higher-cost reserves. Such speculation, however, is not irrelevant to this dicussion. While the trend of comparative fossil fuel prices might not justify the exploitation of higher-cost uranium reserves for existing reactor systems with low thermal efficiencies, the

eventual introduction of fast breeders could make economic and efficient use of these reserves.

Uranium mining and milling capacity should be sufficient to meet an annual consumption of 45 000 metric tons by 1975, but on present indications some new low-cost reserves and additional mining and milling capacity will be needed in the late 1970's. By about 1985 cumulative requirements could exceed current estimates of Reasonably Assured Resources recoverable at $10 per lb. Should annual requirements build up to 90 000 metric tons after 1985, it will be necessary in the late 1980's to discover and develop an additional one million short tons of uranium if an 8–10 years' forward reserve is to be maintained.

Whether uranium reserves will be sufficient over the next century is anyone's guess and will depend partly upon unborn technologies such as fusion power. Over the next 30 years, however, there should be no serious shortage of low-cost uranium *provided that* the level of exploration activity is maintained; it continues to yield new low-cost discoveries; or fast breeders are introduced for commercial power generation in the late 1980's. Much larger reserves are believed to be recoverable at prices ranging from $10 to $1 000 per lb of U_3O_8, but current estimates are necessarily speculative. Although the prospect on uranium supplies is therefore reasonably hopeful, optimism must be tempered by three considerations. First, one major accident with a nuclear reactor—especially with light water designs which account for the bulk of reactors being installed over the next decade—could set back the whole development of nuclear power. Second, the rapid development of the fast breeder is crucial, but it requires the solution of difficult technical problems. Third, the spread of nuclear reactors—especially of fast reactors breeding plutonium—will accentuate the difficulties in restricting the proliferation of nuclear weapons capabilities and the handling and disposal of radioactive materials.

Non-conventional hydrocarbons

Real challenges will no doubt arise if world energy consumption continues to grow in the long-term at the current rate, but limited reserves of non-renewable energy resources are unlikely to represent a serious threat on reasonable assumptions about the ultimate size of the reserves and technical progress. It is necessary to consider whether this conclusion would hold for the worst combination of circumstances, that is if few of the expected additional reserves of oil, gas and uranium can be found and recovered.

It is not unreasonable to expect that within 30 years a breakthrough with fusion power will provide virtually inexhaustible cheap energy supplies, but should this breakthrough take considerably longer, pessimism would still be unjustified. There are untapped reserves of non-conventional hydrocarbons which will become economic after further technical development and if prices of conventional fossil fuels continue to rise. These untapped reserves, which are many times greater than those of conventional fossil fuels, include heavy oil deposits, tar sands, oil shales and the conversion of coal to oil and gas.

As their name suggests, heavy oils are highly viscous and they cannot be recovered by normal oilfield methods. No published estimates of heavy oil

reserves are available but large deposits exist in Canada, the USA and Venezuela. The principal recovery method now under examination involves the injection of high pressure steam.

Tar sands occur in such concentrations and sufficiently near the surface that in some cases they could be mined by opencast methods with 80% to 90% recovery of the oil in place. The biggest single deposit is at Athabasca (in Alberta), estimated to contain 635×10^9 barrels.[19] If only half this amount can eventually be recovered it would represent a major addition to proven world oil resources. At present, however, only about one-tenth of Athabascan reserves could be recovered by opencast methods, and *in situ* methods would be less efficient. Small-scale production from Athabasca tar sands has been achieved for several years and large-scale production within the next decade is expected if North American oil prices rise as predicted. Large tar sand deposits also exist in the Venezuelan Orinoco Tar Belt, but they cannot be mined and would require *in situ* methods of recovery (eg, thermal drive).[20]

Long before the development of the international oil industry based upon crude oil, oil was produced in Scotland, France and Germany from oil shale deposits. China and the USSR still have oil shale industries, although the Russians are phasing theirs out owing to their discoveries of more economic crude oil and natural gas in Siberia. The USA oil shale deposits in Colorado have been estimated to contain $1\,800 \times 10^9$ barrels of oil,[21] and those in Brazil are thought to contain 800×10^9 barrels. Taking the 1965 estimate by the US Geological Survey of world oil shale deposits, and assuming a 50% recovery factor and a yield of 10 gallons of oil per ton of shale, world recoverable reserves from oil shales would be $6\,850 \times 10^9$ barrels. This figure is three to six times larger than King Hubbert's estimated range for *total* crude oil reserves, and more than 10 times *proven* crude oil reserves.

In North America research and development is being actively pursued on tar sands and oil shales technology, and there is also lively interest in the conversion of coal into synthetic oil and gas. At present prices none of the processes being tested are economic, but coal conversion is generally expected to become economic over the next decade with further development work. Coal conversion is expected to yield about $4\frac{1}{2}$ barrels of oil per ton of coal. If this factor is applied to Averitt's estimate of world coal reserves ($16\,800 \times 10^9$ short tons) one can get some idea of the huge addition to long-term oil supplies potentially obtainable from coal conversion. As we have seen, world coal reserves are so large that the large-scale development of coal conversion would be possible even if there were also a large expansion of traditional forms of coal consumption.

It is worth emphasising that the economic use of oil shales, tar sands and coal conversion requires a moderate rather than a dramatic rise in prices, and further development work rather than a fundamental technical breakthrough.

Prospects and choices

There is simply no way of accurately assessing total world energy resources.[22] The techniques of measurement are not available. Neither is there any way

of knowing what materials will constitute energy resources in the distant future A 100 years ago oil, natural gas and uranium would not have featured in an inventory of world energy resources. At that point in time the inventory would have consisted of easily-accessible coal, peat, wood, animal power and other forms of energy used in traditional societies. A 100 years hence the inventory will doubtless be different from one attempted now and might include thorium and solar energy for example.

Within the static framework imposed by the assumptions of fixed techniques of energy production and finite reserves of particular forms of energy, exponential growth in energy consumption inevitably leads to the depletion of world resources. A dynamic and more realistic analysis would have to allow for changing costs and techniques of energy production and transport. Over the past quarter-century the combination of expanding demand, technical innovation and economies of scale has extended the economic area and depth of search for fossil fuels and has added uranium as a major form of energy.

This is not to imply that market forces and technical progress can or should be relied upon to relieve the mounting pressures on world supplies of fossil fuels. But it would be quite unrealistic, and possibly dangerous, to assume that technical progress will halt, with the implication that world reserves of fossil fuels can be eked out only by zero-growth policies. Such a view ignores many developments now at the research or prototype stage which have a good chance of eventual commercial application. These developments include not only possible technical breakthroughs with fusion, magneto-hydrodynamics, solar energy, fuel cells and the exploitation of non-conventional sources such as tar sands, oil shales and the conversion of coal into synthetic oil and gas, but also developments such as electric vehicles, mass transit systems and better insulation of buildings.

Serious problems will arise in the not-too-distant future if world energy consumption continues doubling every 15 years and if oil consumption continues doubling every decade. Contrary to the popular view, the real problem is not the prospect of physical shortage but the economic and social adjustments needed if this rapid growth of consumption continues. The solution lies in the pursuit of policies to foster the developments needed to ensure that adequate energy supplies will be available before reserves of conventional fuels become excessively depleted and to discourage profligate uses of energy.

Recognising that current prices of different fuels do not reflect their true long-run supply costs, what are needed are far-sighted energy policies which are compatible with the aim of economic growth, and government sponsorship of research and development on new energy sources and technologies which are beyond the normal planning horizons of individual firms. Promoting the efficient use of energy need not conflict with other policy objectives. Indeed, government sponsorship of the development of electric vehicles, mass transit systems, and fast breeder reactors would further the aim of making the best use of energy, as well as reducing pollution and traffic congestion.

The probability of a *physical* energy shortage appears low; and the fear that energy will require an ever-larger share of real resources, as implied by Meadows, would be justified only if one ignored the possibilities for further technical progress, improved fuel efficiencies and new sources of energy.

However, temporary and localised difficulties may occur owing to the short-term inelasticity of energy supplies; and if governments fail to take the necessary far-sighted initiatives, rising world energy prices in the next few decades are likely to have undesirable economic, social and perhaps political consequences. For all countries, except a favoured few that are large net exporters of energy, a significant increase in energy prices would make it more difficult to satisfy other economic and social needs. The hardship will be greatest for those that import the bulk of their energy requirements—especially the poorer countries whose economic development is already restricted by chronic shortage of foreign exchange.

Some energy developments will no doubt present further difficulties. The expansion of nuclear fission will create large quantities of radioactive material requiring safe and permanent storage and will make it increasingly difficult to prevent the proliferation of nuclear weapons. With fossil fuels a major problem may arise from the geographical location of the reserves—eg, oil in the Middle East; oil, coal and natural gas in the USSR—which implies increasing dependence by the importing countries and requires major re-alignments in international trade and international politics. The extraction, processing and use of most forms of energy create social costs which, until recently, have been largely ignored but are now provoking vociferous public reaction.

Much of the responsibility for a rational approach to energy policies rests with the industrialised countries which account for the bulk of world energy consumption. For the USA the era of abundant indigenous energy supplies is over. With present policies the USA will have to import massive quantities of oil and gas by 1980 to support its exceptionally high energy consumption. If this happens the USA, because of the scale of its energy consumption, will be the main contributor to rising world energy prices and will also accentuate its own balance of payments burden. Other industrialised countries also share the responsibility. It is difficult to see that real progress can be made except through a concerted *international* approach to energy policies. This will become possible only when governments realise that it will be in their own direct interest as well as carrying benefits for posterity.

References

1. Professor Dennis Gabor, "The new responsibilities of science", *Science Policy*, May/June 1972: "It is regrettable that some ecologists, along with real dangers, have raised the bogey of "heat pollution", If this were fatal, there would be indeed no hope for us, because all use of power generates heat. But I accept Alvin Weinberg's estimates, that if twice the world population would consume power at the American standard, the heat generation would be only 0.01% of the heat which we receive from the sun. The danger of excessive CO_2 generation is probably also a bogey, and it would be lessened anyway by using mostly atomic power."
2. A noteworthy concern with the prospective exhaustion of British coal reserves was that shown by Professor W. S. Jevons in *The Coal Question* (London, Macmillan, 1866). In his preface to the second edition, Professor Jevons stated that "Renewed reflection has convinced me that my main position is only too strong and true. It is simply that we cannot long progress as we are now doing . . . not only must we meet some limit within our own country, but we must witness the coal produce of other countries approximating to our own, and ultimately passing it . . . Our motion must be reduced to rest, and it is to this

change my attention is directed." On pages 239–240 he assumed that British coal con-sumption would continue rising at $3\frac{1}{2}\%$ *per annum* from 83·6 million tons in 1861 to 2607·5 million tons in 1961. (In fact British coal consumption in 1961 was approximately 200 million tons.)

3. *World Energy Requirements in the Year* 2000, A/CONF.49/P/420, Fourth UN International Conference on the Peaceful Uses of Atomic Energy, United Nations July 1971

4. US Office of Emergency Preparedness, *The Potential for Energy Conservation* (Washington, DC, US Government Printing Office), October 1972. This study outlines various conser-vation measures which could reduce US energy demand by 1980 by the equivalent of 7·3 million barrels of oil per day. (Total US oil consumption in 1971 was 15·1 million barrels per day.)

5. *World Oil*, 15 August 1972 and 15 July 1952. For the latter year proven reserves of crude oil were 100×10^9 barrels.

6. W. E. Pratt, "The earth's petroleum resources", in Leonard M. Fanning, ed, *Our Oil Resources*, (1950), pages 137–153. I. Levorson, *Proceedings of the UN Conference on the Utilisa-tion of Resources*, Plenary meetings, Vol. 1, Lake Success, NY, pages 94–110, 1950. Shell, *Australian Petroleum Gazette*, June 1968. J. D. Moody, *Nickle's Daily Oil Bulletin*, 25 June 1970, pages 1–5. L. G. Weeks, Sixth International Petroleum Congress, Frankfurt—Proceed-ings General volume 1963, pages 231–271. L. G. Weeks, *Offshore*, 20 June 1970, pages 37–42. T. A. Hendricks, US Geological Survey, Circular 522, 1965

7. M. King Hubbert, "Energy resources", in *Resources and Man*, US National Academy of Sciences and National Research Council, (San Francisco, W. H. Freeman, 1969)

8. H. R. Warman, "Future problems in petroleum exploration", *Petroleum Review*, March 1971; and "Why explore for oil and where?", *The APEA Journal*, 1971

9. H. R. Warman, "Why explore for oil and where?", *op cit*

10. This figure was quoted by C. Tugendhat in "Financing the future of oil", *The Banker*, May 1972. This well-briefed account of cost trends and the financial implications of the future expansion of the oil industry also gave the average per ton exploration costs in the 1960's as 13 cents for Africa, 15 cents for Venezuela, $1·40 for the USA and Canada and $3·00 for Western Europe.

11. H. R. Warman, "Future problems in petroleum exploration", *op cit*

12. H. R. Warman, "Why explore for oil and where?", *op cit*

13. G. Lawrence, Vice-President of the American Gas Association, has recently stated that demand for natural gas in the USA has soared partly because it meets rigorous air and water pollution standards and more especially because of its low price. The cost of domestic heating by gas in the USA has averaged 30% below the cost of using oil and 55% below the cost of electricity. The cost of natural gas has also been below the cost of low-sulphur fuel oil and coal for industrial use. *Oil and Gas Journal*, 28 August 1972

14. *US Energy Outlook, An Initial Appraisal*, 1971–1985. An Interim Report of the National Petroleum Council, Vol. 2, Table III, page xxvii

15. Reported to the Twelfth International Geological Congress in Toronto, 1913

16. Paul Averitt, "Coal resources of the United States, 1 January 1967"; *Geological Survey Bulletin* 1275 (Washington DC, US Government Printing Office, 1969)

17. M. King Hubbert, "Energy resources", *op cit*

18. *Uranium Resources, Production and Demand*, September 1970. A joint report by the European Nuclear Energy Agency and the International Atomic Energy Agency (Paris, OECD, 1970)

19. Alberta Oil and Gas Conservation Board, *A Description and Reserve Estimate of the Oil Sands of Alberta*, Calgary, 1963

20. *US Energy Outlook*, *op cit*, page 174

21. *US Energy Outlook*, *op cit*, page 155

22. Sam Schurr, "Energy", *Scientific American*, September 1963: "There is no true measure of the world's endowment of energy resources, nor, in the nature of things is there ever likely to be one. Cost alone would prohibit a comprehensive probing of the earth's crust to provide anything approaching a true measure of the resources. More to the point, society's interest is confined to resources that are exploitable now or seem likely to be in the future. As time passes, the standards of exploitability keep changing, mainly as a result of advances in technology and changes in the economic circumstances. Consequently resource supply estimates are subject to at least as much uncertainty as energy demand estimates."

9. AN EVALUATION OF THE WORLD MODELS

H. S. D. Cole and R. C. Curnow

After summarising the findings of chapters 2–8, exercises which demonstrate shortcomings in the general structure of the world models are described. Alterations to the World 3 model, suggested in chapters 3–8, are tested, and comments are made on the results and on world models in general.

A brief summary of chapters 2–8

In the world models, the factors putting a strain on the world's fixed physical limits are capital accumulation and population growth. The growth of capital is the main driving force in the resource depletion and pollution modes of "collapse". If these two "collapses" are avoided, it is the growth of population which causes "collapse" by the draining of capital into a decreasingly productive agricultural sector necessary to feed a growing population.

In chapter 2 the structure, method of calculation and data base used in the world models have been examined in broad terms. Many different possible sources of error within the models are pointed out, some more serious than others. The absence from the models of certain adaptive economic, technological and social feedback processes is considered to be particularly suspect. In addition it has been observed that the high level of aggregation used in the models could distort the world trends generated by the models. A further source of error is a possible systematic bias of the numerical values used in many of the relationships.

Chapters 3–8 have looked at both the data and structural relationships of the World 3 model and have questioned the basis of the major assumptions in each sub-system, especially those assumptions which determine "collapse". Each chapter has taken a slightly different standpoint, reflecting both the views of its author and the subject under consideration. However, in every case the same set of questions has been asked: To what extent do the assumptions reflect actual historical trends and the theories constructed on the bases of these trends? If it is assumed in *The Limits to Growth* that future trends will be different from those of the past, what evidence is produced to justify the historical discontinuity?

One fact emerges clearly. The data base for the model is inadequate, but not through any fault of Meadows and his colleagues. Even so, in each chapter there is sometimes severe criticism of the use made of the data that were available. It is to be hoped that the MIT work will stimulate the collection of better statistics on a number of economic variables listed by Julien and Freeman (chapter 6). Sinclair and Marstrand point out (chapter 7) that the pollution sub-system is one of the sources of "collapse", yet very little is in fact known about the relationships postulated in the model as causing the "collapse".

In view of its singular importance, energy has been considered (chapter 8) separately in this work, although in World 3 it is treated as part of the "non-renewable resources". Surrey and Bromley have discussed world fuel reserves. They argue that for many reasons it is impossible to know what resources actually are, but conclude that although stocks of current fuels are limited they are not yet scarce and there is every possibility of new technologies arriving before they become so, providing conservation and research and development policies are adopted.

Least criticism is levelled at the population sub-system of World 3. Page finds (chapter 4) that historical experience has not yet led to an adequate understanding of the factors affecting rates of population growth, but that the World 3 population sub-system includes most of the likely factors, although leaving untouched the issue of policy changes. Given the limited state of knowledge none of these factors can be said to be definitely in error, but many are very controversial. The sub-system is sensitive to changes in certain para-meters (for example, those relating desired family size to social structure and expected income) whose empirical values are not well known. Since so many parameters and relationships are debatable the probability of the results of the model being correct is reduced.

Julien, Freeman and Cooper (chapter 6) show that the capital sub-system contains many internal inconsistencies and that it does not make full use of operationally proven economic theory. Further, although it is not in itself implausible, the assumption of continuous and constant technological change (sufficient to offset diminishing returns to investment) in the industrial sub-system is both different from and inconsistent with the assumptions in the pollution and agriculture sectors. The result of including technical progress in the capital sector but not in the resource sector is to bring forward the date of "collapse". The behaviour of the capital sub-system and of World 3 as a whole is very sensitive to relatively small changes in the industrial output/ capital ratio and other economic relationships which are assumed, with very little empirical justification, to be constants. Relatively small changes to this ratio can prevent any economic growth occurring or, at the other extreme, lead to collapse by 1970. While in themselves these inconsistencies would not necessarily cause the results of the models to be in error, they again cast doubt on the reliability of forecasts made using the model. In the opinion of Julien and Freeman the capital sub-system is poorly modelled. It simply does not contain many of the adaptive mechanisms known to operate in the real world, many of which would tend to avert "catastrophe" or, in the event of a limit being approached, render the mode asymptotic rather than, as forecast by the models, "overshoot" followed by collapse.

In chapters 3, 5 and 7, Page, Pavitt and Marstrand are critical of the major assumptions in the natural resources, agricultural and pollution sub-systems, each of which might be the cause of eventual collapse. They all argue that the assumptions of World 3 are, on the basis of historical record, pessimistic about the future possibilities for technological improvements which would reduce the net use and cost of resources, increase the productivity of investment in agriculture and reduce pollution. They argue that no satisfactory case is made justifying the apparent assumption that in the future there will be a change in the historical trend of technological improvement. They also note that the use of world averages is a poor approximation and could obscure important issues.

Furthermore, in the natural resources and agricultural sub-systems, Page, Marstrand and Pavitt argue that the World 3 assumptions about physical limits are unduly restrictive. In the resources sub-system, Page points out that in geological terms the earth's resources are many times larger than assumed in the world models, that economically exploitable resource supplies depend on the state of technology and of the market, and that the known amounts of these exploitable resources have generally been steadily increasing over time. World 3 does not even contain the "feedback loop" between the market, technology, and economically exploitable resources. Neither does the model contain the social, economic and technological "feedback mechanisms" which would operate to keep pollution at an acceptable level. In the agricultural sub-system, Marstrand and Pavitt argue that the estimates for the cost of developing the world's new land are unjustifiably high, that the procedure for calculating the aggregate world costs of developing new land is methodologically faulty (considerably overestimating the development expenditures that would be necessary if only physical constraints existed), and that the real problems of feeding the world may well be political limits rather than physical limits. Similar conclusions are reached by Surrey and Bromley with respect to energy reserves. Julien and Freeman, too, believe political constraints to be the most important rigidities in the capital system.

For each of the resources, pollution and agriculture sub-systems the authors point to relationships they believe to be wrong. The effect of changing these relationships on the results of the model will be considered later.

Exercises with the models

Chapter 2 has presented possible sources of error in the World models, and chapters 3 to 8 have illustrated these and raised others. It is important now to test the models to find whether (and to what extent) errors which have been made will significantly alter or contradict the forecasts made in the major conclusions of *The Limits to Growth*.

If present growth trends in world population, industrialisation, pollution, food production, and resource depletion continue unchanged, the limits to growth on this planet will be reached sometime within the next one hundred years. The most probable result will be a rather sudden uncontrollable decline in both population and industrial capacity. *The Limits to Growth* (page 23)

Since Meadows' model is a more complex version of Forrester's model, and

since both models give in essence the same results, it seems sensible initially to carry out any tests on the simpler model in order to expose more easily the important shortcomings (which after all are likely to be common to both).

The models examined by us are World 2 as published in *World Dynamics* and World 3 as described in *The Limits to Growth*. The World 3 program was taken from the first draft of the Technical Report (April 1972) as this was the version current at the time *The Limits to Growth* was published. A later version of the Technical Report contains some amendments and tests not previously considered; but the main conclusion remains unaltered, although stated with rather less conviction. A shift in emphasis from overwhelming physical limitations towards social and technological limitations to growth may be detected in the later version.

Problems of testing complex models. The general examination of the world models in the previous chapters exposed several pitfalls. Those of particular relevance to the exercises of this chapter are described below.

● Many tests could be carried out on the world models in an attempt to check whether the results are really as insensitive to changes in the models as Forrester and Meadows claim. The models are non-linear and dynamic, so the importance of each relationship will not always be the same. Relationships which are unimportant in some circumstances may become critical in others. For example, none of the pollution parameters are important in the standard runs of the models, because the system collapses before pollution reaches danger level. The entire pollution sub-system can be removed without seriously changing the results. On the other hand, when resource parameters are given more optimistic values, the pollution sub-system becomes the critical factor in the collapse.

● A systematic bias in the original values given to many parameters could have a greater effect on the results than a large bias in a single value, so it may be insufficient simply to look for large errors on individual parameters.

● The parameter values in system dynamics equations are not as independent as is implied by giving them separate initial values (ie, population, investment, pollution, etc, are all given separate initial values, but they are related through the equations of the model). If the initial values given to the parameters are inconsistent in terms of the equations of the model, then the feedback mechanisms in the models cause the parameters to adjust rapidly to find mutually consistent values once the dynamic calculation begins. In system dynamics jargon this is called "letting the system settle down"; to the extent that this reflects feedback processes in the real world it can be ignored. However, in cases where the feedback processes have been incorrectly modelled trends may become distorted as a result of the settling down process. Inspection of Figure 4 (chapter 2) shows a rapid shift in FPC (Food *Per Capita*) just after 1900. Figure 2 (chapter 2) shows an unrealistic dip in population from 1900 to 1904.

The "settling down" process makes the effects of a change to an individual parameter difficult to assess because a large change in one parameter may be damped out and, instead, parameters throughout the system will be altered by smaller amounts (so making them no longer in agreement with their historical values).

● Since, as was noted in chapter 2, the models appear superficially to give a plausible fit to historical trends between 1900 and 1970, processes which are omitted explicitly from the models, but which do operate in reality, may actually have been subsumed into other relationships to a greater or lesser extent. If that is the case and a process so subsumed (which thus appears to have been omitted) is subsequently built onto the model (in order to improve or test the model), it might be necessary to refit all the other parameters around this addition. Otherwise, the "overcounting" may cause the results no longer to agree with historical trends. Overcounting is a particular hazard for the world models since most of the parameters have, in reality, varied simultaneously and monotonically between 1900 and 1970.

Some shortcomings in the historical trends generated by the models. We have already noted the occurrence of false perturbation between 1900 and 1904 for the population trends generated by World 2. Population is calculated from birth and death rates (as shown by equation 1 in chapter 2). The rates calculated by World 2 for the 1900 to 2100 period are shown in Figure 1 (the graph shows total birth and death rates per thousand of population). Death rate is quite different from the historical trend in the vicinity of the year 1900. One obvious thing to investigate, therefore, is what the model has to say about

Figure 1. World 2 standard run: births, deaths and total population changes

the period before 1900. The mathematical relationships used in the World models are reversible, so if set to run back they "project" a view of the past. In any case, much of the credibility of the futures portrayed by the models rests on their ability to reproduce to a plausible degree historical trends between 1900 and 1970 and, in general, the longer the period over which trend forecasts agree with history, the more valid they appear. As it stands, World 2 will not run backwards from 1900 for more than a little over 20 years. Figure 2 is obtained by first running the model back to 1880 and then running it forwards from that date using the parameter values so obtained. The curves are curious— they seem to indicate that the 20th century lies in the aftermath of a cata- strophic population collapse (from a previously infinite population) dated about 1880 with population still decreasing as late as 1904. Even if this exercise is an indictment of Forrester's "guesswork", it does not necessarily mean his model is totally ridiculous. But if he had started his model run at 1880 with

Figure 2. World 2. History from 1880

initial values based on his arguments in *World Dynamics* the collapse predicted
by the standard run model would be brought forward by 20 years. And if he
had started the model at 1850 the collapse would be predicted for around
1970. It is useful to examine the great "catastrophe" of 1880 in particular,
because one does have an idea of what events really did occur both before and
after this date, and also because it is possible to see the few relationships that
are dictating the behaviour of the model.

In the late 19th and early 21st centuries World 2 predicts that material
standards of living are low compared with 1970. In his book, Forrester argues
for a strong relationship between material standards of living and death rates.
He assumes that changes in average world material standards (this does not
include food) can cause death rates to vary by a factor of six (see Figure 6,
chapter 2, for the look-up table of DRMM, the Death Rate from Material
Multiplier). If this variation is reduced to a factor of three, the peculiar be-
haviour of the model before 1900 disappears and it is possible to run it back to
before 1850 (as shown in Figure 3). Even the post 2000 view is rather less

Figure 3. World 2. History from 1850 with a changed death rate assumption

frightening, since the reason for the end to population growth is now almost entirely due to a lowering in birth rate rather than a high death rate. This change in a death rate multiplier seems to be an improvement to World 2. However, altering a death rate multiplier is by no means the only way to give plausible starting figures to the model to achieve a better historical view. For example, by setting the initial levels of population, capital, pollution and resources on the basis of arguments in Forrester's book but changing the fraction of capital allocated to agriculture from 0·2 to 0·9, reasonable pre-1900 trends are generated. However, this time (as Figure 4 shows) there is no change in the post 2000 scene. What is happening in this run is that the increase in food *per capita* (because of the higher agricultural investment rate) compensates for the high death rate due to low material standards, but because of strong feedback mechanisms in the model which favour industrial rather than agricultural investment, food levels fall rapidly during the dynamic calculation. Indeed by 1900 the fraction of capital invested in agriculture has diminished to Forrester's value and so the post 1900 future is the same as his. The feedback mechanism which in World 2 adjusts agricultural investment is unrealistic. In

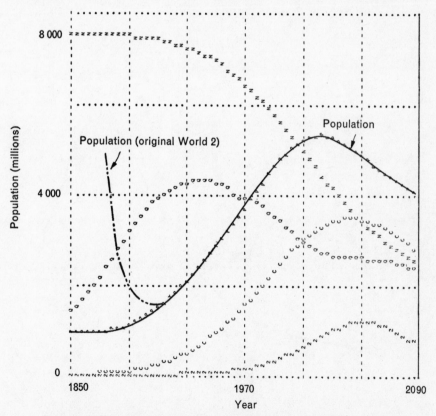

Figure 4. World 2. History from 1850 with changed agricultural investment

many runs carried out the level of food consumption remains faithfully at the rather low 1900 level even when material standards rise to very high levels.

This analysis puts into serious doubt several mechanisms in Forrester's original model. More importantly it casts doubt on the use of "plausible" guesswork as a basis for a predictive world model.

● Meadows claims, on page 135 of *The Limits to Growth*, that his model reflects the functioning of the global population-capital system as it has operated for the last one hundred years, but his runs only show trends from 1900. The performance of World 3 pre-1900 is far less dramatic for the major parameters than World 2 (Figure 5). Nevertheless it can be seen that the trend in food levels *per capita* is unrealistic before 1880. Some of the less important variables also behave in a disconcerting manner. For example, the unemployment

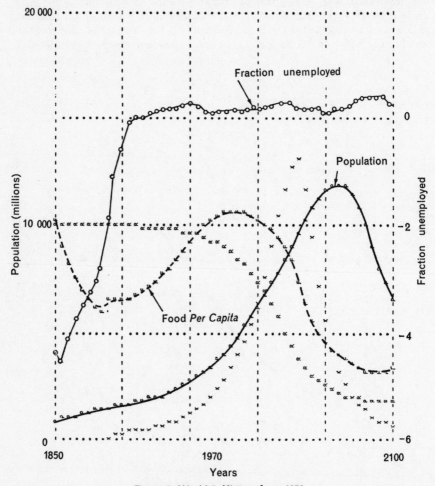

Figure 5. World 3. History from 1850

fraction (added to Figure 5) which varies between 0·1 and 0·3 for most of the period 1900 to 2100 actually starts with a negative value (−0·3 in 1900) and this falls to a value of −4·2 in 1850. It is not easy to decipher the particular errors in other relationships which are compensating for this effect in the 1900–1970 interval although evidently they must be located somewhere in the capital sub-systems.

Thus it can be seen that neither model quite lives up to the claims of its author with respect to the generation of trends that match historical data and, of course, this must throw a certain amount of doubt on the validity of the results and any conclusions drawn from them about the future.

Changes in the structure of the model. In some of the earlier chapters it was suggested that certain technological, economic and social feedback mechanisms should have been included in the models. In the real world these processes give rise to steady and continuous technological change. Forrester and Meadows have included the possibility of progress in their models only as single and discontinuous improvements in any given technology (eg, pollution control) with the result that catastrophe was merely delayed for a generation or so. Here, the effect of adding small incremental improvements to technology will be considered. For agriculture and pollution technologies this is done by letting the capital-output ratio assumed by Forrester improve by a given fraction annually. For natural resource technology (discovery and recycling) an

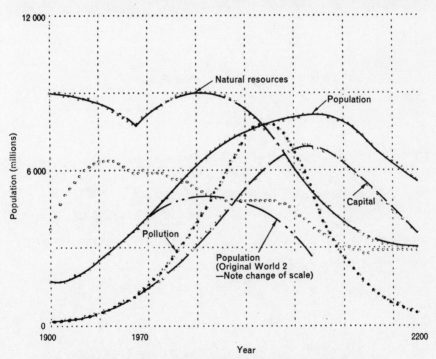

Figure 6. World 2 with a technological progress assumption

annual increment which is a fixed fraction of the reserves at the beginning of each year is added to the existing stocks.

Figure 6 shows the result of including in World 2 a 1% *per annum* rate of natural resource discovery (taken to include recycling processes) and a 1% *per annum* increasing technical ability to control the emission of pollution from 1970 onwards. This is not sufficient to remove the collapse from resource shortages completely but does postpone it significantly. Pollution rises to four times its 1970 level but is not an important factor in the collapse. If, however, the rates of progress are increased to 2% *per annum* collapse is postponed indefinitely (Figure 7). In the model, known natural resource supplies grow rapidly, far exceeding demand (quite unrealistically) and pollution only rises to a maximum of twice the 1970 level. The slowing down of population growth is now due to food shortage which is itself easily removed if a 2% annual improvement in food production is assumed. The question of "overcounting" does not arise for either resource technologies or pollution technologies because in the main they are at the moment fairly primitive (see chapters 3 and 7). However, some overcounting may be present for agricultural technology.

Oerlemans, Tellings and de Vries[1] have also examined the results of remodelling the natural resource sub-system of World 2. They change Forrester's assumption of finite natural resources and instead assume that the cost of extraction depends on the amount already extracted and that the capital

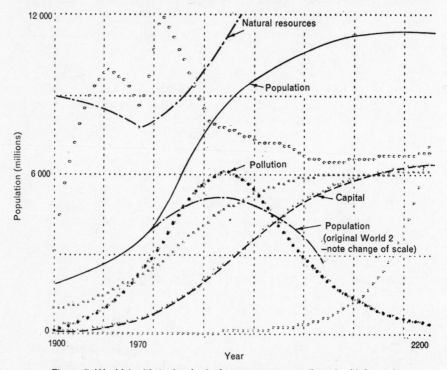

Figure 7. World 2 with technological progress assumption at a higher rate

allocated to extraction adjusts accordingly. At the same time they introduce a feedback process, similar to Forrester's mechanism for regulating agricultural investment, which causes increasing capital to be allocated to pollution whenever the level of pollution rises. They find that such adaptive processes can remove the threat of collapse from these causes. It would seem, in view of both these sets of results, that continuous technological improvement ought to be included in any model of the world system, even though its effects may not be quite so far-reaching as suggested by these elementary exercises.

It should also be pointed out that the "delays" in introducing technological change are implicitly accounted for in the exercise (increasing the delays would have the effect of slowing down the overall rate of improvement). World 2 does not contain any delays explicitly (they are all included implicitly through the rate equations). The results are very similar to those of World 3 which does have some additional explicit delays and therefore, since the general form of collapse is the same for both models, one can conclude that the delays Meadows has explicitly included are not critical to the major results. The actual numerical values used as improvement rates for the various technologies in the exercises are not significant except that they are fairly small and not improbable in the real world. To postpone collapse indefinitely these rates of improvement must obviously be competitive with growth rates of population and consumption so that even if the overall growth is rapid it is also "balanced". In this case some kind of stable but dynamic equilibrium is obtained. Ironically the "no growth" equilibrium which Forrester and Meadows speak of, if their projections are to be believed, could only last until the year 2400 because, by this time—according to their assumptions—all resources would be depleted.

The result of dividing up the model into linked "developed" and "underdeveloped" regions. Several of the previous chapters have pointed out that the use of world averages that represent both developed and underdeveloped regions is often an unrealistic approximation. As noted in chapter 2, the approximation involved in the use of world averages for the parameter values might prevent the model from capturing the true pattern of catastrophes in the world. One example to demonstrate the possible shortcomings of assuming uniform distribution of world problems is given here for the case of pollution. A simple "dual-world" model was made. Because of the implicit assumption in Forrester's book that time series data and cross-section data are equivalent, the sub-models could be constructed simply by using approximate values corresponding to the 1900 levels of population, resources, etc, in the developed and underdeveloped regions of the world, to set up two copies of the original World 2. When run separately the two models do not generate good histories of their respective regions nor does the total match the trends of the original model. One possible reason for this is that in the real world there are flows of capital, resources and pollution between the two regions.

For many reasons, resource transfers and capital transfers between the developed and underdeveloped world are not easy to estimate. However, one can ask what transfers of capital and resources need to be included in the dual model in order to make its trend curves for world totals agree with the standard run of World 2, and the trend curves for the regional models give a plausible

history. With the assumption that pollution from the two regions is uniformly distributed across the world, both resource and capital flow have to be in the direction of the developed region. Pollution transfer is in the opposite direction. (Although this is an interesting result and ought to be examined further, very little reliance should be placed on it as the model is extremely crude.) The results of this model for the world totals are compared in Figure 8 with the World 2 standard run. The results are very similar: collapse due to resource shortages occurs just about simultaneously in both regions. If instead of assuming a uniform world-wide distribution of pollution it is assumed that pollution remains in the region of its origin (and all other relationships are unchanged) a quite different result is obtained. As Figure 9 shows, two distinct catastrophes occur: the developed world is the first to go, rapidly overcome by rising pollution; population and capital continue to grow in the underdeveloped

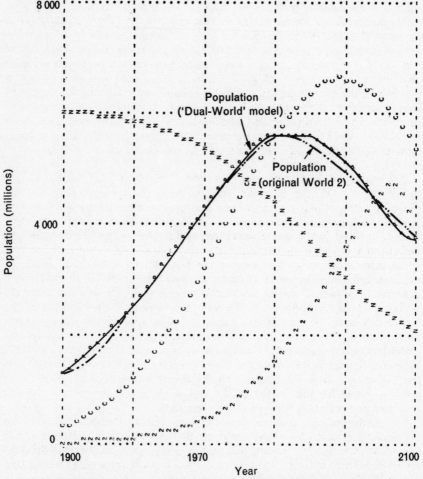

Figure 8. World 2. Dual-world version, with pollution distributed globally

region until eventually suffering in the same way. Besides the occurrence of a double catastrophe it can be seen that the first local collapse is much earlier than that forecast by the model carrying the assumption that pollution is averaged across the world. With the assumption of localised pollution and further dividing up of the world model, the series of sudden collapses which would be forecast would appear on a plot of world population trends as a wavy line rather than as a single hump. Consequently it must be concluded that it is very important for the construction of a world model to know whether pollution (or indeed any other problem) is likely to be localised or widespread.

Errors arising from the method of calculation. The two possible sources of error mentioned in chapter 2 were rounding errors arising from the dynamic calcu-

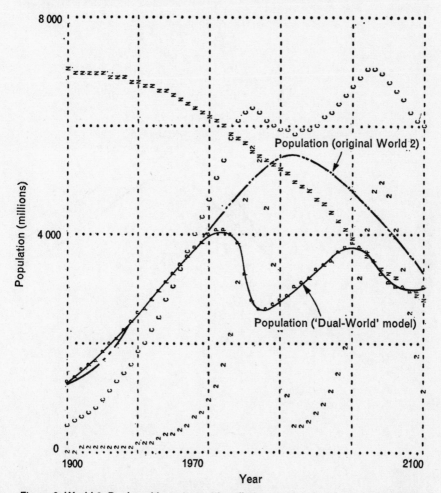

Figure 9. World 2. Dual-world version, with pollution restricted to region of emission

lation and the Euler approximations in the look-up tables. Changing DT from its original value of 0·2 (years) to 0·05 (years) and 1 (year) made no perceptible difference to the results (nor would one expect it to do so as the characteristic time periods of the models are relatively long). Apart from occasional spurious "kinks" in the trend curves, no serious effects seem to arise in the World 2 runs from the approximations of the look-up tables (see, for example, the "death rate" trends in Figure 1). The exercises with World 3 (described later in this chapter) exhibit some still unimportant, but more pronounced "kinks".

Changes in population and capital growth rates can be usefully examined for two reasons. Birth and death rates, and investment and depreciation rates are

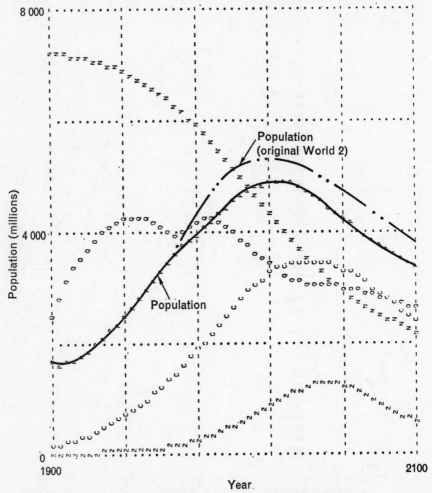

Figure 10. World 2. Sensitivity to a reduced population growth rate

not well known, yet, in the model, population growth rates and capital growth rates are calculated from their differences (see, for example, equation 1, chapter 2). Consequently the uncertainty in the net rates may be large; this is obviously a potentially serious source of uncertainty for the results of the models. The second reason is that although World 2 is a model of the world, it can be used to demonstrate roughly regional effects (as with the dual-region model). Hence the factors generally important for local as well as world-wide collapse can be inferred from the results of the model.

Decreasing or increasing the population birth and death rates by 20% from 1970 onwards has little effect on the standard run as can be seen from Figures 10 and 11. However, changes of 20% in the investment rate from 1970 onwards

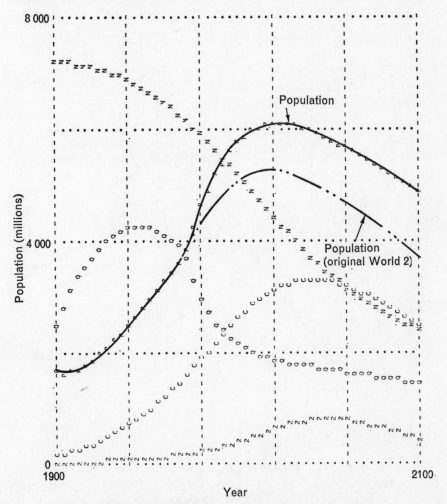

Figure 11. World 2. Sensitivity to an increase population growth rate

have a very marked effect. When the rate is lowered, population growth rapidly ceases (because of lower living standards and food levels) and the onset of a slower collapse is brought forward to 1980 (Figure 12). When the investment rate is raised the consequent improvement in living standards and food levels causes population to grow rapidly. This growth is, however, cut short by the high levels of pollution. A precipitous population collapse occurs around the year 2000 (Figures 13). It would appear from these results that although a reduction in capital growth rate has more effect on the rate of collapse during a resource crisis than a similar reduction in population growth, neither reduction would seem to postpone the time of collapse by very much. However, during a collapse due to food shortages population growth would actually be the more important of the two (this is because, unlike material consumption,

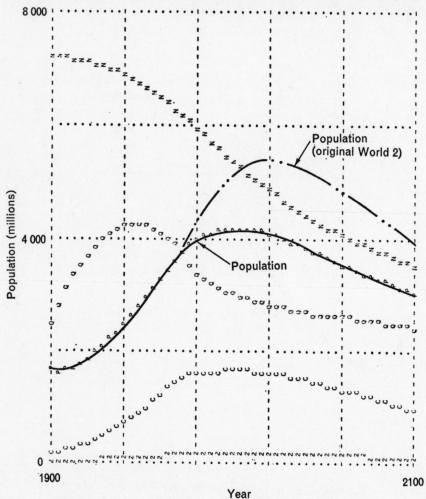

Figure 12. World 2. Sensitivity to a reduced capital investment rate

food consumption *per capita* does have an upper limit). In other words, the important growth parameters depend on the particular circumstances of the collapse and it is misleading to imply, as Forrester does, that industrialisation is a "more fundamental disturbing force in world ecology" than is population growth.

Some exercises with the World 3 model

There was general agreement in chapters 3–8 that the premises on which the relationships in World 3 are based are pessimistic and tend to overstate the physical and technological constraints on continued growth. For the natural

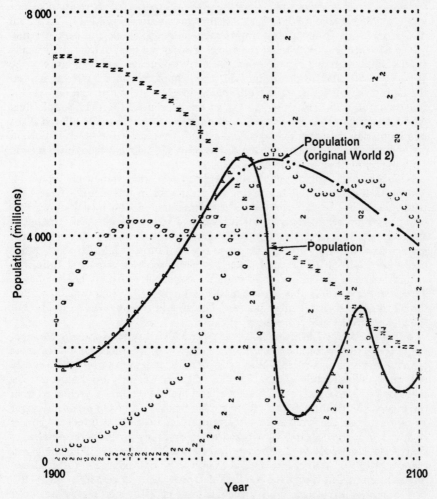

Figure 13. World 2. Sensitivity to an increased capital investment rate

resource, pollution and agriculture systems, suggestions were made for inclusion of one or two rather more optimistic, but equally well founded, relationships which take account of continued improvements in technological efficiency. The suggested alterations will now be included successively into the World 3 model so that the importance of each can be judged. The changes in the computer program are made in the simplest possible way by altering look-up table values. Just as certain continued gains in resource and pollution technologies were included in the World 2 model by assuming incremental growths, alterations in look-up tables can be used to give roughly the same overall effect as the feedback mechanisms which control the rate of technological change. The main problem in doing this (as will be seen later) is that the alternative values are arbitrarily assumed at the outset and so improvements in the various technologies are not optimal or well balanced in relation to one another. This simple method is satisfactory for sensitivity analyses, but would not be so for a serious attempt at re-modelling. However, the exercises described here are sensitivity tests; the model is not being used to forecast. Already in this chapter it has been seen that there are differences between some of the World 3 results and historical data. Further, chapters 3 to 8 have argued that the high levels of aggregation (with regard to geographic distribution, specific resources and pollutants) used in the model are unrealistic. The simple dual model has shown that the results of the models are substantially altered if the approximation to world averages is not used. So even when other important changes are made to the model the results must still be regarded with suspicion from the point of view of forecasting.

● To facilitate comparisons the standard run of World 3 is shown in Figure 14. The vertical scales for each variable for all graphs in this chapter have been made the same. In this run, it will be remembered, the model shows that collapse occurs before the year 2050 because of resource shortages. Instead of showing resources as the fraction remaining from the initial 1900 reserves, the graph shows the total number of years' resource supply (at 1970 usage rates) used since 1900. This quantity is taken to include recycled resources. Industrial output *per capita* (an indicator of material standards of living) is also shown. The time horizon has also been extended a further 100 years to 2200 so that the effect of each change may be seen. This should not be taken to imply that the validity of the model has been extended.

● It was suggested in chapter 3 that an equally realistic hypothesis concerning resource costs would be to let the Fraction of Capital Allocated to Resources (FCAOR) be fixed and to assume the amount of resources to be effectively unlimited. The fraction chosen for this first run was 0·1, the assumed 1970 level. If, then, the concept of a finite physical limit to resources is removed from the model, the fraction of capital spent on resources (FCAOR) can no longer be calculated on the basis of the remaining stock. Instead the fractional cost of resources in a given year is now taken to depend only on the total number of years' resource supply (at 1970 usage rates) used NRYU since 1900 (the U's in Figures 14 to 19) (With this scheme the equivalent approximation to Meadows' original assumption is that the fraction of capital spent on resources (FCAOR) rises steadily and reaches unity when a total of 250 years' supply has been consumed). The results of this change on the behaviour of the model are shown

in Figure 15. As might be expected on the basis of Meadows' own results, described in chapter 2, this change alone removes the resource crisis but substitutes a pollution crisis. Rising pollution, coupled with food shortages (the result of reduced land yields brought about by pollution) bring a population collapse. By the year 2100, 450 years' supply of resources are used (expressed in terms of the 1970 consumption rate). Thus eliminating the resource problem brings pollution to the fore.

● There are two forms of pollution considered in the model: industrial and agricultural, and the conclusion of chapter 7 was that both these could be controlled to far below the levels assumed by Meadows. Since no firm empirical evidence is available, any relationship assumed in the model must be arbitrary. The changes made here are certainly no less plausible than Meadows' original

Figure 14. World 3 standard runs with scales adjusted to facilitate comparison with succeeding graphs

Figure 15. World 3 with changed resource costs

estimates. In Figure 16 it has been assumed that the rate of industrial pollution produced as a function of industrial output *per capita* (PGMO) can be held at about 10% of the level assumed by Meadows. The trend curves for the model are little different from the previous run and the collapse is only slightly delayed. Reducing agricultural pollution has a far greater effect. Figure 17 shows the result of reducing agricultural pollution levels (as determined from agricultural inputs (PGML)) to 10% of the original. This removes the pollution threat and population rises until diminishing returns to agricultural investment bring on a food crisis. The important change (removal of the pollution crisis) is not very sensitive to the shape of the PGML look-up table; what matters is that the overall effect of pollution assumed in the model is kept well below its original value.

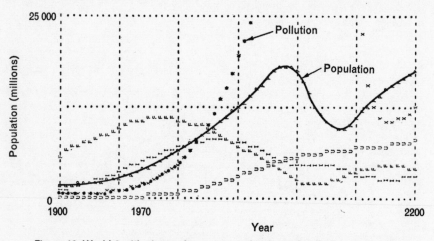

Figure 16. World 3 with changed resource and industrial pollution assumptions

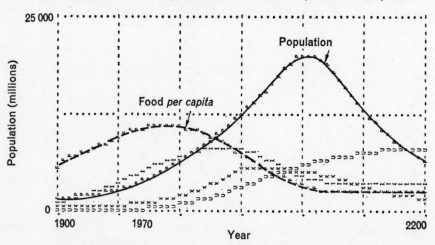

Figure 17. World 3 with changed resource and pollution assumptions

Thus eliminating the resource and, now, the pollution problem, brings food problems to the fore.

● Two suggestions were made in chapter 5. One questioned the relationship postulated by Meadows for diminishing returns from inputs into agriculture; the other took account of the possible reallocation of capital to make best use of agricultural land throughout the world (ignoring political constraints) and the use of more appropriate technologies. Figure 18 shows the effect on the result of the model of changing the land yield from agricultural inputs multiplier look-up table (LYMC) to the form shown in chapter 5 (page 64). Although population now continues to rise almost until the year 2200, the same diminishing returns mechanism as in the previous run does eventually operate to lower substantially food levels *per capita*. Hence the new postulated improvements in land yield do not appear sufficient to prevent food shortages. Industrial output *per capita*, which at one stage rises to six times the 1970 level, also falls when increasing capital has to be diverted into the food sector (in an attempt to put off the food crisis). Pollution also rises continually but does not reach dangerous levels. By the year 2100, fifteen hundred years' supply of resources (at 1970 rates) have been consumed.

Changing the shape of the Development Costs Per Hectare look-up table (DCPH) to the form suggested in chapter 5 removes from the model, at least temporarily, the final constraint on growth. But the model is now becoming unstable, since there is insufficient control built into it, and Figure 19 shows industrial output *per capita*, resource use, food levels and pollution growing rapidly and unrealistically. In part this is due to the fact that output *per capita* and food levels have risen beyond the "optimistic" end of the look-up tables used to calculate birth and death rates. For example, industrial output *per capita* reaches the maximum value used in the model, the current USA average level, some time after the year 2100. Consequently the latter cannot adjust

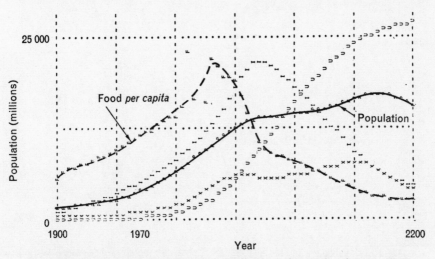

Figure 18. World 3 with cnanged resource, pollution and agricultural assumptions

further and this is why population shows an approximately steady rate of increase after this time. This has the added effect of raising *per capita* food and output levels.

What the exercises show. As explained earlier, the purpose of the exercises was simply to discover how sensitive the results of the World 3 model are to certain alterations. The model appears to be very sensitive to input parameters which have a wide margin of error and in fact it would appear that according to World 3 a high rate of growth is just as likely as a catastrophic collapse.

Although the model is becoming unstable (ie, very sensitive to changes in the important parameters) the main point of the exercises has been made; on the basis of the suggestions in earlier chapters and results of this chapter, it seems that, far from the results of World 3 being insensitive to changes in the assumed values of parameters, the reverse is the case. Furthermore, only five selected alterations have been made. Although each of these changes could be

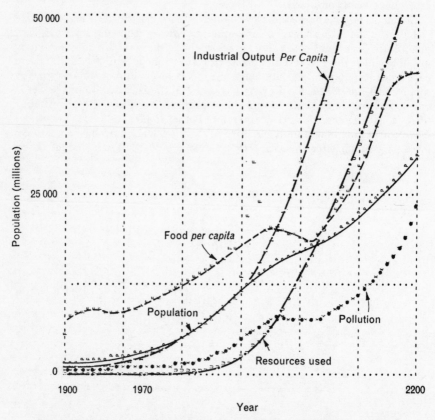

Figure 19. World 3 with changed resource, pollution, agricultural and capital distribution assumptions

criticised as being over-optimistic (in that they are based on the belief that certain trends in technological advance will continue) the general impression of chapters 3 to 8 was that many of the other parameter values used in World 3 are pessimistic. The removal of this systematic bias should compensate for any over-optimism in the changes made in this chapter. For example, tests on the modified World 3 model (that which generated Figure 19) show that continued growth is possible provided that the total costs of resource extraction and pollution do not exceed about one-quarter of total industrial investment (which is far above the levels considered likely in chapters 3, 7 and 8). However, even costs there could be balanced by realistic industrial technology improvements which have so far not been added to the model.

For what they are worth, the results presented in this chapter indicate that, even on the basis of the World 3 model and even with a very high population figure, continued growth, at least for the next two centuries, will not inevitably stop at an early date because of physical limits.

However, as pointed out above, this depends on the assumption that, in the future, advances in technological, economic and socio-political activities will be made continually. This assumption contrasts sharply with Forrester's and Meadows' method of including improvements in technologies and changes in social values, which might mitigate disaster, as single and discontinuous jumps. The effect of such discrete changes is merely to delay catastrophes since the underlying process of growth is still exponential and the constraints are still fixed or at best slowly relaxing. Some overcounting of technological change will occur with both methods so the sensitivity tests really only illustrate the importance of having the correct form for the relationships used to describe the process.

Previously a simple dual-world model (derived from World 2) was used to show how the results of the World 2 standard run change when the model is divided up into developed and underdeveloped regions. In neither of the two examples using this model did capital investment in the underdeveloped region approach the levels of the developed region. Nor is there any reason to suppose that rapid growth (as in Figure 19) would be uniform, or even that local catastrophes would not continue to occur. For the examination of these problems a disaggregated model, which explicitly dealt with, at the very least, the problems of transfers between the developed and underdeveloped world regions, would be useful for testing the various theories of development.

The results of this chapter do not imply that the rapid growth which appears to be physically possible is more desirable than Forrester's and Meadows' proposed equilibrium state (in which population, industrial output *per capita* and so on would remain fixed at about twice 1970 levels). The results simply indicate that a fairly high growth rate *could* be the upper limit of a wide spectrum of choices of futures with respect to growth and that the range of choice is far greater than that conceded by Forrester and Meadows. Actually, because the model is so sensitive to changes in the feedback mechanisms even the upper limit cannot be well estimated. To obtain reliable figures would require an analysis of maximum possible growth rates in each of the sectors. Any model based on this analysis would have to include realistic social control mechanisms to balance the various growth rates.

Conclusions

The conclusions to this chapter fall, broadly speaking, into two categories: those concerned with the models themselves and those concerned with the general approaches to modelling adopted by Forrester and Meadows.

● Although Forrester deserves credit for his original formulation of the world model, World 2 emerges rather poorly from our examination. Even in terms of the factors it *does* include, World 2 must be considered unsatisfactory. The fact that the model can be made to run successfully in the 1850 to 1970 interval by changing a variety of parameter values shows that, however plausible the numerical relationships constructed from "impressions" of the real world may be, computations using them ought not to be credited with any special reliability. Also because the results are so sensitive to the inclusion of small rates of technological change and resource discovery (indeed the threat of an early catastrophe from *physical* limitations is removed), it seems that some very important factors have been omitted from the model. Although as a first attempt at global modelling the use of world averages is sensible, it can be very misleading, in that, in the conditions Forrester envisages, local catastrophes would occur long before the time predicted by World 2 for "collapse". So not only are the results of World 2 nothing like as invariant to the inclusion of "conventional responses to economic and social problems" as Forrester has claimed, they would also not be invariant to inclusion of a more realistic world structure.

In terms of the factors that are considered, World 3 appears to be more satisfactory than World 2, in that, whereas Forrester built his model with a virtual disregard of any empirical data, Meadows did make a remarkable effort to collect information from many sources. Even so, as other chapters have shown, the data base for his model is weak and insufficient for the elaborate structure he has built upon it. Although the technical examination of the world dynamics models forced the conclusion that the results of Forrester's model are of little value for prediction, sensitivity tests on his model could have provided clues for the construction of World 3. For instance, it is surprising that the natural resource sub-system is so crudely modelled when, even intuitively, it is critical to both models' behaviour just as the tests on World 2 confirm. On the other hand much effort has been spent on the details of the population sub-system which is far less important for the major conclusions of the model. Furthermore, as the simple dual model showed, a model which takes account of heterogeneity in the world need not always give the same trends as a model which deals only with world averages. This applies just as much to World 3 as to World 2, and disaggregation of the model would seem, therefore, to be at least as important as the inclusion of extra detail. As it stands, however, the major assumptions of World 3 are the same as World 2. The same important omissions are made: the inclusion of technical, social and economic feedback processes have been shown to have a similarly important effect on the results. The extra complexity of World 3 contributes little to its utility as a forecasting device and tends to give a false air of sophistication and exactitude.

The results of World 3 were first published in *The Limits to Growth* in March 1972. Readers of that book were referred to a forthcoming Technical Report for justification and clarification of the assumptions, data and technical details of

the model. The second draft of the Technical Report (available in June 1972) contains tests and amendments to the model not considered, and in some cases dismissed, in *The Limits to Growth*. For example, continuous incremental improvements in various technologies have been tested in World 3 and not surprisingly the results are similar to those presented in this chapter.

Of his new results Meadows says: "As the runs presented here (in the Technical Report) have shown, it is possible to pick a set of parameters which allow material capital and population growth to continue through the year 2100. Whether the policy assumptions in that set are viable or not, the assumption of finite limits would dictate a later decline through the same physical pressures only at higher values."

In the light of what has been said above, the categorical nature of some of the statements and conclusions in *The Limits to Growth* are open to very severe criticism. Statements like: "The limits to growth on this planet will be reached in the next one hundred years"; "The basic behaviour mode of the world system (is the same) even if we assume any number of technological changes in the system"; "Even the most optimistic estimates of the benefits of technology in the model did not prevent the ultimate decline of population and industry or in fact did not in any case postpone the collapse beyond the year 2100"; do not appear to stand up to examination. Neither does another confident statement in the book that "we do not expect our broad conclusions to be substantially altered by further revisions".

● The mental model one chooses to describe the real world (especially the human world) is an inextricable part of one's values, interests, hopes and fears. This still applies even when the mental model is translated into a computer program. As will be argued in Part 2 of this collection, Forrester's and Meadows' assumptions are very much a reflection of their generally pessimistic view of the world. Earlier chapters have shown that in many cases the data from which the numerical values used in the models are estimated are poor. It is all too easy for a systematic bias reflecting a particularly pessimistic (or for that matter optimistic) view to influence the actual estimates used. The exercises of this chapter have shown that the results of the models can be changed radically by altering a few of the principal assumptions. Whether or not these particular changes are merely "optimistic", as Forrester and Meadows claim, or only marginally so, as we believe, is still a matter for debate. It is the contention of these papers that the perspective of world problems given by the models is both inadequate and incomplete.

As we have tried to show, models as complex as the world models cannot easily be tested by traditional sensitivity analysis, because of the severe problems of deciphering feedback processes. Even to test particular effects is by no means straightforward, and there are many pitfalls. However, as seen from the results of the world models, even with high complex dynamic systems the important behaviour at any time or under any circumstances is usually dominated by relatively few parameters, so that, although the models are complex, much of the complexity is false. The results can be considered to arise from a succession of less complex processes which makes the models less awesome than they appear at first sight. But at the same time we cannot accept fully Forrester's assertion that the need to formalise each interaction of the system modelled ensures that

every assumption can be critically examined and discussed. And even if this were true, an understanding of the separate relationships of a system does not, unfortunately, imply an understanding of its behaviour as a whole. Forrester would be the first to admit that a system is more than the sum of its parts. The total behaviour of a complex model can only be understood from a thorough examination of the overall properties of the model. When, as with the world models, this requires access to large scale computer facilities, it is questionable whether much of the "openness" of formal modelling remains. Forrester's claim that computer models are necessarily superior to mental models is not borne out by either World 2 or World 3. Decision-makers concerned with, say, pollution control, agriculture or natural resources might have very simplified and imperfect mental models but, given their first-hand knowledge of the subject matter, they might also have avoided the rather elementary mistakes made in the assumptions of World 2 and World 3.

Perhaps the best result one could hope for from any model like the two discussed here is that they contain the seeds of their own destruction—and of their replacement by superior models. Worlds 2 and 3 may prove to be useful stepping-stones to better models.

Although many of the criticisms of the world models in chapters 2 to 9 could be applied to models in general, the main objections have been against the assumptions underlying the world models. What the general criticisms have shown is that caution is needed with respect to claims made for the results of a model. Admittedly, to date, mathematical models of social systems have not achieved spectacular success, but neither have they been as totally unproductive as some would argue. There seems to be no reason why mathematical models (including system dynamics models) should not eventually become an important tool for structuring, classifying and communicating ideas in the social sciences, as they already are in the natural sciences. What does seem especially important, however, is that the work of modellers (and their critics) should not be viewed as a totally objective or apolitical statement of real world situations. Neither should modellers pretend that it is.

References

1. T. W. Oerlemans, M. M. J. Tellings, H. de Vries, "World Dynamics", *Nature*, Vol. 238, No. 5362, August, 1972, page 251
2. Kaya and Deiters (in the Activity of the Japan Work Team of the Club of Rome, Japan Techno-Economics Society, June 1972) have built a preliminary model which does take account of income distributions across the world. They intend to extending the work to examine the effect of localised natural resource shortages in greater detail using a model in which similar growth patterns are classified separately.

Acknowledgment

The author is indebted to Patte Cole who transformed the technical jargon of chapters 2 and 9 into something that we hope is more readable.

Part II: The ideological background

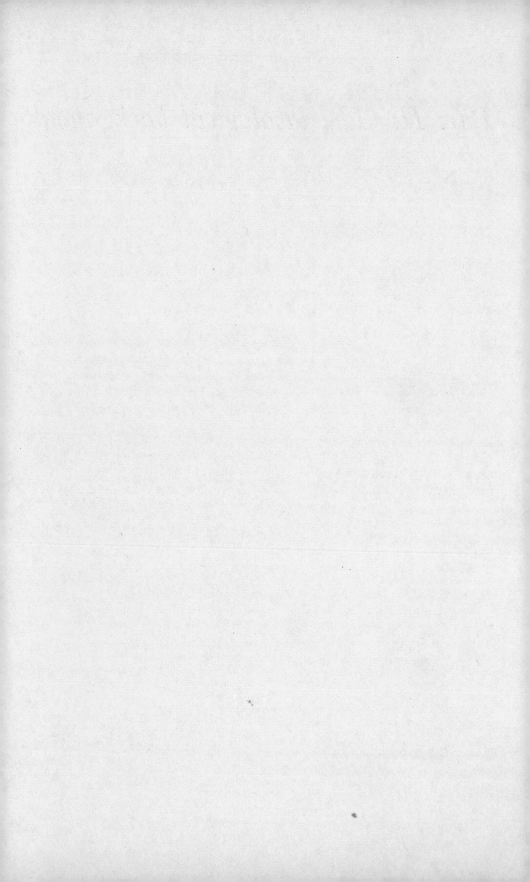

Part II: The ideological background

10. MALTHUS AND OTHER ECONOMISTS

Some doomsdays revisited

K. L. R. Pavitt

The feasibility and desirability of continued economic growth has been seriously questioned by an increasing number of people since the late 1960's. The debate, however, is not a new one and can be traced back at least to the writings of the classical economists of the late 18th and early 19th centuries. This chapter looks for lessons to be learnt from these past forecasts. The first section looks at what they predicted about the feasibility of continued economic growth, the second at how they viewed its desirability and the third looks at the structure, assumptions and public impact of the MIT models in the light of these previous predictions.

Is growth feasible?

ECONOMIC growth, its characteristics, its causes and its pattern, is the focus of Adam Smith's major book *An Enquiry into the Nature and Causes of the Wealth of Nations*. He saw capital accumulation and technical progress as the main motors of economic growth. Productivity increases were the result of greater specialisation of the labour force, which raised the level of skill and dexterity, saved labour's time in moving from one task to another, and facilitated the introduction of machinery to undertake simple, mechanical operations.

Smith (1723–1790) recognised clearly some of the essential characteristics of the process of technical change in the following, often quoted, passage:

All the improvements in machinery, however, have by no means been the inventions of those who had occasion to use the machines. Many improvements have been made by the ingenuity of the makers of the machines, when to make them became the business of a peculiar trade; and some by that of those who are called philosophers or men of speculation, whose trade it is not to do anything, but to observe everything; and who, upon this account, are often capable of combining together the powers of the most distant and dissimilar objects.[1]

For sustained economic growth, Smith predicted that, with the termination of the mercantile system of combination and control (both public and private), with adequate market possibilities, and with the basis for capital accumulation,

the division of labour would raise labour productivity, ensure a high rate of profit and capital accumulation, lead to wage increases, and thereby further increase the size of markets and offer renewed opportunities for specialisation and technical change. Growth would be reinforced by the opening up of additional markets through better transportation and communications and through the extension of foreign trade, and by the greater health and vigour of the labour force resulting from higher living standards.

However, he did accept the inevitability of the stationary, economic state:

As capitals increase in any one country, the profits which can be made by employing them necessarily diminish. It becomes gradually more and more difficult to find within the country a profitable method of employing any new capital.[2]

He also predicted that economic growth would increase the relative prices of agricultural products and raw materials. According to Barber, Smith considered that "the emergence of a stationary state, when further expansion would be halted and capital accumulation restricted to replacement require-ments, was too remote to call for serious analysis".[3] Smith was nonetheless quite explicit in his view on what such a stationary state would eventually be like:

In a country, which had acquired that full complement of riches which the nature of its soil and climate, and its situation with respect to other countries would allow it to acquire . . . both the wages of labour and the profits of stock would probably be very low. In a country fully peopled in proportion to what either its territory could maintain or, its stock employ, the competition for employment would neces-sarily be so great as to reduce the wages of labour to what was barely sufficient to keep up the number of labourers . . . In a country fully stocked in proportion to all the business it had to transact . . . competition . . . would everywhere be as great, and consequently the ordinary profit as low as possible . . .[4]

Malthus

Unlike Smith, Malthus was explicitly and militantly pessimistic. While Smith viewed population growth as an inevitable and desirable concomitant of economic growth, Malthus saw population growth, coupled with the inability to maintain similar rates of growth in agricultural production, inevitably defeating the dual promise of economic growth and social reform. Since it has become a habit to describe many of today's doomsday forecasts as Malthusian it will be useful to examine what Malthus did in fact predict in his essay *A Summary View of the Principle of Population.*[5] This was published in 1830 as an abbreviated version of what he had already written in the 1824 supplement to *Encyclopaedia Brittanica.* According to Glass, it contains the essence of Malthus' views on population. His first essay had been published in 1798. Subsequent editions were expanded and qualified, and supporting data were added, so that ". . . the fifth and sixth editions are by no means easy reading".[6]

After examining data on population changes in Europe and the Americas, Malthus concluded ". . . it must appear that the assumption of a rate of increase such as would double the population in 25 years as representing the natural progress of population, when not checked by the difficulty of procuring the

means of subsistence or other peculiar causes of premature mortality, must be very decidedly within the truth".

He then went on to reject the possibility that agricultural production could increase at the same rate as population:

If, setting out from a tolerably well-peopled country such as England, France, Italy, or Germany, we were to suppose that by great attention to agriculture, its produce could be permanently increased every 25 years by a quantity equal to that which it at present produces, it would be allowing a rate of increase decidedly beyond any probability of realisation. The most sanguine cultivators could hardly expect that in the course of the next 200 years each farm in this country on an average would produce eight times as much food as it produces at present, and still less that this rate of increase could continue so that farms would produce 20 times as much as at present in 500 years, or 40 times in 1 000 years. Yet this would be an arithmetical progression and would fall short, beyond all comparison, of the natural increase of population in a geometrical progression, according to which the inhabitants of any country in 500 years, instead of increasing to 20 times, would increase to above a 1 000 000 times their present numbers.[7]

It is worth noting that Malthus was not above producing a shock effect by projecting exponential as against arithmetic growth well into the distant future, and thereby arriving at very large differences. Roll has argued that this helped make his theory spectacular and to draw upon it support and criticism in abundance.[8] Things have not changed since then; Forrester and Meadows use the same technique.

The third and final pillar of Malthus' argument was the assumption—based on differences between Europe and the Americas—that rates of population growth grew with income levels: ". . . The actual progress of population is, with very few exceptions, determined by the relative difficulty of procuring the means of subsistence . . ."[9] From this he concluded that economic growth, by inducing a larger population, would quickly be stunted because of the difficulty of finding sufficient food.

This dismal prediction led Malthus to question the usefulness of redistributing wealth more equitably. He readily admitted that the unequal distribution existing at that time reduced actual production well below potential production by keeping land uncultivated, among other things because of ". . . a taste for hunting and the preservation of game among the owners of the soil."[10] However, he rejected a more equitable distribution of land and wealth, because he felt that the benefits accruing in the prevailing system to the privileged few outweighed the disadvantages to the underprivileged many: ". . . By securing to a portion of society the necessary leisure for the progress of the arts and sciences, it must be allowed that a check to increase of cultivation confers on society a most signal benefit." And in any event, given the iron law of population and agriculture, reform was futile:

It makes little difference . . . whether that state of demand and supply which occasions an insufficiency of wages to the whole of the labouring classes be produced prematurely by a bad structure of society and an unfavourable distribution of wealth, or necessarily by the comparative exhaustion of the soil. The labourer feels the difficulty in the same degree, and it must have nearly the same results, from whatever cause it arises . . .

Given this framework, Malthus was, of course, opposed to income maintenance for the poor because it would increase the pressure of population.

Malthus' analysis of population and agricultural production was absorbed into the main current of economic thought, so that for Ricardo "the difficulty of providing food for an expanding population serves as the focal point for his entire analysis".[11] Capital accumulation and economic growth would lead to higher wages and then to greater population. But the diminishing returns of more extensive investment in agriculture would increase the relative price of agricultural goods. Profits would diminish because a greater proportion of national wealth would be paid in rent for the land. Wages would be reduced by the higher relative cost of food and the greater competition for employment, both induced by increased population.

Ricardo acknowledged the importance of technical progress in agriculture but, like Malthus, he did not expect it to offset the long-run trend towards diminishing returns. He also concluded that technical progress in industry was not necessarily in the interests of the labouring classes since, although such change could increase the capitalist's profit, it could also cause a permanent displacement of labour.

... the opinion entertained by the labouring class, that the employment of machinery if frequently detrimental to their interests, is not founded on prejudice and error, but is conformable to the correct principles of political economy.[12]

However, he went on to say that this would be the case only when "... improved machinery is *suddenly* discovered and extensively used; but the truth is that these discoveries are gradual ..."

And in any event, international trade and investment made opposition to technical change self-defeating:

The employment of machinery could never be safely discouraged in a state, for if a capital is not allowed to get the greatest net revenue that the use of machinery will afford here, it will be carried abroad, and this must be a much more serious discouragement to the demand for labour than the most extensive employment of machinery ...[13]

Thus all three classical economists showed important insights into the influence of technology, population, agricultural resources and capital accumulation on long-term economic growth. Smith's descriptions of the mechanisms of technical change are still pertinent today, as are Ricardo's observations on the effects of technical change on the labour force and on the role of the international economy as a stimulus to technical change. And Malthus did raise the important problem of the limits to exponential growth in a physically finite world.

Yet about the physical possibilities for sustained economic growth, Smith was vaguely pessimistic, and Malthus and Ricardo unequivocally so. Physical limits to agricultural production would inevitably be reached by the population increases induced by greater wealth. But this has not happened. Increased wealth has gone hand in hand with more birth control (a practice of which Malthus strongly disapproved) and has now resulted in lower birth, death and population growth rates in the richer countries. Agricultural production has not reached physical limits because of more extensive and intensive cultivation

and of allied technical progress. A great deal of good quality land came under cultivation in the newly colonised regions of North America, Australasia, and Russia; Malthus had dismissed this possibility as a short term palliative because ". . . the increase of population . . . would be so rapid, that, in a period comparatively short, all the good lands would be occupied, and the rate of the possible increase of food would be reduced much below the arithmetical ratio above supposed".[14] He also dismissed it because the exploitation of these regions through ". . . emigration from the more improved parts of the world . . . must involve much war and extermination". Given what happened to the American Indians, the Australian Aborigines, the Maoris and the populations on the periphery of Russia, it must be allowed that this prediction of Malthus was somewhat nearer the truth. Furthermore, his scepticism about the impact of technological progress on land yields appears at first sight to have been nearer the mark. In certain underdeveloped countries today, population pressures may well be knocking up against physical limits to land yields. But this has not happened as a result of the mechanism that he foresaw, namely, population pressures as a result of increased wealth. Rather, it has happened as a consequence of the sudden introduction of health and sanitation technologies, and is a *cause* of poverty because of the consequent reduction of the surplus available for investment.

Even in the richer countries, it can be argued that no country has managed to double its land yields every 25 years (equivalent to 2·8% *per annum*) over a long period, and that this is in line with Malthus' prediction. But, between 1880 and 1960, land yields in Denmark improved at 1·7% per year; and in four countries that Malthus would have described as "tolerably well-peopled", Denmark, France, Japan and the UK, where the possibilities for more extensive cultivation have been very limited, the growth of agricultural output more than managed to keep pace with the growth of population.[15]

Thus, a mixture of birth control, colonisation and trade, and technical progress has so far proved the classicists' predictions of physical constraints to be wrong. According to Roll, Malthus and the other classical economists fell into the same trap as many forecasters. Although they were able to discern essential characteristics of the society in which they lived and to appreciate that earlier societies had had different structures and mode of conduct, "they could not bring themselves to envisage the possibility that there might be further change in the course of time".[16]

But to predict what these changes might be is a very hazardous task. In the early 19th century, the full possibilities of more extensive cultivation or of technical change were hardly known. Barber has argued that the classical economists had little reason to anticipate a radical transformation and that, if Britain had escaped the Malthusian trap in the 19th century, Ireland certainly had not done so.[17] However, some economists would disagree with Barber, and argue that colonial exploitation of Ireland by England was the root cause of famine and large-scale emigration from Ireland.

On the other hand, perhaps Malthus could have foreseen, on the basis of the evidence available to him, that higher living standards did not inevitably lead to greater population growth. In his *Principles of Political Economy*, he did eventually concede that higher wages could lead to higher birth rates or to

higher living standards.[18] And in his 1830 essay he observed the contrast between ancient and contemporary Europe, and between Europe and other parts of the world, and concluded that "as civilisation and improvement have advanced", so "prudential restraint in marriage" tended to replace "plagues, famines and mortal epidemics" as the principal means of checking the growth of population.[19] He also considered data which showed that more "healthy" communities with death rates at a lower-than-average level also had lower-than-average birth rates.[20] In other words, death rates were negatively correlated with "healthiness", and "prudential restraint" was a function of "civilisation and improvement", adjusting birth rates downwards as death rates decreased.

But Malthus did not make the further jump and examine the consequences of assuming that "healthiness" and "civilisation and improvement" were themselves a function of greater wealth and higher wages. Perhaps there was no empirical justification for entertaining such a speculation in Malthus' time. He was of the opinion that large towns "are known to be unfavourable to health, particularly to the health of young children,"[21] and he may have been right. But perhaps he was unwilling to consider the possibility simply because it would have struck the foundation of his whole intellectual construct. Such sins have been committed by many other great thinkers, so one might be tempted to let the matter rest there. But there is one other important element. Malthus' work can be seen as an elaborate rationalisation of the interests of the class to which he belonged, namely the landed gentry.

Joan Robinson has said that no-one is conscious of his own ideology, any more than he can smell his own breath. Be that as it may, Roll has a pretty clear idea of how Malthus' ideological breath smelt. He sees Malthus' theories and policy recommendations—from protectionism to complacency about the public debt—as an attempt to find a secure place for landed interests in a society increasingly dominated by capitalism; but although Malthus was a reactionary, he did show great insight into what was to become one of the major problems of an industrialised economy—maintaining the level of aggregate demand and avoiding unemployment.[22]

In relation to social forecasting and public policy one must, however, be less indulgent. The empirical data available to him on population could, as we have seen, have been interpreted differently and have led to an entirely different prediction about the course of future events. His contribution to the notion of effective demand was ignored by policy-makers until it was dug up again by Keynes a hundred years later. Some would argue that Malthus' effect on contemporary and ensuing events was not very great and that none of his policies eventually succeeded in taking hold in the industrially advanced countries.[23] On the positive side, his predictions did succeed in bringing into existence the beginnings of the birth control movement but it is unlikely that they stimulated the mechanical, chemical and social inventions that were to revolutionise agriculture. On the negative side, they did give a rationale to the more stringent and inhumane policies that were introduced to deal with the poor. According to Beales:

The *Essay on Population* was a godsend to the conservative and frightened people who feared the spread in England of French revolutionary ideas and behaviour . . .

The quiet philosopher had laid down the missing half of the ideological foundations of economic liberalism (that is, social conservatism) . . . he had driven such proposals as that of Whitbread (1796) for a national minimum wage out of the arena of significant discussion; he had made impossible such safety-valve flirtations with sentimentalism as Pitt's Poor Law reform project (1796). He had found the magic word which enabled people to see daylight at the far end of the grim and threatening forest of "proletarian" revolution—and his generation may be forgiven their fears, for their memories included, as well as the terrifying Gordon Riots (1780), the agrarian troubles at the end of the wars (1815–1816); the "last labourers' revolt" (1830) . . . and the portentous Luddite disturbances in the new industrial regions . . . [24]

Are today's doomsday forecasts similarly related to the interests of privileged minority groups and will they have similarly regressive effects? The question naturally poses itself and we shall return to it briefly in the concluding section of this chapter.

Marx

Marx also had very strong and clear views on what Malthus was up to:
The hatred of the English working class against Malthus—the "mountebank-parson" as Cobbett rudely calls him—is therefore entirely justified. The people were right here in sensing instinctively that they were confronted not with a *man of science* but with a *bought advocate*, a pleader on behalf of their enemies, a shameless sycophant of the ruling classes.[25]

Marx rejected Malthus' population law, arguing that population pressures were not universal throughout space and time but that capitalism created the appearance of a redundant population. He also rejected diminishing returns in industry and agriculture because of the tremendous technological dynamism that he detected in the capitalist system. Even without these two essential assumptions of the classical economists, his conclusions were to some extent the same as theirs. He foresaw a falling rate of profit and wages driven down to subsistence. But he disagreed with them on both causes and consequences: the cause was not inherent physical limits but faults in social organisation inherent in the capitalist system; and the result would not be a genteel, equilibrium poverty but the overthrow of the capitalist system. Whereas for the classical economists the pace of technological progress would not be rapid enough to forestall long-run diminishing returns, for Marx "the enticement of ever-improving technology leads the capitalist class to its eventual doom".[26]

Stated briefly, Marx's reasoning ran as follows. It was conceivable that the real wages of the labouring class could increase through capital accumulation with technology remaining unchanged. But the capitalist's drive to increase his profit in a competitive situation would lead him to develop and introduce technology which increased labour productivity considerably, while also substituting machinery for labour and reducing the total demand for the latter; in other words, Marx accepted Ricardo's "strong" or "pessimistic" case on the effects of introducing machinery, cited above. This dynamic process of competition and technological change would, therefore, increase the rate of unemployment and drive wages down to subsistence levels. It would also increase the degree of concentration of capital. The rate of profit would ultimately drop because technological change would increase "the organic

composition of capital" (ie, the ratio of expenditure on machinery to that on wages). At the same time, given the increasing concentration of wealth, the growing capacity of production would find itself at variance with the purchasing powers of consumers.

It is impossible to make any short assessment of the impact and the accuracy of Marx's predictions. All would agree that moral outrage at what he saw of the excesses of industrialisation was an important driving force in his work. All would agree that the social and political impact of his analysis has been enormous, of a completely different order of magnitude to that of almost all other economists. To say that contemporary society can be seen as a battle of groups trying to prove his predictions right or wrong would be a gross oversimplification but. sometimes an operationally useful one. And, as Barber has pointed out, even "non-" or "anti-" Marxists have inevitably been influenced by his insights:

Whatever the deficiencies of Marx's single-minded deterministic account of the economic and social process, it had the clear merit of shaking the mood of confidence and self-congratulation about the consequences of economic progress that had settled over much Western thought by the middle of the 19th century.[27]

Furthermore, Marx saw more clearly than many of his predecessors the great power of technology to transform the material and social base of industry, agriculture, and indeed the whole of society. And *Capital* contains a painstaking description of the process of technological change in the middle of the 19th century.

As to the accuracy of his analysis, Joan Robinson has shown that it does not necessarily follow that the "rising organic composition of capital" leads to a lower rate of profit; and that, if it does, then the wages of employed labour would be increasing, in contradiction with another of Marx's major predictions.[28] She also rejects it on empirical grounds:

It is true that physical capital per man, measured in horsepower or tons of steel, is raised by modern technology but, since output per head can rise just as fast in producing capital equipment as in using it, there is no necessary reason why the value of capital per man, in Marx's sense, should increase; in recent times it seems, if anything, to have been falling.[29]

Furthermore, wages have not been driven down to subsistence in the capitalist economies; they have remained a more or less constant share of continually increasing material wealth. Some later economists, notably Lenin, most of whom had strong Marxian roots, explained the non-appearance of crises through colonial exploitation, namely, the annexation by the capitalist powers of colonial territories and consequent trade and investment with them. This was not the first time that the importance of foreign trade to the industrialising powers had been mentioned and stressed. Smith and Ricardo had advocated its beneficial effects for these countries, and Ricardo saw foreign trade as a means for Britain to avoid the Malthusian trap of diminishing returns in agriculture. But it was now argued that colonial exploitation, and in particular the great spate of colonial annexation at the end of the 19th century mainly in Africa, was the reason why the capitalist states had not reached the crisis state.

Objections have been raised to this hypothesis. First, investment and trade

with the newly annexed territories were never very significant to the colonial powers; trade followed effective demand rather than the flag and there was never much of the former in the colonies. Second, an equally plausible, alternative explanation can be offered of late 19th century colonisation which depends not on the contradictions of capitalist production but on the geopolitical situation existing in Europe at that time. These objections do not necessarily deny the fact of imperialism nor that the surplus from colonial investment and trade benefited growth in the industrialised countries to the detriment of the growth of the colonies. They do question the thesis that colonisation was the inevitable consequence of capitalist production and that continued capitalist development depended on the colonial annexations of the late 19th century.

And after

After the classical economists and Marx, the "magnificently bold" approach to try to understand the factors behind long-term economic growth faded. As Meier and Baldwin have said:

The reasons . . . are not hard to discover. By this time, the significance of the great 19th century technological and resource discoveries were apparent to all. . . Real wages were considerably above the subsistence level, the rate of profit was high, and rents did not constitute an alarming share of national income. In short, the fear of a stationary state with subsistence wages ceased to be a matter of general, current interest . . .
. . . changes in the so-called "heavy" variables, ie, population, the capital stock, and technology, which affect the rate of change in national income, appeared to be determined to a large extent by forces considered outside the realm of economics . . . Neo-classical economists turned their attention to shorter-run problems . . .[30]

For the neo-classicists, changes in population, technology and resources were steady and incremental. Marshall, for example, took a very different view from Schumpeter about the role of the entrepreneur and of technological change in economic development. For Schumpeter, the entrepreneur was a key factor in economic development and technological change caused great upheavals. For Marshall the entrepreneur's role was exaggerated and technological change was a gradual process.[31]

This optimism and faith in invisible hands to take care of population, resources and technology did not, however, stop neo-classical economists from being bitten from time to time by neo-Malthusian bugs. Both Marshall and Wicksell echoed Ricardo's earlier fears by suggesting that population growth and concentration in Europe could lead to huge increases in land rents and to eventual economic stagnation. Prior to the great depression of the 1930's Keynes, too, took a Malthusian position on population. Thereafter, the focus of social concern was no longer the possible physical limits to growth but exactly the obverse problem, whether and how the level of demand could be made to match productive capacity and thereby avoid mass unemployment. Keynes revised his position and in 1937 wrote: ". . . We have now learned that we have another devil at our elbow at least as fierce as the Malthusian— namely the devil of unemployment escaping through the breakdown of effective demand. Perhaps we could call this devil too a Malthusian devil, since it was

Malthus himself who first told us about him. . . . Now when Malthusian devil P is chained up, Malthusian devil U is liable to break loose. When devil P of Population is chained up, we are free of one menace; but we are more exposed to the other devil U of Unemployed Resources than we were before."[32]

As a consequence, Hansen and others explored in the 1940's and 1950's the possibilities of stagnation in economic growth due to the closing of frontiers, a slowdown in technical progress, and . . . inadequate growth in population. However, Joan Robinson—a disciple of Keynes—has little sympathy for these "neo-stagnationists". She calls them "vulgar Keynesians" and argues that, if profitable investment opportunities do vanish because of the satisfaction of all useful demands, then it might be bad for capitalists looking for profit but that it would nonetheless be the advent of an age when ". . . saving would have become unnecessary, high real wages would have reduced that rate of profit to vanishing point, and technical progress could be directed to lightening toil and increasing leisure . . ."[33]

And so the focus of concern as to possible hindrances to continued economic growth tended to shift from the preoccupation with physical limits of Malthus, Ricardo and the early Keynes to Marx's and the later Keynes' discussion of social, economic and political defects. There was also a continuing debate on the desirability of economic growth, and it is to this that we shall now turn.

Is growth desirable?

Economists have no special authority in their professional capacity to say whether or not economic growth is a good thing or what patterns of growth should be chosen. Beckerman has pointed out recently that economists can have authoritative views on the relationships between economic growth and other parameters; and they can also advise on whether certain economic choices are good or bad for the chooser. But "no question involving choice, whether between growth and happiness, or between roads and schools or between apples and pears, can be answered without reference to a value system . . . and no amount of knowledge of the positive technical relation between the alternatives . . . provides the economist with any objective or special insight into what is a "good" preference pattern."[34] Nonetheless, the economists' professional activities have naturally led them more often than most people to ask questions about the desirability of economic growth and to give their personal answers to these questions. Some of these answers we shall now review.

For most of the 19th century economists, economic growth was a good thing. Smith and Ricardo agreed that:

The desire for food is limited in every man by the narrow capacity of his stomach, but the desire for the conveniences and ornaments of building, dress, equipage, and household furniture, seems to have no limit or certain boundary.[35]

The main debates in the first half of the 19th century were not then about whether economic growth should continue but about how its fruits should be divided amongst landlords, capitalists and workers. As we have seen, Malthus was concerned that the status of the landlords should not be eroded. Ricardo,

on the other hand, was concerned that the landlord would get a greater share of the surplus, at the expense of the capitalist class which he considered instrumental to economic growth; hence his advocacy of the abolition of the Corn Laws and the large-scale importation of foreign food. Marx predicted that an increasing concentration of wealth in the hands of ever-fewer capitalists would lead to the overthrow of the system by impoverished workers, but he regarded an economy of abundance for all as the goal for mankind.

Some doubters

There were, however, dissenting views about the desirability of economic growth in the 19th century. Sismondi (1773–1824) was one of the early socialist critics of the suffering caused by industrialisation. He rejected the essential harmony of interests amongst the social classes in promoting economic growth. He laid some of the foundations for Marx's later analysis of the progressive concentration of wealth and the consequent imbalance between supply and demand. But, unlike Marx, he did not see the resolution of the problems through communist revolution and "modern industry". Roll's account of Sismondi's solution shows that it was not very different from that suggested by certain contemporary opponents of economic growth:

He rejected communism, because he was too great a believer in the importance of private interests. He rejected feudalism, too, because he regarded it as a restriction of the productive powers of mankind. But his policy did in the end amount to a return to more primitive conditions. He defined the aim of policy as the reunion of property and labour and the re-establishment of equilibrium between production and consumption . . . Sismondi wanted to see a revival of the independent producer, the small farmer and the artisan. Pending this return to the golden age it should be the task of government to prevent the increase in disequilibrium. This could best be done by slackening industrial progress. Government should, above all, put a brake on invention and aim at having such a rate of progress that the necessary adjustments could be made smoothly and without causing overproduction and misery.[36]

John Stuart Mill looked forward to the stationary state with equanimity and even impatience:

It is scarcely necessary to remark that a stationary condition of capital and population implies no stationary state of human improvement. There would be as much scope as ever for all kinds of mental culture, and moral and social progress; as much room for improving the Art of Living, and much more likelihood of its being improved, when minds ceased to be engrossed by the art of getting on.[37]

This passage from Mill's *Principles of Political Economy* has been cited to support the desirability of the stationary state by Meadows and his colleagues in *The Limits to Growth* (page 175)—except that Mill's last phrase ". . . when minds ceased to be engrossed by the art of getting on" was left out. The point is not unimportant. Mill's reservations about the benefits of economic growth had clearly been magnified by what he had seen of the "art of getting on" in the USA:

I must confess I am not charmed with the ideal of life held out by those who think that the normal state of human beings is that of struggling to get on; that the trampling, crushing, elbowing, and treading on each other's heels, which form the existing

type of social life, are the most desirable lot of human kind, or anything but the disagreeable symptoms of one of the phases of industrial progress. The northern and middle state of America are a specimen of this stage of civilisation in very favourable circumstances; having apparently got rid of all social injustices and inequalities that affect persons of Caucasian race and of the male sex . . . all that these advantages seem to have yet done for them (notwithstanding some incipient signs of a better tendency) is that the life of one sex is devoted to dollar-hunting, and of the other to breeding dollar-hunters.[38]

It could be argued that these characteristics do not necessarily result from the process of economic growth but from the particular institutions, values and history of the USA. De Tocqueville, who was Mill's contemporary, warned against generalising from the USA to all modernising countries:

The position of the Americans is therefore quite exceptional, and it may be believed that no democratic people will ever be placed in a similar one. Their strictly Puritanical origin—their exclusively commercial habits—even the country they inhabit, which seems to divert their minds from the pursuit of science, literature, and the arts . . . a thousand special causes, of which I have only been able to point out the most important—have singularly concurred to fix the mind of the American upon purely practical objects. His passions, his wants, his education, and everything about him seem to unite in drawing the native of the United States earthward: his religion alone bids him turn, from time to time, a transient and distracted glance to heaven. Let us cease then to view all democratic nations under the mask of the American people, and let us attempt to survey them at length with their own proper features . . .[39]

And more recently, Schumpeter—another European—suggested an additional important difference between the USA and Europe:

The bureaucracies of Europe are of pre- and extra-capitalist origin. However, much they may have changed in composition as the centuries rolled on, they never identified themselves wholly with the bourgeoisie, its interests or its scheme of values, and never saw much more in it than an asset to be managed in the interest of the monarch or of the nation.[40]

If Schumpeter is right, this might serve to reinforce those who believe that Europe has on the whole been more successful than the USA in dealing with the harmful side-effects of economic growth. It also suggests that Forrester and Meadows might have directed at least some of their attention to the specific circumstances of "American Dynamics" as well as to those of the world.

Mill, like Malthus before him, also showed an aristocratic concern for enjoying amenity and environment without disturbance by others.

The density of population necessary to enable mankind to obtain, in the greatest degree, all the advantages of co-operation and social intercourse, has, in all the more populous countries, been attained. A population may be too crowded, though all be amply supplied with food and raiment . . . Solitude, in the sense of being often alone, is essential to any depth of meditation or of character; and solitude in the presence of natural beauty and grandeur is the cradle of thoughts and aspirations which are not only good for the individual, but which society could do ill without.[41]

But Mill was perfectly clear that economic growth was a necessary—if, for his refined tastes, a rather distasteful—process through which society should go before reaching its blissful, stationary state:

That the energies of mankind should be kept in employment by the struggle for riches, as they were formerly by the struggle for war, until the better minds succeed in educating the others into better things, is undoubtedly more desirable than that they should rust and stagnate. While minds are coarse they require coarse stimuli, and let them have them.

. . . society would exhibit these leading features: a well paid and affluent body of labourers: no enormous fortunes, except what were earned and accumulated during a single lifetime; but a much larger body of persons than at present, not only exempt from the coarser toils, but with sufficient leisure, both physical and mental, from mechanical details, to cultivate freely the graces of life, and afford examples of them to the classes less favourably circumstanced for their growth. This condition of society, so greatly preferable to the present, is not only perfectly compatible with the stationary state, but, it would seem, more naturally allied with that state than with any other.[42]

Transition to abundance

Eighty years after Mill, Keynes addressed himself to the same problem but did not see the ideal, stationary state happening for yet another 100 years, at which time:

. . . man will be faced with his real, his permanent problem—how to use his freedom from pressing economic cares, how to occupy the leisure, which science and compound interest will have won for him, to live wisely and agreeably and well . . .

We shall be able to rid ourselves of many of the pseudo-moral principles which have hag-ridden us for 200 years, . . . The love of money as a possession—as distinguished from the love of money as a means to the enjoyments and realities of life—will be recognised for what it is, a somewhat disgusting morbidity . . .

I see us free, therefore, to return to some of the sure and certain principles of religion and traditional virtue—that avarice is a vice, that the exaction of usury is a misdemeanour, and the love of money is detestable, that those walk most truly in the paths of virtue and sane wisdom who take least thought for the morrow . . .

But, of course, it will all happen gradually . . . The course of affairs will simply be that there will be ever larger and larger classes and groups of people from whom problems of economic necessity have been practically removed. The critical difference will be realised when this condition has become so general that the nature of one's duty to one's neighbour is changed. For it will remain reasonable to be economically purposive for others after it has ceased to be reasonable for oneself.

The *pace* at which we can reach our destination of economic bliss will be governed by four things—our power to control population, our determination to avoid wars and civil dissensions, our willingness to entrust to science the direction of those matters which are properly the concern of science, and the rate of accumulation as fixed by the margin between our production and our consumption . . . [43]

Schumpeter was more gloomy than Keynes about this eventual transition. This reflected in part his greater sympathy for what he considered to be the prime mover in economic growth and welfare, namely the entrepreneurial capitalist, for, on the arrival of the stationary state; ". . . the management of industry and trade would become a matter of current administration, and the personnel would unavoidably acquire the characteristics of a bureaucracy . . . Other than economic pursuits would attract the brains and provide the adventure."[44] Even before then the risks and rewards associated with entrepreneur-

ship and innovation would tend to diminish: "... It is much easier now than it has been in the past to do things that lie outside familiar routine—innovation itself is being reduced to routine. The romance of earlier commercial adventure is rapidly wearing away, because so many more things can be strictly calculated that had of old to be visualised in a flash of genius".[45] For many contemporary writers, this prediction of Schumpeter has come true, with the emergence of the giant corporation and the "techno-structure". However, although giant corporations certainly reduce the effects of failure of any particular innovation, the chance of failure (ie, the level of unpredictability) in technological innovation today is still very high.

Furthermore, Schumpeter had been brought up in the turmoils of central Europe, not like Keynes who had lived among the Whiggish certainties of Cambridge before the First World War. He thought that the transition to "equilibrium" would be much less smooth and more ridden with conflict than Keynes would have us believe:

... the ever-rising standard of life and particularly the leisure that modern capitalism provides for the fully employed workman . . . well, there is no need for me to finish the sentence or to elaborate one of the tritest, oldest and most stodgy of all arguments which unfortunately is but too true. Secular improvement that is taken for granted and coupled with individual insecurity that is acutely resented is of course the best recipe for breeding social unrest.[46]

"Intellectuals" would play a key role in exploiting this unrest. Schumpeter defines intellectuals as "people who wield the power of the spoken and the written word, and one of the touches that distinguish them from other people who do the same is the absence of direct responsibility for practical affairs". Members of the liberal professions are defined as intellectuals insofar as "they talk or write about subjects outside their professional competence which no doubt they often do . . ."

According to Schumpeter, the very great expansion of higher education in the later stages of capitalist development increases the potential size of the "intellectual" group. It also increases un- and under-employment among university graduates, and:

They swell the host of intellectuals . . . in a thoroughly discontented frame of mind. Discontent breeds resentment. And it often rationalises itself into that social criticism which is . . . the intellectual spectator's typical attitude toward men, classes and institutions especially in a rationalist and utilitarian civilization . . .
Of course, the hostility of the intellectual group—amounting to moral disapproval of the capitalist order—is one thing, and the general hostile atmosphere which surrounds the capitalist engine is another thing. The latter is the really significant phenomenon; and it is not simply the product of the former but flows partly from independent sources . . .[47]

The ultimate result would be "socialism", which might happen through anything from "a gradual bureaucratisation" to "the most picturesque revolution."[48]

Abundance and underdevelopment

Since the Second World War, economists' views on economic growth have been influenced by two significant changes. First, in the rich capitalist countries,

Keynesian counter-cyclical policies to maintain a resonably steady rate of economic growth have been accepted; second, there has been widespread recognition in the rich countries that two-thirds of the world's population has generally enjoyed much smaller increases in *per capita* income. In 1954, a dozen years after Schumpeter, W. Arthur Lewis asked the question "Is economic growth desirable?" in the Appendix to his book, *The Theory of Economic Growth*. His main conclusions are pertinent to the current debate about growth, and although—like Keynes and Schumpeter before him—Lewis is a member of an intellectual élite, he happens to be black and to have made the problems of the underdeveloped countries the starting point for many of his theoretical analyses.

For Lewis, the "advantage of economic growth is not that wealth increases happiness but that it increases the range of human choice". In addition, it reduces physical servitude, increases leisure and reduces vulnerability to famine and disease. It also increases appreciation of the arts, frees women from drudgery and "permits mankind to indulge in the luxury of greater humanitarianism".[49]

However, Lewis is sceptical whether growth leads to greater political stability. He concedes that it makes distributional problems easier to deal with but notes that it "may . . . have the effect of disturbing stable social relationships, of stimulating envy and desire, and of precipitating class, racial or religious conflict". He is also doubtful if great differences in wealth between countries provoke war and if the world would be nearer to peace if there were not wide disparities in standards of living: "Societies which are undergoing rapid economic growth are often tempted to fall upon their neighbours".

As to the effects of economic growth on resource depletion, he suspects that technical change will deal with the problem and that, if it does not, "It may be taken as a counsel to Europe and North America to stop raising their standards of living any further, but it is much less forceful as counsel to Asians and Africans, whose current draft on accumulated reserves is so small, to continue in their present poverty".

He notes but is not convinced by the argument that economic growth is harmful because it increases specialisation and scale. He suggests that economic growth depends on some inequality of income "since growth would be small or negative if differential awards were not available for hard work, for conscientious work, for skill, for responsibility and for initiative". He also feels that "some of the alleged costs of economic growth are not necessary consequences of growth at all—the ugliness of towns or the impoverishment of the working classes, for instance . . . some of the alleged evils are not intrinsically evil—the growth of individualism, or of reasoning, or of towns, for example. As in all human life, such things can be taken to excess, but they are not intrinsically less desirable than their opposites. From this it follows, however . . . that the rate of economic growth can be too high for the health of society. Economic growth is only one good thing among many, and we can take it to excess."

On the problems of transforming traditional societies to those capable of sustained economic growth, Lewis points out that: "Painful transitions are inherent in the transformation of a society from one way of life to another; they cannot be altogether avoided except by avoiding change itself . . ." But he concludes that: "In practice, we have no opportunity to choose retardation.

The leaven of economic change is already working in every society . . . thanks to the linkage of the world that has been achieved in the past 80 years by steamships, by imperialism, by aeroplanes, by wireless, by migration, by Hollywood and by the printed word. There have, in particular, been two developments which make it imperative not to retard but to accelerate further growth. One of these is the fact that aspirations have grown faster than production. And the other is that death rates are falling faster than birth rates." On this latter change, Lewis concludes that ". . . those who argue for retardation have usually overlooked what is happening to population, and have forgotten that the consequence of a population explosion may be much more damaging to existing social structures and moral codes than the consequence of any likely increase in production would be".

However, for contemporary critics of capitalism and of neo-colonialist exploitation, it is the very nature of what Lewis calls the "linkage of the world" which, together with the patterns of growth in the advanced countries, causes the "development of underdevelopment" in the poor countries.

For Baran and Sweezy, the trend in the advanced capitalist societies is no longer that of a falling rate of profit.[50] According to them, Marx made his prediction when competitive conditions existed in capitalist societies. But now, in conditions of "monopoly capitalism", where producers are few and big enough to fix market conditions, there is the tendency for the gap between productive potential and socially necessary consumption to grow. This gap has been filled by "wasteful" expenditures inherent in the capitalist system such as accelerated obsolescence, the stimulation of unnecessary or "luxury" consumption and growing expenditure by government. Within this increase, that of expenditures on armaments has been the most significant and has served not only to stimulate effective demand and reduce unemployment but to defend American industry's ever-growing foreign investments. Harry Magdoff emphasises the growing dependence of the American economy on raw materials, including "strategic" materials, from foreign sources as one of the main driving forces behind what he describes as US imperialism.[51]

However, the transfer of American funds abroad for investment purposes does not help to reduce the gap between productive potential in the USA and effective demand, since the funds repatriated to the USA are larger in volume: "Foreign investment must be looked upon as a method of pumping surplus out of the underdeveloped areas, not as a channel through which surplus is directed into them." Indeed, for Furtado and Frank[52] the "development of underdevelopment" in the poor countries is a direct consequence of the pattern of flows between them and the rich countries in trade, investment and technology, and of the political, social and structural conditions thereby created.

In spite of the variations in emphasis, analysis and conclusion among such contemporary critics of the existing order, they do have essential features in common: they see the dynamics of the development of the world as a whole; they are hostile to the present patterns of growth in the rich, capitalist countries; and they propose radical change. In these respects, they are similar to the authors of *World Dynamics* and of *The Limits to Growth*. But there the resemblance ends. Unlike the authors from MIT, they *do* have a "two world" model, with an

explicit set of relations worked out between the two parts and different internal mechanisms within each part; and they see the fundamental problem as one of social organisation rather than of physical limits.

Forrester and Meadows in context

In the light of what has been said in the past about the feasibility and desirability of economic growth, what can one say about the scope, structure and assumptions of Forrester's and Meadows' models? About the reasons for their very considerable impact on the public? And about the influence that they may have on the future course of events? It is to these three questions that this conclusion will address itself.

First, it is necessary to repeat that the debate on the feasibility and the desirability of economic growth is not new. It goes back even beyond the beginning of the 19th century when the classical economists enquired into the physical feasibility of growth. As time went on and growth and technical progress continued so the concern shifted from whether growth was feasible to whether it could be sustained with existing political and financial institutions and to whether it was worth it anyway.

The models in *World Dynamics* and *The Limits to Growth* are part of a revival of interest in the preoccupations of the classical economists, and are closest to those of Malthus and Ricardo. Exactly the same parameters are explored except that Forrester and Meadows have added the new physical constraint of environmental/ecological balance. In all cases, growth is seen to be impossible because of physical limits and whether and when "catastrophe" happens is rigidly determined by these limits. It is not like Marx's model, where "catastrophe" had social causes and social remedies.

Although Forrester and Meadows assume continuous and steady technical progress in industry, they also assume diminishing returns to investment in agriculture and other natural resources and no continuous improvement in anti-pollution technology. Given these assumptions, they arrive at conclusions that are virtually the same as those of Malthus and Ricardo, that growth will be stopped because of depletion of natural resources, asphyxiation through pollution, or the draining of capital investment into an ever less productive agricultural sector—this last mode of collapse being exactly the same as Ricardo described without the aid of a computer some 150 years ago. That it has not yet happened is in part because Malthus and Ricardo underestimated technical progress in agriculture, just as Marx underestimated technical progress in capital goods. Cole and Curnow have shown in Chapter 9 that, by building technical progress in natural resources, pollution and agriculture into both Meadows' and Forrester's models at rates that have been achieved historically for large parts of the world, all modes of "collapse" are avoided. In other words, one could argue that there will not be a crisis of the form described in the models, if historical trends do continue.

This does not mean, of course, that these historical trends will in fact continue. The continuous rise in productivity in capital goods and agriculture since the 19th century did not happen without considerable social change, and similar changes—social and political as well as technical—may be necessary

in future to deal with the requirements for, say, food and the reduction of pollution. Furthermore, there may be historical discontinuities.

Even if the models' assumptions do prove to be wrong, we may still reach physical limits through mechanisms that are not discussed in the models. For example, resources may not be allocated to investment in agriculture, pollution or natural resources in a manner best suited to avoid these limits, either locally or on a world-wide basis; social and political change may push us to limits in a manner that we have not yet imagined or recognised; and we are still quite capable of blowing ourselves up with nuclear bombs.

All that one can safely conclude is the following: the combination of what Keynes called "science and compound interest" has been and perhaps will be, instrumental in transforming things by degrees over long periods of time into states that are very difficult to imagine now. In the short term, Marshall was right about the incremental nature of technical change; in the long-term, Schumpeter was right about its revolutionary effects.

This at least offers one possible explanation for the scepticism of economists towards the present fears about the limits to growth in general and the MIT models in particular. Mishan attributes this scepticism to economists' worship of "growth for growth's sake". A reading of what some eminent economists have said above suggests that this is too sweeping a simplification. There is perhaps another reason. Economists are more aware than most others that similarly pessimistic predictions about physical limits have been made in the past and have turned out to be wrong. Given their experience with short-term econometric model-building, they are also aware that economic models—even when on a computer—have very severe limitations, are not very good at catching turning points, can be unnecessarily "sophisticated" and should not be advanced for policy purposes before thorough validation.

But why, then, the tremendous public impact of these contemporary dooms-day models? Earlier in this chapter it was noted that the original Malthusian concern with physical limits was allied to the interests of economically privileged groups. It is therefore legitimate to ask whether the same might not be true today. It is clear that the physical environment in factories and in areas where those who work in factories live and play obviously could benefit from improvement. One could argue, nonetheless, that it is not these problems that have been the focus of the environmentalists' concerns, which instead have often tended to concentrate on the natural rather than the urban environment, and on the environmental problems of leisure and amenity rather than on the environment of the work place.

More generally, some contemporary economists have argued that the movement hostile to economic growth can be seen as supporting the interests of the materially well-off, who find that life is less pleasant for them when an ever larger number of people begin to approach the same living standards as their own and, in particular, when they start using the same, scarce infrastructure.

Wilfred Beckerman has warned that "if we are concerned with the welfare of the population as a whole we need to be sure that we are not attributing to the population as a whole a system of preferences that is, in fact, owned only by a minority".[53] He thinks that this is the case when he examines what Mishan

considers to be the external diseconomies of air travel. According to Mishan, this causes not only noise and pollution but also leads to overcrowding and ugliness in what had hitherto been quiet and pleasant holiday resorts. Beckerman agrees that ". . . all this may well be true but to propose, as Mishan does, an international ban on all air travel cannot be justified on these grounds alone. It may be perfectly feasible for a small 'élite' to make their way slowly to Delphi by road and mule, but for the average American secretary or Lancashire textile worker, with only 2 weeks' paid holiday, it is quite out of the question. To presume that the benefits obtained by thousands or millions of such people from their packaged tours . . . would be less than the loss incurred by a much smaller number of people on account of the disruption of their solitude is either a reflection of a value judgement or an unsubstantiated guess . . . I suspect that it is the former and that the presumption reflects what many of Mishan's disciples would describe as 'bourgeois' values, namely those of the middle class, middle aged, with enough time and money to go a little way off the beaten track but not quite rich enough to be protected from the masses on their yachts or private islands."[54]

This is not to argue that there is no ground for concern about the problems of the natural environment, nor that the present patterns of economic growth are the right ones. Nor is it to suggest that all parts of the environment movement are the natural allies of the well-off; radical political movements have clearly played an important role.[55] Nor again is it to suggest that all materially well-off environmentalists are concerned only with their personal interests. It is simply to say that, in the movements to improve the environment and to stop economic growth, there may often be some confusion between the general interest and the interests of a specific, materially well-off group, and that Forrester and Meadows make some appeal to this group.

There is one fundamental difference between the original Malthusians and their modern counterparts. The former was a group diminishing in size and power while the latter is increasing. As long as growth does continue, the neo-Malthusians are bound to increase in number and to be right about the end of economic growth sometime in the future. In the industrially advanced countries, this should be relatively soon. In a recent piece of pop futurology, Norman Macrae made the point that ". . . even the average growth rate of just over $4\frac{1}{4}$% *per annum* in gross national products in the 1960's would enable world GNP to grow to thirty-two times its present level in the next 80 years—and thus give today's richest country, America, an average family income of around $250 000 by early in the second half of the 21st century, at a date when many of today's children will still be alive. As we get anywhere near to that living standard people will rightly come to regard purely economic issues as pretty trivial . . ."[56]

For the rich countries, then, at what point and how should the stationary state come about, and what should it be like? To these questions, the responses of past economists are not very helpful because they are so different. J. S. Mill would surely have disapproved of Keynes' hedonistic utopia—and Schumpeter did not like the whole business of the stationary state at all. Mill and Keynes might have agreed on the eventual desirability of a stable state, but Mill thought it should happen around 1860, whereas Keynes did not see it coming

about before the year 2000. This is a very large gap indeed. No doubt it reflects the greater aspirations and power of the working class when Keynes was writing than when Mill set down his somewhat aristocratic views. It might also reflect the invention of durable consumer goods which happened during the intervening period. For some, the widespread use of these inventions helped liberate millions of people from physical drudgery. For others, the production and consumption that they induced can be attributed to "want-creation". But would not a middle-class reaction against growth suggest that diminishing returns are beginning in the want-creation business? And, if this is the case, and when imitating one's "betters" means being more concerned about the environment than about buying another consumer durable, does "emulation", "trickle-down", and "keeping up with the Joneses" suddenly and miraculously become transformed from a "bad thing" to a "good thing"?

Certainly, it would be easy to overestimate the influence that Forrester's and Meadows' models will have on the course of events. It can also be argued that these models are only tentative first attempts and that—even if the models' structure/assumptions/conclusions/policy implications are open to serious reservations—they have at least opened a debate on a major issue. However, people tend to believe predictions and their conclusions and policy recommendations tend to creep into the collective psyche—a tendency that Forrester and Meadows (methodological *mea culpa* notwithstanding) have done little to discourage. We have seen that today's Malthusianism can be viewed as in the interests of the materially well-off in the rich countries. It may also have the effect of giving the rich countries a clear conscience about their selfish behaviour towards the poor.

A recent issue of the *IDS Bulletin* looked at the likely implications for the under-developed countries of the current concerns about the environment and population.[57] The conclusions were pessimistic. Concern for the environment in the rich countries will justify restrictions on the kind of technology supplied through aid: "There are reports that US aid agencies will bar shipments of pesticides which are subject to domestic regulation in the USA. It may become difficult to obtain DDT for those purposes where there is no better alternative."[58] It will justify similar restrictions on imports from poor, "cheap environment" countries: "In 1969 . . . the Peruvian and Philippine tuna fishing industries were struck crippling blows by the revision of official US standards on mercury content of tuna fish."[59] And it will sanctify the reduction of aid because it will be argued that, given physical limits, aid is harmful and that the money could be better spent in cleaning up the environment at home. At the same time, slower economic growth in the advanced countries would reduce the demand for the poor countries' raw materials and slow down financial aid. Lipton concludes: "The young people who 10 years ago spent their time and energy working for the alleviation of gross poverty, at home as well as in poor countries, are more concerning themselves with traffic congestion, smoke pollution and clean bathing water in their own backyards . . . The Third World—now (as always) in much greater danger from being ignored than from being exploited— suffers increasing neglect, while those who should be organizing and informing our concern for it are instead copperplating their navels".[60]

And perhaps the models will do other disservices. They lump together the

problems of the poor and the rich; yet the population problem in Bangladesh is very different from that of the Netherlands; and the problem of air pollution in Tokyo derives from very different social mechanisms than the mismanagement of the use of pesticides in Ceylon. This paper suggests that the more important debate about the economic, political and moral problems of using the world's resources in a more equitable and effective manner is being relegated to a debate about physical limits. How could the economic resources at present being mobilised in the rich countries for armaments be diverted to the problems of the underdeveloped countries? Would a natural resource shortage—real or imagined—increase the temptation for more imperialism? If the shortage is real, will the rich countries use up the cheap, available stocks and make the problems of the underdeveloped countries that much more difficult? If the shortage is imaginary, will the advanced countries nonetheless develop recycling and substitution technologies and thereby turn the terms of trade even more against the poor countries? Does the USA have a particular problem in rationalizing the use of its economic and natural resources for the reasons mentioned by J. S. Mill, de Tocqueville and Schumpeter cited earlier in this paper? Is a change in the pattern of use of natural and productive resources in rich and poor countries towards more desirable ends possible through incremental reform, or does it require, say, the radical transformation of the capitalist or the socialist systems existing in the rich countries of the world? The MIT models address themselves to none of these questions.

References

1. A. Smith, *The Wealth of Nations* Volume 1 (London, Dent, 1910) pages 9–10
2. W. J. Barber, *A History of Economic Thought* (Harmondsworth, Penguin, 1968) page 43
3. *Ibid*, page 45
4. Smith, *op cit*, page 84
5. D. Glass, ed, *Introduction to Malthus* (London, Watts, 1953)
6. *Ibid*, page viii
7. *Ibid*, page 140
8. E. Roll, *A History of Economic Thought* 3rd Edition (London, Faber and Faber, 1954) page 196
9. D. Glass, ed, *op cit*, page 169
10. *Ibid*, page 148
11. G. Meier and R. Baldwin, *Economic Development: Theory, History, Policy* (New York, Wiley, 1957) page 25
12. D. Ricardo, *The Principles of Political Economy and Taxation* (London, Dent, 1911) page 267
13. *Ibid*, page 271
14. D. Glass, *op cit*, page 141
15. Y. Hayami and V. Ruttan, *Agricultural Development* (Baltimore, Johns Hopkins, 1971) Appendix B, pages 327–331
16. Roll, *op cit*, page 200
17. Barber, *op cit*, page 65
18. Glass, *op cit*, page 155
19. *Ibid*, pages 158–159
20. These data had been collected by Sussmilch, who showed a declining ratio from the 16th to the 18th centuries in marriages to population in a number of European regions and cities (*Gottliche Ordnung*); and Muret, who collected data which showed that birth rates were relatively low where mortality rates were relatively low and where life expectancy was relatively high (*Mémoires, etc, par la Société Economique de Berne*, 1776).
21. Glass, *op cit*, page 159
22. Roll, *op cit*, page 210
23. H. Beales, "The historical context of the *Essay* on population", in Glass, *op cit*
24. *Ibid*, pages 8–9

25. K. Marx, "Theories of surplus value", as reprinted in Ronald L. Meek ed, *Marx and Engels on Malthus* (1954) page 123
26. Meier and Baldwin, *op cit*, page 52
27. Barber, *op cit*, page 45
28. J. Robinson, *An Essay on Marxian Economics* (London, Macmillan, 1942) page 61
29. J. Robinson, *Economic Philosophy* (Harmondsworth, Pelican, 1964) page 96
30. Meier and Baldwin, *op cit*, pages 65–66
31. *Ibid*, pages 70–71
32. J. M. Keynes, "Some economic consequences of a declining population", *Eugenics Review*, April, 1937
33. Robinson, *Economic Philosophy, op cit*, page 126
34. W. Beckerman, "The desirability of economic growth", in N. Kaldor, ed, *Conflicts in Policy Objectives* (Oxford, Blackwell, 1971) pages 39–40
35. Ricardo, *op cit*, page 264
36. Roll, *op cit*, page 239
37. J. S. Mill, *Principles of Political Economy*, Volume 2, third edition, (1852)
38. *Ibid*, page 319.
39. A. de Tocqueville, *Democracy in America* (Oxford University Press, 1946) page 314
40. J. A. Schumpeter, *Capitalism, Socialism and Democracy*, 4th edition (London, Allen and Unwin, 1954) page 155
41. Mill, *op cit*, page 321
42. *Ibid*, pages 319–320
43. J. M. Keynes, "Economic possibilities for our grandchildren", in *Essays in Persuasion* (London, Macmillan, 1931) pages 358–373
44. Schumpeter, *op cit*, page 131
45. *Ibid*, page 132
46. Schumpeter, *op cit*, page 145
47. *Ibid*, page 153
48. *Ibid*, page 167
49. W. A. Lewis, *The Theory of Economic Growth* (London, Allen and Unwin, 1955)
50. P. Baran and P. Sweezy, *Monopoly Capital* (Harmondsworth, Penguin, 1968)
51. H. Magdoff, *The Age of Imperialism* (Monthly Review, 1968) pages 35 and 45–54
52. C. Furtado, *Development and Underdevelopment* (University of California Press, 1964); A. G. Frank, *Capitalism and Underdevelopment in Latin America* (Monthly Review, 1967)
53. Beckerman, *op cit*, page 42
54. *Ibid*, pages 44–45
55. The political radicals are certainly not united either on the issue of environment and ecology or on the issue of economic growth. Some marry the views of Ehrlich on the acute dangers of a world-wide ecological crisis, with those opinions of Baran and Sweezy on the inability of capitalist societies to implement effective social regulation and social investment, in order to reject the models of development of both the USA and the USSR, in favour of what they think to be the Chinese model (see R. England and B. Bluestone, *Ecology and Class Conflict*, mimeo, Union for Radical Political Economists, Inc, February, 1971). Others take the view that although capitalism does make the environment unnecessarily dirty, which is just one more reason to get rid of it, there need not necessarily be any ecological disaster as a result of economic growth. At the height of the Earth Day movement in the USA two years ago, I. F. Stone wrote in *The New York Review of Books* that one of the purposes of the movement is to take attention and energies away from the important problems.
 This author has not found any left wing movement representing industrial workers that is hostile to economic growth. What happened in France in the spring of 1972 during the campaign before the referendum on Europe is instructive. Sicco Mansholt, who was then Acting Head of the European Commission, made a public statement supporting the analysis and conclusions of *The Limits to Growth*. He was immediately attacked by the French Communist Party, the communist trade union and the "Patronat" (The Confederation of French Industry, representing French business interests). See *Le Monde*, 6 April 1972, and the ensuing 2 weeks.
56. N. Macrae, "The future of international business", in *The Economist*, 22 January 1972.
57. *IDS Bulletin*, Vol. 4. No. 1. December 1971 (Institute of Development Studies, University of Sussex)
58. *Ibid*, page 9
59. *Ibid*, page 26
60. *Ibid*, page 34

11. POPULATION FORECASTING

William Page

Forecasts of future trends in population are as central to the contemporary pessimism about the future as they were to that of certain classical economists at the beginning of the ·19th century. Here earlier forecasts are examined to see how the methodology has changed and if past performance justifies the placing of much confidence in contemporary forecasts. The emphasis is upon British and American experience and upon total population sizes (rather than age or sex breakdowns). A concluding section raises the question of today's world population situation and the context of *The Limits to Growth* population considerations.

Projections in the 19th century

THE man often taken as a founding father of modern demography is Thomas Malthus (1766–1834), an English clergyman associated with Jesus College, Cambridge, and the first Professor of Political Economy (at the East India Company's Haileybury College). Malthus was not foremost a forecaster; his concerns lay rather with economic growth and it was in this context that he saw population as important. His belief was that, given no checks to population growth, the increases would be such that any additional production in an economy would not contribute to an improved standard of living for that population but maintain or lower the standard for an increased population. Such views were not original (although his theory on the checks to population were), but his exposition remains one of the most significant and authoritative.

I think that I may fairly make two postulata. First, that food is necessary to the existence of man. Secondly, that the passion between the sexes is necessary, and will remain nearly in its present state.

These two laws ever since we have had any knowledge of mankind, appear to have been fixed laws of our nature; and as we have not hitherto seen any alteration to them, we have no right to conclude that they will ever cease to be what they are now, without an immediate act of power in that Being who first arranged the system of the universe; and for the advantage of his creatures, still executes, according to fixed laws, all its various operations.

... Assuming then, my postulates as granted, I say, that the power of population is indefinitely greater than the power in the earth to provide subsistence for men.

Population, when unchecked, increases in a geometrical ratio. Subsistence increases only in an arithmetical ratio.[1]

He suggested that, *without checks*, populations would tend to double every 25 years. The checks appearing in his first essay (1798) were positive and preventive; the former were concerned with death rates (famine, disease, war, etc) and the latter with birth rates (marriage age, "passion", etc). Because of these checks Malthus did not in fact anticipate realisation of the 25 years doubling time, and it seems that he produced no quantitative projections. Thus to produce projections using a 25 year doubling time (or a decennial growth rate of 32%) and to call them Malthusian is misleading. This is why quotation marks are used in Tables 1 and 2, where such projections for the USA and Britain are compared with census figures. From 1790 (the first census) to around 1890, the American "Malthusian projection" is generally within a few per cent of the census figure; Malthusian checks clearly did not operate during this period. For Britain and the world, however, the rate of population increase has been slower than the 25 year doubling time implies but this had little to do with Malthusian checks. The slowdown of British population growth was due in part to a voluntary reduction of the birth rate which was a result of increasing wealth rather than the increasing poverty which Malthus had foreseen. For the world as a whole, the increase in population growth rates has resulted from the introduction of health and sanitation technology in the poor countries, rather than from increasing wealth, as Malthus would have predicted.

Malthus' 25 year doubling time (in association with the checks) may be considered as a conceptually useful abstraction; but as with Meadows' World 3 assumption that, "if no other factors were at work" each family would desire four children, it is impossible to obtain direct verification.

TABLE 1. "MALTHUSIAN PROJECTION" AND USA POPULATION

Year	Population census (millions)	Growth over decade (%)	"Malthusian projection" (millions)	Ratio Malthus : census (%)
1790	3·9	35·9	(3·9)	(100)
1800	5·3	35·8	5·1	96
1810	7·2	33·3	6·8	94
1820	9·6	34·4	9·0	94
1830	12·9	32·6	11·8	91
1840	17·1	35·7	15·6	91
1850	23·2	35·3	20·6	89
1860	31·4	26·8	27·2	87
1870	39·8	26·1	35·9	90
1880	50·2	25·3	47·4	94
1890	62·9	20·8	62·4	99
1900	76·0	21·1	82·4	108
1910	92·0	14·9	108·7	118
1920	105·7	16·3	143·5	136
1930	122·8	6·8	189·4	154
1940	131·1	15·0	249·6	190
1950	150·7	18·0	330	219
1960	179·3	13·3	435	243
1970	203·2	—	574	282

TABLE 2. "MALTHUSIAN PROJECTION" AND BRITISH POPULATION

Year	Population census (millions)	Growth over decade (%)	"Malthusian projection" (millions)	Ratio Malthus : census (%)
1801	10·5	14·3	(10·5)	(100)
1811	12·0	1·7	13·9	116
1821	12·2	33·6	18·3	150
1831	16·3	13·5	24·2	148
1841	18·5	12·4	31·9	172
1851	20·8	11·1	42	202
1861	23·1	13·0	55	240
1871	26·1	13·8	73	280
1881	29·7	11·1	97	327
1891	33·0	12·1	128	386
1901	37·0	10·3	168	454

Note. Decennial growth rate for a 25 year doubling time is 32%.

The Malthusian model is not strictly suitable for quantitative forecasting, being more oriented towards the general qualitative processes involving population growth. However, in many respects it is much more sophisticated than some of the others we shall be mentioning shortly. First, many of the assumptions and reasonings are made explicit and thus specific weak parts can be identified. Secondly, there are many items in the model, including the postulated determinants of birth and death rates, which suggest relationships with other sectors. As we shall see, few quantitative projections of the last century even considered such detail. It can also be noted in passing that the Malthusian model was far from being apolitical: poverty, famine and the like were the natural checks to population growth, and so not to be interfered with; thus the old Poor Laws and the relief of the Irish famine could be righteously opposed and a harsh attitude to the relief of destitution found apparent justification.

The earliest quantitative projection to which reference has been found here was made in 1815 by an American named Watson. The 1800 American census count had been a third higher than that of 1790, and a similar proportional increase was revealed by the 1810 census. Watson took this as a constant rate of increase for his projections; the Watson (published) column in Table 3 gives the figures he allegedly produced.[2] As they do not in fact reflect the constant increase he used, a second column Watson (principle) is also given in Table 3. Tucker in 1843 assumed not a constant compound rate of increase but rather a decline of 1% per decade, reflecting a reduction in the birth rate which he expected "crowding" to bring about. This technique—a simple, constant change in the rate of growth—will be met again in later forecasts. Bonynge used what could be called a method of components: he projected separately for whites, slaves and free Negroes, thus following the breakdowns used in the census at that time. This approach permitted a more detailed study of specific growth rates and could make more apparent the consequences of exceptionally fast or slow growth rates in one component than would be apparent in an aggregated projection. In this case, it would also be possible to obtain a theoretical indication of the effects on population growth of a decision such as to abolish slavery, if one assumed that the growth rate of the

TABLE 3. SOME EARLY FORECASTS OF USA POPULATIONS

Year	Population census (millions)	Watson (1815) (published)	Watson (1815) (principle)	Tucker (1843) Low	Tucker (1843) Average	Tucker (1843) High	Debow 1850	Bonynge 1852
1820	9·7	9·6	9·6					
		99%	*99%*					
1830	12·8	12·8	12·8					
		100	*100*					
1840	17·1	17·1	17·1					
		100	*100*					
1850	23·2	23·2	22·7	22·0		24·4		
		100	*98*	*95*	*100*	*105*		
1860	31·4	31·8	30	28·8		29·4	31·5	30·9
		101	*97*	*92*	*93*	*94*	*100*	*98*
1870	39·8	42·3	40·5	36·5		38·3	42·8	39·9
		106	*102*	*92*	*94*	*96*	*108*	*100*
1880	50·2	56·4	54·0	46·5		49·6	58·2	49·7
		112	*108*	*93*	*96*	*99*	*116*	*99*
1890	62·9	77·3	72·0	59·8		63·0	79·0	61·9
		123	*114*	*95*	*98*	*100*	*126*	*98*
1900	76·0	100·4	95·9	74·0		80·0	100·3	77·3
		132	*126*	*97*	*101*	*105*	*132*	*102*

Note. Figures in italics indicate the ratio: $\dfrac{\text{forecast}}{\text{census}} \times 100$

(now freed) slaves approached that of the free Negroes. The result could have been entirely wrong but at least the principle of being able to explore the impact of policy changes had been introduced.

Table 3 shows that the figures projected for around 1870 onwards are generally more in error than those for earlier years. Table 1 gave the actual decennial percentage increases in the American population; between 1800 and 1860 they varied between 35·9% and 32·6%, and then suddenly dropped; the highest increase since then has been 26·8%. Thus any forecaster who assumed a constant increase rate came unstuck at this discontinuity. In fact, they had come unstuck to an extent already: the natural rate of increase (ie, native births minus native deaths) had been slowing down but this had been compensated for by increases in immigration.

The great number of American forecasts during this period may well have been due to the territorial expansion, the scale of immigration and official interest in the problem. The expansionist ethos was not to be found in Britain. Another source of difference could have been the apparent ease of projecting population numbers in America. The American forecaster, for example, had the advantage of a fairly consistent growth pattern, whereas the British forecaster would have had to complete a series like 14·3%, 1·7%, 33·6%, 13·5% . . . This could have led to the application of much ingenuity as forecasters sought explanations and underlying principles—but this did not happen. As for the rest of the world, useful census figures were not available.

So far, then, the picture has derived from the American experience, and the projections tend to be within a few percentage points of the census figures up to 1860. However, no discontinuities were foreseen so that projections for the

years thereafter are generally gross overestimates. The techniques used were simple extrapolations, sometimes assuming simple changes to future growth rates and sometimes disaggregating various subgroups of the population before extrapolating. The picture for the early part of the 19th century is one of successful forecasting—but success for the wrong reasons.

Forecasters appeared content with simple extrapolative techniques and were not generally concerned with comprehending the underlying processes. This is understandable. The simple extrapolative model fitted the historical data and no obvious constraints to population growth existed in the USA. Malthus' basic principle of 1798 could justifiably have been regarded as incontrovertible: that the laws of population growth "appear to have been fixed laws of our nature, and as we have not hitherto seen any alteration to them, we have no right to conclude that they will ever cease to be what they are now".[1]

Nineteenth century models were all on the lines of "If present trends continue (or are changed in a given, simple manner), then the population will be such-and-such". The logic of the "then" part was correct—given correct arithmetic— but, as we know now, the "if" part was wrong—those present trends did not continue. One should not, however, be too denigrating about these techniques. As we shall see, many of those in use today are not that much different.

Twentieth century forecasts

During the 1930's and 1940's, interest in demography grew rapidly. "Fifty years ago", wrote Warren Thompson in 1943,[3] "there was almost no interest in population except in matters of local importance (such as) the settling of large numbers of immigrants in the cities . . . Such general and theoretical interest in population questions as was manifested was confined to brief statements of the Malthusian position with comment to the effect that this view was no longer of any significance, since population had grown faster in the century following Malthus' first essay (1798) than ever before, while the standard of living had also increased more than in all prior human experience. There was no recognition of population as a field of study within any of the social science disciplines as then taught." By 1945, however, demography had arrived as a distinguishable discipline. There were a number of university research centres, courses for students and postgraduates, journals and abstracting services and the whole eugenics movement had come (and gone?).

Population forecasting during this period did not really show a marked degree of improvement over earlier attempts. Although older approaches were improved upon and some techniques such as curve-fitting were elaborated, it cannot be said that the underlying mechanisms were more clearly understood, and the results suffered accordingly.

F. J. C. Honey[4] published a paper in 1937 under the title: "The estimated population of Great Britain, 1941–71". Honey was associated with the British National Confederation of Employers' Organisations, a link which is symbolic of a small change—most of the forecasters of the previous century were either private individuals or else associated with government. This author gave generous reference to other authors who produced similar forecasts or contributed to the methodology—such as Derick and Harvey[4] (on forecasting

methodology), and Enid Charles[5] and Grace Leybourne[6] (forecasts for Britain). His work may be taken as a good example of forecasts made in the inter-war period.

"An attempt is made to forecast the probable future course of mortality and fertility in Great Britain, in the light of the experience of the past, and such indications as there may be regarding the factors which will influence the future." Three points made explicit in this passage are: the use of historical data (traditional approach); the consideration of possible sources of change in the future (rarely explicitly raised in past work); and the attempt to understand the underlying processes involved in population dynamics (also rare in past work). The last two points hint at the introduction of some social science. Honey adds that, in his opinion, "in none of the previously published estimates has full account been taken of the available data". This is clearly intended as a criticism, not simply an observation.

Mortality rates are analysed first, using so-called "survival factors" which, when applied to specific age–sex groups, show the number of survivors in 10 years time, given no change in the rates. These were obtained from Life Tables, whose data covered 1891 to 1932; these were then "plotted on squared paper and smooth curves drawn through the points . . . These curves were then continued to give factors for future years". There is no pretence at using cunning mathematical techniques for this stage; "there is, of course, a large element of speculation as to where the curves should be drawn, and much is left to the taste of the individual operator". Despite the great importance of this point, it is very rarely raised in the literature. It does, after all, detract from the apparent objectivity of the research. Honey argued that the general direction of the curve was not controversial—there had been virtually continuous improvements in mortality since the 1890's, and there was no reason to assume an immediate levelling off (let alone a regression). Unfortunately, the case of the over-85's was an exception: their life expectancy had gone *down* since 1921, and this could not be explained. Although not of great significance, this did leave open the possibility of a similar decline appearing in age groups adjacent to the over-85's. (It was decided to assume no further change, up or down, in this specific case.) In these mortality extrapolations, historical data for the three areas (England and Wales, Scotland, and Northern Ireland) were processed together, using weights; it is unlikely that this would be done now, but then it must have eased calculating. Also five-year age-group intervals were used, one reason given being the mis-statements of age found to exist in the 1931 census.

As regards fertility rates: the Registrar General's office is quoted as having written:

The element of personal control in the matter of reproduction which alone can account for so great change in the birth rate over a period of so few decades must generally frustrate any attempt at statistical forecasting and the most that can be said is that, having regard to current economical and industrial conditions (1932), the birth rate appears likely for some time to remain low in relation to all earlier periods for which we have reliable records.

Given the objective of his study, Honey clearly could not accept the death-knell implications for quantitative projections, and so he tried to identify and

consider those factors "which are likely to influence public opinion in the future". These included the increasing burden of looking after aged parents and relatives which would appropriate resources otherwise spent on having children and thus would help reduce the birth rate. Secondly, the standard of living was tending to improve, and the consequential life style was seen as not conducive to having funds to spend on children. Thirdly, birth control was spreading, and the Church of England had recently withdrawn its disapproval of the practice. Lastly, birth rates were known to be inversely correlated with socio-economic status and—given that this would continue to increase—a continued decrease in the birth rate was in keeping. This trend also agreed with the world-wide downward trend. Strangely enough by today's thinking an argument for an *increasing* birth rate at that time might well have made the final forecasts "implausible" to many readers.

The total number of births in a year was derived through age-specific fertility rates for married women, and so the single:married proportions for women had to be obtained. At this point we encounter a new problem: the meaning of "extrapolating present trends" is usually taken as fairly simple and obvious—but what if there is more than one form of time-series available and they lead to significantly different conclusions? The first time-series technique here involved the single:married ratios for women; past data were available, and in fact the contemporary level was taken and used as a constant. But because of changes in age-specific sex ratios, this constant implied changes in the contemporary male single:married ratios. So this time, the male rates were taken as the base (again, in fact, no change was assumed), and the implied female rates were calculated. The answers to the two calculations being different, the average was taken.

The projections are shown in Figure 1. They were wrong—total population did not decline by 14% between 1931 and 1971, but went up by 25%. Why were they wrong?

Honey's 1971 life expectancies were 62 years for men, 66 for women. The actual figures are nearer 69 and 72. His infant mortality rates went down to 64 per 1 000 for males and 50 per 1 000 for females by 1951 and remained there. The actual (combined) 1970 rate was around 18, and, as was pointed out at the time,[7] the projected 1951 rate was only marginally less than the contemporary level which itself ranged between 79 (County of Durham) to 38 (Hertfordshire). Because of the technique used (freehand extrapolation) and lack of detailed commentary, it is impossible to identify any exact causes for the error; it could lie in not expecting medical developments, or in believing that living standards for the old (implying food and heating and the like) would not improve significantly, or even in thinking that there was no way possible to reduce infant mortality. One lesson is clear—if future generations of forecasters are to learn from present-day exercises, then they must be given details of background thinking to these forecasts.

Important errors also occurred on fertility. Take births per 1 000 women aged 15–19; the 38·5 of 1931 was forecast to decline to 33·9 by 1971, the actual figure in 1971 was 49·0; for those women aged 40–44 the expected drop from 34 to 9 did occur. As Honey had assumed, standards of living continued to rise and the use of contraception did spread; his third assumption—an ageing

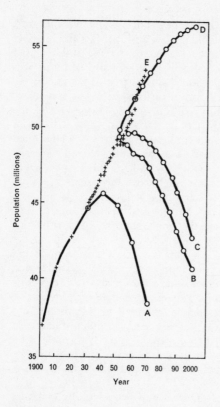

Figure 2. Some population forecasts for the United Kingdom. These projections are all taken from the *Annual Abstracts of Statistics.* A = 1955; B = 1960; C = 1965; D = 1970.

Figure 1. Forecasts of Honey (1937) and the Royal Commission (1951) for the population of Great Britain. Key: A = Honey; B = Commission: lowest for 1972; C = Commission: median; D = Commission: highest for 1972 (also the nearest); E = Actual population of Great Britain.

population—did not materialise. This means that either more important factors were at work, or else he miscalculated the relationship between his assumption and its consequence. The latter is the case. It appeared that people were prepared to sacrifice the possibility of a yet higher living standard for children. The birth rate started to increase. Like the Americans of the last century, Honey did not allow for a discontinuity in the projections. This problem will be referred to again later. It should also be noted that, although the use of sociological considerations did not lead Honey to the right conclusions, it did assist in clarifying the reasoning involved.

Honey has been cited at some length because he illustrates an approach used (with variations) by other authors at the time, and they mostly concluded that population declines were on the way. Book titles such as *The Menace of British Depopulation* and *Renew or Die!* were quite commonplace.

In America, P. K. Whelpton[8] pointed out in 1932 that "each decade up to the World War showed a large numerical increase over the preceding (and this) tends to obscure the speed at which (American) population gains have been dwindling recently". The annual rate of population increase was 18·4 per 1 000 of population in 1920, 19·0 in 1923, but by 1930 was only 9·1. "The birth rate has again been falling, and probably will continue to do so, though at a decreasing rate."

With hindsight, Whelpton's next statement illustrates the extreme difficulty of identifying future trends with any certainty: "Mankind is somewhat more handicapped in its efforts to prolong life than to prevent births. A perfect application of the best-known methods of contraception would accomplish the latter end, but science has not yet indicated how all the present inhabitants of this earth may secure everlasting life." Here was an eminent demographer, using historical data and his experience, anticipating no major problems in reducing birth rates, but believing major reductions in death rates to be unlikely. The so-called population explosion, generator of so many qualms, has come about through the exact opposite happening. And yet so much of the evidence was on Whelpton's side, as was so much of the general opinion of the time. Needless to say, he underestimated the future population size: his 1960 figure was 80% of the census, and the 1970 figure was 71%.

At the same time, Dublin[9] presented two forecasts. The first gave a peak American population of 154 million (for 1990), the other, 148 million (for 1970). These figures were exceeded during the late 1940's and early 1950's. This also shows that, given hindsight, the differences between alternative sets of assumptions may be less significant than they seemed at the time.

The 1949 (British) Royal Commission on Population,[10] established to recommend any necessary action in the light of probable future population trends, ran into most of the above problems and did not produce markedly superior results. First, the problems of a dearth of coherent data and theory meant that the Commission had to collect much of the required data itself.

Secondly, in order to measure present trends, the Commission produced a number of projections, and so did not have to identify a best assumption. A similar escape was used in discussing fertility (5 different assumptions drawn up), mortality (2) and migration (5 again). Explicit attempts were made at understanding the causes of past trends, and at anticipating future economic and social conditions.

Of the possible 250 permutations of assumptions, only 16 were followed through. What we can now see to have been the correct marriage rate assumption (towards earlier marriage) features only once in the 16, and likewise rising fertility. The former came in conjunction with unchanging fertility and death rates, the latter with constant marriage rates—but also (correctly) with declining mortality; both assumed zero net migration. It is clear from both explicit and implicit statements that the Commission did not expect either assumption to materialise. Figure 1 shows three of the Commission's 16 projections: that closest to the actual 1972 population (which happens to be the highest figure projected for that year); that which included the lowest 1972 figure; and a median projection (in fact, the ninth when they are in ascending order).

As with the other forecasters, the Commission was fooled by history and their intuition. Had more attention been paid to the trends recently preceding their work (much of the data being for the late 1930's), they might have anticipated the actual trends: fertility was then on the increase. On the other hand, there were many possible ways of interpreting this increase as a short-term fluctuation and, if we go back to Whelpton, we find that his forecast was a revision of an earlier exercise and the revision was done in the light of short-

term changes (and was more in error than the original). The Commission did at least do its utmost to make its reasoning clear and comprehensive.

Another method of forecasting became popular for a while in the USA: curve-fitting. Its essential philosophy is that phenomena grow according to mathematical laws and, to foresee their future, it is not necessary to make guesses, but simply to uncover the mathematical formulae at work and to calculate the future values. Although this summary may be verging on the extreme, the contrast with approaches which include the freehand continuation of graphs is marked.

The logistic curve was a slightly more sophisticated development of the 19th century extrapolative techniques. A key problem of extrapolation was that it logically led to an infinite population, when the curve was upwards. More sophisticated mathematical forms could avoid this defect. Pritchett[11] had published one solution to this problem at the end of the last century (1892). The logistic curve (also often called the S-curve) provided another solution. It was initially put forward by Verhulst, a Belgian writing in 1838[12]; he applied it to the American population but his data were far too poor to permit meaningful projections. It was brought into prominence during the 1920's and rapidly became a very popular tool; there was a spree of applications over the next twenty-odd years. A 1945 paper[13] surveyed "logistic social trends", and refers to some 219 applications; their range of topic is amazing—from the growth of population in various countries, through lynchings per million of American population and the number of "independent countries . . . which had adopted postage stamps" to the size of empires in Asia.

A general equation for the logistic curve is:

$$P = \frac{K}{1 + e^{1/(a+bt)}}$$

P is the population at time t; $K/2$ is the final maximum population size (which may be the carrying capacity of the land), while a and b are constants. It is sometimes referred to as the Pearl–Reed logistic curve, after Raymond Pearl and Lowell Reed who exploited it in the USA during the 1920's and 1930's.

Pearl was a zoologist, whose theory was inspired by the study of animal populations. If some drosophilae (fruit flies) are put into a closed system, such as a bottle with a fixed supply of food, they reproduce and the population increases in a pattern fitting the above equation. The growth rate reaches a peak, then slows down (in a manner symmetrical with its earlier acceleration) until reaching the final limit.

In their 1922 paper, "On the rate of growth of the population of the United States since 1790 and its mathematical representation",[14] Pearl and Reed calculated values for a, b and K which best fit the historical data.

Reed, writing in 1937, described this as an "excellent" agreement, and added that ". . . the values at 1920 and 1930 may be used to check the adequacy of the curve for prediction over a 20 year period . . ." The closeness of agreement with actual developments has not been maintained; the 1960 census was 113% of the forecast value, and 1970, 121%. The slow-down of growth is not as rapid as was anticipated—the final limit of 185 million people had been passed

by 1963. Table 4 compares this forecast (Logistic 1) with census results. A similar forecast of world population was done. It suggested an ultimate population of 2000 million, which was in fact exceeded around 1940.

When the 1940 census was published, Pearl and Reed noted their mistaken forecast of US population and decided to revise the forecasts by obtaining new values for *a, b* and *K*. Their two American forecasts were now labelled Logistic 1 and 2. Unfortunately, 2 moved in the wrong direction; it suggested even smaller population changes. Thus it underestimated the 1950 population by 7 million, against 2 million for 1. (See Table 4.) The forecasts by Whelpton, to which we have already referred, were also a revision and up-dating of earlier forecasts done by the Scripps Institution, and were also less accurate than the original.

Despite any illusions to the contrary, the logistic approach implies constancies; the growth rates may vary from decade to decade but the underlying values *a, b* and *K* from which these rates are derived are, by definition, constants. The real-world sociological meaning of *a* and *b* is far from clear and the way they are derived means that they represent an average obtained from historical periods. The approach makes it very difficult to identify the reasons for failure in the forecasts; it cannot be argued, for instance, that they misjudged the rate at which contraceptive practice spread, because it is not known how this would be subsumed in the values of *a* and *b*. It is not even clear how fluctuations in birth and death rates emerge in the forecasts. Pearl and Reed recognised that the historical average changed between 1910 and 1940 when they made this revision. And of course it has changed in many other cases, such as the Algerian; when the population of Algeria did not grow as Pearl expected, he revised his values for the constants, and attributed the discontinuity to a change in the Algerian political situation. However, changes in political situations are not uncommon and, if they cause changes in the values of the constants, then operationally this reduces the value of the whole approach.

TABLE 4. COMPARISON OF PEARL AND REED'S USA FORECASTS WITH CENSUS DATA

Year	Census population (millions)	Logistic 1 (millions)	Logistic 2 (millions)
1920	105·7	107·4 *102%*	106·1 *100%*
1930	122·8	122·4 *100*	120·1 *98*
1940	131·1	136·3 *104*	132·8 *101*
1950	150·7	148·7 *99*	143·8 *95*
1960	179·3	159·2 *89*	153·0 *85*
1970	203·2	167·9 *83*	160·4 *80*
1980	—	174·9	166·3
1990	—	180·4	170·8
2000	—	184·7	174·3

Figures in italics indicate the ratio: $\frac{\text{forecast}}{\text{census}} \times 100$

We are no longer playing a mathematical curve-fitting game but a social forecasting game. The conceptual neatness has gone and with it the main selling point of the approach.

Putting aside this fundamental problem, we find others in the derivation of the approach: it is an example of applying principles noted in some animal populations to human populations. In experiments along the lines of Pearl's (fruit flies in a closed space, with fixed food supply), two main factors may eventually cause zero population growth, food and waste disposal problems. Regardless of what may happen in the future, it cannot be argued that either has, historically, been a limiting factor in American population; nor, in recent centuries, has food supply curtailed long-term growth in many countries.

Other simple mathematical forms have been proposed, such as von Foerster's "coalition law" (1960); coalition because "humans possess an effective means of communication (and so) they are able to form coalitions until all the elements are linked. This . . . proceeds until the population as a whole can be considered as acting as a single element, or person, engaged in a gigantic game with nature as the opponent. This is evidenced by such phenomena as urbanisation, industrialisation, medical technology, etc".[15] The law implies that populations must always grow, for the growth rate given by it is population size to the power of $(1/k)$—k always being one or greater. The result of this formula is that population sizes reach infinity—the doomtime for the world in one application being 2027—plus or minus five years. "As might be expected however, there is a flaw in this reasoning . . ."

Consequently, a modified coalition law has been suggested.[16] Its mathematical form is:

$$\frac{\mathrm{d}P}{\mathrm{d}t} = A \left\{ 1 - \exp\left(-\frac{a}{A} p^{1/R}\right) \right\} \left\{ 1 - \frac{P}{K} \right\} (P)$$

P = population size, t = time, a = constant, R = constant $(\leqslant 1)$
A = constant (implying the upper bound to the growth rate)
K = upper bound to P.

If nothing else, this equation is more complex than the others mentioned above. The value of the constants has been calculated using data and estimates relating to world population back to 0 AD. The upper limit comes out at 50 000 million, although it can be changed by 20% with a 1% change in K. (Changing A and a only shifts the curve laterally.) "The most obvious conclusion is that world population continues to rise despite the considerable efforts to institute birth control methods during the last decade. Further, note that the effect of World War 2, a major catastrophe, has been negligible. It seems clear then, that if future population growth is to fall significantly below the predicted growth . . . it will require an effective, massive population control programme, or a catastrophe many times greater than that of World War 2."

The above is intended seriously. That the methodology does not permit such definite conclusions is not discussed by the authors. That growth has historically fitted a certain mathematical pattern by no means proves it will so continue (as many of the early logistic exercises permit us to see). Is an "effective massive birth control programme" in fact needed, or might a decline in growth rates occur without it—and without catastrophe? The methodology

has nothing whatsoever to say on this point; societal mechanisms are what can be read into it, rather than what comes out of it. Again, the plausibility of supporting a total population of 50 000 million can be argued (and is); but so can that of other figures (including the 2 000 million mentioned above).

One reason for mentioning this contemporary study is to show that the curve-fitting methodology is not yet dead. It is a perfectly valid way to show one outcome of "present trends continuing"—if one is prepared to accept the curve as representing the past trend. The real world is different and more complex, however, so that the approach has no sound basis as a kind of fore-casting technique which can generate the most likely future—or alternative futures which are useful in a policy context.

The other variation on this theme—extrapolate and guess—thrives. It is used by both the British Government agencies (the Government Actuary, Office of Population Censuses and Surveys) and the American Bureau of the Census. The OPCS "basic principle is that the number of people of a given age and sex who will be in the population in one year's time is the number in the population now a year younger, less deaths which will occur in the year, plus or minus migrants."[17]

The mortality rates are derived from those of the last three or four years, examined in the context of the post-1900 trends. The conclusion is that the rates will "continue to decrease in geometric progression at about the same average pace as over the past half century". The resulting life expectancy for those born in 2009–10 is 72 years (males) and 79 (females) (against the present 69 and 75). Infant mortality is taken as 40% of its present level.

Births appear harder to forecast; this is a pity, because the projections are more sensitive to them. The total number of births rose between 1955 and 1964 (from 789 000 to 1 014 000) and then started to fall; a halt looked likely in 1968 but did not materialise. At the end of 1970 and the start of 1971, there was an increase but we now know that it turned out to be short-lived. Much detail is introduced: fertility by duration of the marriage and date of marriage. Sociological factors are considered: it seems that family completion is being held over until later in marriage than was the case before, for instance. The overall conclusion on fertility is that the size of completed families will settle down to slightly less than it was during the post-war baby boom—a conclusion in keeping with the general findings of the OPCS *Family Intentions* survey which explored desired family sizes.[18]

The Government Actuary/OPCS projections are very sensitive to trends of the preceding three of four years; this is reflected in the way they are revised annually. Trends change, often rapidly, and we saw before that some of the 1930's revisions, done in the light of such recent trends, were more in error than their originals. Figure 2 shows how UK forecasts have varied between 1956 and 1970, the projected figure for the end of the century ranging from 53 to 75 million people.

Optimism and pessimism

The record in population forecasting is not impressive. Forecasts of the last century tended to be correct for several decades ahead, but this could hardly

be attributed to forecasting expertise. Those of the inter-war period foresaw declines in the following few decades, whereas increases occurred. This is not a small quantitative quibble, it is qualitative error in forecasting the direction of the trend. The methodology of current extrapolative forecasts is not significantly different from those of the past, and so one does not have a sound basis for expecting present-day exercises to prove superior. The main problem lies, perhaps, in the implication of these techniques that population growth is an autonomous phenomenon, whereas it is clearly influenced by other natural and, to a greater extent, societal happenings.

The conclusion of this paper is that it is impossible to know with certainty and accuracy a country's population over the long-term future. Although there is a philosophical route to such a conclusion, in this instance the route is by way of the past failures of forecasting exercises.

The implication is that it is a gamble to base decisions in governmental or other spheres upon long-term population projections, given the uncertainties in that base. What bearing does this have upon the world models of Forrester and Meadows?

The forecasts reviewed above have all been attempts at producing most likely future population estimates. There is one context in which forecasts can be used with a form of safety, namely, as warnings. Many contemporary authors are making forecasts of the hypothetical consequences of present trends continuing. This applies particularly to world population estimates. Paul Ehrlich provides a good instance of the use of such forecasting: "Perhaps the meaning of doubling times of around 35 years is best brought home by a theoretical exercise. Let's examine what might happen on the absurd assumption that the population continued to double every 35 years into the indefinite future".[19] The result—6×10^{16} people after 900 years—is patently not a most likely forecast. The MIT world models could conceivably be seen in a similar vein: they are not attempting to predict The Future, but to show the possible consequences of present trends and relationships continuing without drastic change. Indeed the message of most of the doomsday authors is not that forecasts are necessarily expected to materialise—but that they could do so if appropriate action is not taken now.

The recent increase in such warning forecasts reflects the contemporary concern with the problems of the under-developed countries, a concern which has grown considerably over the last two decades. This chapter has suggested that there is a relationship between an interest in population forecasting and the mood of the country—expansionist America in the last century produced forecasts of an ever-increasing population while the British were silent, and both countries expected, during the depressed late 1920's and 1930's, an eventually declining population. The consequences of the decline were expected to be serious (race suicide), in a manner analogous to the expected possible explosion currently underway in the world as a whole. It is easy to find grounds for concern today, and to understand why the Forrester/Meadows models are of interest to such a large number of people.

In 1900, world population was around 1 600 million people with a doubling time of 140 years—3 200 million would have been reached by 2040 had this rate continued, rather than in the early 1960's. Table 5 gives some estimates

TABLE 5. WORLD POPULATION AND ESTIMATED DOUBLING
TIME

Year	Population (millions)	Doubling time in years	Average % increase p.a.
1750	791		
1800	978	175	0·4
1850	1 262	140	0·5
1900	1 650	140	0·5
1950	2 486	85	0·8
1960	2 982	39	1·8

Source: *Human Fertility and National Development*, UN, 1971, page 10

of past world population size. By 1950, there were 2 500 million people and a doubling time of 85 years, but optimism was viable. A group of experts appointed by the UN Secretary-General could still report in 1951: "The belief that economic development must inevitably be dissipated in population growth causes pessimism in some quarters. We do not share this view. If vigorous effort is put into developing the under-developed countries, we see no reason why their national incomes should not rise at rates higher than the rates at which their populations are currently increasing or may be expected to increase. The problem is difficult, but it is not insoluble."[20]

Come 1960, there were nearly 3 000 million people with a doubling rate of 39 years, and 1970 saw 3 600 million with forecasts for 2000 around the 6 500 million mark.[21] This explains why even the qualified optimism of the above-quoted 1951 report was seen as too optimistic by the Lester Pearson Commission report in 1969: "No other phenomenon casts a darker shadow over the prospects for international development than the staggering growth of population. It is evident that it is a major cause of the large discrepancy between rates of economic improvement in rich and poor countries. On the other hand, the likelihood of a rapid slowing down of population growth is not great."[22]

It should not be thought that, because the record of population forecasting as presented here is not an impressive one, the present-day warnings should not be heeded: this would be a most unfortunate prelude to a very dangerous complacency. Indeed, the main historical era discussed in this paper (this century) was one in which future population sizes were underestimated—not overestimated.

References

1. Thomas Malthus, *First Essay on Population*, 1801 edition
2. Lowell J. Reed, "Population growth and forecasts", *Annals of the American Academy of Political and Social Science*, November 1936; and William Peterson, *Population* (London, Macmillan, 1961)
3. Warren Thompson, "Population studies", *American Journal of Sociology*, Vol. 50, No. 6, May 1945
4. F. J. C. Honey, "The estimated population of Great Britain, 1941–71", *Journal of the Institute of Actuaries*, Vol. 68, No. 3, 1937, pages 324–347
5. Enid Charles, "The effects of present trends in fertility and mortality upon the future population of Scotland and upon the age distribution", *Proceedings of the Royal Society of Edinburgh*, Vol. 56, No. 1, 1936; and, "The effects of present trends in fertility and mortality upon the future population of England and Wales", *London and Cambridge Economic Series*, Special Memo No. 40, August 1935, pages 1–19

6. Grace Leybourne, "The future population of Great Britain", *Sociological Review*, Vol. 26, No. 2, April 1934
7. *Journal of the Institute of Actuaries*, Vol. 68, No. 3, 1937, page 349
8. P. K. Whelpton, "The future growth of the population of the United States, in G. H. L. F. Pitt-Rivers, ed, *Problems of Population* (New York, Kennikat Press, 1932)
9. L. I. Dublin, "The future American population", in Pitt-Rivers, *op cit*
10. *Royal Commission on Population* (London, HMSO, 1949)
11. Reed, *op cit*
12. Reed, *op cit*
13. H. Hart, "Logistic social trends", *American Journal of Sociology*, Vol. 50, No. 5, March 1945
14. R. Pearl and L. J. Reed, "On the rate of growth of the population of the United States since 1790 and its mathematical representation", *Proceedings of the National Academy of Science*, Vol. 6, No. 6, pages 275–288
15. Quoted in A. L. Austin and J. W. Brewer, "World population growth and related technical problems", *Technological Forecasting and Social Change*, Vol. 3, No. 1, 1971
16. Austin and Brewer, *op cit*
17. Office of Population Censuses and Surveys, *Population Projections* 1970–2010 (London, HMSO, 1971)
18. Myra Woolf, *Family Intentions* (London, HMSO, 1971)
19. Paul R. Ehrlich, *The Population Bomb* (New York, Ballantine and London, Ballantine/ Friends of the Earth, 1971) page 3
20. UN, *Measures for the Economic Development of Under-Developed Countries*, Report by a Group of Experts Appointed by the Secretary-General of the United Nations, UN Department of Economic Affairs, New York, May 1951, Sales number: 51.II.B.2, paragraph 135
21. Figures from: *Human Fertility and National Development* (UN, 1971)
22. Lester B. Pearson, Chairman, *Partners in Development, Report on the Commission on International Development* (New York, Praeger, 1969)

12. ENVIRONMENTALISM:
A la recherche du temps perdu - bien perdu?

T. C. Sinclair

Four themes are developed here. Pollution has occurred locally for many years and has been countered by social action and administrative and technical adaptation; extremely subjective responses to this problem are widespread and these have been used as a background by the model-builders who have ignored the evidence that such responses can be channelled into abating the hazards while permitting growth; crisis orientation is only partially justified yet this belief is being used to attack the idea of technological progress; and problems and local crises tend to be obscured by premature aggregation into a world model.

A disamenity of economic growth: pollution

THE idea of increasing social costs with increasing production, confined to physically definable and measurable levels of pollution, is of fairly recent origin. This is so because, firstly, the means of measuring and recording such levels have only recently developed and, secondly, other social ills were greater and occupied more of society's attention. Even though attempts to control pollution began in London as early as the 13th century, the ethic or creed of economic progress, in 17th century England for example, was more likely to be opposed, albeit ineffectively, on grounds of moral degradation than the physical disruption of the environment. As Tawney observes, in *Religion and the Rise of Capitalism*:

The idea of economic progress as an end to be consciously sought, while ever receding, had been unfamiliar to most earlier generations of Englishmen, in which the theme of moralists had been the danger of unbridled cupidity, and the main aim of public policy had been the stability of traditional relationships.

While the moral theme of opposition to avarice as a principle of behaviour has remained one of the major strands in the utopian and socialist critique of industrial capitalism, it is only much more recently that pollution has come to be regarded as a major threat to the human species, rather than a local nuisance. Much of the moral idealism which in earlier times found expression in various movements of social reform appears now, particularly in the USA, to seek an outlet in the environmentalist movement. It is this environmentalist critique of industrialism, rather than the socialist critique of cupidity, which finds explicit representation in the MIT model.[1] As Simmons points out

(chapter 13), the ideal of more just and less selfish social arrangements is an important influence, particularly on Meadows, but this emerges as a bonus from the stable state, and not as its primary justification.

The necessity for a stable state is overtly argued not on moral grounds but on the grounds of the physical impossibility of the continuation of economic growth. These physical limits can be attributed on the one hand to pollution effects of growth and on the other to the classical economic variables: land, resources and population. The distinctive feature of the MIT work is this marriage of neo-Malthusian economics with a contemporary stream of ecological environmentalism. Pavitt (chapter 10) deals with the classical economic stream, this chapter with some background to the environmentalist movement.

A good deal of attention is given here to earlier comments on pollution problems and there are a number of quotations. This is not simply because of the intrinsic interest of such comments but because it is important to convey the full flavour of 18th and 19th century views. In the absence of satisfactory physical measurements these comments reveal the extent to which attitudes colour observations and the way in which attitudes vary with time and social position. They also show that some pollution problems which are occasionally thought of as purely contemporary are in fact long-standing and may actually have been ameliorated, rather than the reverse. The absence of historical statistical data on pollution levels which necessitates inference from other sources is not entirely different from the situation today where the available data are at best scattered and equally open to subjective responses. An essential assumption of the MIT work is that industrial growth and capital investment necessarily carry with them an inevitable and increasing pollution penalty. This view is explicitly justified by the assumption that social control mechanisms will be too little, too ineffective and too late to diminish hazards significantly. While there is much in the historical evidence to justify such a pessimistic view it is argued here that this is by no means the only possible interpretation of events. How much justification there may be for the detailed assumptions and numerical estimates in the MIT model itself was discussed in Part I. It has become clear however that there are in fact so few reliable data on pollution (as Meadows and his colleagues themselves admit) that attitude and judgement inevitably play a very large part in determining the assumptions that are made.

The nature of the impacts

The debate over the assault on the environment today is most often conducted in terms of exponentially rising levels of pollutants or disamenities. Since the coining of the word ecology by Haeckel in 1866 there has been a rise, dare it be said exponential, in articles and books discussing ecology, environment and pollution, and the trinity are certainly now interchangeable in current idiom. Three hundred books were published last year in the US alone on this theme and words have been invented, *ad nauseam*—'ecocide', 'ecopolitics' and so on to 'pollutics'.

The current set of forecasts for pollution levels are, at once, very recent and usually apocalyptic. The general technique used is straightforward trend

extrapolation, usually with little or no allowance for technical improvement, and is adequately summarised by such titles as *Can we Survive our Future, The Death of the Oceans,* and *This Dirty Earth.* In *Can Britain Survive?*[2] a title that limits the area of catastrophe with an unaccustomed reticence, Mishan says:

The belief that the end of the world was drawing nigh was widely held at different times in human history. But from this historic fact there is no consolation. Only since the last war have men prised open Pandora's box, and have discovered technologies for destroying all life on earth many times over and in a variety of ghastly ways . . . To annihilation from military mishap or irresponsibility must be added the possibility of extinction of the species from an uncontrollable epidemic (arising from man's organism being unable to adapt quickly enough to new and more deadly viruses resulting from the wholesale application of 'miracle' drugs), from an ecological calamity (arising from the inadvertent destruction of animal and insect life that preyed on the pests that consume men's harvests while the pests themselves become resistant to the chemical pesticides), and the possibility of a slower and more painful death from choking in the waste products of advancing technology.

For each pollutant statistics of greater or lesser accuracy can be found that indicate that safety margins, tolerable doses and level of risk to particular groups or whole populations exist with a high degree of variability. They most often relate to local situations[3,4] and, indeed, Meadows is forced (see chapter 7) to extrapolate from such scanty data as exist at the local level to world situations. It is argued here that local situations as unacceptable as those of today have existed in the past and have been dealt with more or less successfully. Where there does appear to be a global threat, the reliability of the data is often low. In the absence of reliable data, the possible outcome will be strongly dependent upon what the risk level is judged to be and who makes the judgement. The risk level may be too small to determine it accurately from experiment or prediction while the benefits are more immediate and tangible. In this situation subjective and controversial judgements as to acceptability must frequently be made.

The fact, however, that not only is pollution of the air by dust, chemicals and noise, water and land resources listed, but also moral pollution, alienation and anomy, indicate that in many arguments environmental degradation is used as the basis for a questioning of economic and technical progress which derives from wider concerns and motives. As Mishan observes, such general pessimism about the human condition has often been widespread in the past. It is remarkable only as an indication of a generally pessimistic attitude towards humans or of the decline of a particular civilization, or both.

Simone de Beauvoir[5] clearly sees it as the Nemesis of four or five centuries.

Whatever the country, capitalist or socialist, man was everywhere crushed by technology, made a stranger to his own work, imprisoned, forced into stupidity. The evils all arose from the fact that he had increased his needs rather than limited them: instead of aiming at an abundance that did not and perhaps never would exist he should have confined himself to the essential minimum, as certain very poor communities still do. In Sardinia, for example, and in Greece—communities untouched by technology and uncorrupted by money. There the people did experience an austere happiness, because there certain values were maintained, the truly human values of dignity, brotherliness and generosity which gave life a unique savour. As long as fresh needs continued to be created, so new frustrations would come into

being. When had the decline begun? The day knowledge was preferred to wisdom and mere usefulness to beauty. Along with the Renaissance, rationalism, capitalism and the worship of science. All right. But now things had reached that point, what was one to do? Try to revive wisdom and the love of beauty in oneself and in those around one. Only a moral revolution—not a social or a political or a technical revolution—only a moral revolution would lead man back to his lost truth.

The peculiar interest of this contemporary quotation lies in its demonstration of the convergence of the moral fervour characteristic of the old socialist critique of cupidity with the environmentalist hostility to modern technology. The traditional Marxist approval of advanced technology as the means to abundance is here completely abandoned in favour of the characteristic mediaeval utopian preference for ascetic and egalitarian poverty. This is the flavour of a great deal of the more radical environmentalist literature, and the hippie critique of contemporary values.[6]

An assumption underlying much of the criticism is that the risks run by man in using his technological abilities have risen to unacceptable levels. However, no human activity can be entirely risk free. The question is—what levels are acceptable? If individual risk levels are examined in the industrialised countries, the weight of deaths attributable to technology, such as transport accidents and adverse drug reactions, is rising against a falling risk of death from, say, infectious diseases. The success of social and technical measures in combating natural disease hazards has rendered the risks of technology more apparent.

Moving to more subtle connections with technological advance and growth, the rise in the so-called diseases of civilisation or affluence remains open to analysis. If heart disease is taken as an outcome of a particular life style related to affluence it seems more reasonable to argue that it is social organisation that is the area for concern rather than technology *per se*. That social organisation is, in part at least, a consequence of technology seems undeniable. However, this does not mean that technological factors rigidly determine the social organization. Choice as to how to utilise technology and affluence remains. Here, too, the dangers of exponential extrapolation must be avoided. In an intriguing allegory of economic growth and technological progress Schwab[7] gives values in each of the sectors used in the world model to point out the downward path man is set on. As one of many examples, the incidence of diabetes in Denmark is shown to have increased (even faster than the increase in consumption of technologically whitened sugar) from 1·8 per 100 000 in 1880 to 18·9 per 100 000 in 1934. No discussion is given of the possibility of more efficient detection methods having contributed to the increase or to the eradication of other diseases making diabetes more apparent. Insulin therapy is dismissed by the use of another time series (disadvantageous to medical technology) for a different period and a different country. This approach shows certain similarities to the data extrapolation methods used with regard to pollution in World 3 (see chapter 7).

Classification of impacts

To distinguish the particular issues with which this chapter is concerned, we will aim at some clarification through definition. The current crisis of confi-

dence in scientific and technological values has produced several elaborate and comprehensive taxonomies of the threats to man and environment.[8,9] Accepting a common notion of pollution as that which violates the quality and ultimately the possibility of human life, a relatively simple ascending scale of injury can be drawn up:

Class 1 in which the amenities and aesthetic qualities of life are violated.

Class 2 in which there is injury or death to individuals from environmental contamination.

Class 3 in which whole species are threatened with extinction from distur- bances of ecological inter-relationships.

Class 4 in which fundamental cycles in the biologic pyramid and its natural environment are distorted or destroyed to such a degree that life for whole series of living forms becomes impossible over wide areas and possibly over the globe as a whole.

Such classification in terms of the increasingly complex interaction of cause and effect may allow previous forecasts, where they exist, and descriptions, to be set in some sort of comparative relationship with each other and with present levels. It should also permit policy-making with regard to environmental pro- tection to be pursued while taking account of the level of risk to individuals, groups or society posed by particular pollutants or disamenities.

Most of the early literary references to pollution, when viewed in the light of the above classification, will be seen to be concerned with the first two stages. A major characteristic of the environmentally pessimistic literature including the MIT model is the prediction of events in the Class 3 or Class 4 categories arising from the extrapolation of tendencies in Class 1 and Class 2. Exponential assumptions, we have seen, are fundamental to this mode of thinking. The importance of long-term effects such as the possible man-made climatic changes associated with the increase in carbon dioxide from fuel combustion, however, lies as much with its placing on the above scale (in the later orders) as with the numerical probability of its occurrence. If the impact foreseen is large enough then even highly improbable events must be considered.

If the global effects of the impacts are as catastrophic as they are sometimes predicted then clearly even very small probabilities of occurrence cannot be ignored. It is useful therefore to examine some of the current levels of impact made by technology as exemplified in disaster situations as well as by changes in individual risk levels. Disasters capable of causing disruption at these higher levels were formerly far more likely to arise from nature itself. The Black Death, killing one-third of Europe's population, might be instanced. The eruption of Krakatoa on April 7–12, 1805 and the ensuing dust clouds, caused "the summer that never was in the US" in 1806 when crops failed and average tempera- tures dropped several degrees. Man has succeeded in controlling many of these sources of disruption, so that the simple extrapolation of trends from earlier periods cannot be regarded as a reliable forecasting technique. Conversely the remaining natural hazards will be overcome only by man's technical ingenuity operating within a designed social control scheme.

Introducing the carbon dioxide pollutant question as a practical example, it is relevant to point out that this was originally discussed in its global implica-

tions independently in Sweden in 1896 and in the USA in 1897.[10] The *Scientific American* journal in May 1921 contained the following pertinent remarks on the climatic effect some 20 years later (though this effect is seen only as an interesting side effect to the problem of fuel depletion):

The problem of the world's supply of energy is the subject of an interesting discussion published recently by Dr Arrhenius. It is pointed out that the early exhaustion of our fossil fuels will require the use of such other sources of power as water, wind and sun. The estimated life of the coal fields is put down at 1500 years, and he believes it to be clear that we must soon ration our coal and substitute as far as possible other sources of energy. In view of the greatly increased use of petroleum, it is considered doubtful that mineral oil will constitute an adequate auxiliary supply. Dr Arrhenius calculates that the continual increase of carbon dioxide in the atmosphere from the burning of coal will give the whole world a more uniform and warmer climate.

Systematic monitoring which would have assisted present forecasters did not, however, start till 1958 during the International Geophysical Year.

Control mechanisms

No notice was taken by the electricity planners of the discussion on energy supply; presumably on the grounds of the very tentative nature of the calculations. Recent forecasts, as for instance those of the SCEP report,[10] are still almost as tentative—"this portioning is too uncertain to allow accurate predictions"—ie, of the climatic effects from the calculable physical level. This suggests that, even where modern predictions can be made for future physical levels of pollutants, technical uncertainty as to the effects of these is often such that firm recommendations cannot be made as to safe levels.

This is particularly so when disasters in Classes 3 and 4 above are being discussed. It is almost completely true that the bigger the catastrophe the smaller the probability of occurrence. The reason is that large disasters arise from the concurrent failure of a large number of safety or control mechanisms. The probability is then the combination of many small probabilities. The assumption made by those crying halt is almost invariably pessimistic in these circumstances, on the argument that we should not wait for a disaster, if one can be postulated before banning the activity, however improbable such an event may appear. Similar assumptions are made where the event is not a discrete disaster situation but where very large numbers are exposed to a very low level probability of harm.

Historically, a common mechanism for remedial governmental action has been in fact the occurrence or overwhelming intimation of disaster. Thus far the pessimists are on firm ground. Possibly overworked examples are the Clean Air Act initiated by the 4 000 excess deaths in the London smog of 1952, and the substantial reductions that were obtained in the SO_2 content of New York City air only after the "Thanksgiving" episode of November 1966. The stringent safety precautions which covered railway travel after the death of Huskisson, President of the Board of Trade, at the opening ceremony of a new railway is yet another example of the power of publicity, as is the setting up of the Committee on the Safety of Drugs after the Thalidomide episode.

A pertinent question to be asked of any innovation is does it remove, either within its own system or externally, any of the control or fail safe devices or checks already established. This is, in essence, the basis of Technology Assessment techniques now being developed. Optimists may hold that both nationally and internationally appropriate monitoring, assessment and control techniques may be developed which will diminish pollution and prevent the worst potential disasters from ever occurring.[12]

However, the weight of environmentalist forecasts is heavily on the side of pessimism with respect to future pollution levels. For the reasons which were discussed in chapter 10 economists are generally much more optimistic about physical limits. It is relatively rare to find one like Kenneth Boulding who in an article often quoted in the conservation debate, "Human values on the spaceship Earth",[12] claims that "in the West, our desire to conquer nature often means simply that we diminish the probability of inconveniences at the cost of increasing the probability of very large disasters". This assumption is fundamental to the MIT mode of approach which explicitly rejects the possibility that improved social control mechanisms may diminish the risk of disasters. One is tempted to be persuaded by such predictions that Adam Smith's benovolent 'hidden hand' has been replaced by a malevolent 'hidden boot'. Today's dismal science is no longer economics but ecology. It is not surprising that the leading ecological Cassandras and the MIT system dynamics group quote each other with approval.

Pollution and nuisance: social attitudes

A further useful distinction should be made between pollutants which can be measured in physical terms—mg/m^3 of air, percentage increase in BOD, decibels, etc,—and the degree of human harm on the one hand and the more intangible, in the sense of unquantifiable, nuisances on the other. So many value-loaded attitudes are used in the pollution debate that this distinction becomes more and more necessary. Should, for example, crowding and the possible ensuing stress be taken as an element of pollution? If so, does it belong to Class 1, Class 2 or Class 3?

The links between crowding, violence and possible benefits are not well known. Few measurements have actually been made on humans and much of the available evidence is drawn from rat or monkey behaviour. Anthropomorphism is notoriously inadequate as a guide to animal behaviour. There seems little reason to suppose that ratomorphism will prove more reliable as a guide to human behaviour. Hans Selye, who has made the idea of human stress the centre of his life's work, makes no reference to crowding as producing this ill in his *The Stress of Life*.[13] The subsequent suggestion by the environmentalists that crowding is related to stress may be as much an indication of the rapidity with which such correlations are proposed, for the book was published only in 1956. In any event, a comparison between the USA and Western Europe leads one to doubt whether violence can be correlated with crowding. The difference in murder rates between New York and, say, Brussels, Frankfurt, London, Paris, and Rome cannot be explained in terms of crowding,

even where national comparisons of population density are abandoned in favour of local ones. Insofar as these differences are related to the ease with which firearms can be obtained in the USA, it is worth noting that the right of all Americans to carry firearms is a remnant of the frontier tradition, where both population densities and the effectiveness of law enforcement were very low indeed, not high. The discussion is to some degree academic since though crowding is mentioned in *The Limits to Growth* it is not used in the Quality of Life calculation but held in reserve "in case it might become relevant".[14]

The complaints and forecasts of Mishan about crowding on the Spanish coastline or Greek islands[15] could be taken as a very idiosyncratic judgement and the crowding as an indicator of people's obvious gregariousness and desire for contiguity. In areas where physical measurement is not yet possible greater account must, of course, be taken of perceptions of, and adaptations to, such pollutants. Arthur Young too, in 1769, objected to high density living: "The principal objections to great cities are that the health here is not so good, that marriages are not so frequent, that debauchery prevails and that abuses are multiplied." Among his debaucheries ranked tea drinking.

Attitudes to landscape and land use, major elements in any Quality of Life calculus, are notoriously subjective. The irascible Cobbett, whose *Rural Rides* nowadays often recall a lost and romantic landscape, claimed: "The facilities (ie, the railways) which now exist of moving bodies from place and place are among the curses of the country". Wordsworth both echoes Cobbett and anticipates Mishan in complaining of the intrusion of tourists into his Lake District, the railway "transferring at once uneducated persons in large bodies".

The reaction in the 19th century was much stronger than in the 18th. The Victorian novelists as well as the romantic poets and the pamphleteers all reflected disgust at the decline in quality of life associated with industry. Take for example from *Hard Times* Dickens' Coketown (in reality Preston):

It was a town of machinery and tall chimneys, out of which interminable serpents of smoke trailed themselves for ever and ever, and never got uncoiled. It had a black canal in it, and a river that ran purple with ill-smelling dye, and vast piles of building full of windows, where there was a rattling and a trembling all day long, and where the piston of the steam-engine worked monotonously up and down, like the head of an elephant in a state of melancholy madness. It contained several large streets all very like one another, and many small streets still more like one another, inhabited by people equally like one another, who all went in and out at the same hours, with the same sound upon the same pavements, to do the same work, and to whom every day was the same as yesterday and to-morrow, and every year the counterpart of the last and the next.
These attributes of Coketown were in the main inseparable from the work by which it was sustained.

Mr Gradgrind's sons in this novel were, interestingly enough, christened Adam Smith and Malthus.

George Eliot's *Felix Holt* is typical of the 19th century literature which contrasts the charm of rural life with the changes wrought by industrialisation, and romantically evokes the lost amenities of the past:

Five-and-thirty years ago the glory had not yet departed from the old coach-roads; the great roadside inns were still brilliant with well-polished tankards, the smiling glances of pretty barmaids, and the repartees of jocose ostlers; the mail still announced itself by the merry notes of the horn; the hedge-cutter or the rick-thatcher might still know the exact hour by the unfailing yet otherwise meteoric apparition of the pea-green Tally-ho or the yellow Independent; and elderly gentlemen in pony-chaises, quartering nervously to make way for the rolling swinging swiftness, had not ceased to remark that times were finely changed since they used to see the pack-horses and hear the tinkling of their bells on this very highway . . .
. . . The coachman was an excellent travelling companion. His view of life had origi-nally been genial, and such as became a man who was well warmed within and without, and held a position of easy, undisputed authority; but the recent initiation of Railways had embittered him: he now, as in a perpetual vision, saw the ruined country strewn with shattered limbs, and regarded Mr Huskison's death as a proof of God's anger against Stephenson.

The fact that 19th century writers often viewed the spread of railways with horror, whereas today they are often the objects of nostalgic affection and conservation activity, does not of course mean that all hostility to new tech-nologies can be dismissed as irrational neo-phobia. It does however illustrate the fact that attitudes do vary a great deal over time, as well as between different individuals, social groups and cultures. Technologies (such as rail-ways) and buildings (such as the Eiffel Tower) which were once regarded with hostility may later become the objects even of veneration as familiarity softens the early shock of change and as society learns to tame and civilise the strange new forces which have been unleashed. It is hard to believe that people can accommodate to such obtrusive results of technology as the sonic boom or the destructive impact of private road transport on town and country and it would be unacceptably Panglossian to believe that such adaptation will or should always occur. However, it is perhaps easier to determine either the effects or true public preferences by consideration of each disamenity separately than it is by attempting to integrate all disamenities under an ill-defined quality of life or pollution index. Arguments against such aggregation, which borders on the absurd with the present paucity of data, were developed in chapter 7.

Conservation movements

Much could and has been made of the national origins of the environmental crisis or sense of crisis. The collapse of the American Dream and the boundless frontier may be compared with the relative stability of the European view of nature.[16] Generally speaking Europeans were compelled to take measures of social control over urban development and rural conservation much earlier. Hardy's Jude the Obscure walked to Oxford 100 years ago by a path unchanged today. Could a latterday Huck Finn still float down the Mississippi without surprise and shock?

The first American Conservation Movement, as it has been called, ran from about 1890 to 1920. The movement moved ultimately from natural resource conservation—water, woods and fields—to pure food, anti-industrial-isation, child labour, purity of race (affecting immigration policies) and Anglo-Saxon supremacy. In the beginning, however, conservation of nature

was the particularly American part of a wider revulsion against the social philosophy of the self-regulating market economy. Small entrepreneurs were beginning to discern the threat of the large corporations and the census of 1890 had foretold the demise of the boundless frontier. Can a parallel be made in the 1960's with the moon landings, emphasising the smallness of the Earth, and the rise of the multinational company as the new faceless giant in the economy? Or is the environmentalist and anti-growth movement in the USA a diversion from broader and more uncomfortable questions of war or race?[17] The clearly defined sectorial interests[18] which have espoused the cause have made some suggest latent political purpose.[19] Thus the apparent inability of the system of American local government to deal with what Galbraith described some 15 years ago as private affluence and public squalor could be linked with an unwillingness of middle and higher income groups to pay more taxes to remedy the public squalor.

The popular conservation movement often reflected bigoted and unscientific attitudes to problems of nature and society. On a wider and more ecologically elevated level, however, an example from a scientific journal of 100 years ago,[20] will serve to illustrate the perceptions (if not predictions) of the disamenities of technological advance of the period:

The habits of the present generation are such as to give rise to more refuse matter and poisonous products than those of previous ages. The fuel we use, the articles we manufacture, and the waste of sewage combine to create more impurities than were known to our forefathers, and *if it were not for the fact that science has given us remedies nearly in proportion to the increased evil*, our population would diminish under the high-pressure system which at present prevails.

As suggested here, the peculiar virulence of the American ecological movement and its religious crusading spirit may be related to the relative failure of the American social system to establish elementary planning controls and social services of the type which have long been familiar in Europe. But the pessimism of the MIT group and similar prophets with respect to social control mechanisms may also be explained in part by the failure of many early attempts to control pollution hazards both in the USA and in Europe. Environmental controls in the USA are almost entirely new and the sectorial interests less recognised, but there has been a longer experience in Europe. A short history of one of the pollutions of urbanisation and industrialisation is described below. That such disamenities of society were unevenly distributed even in the early 18th century England was recognised by Defoe in *The Life and Strange Surprising Adventure of Robinson Crusoe.*

He bid me observe it, and I should always find, that the calamities of life were shared among the upper and lower part of mankind; but that the middle station had the fewest disasters, and was not so exposed to so many vicissitudes as the higher or lower parts of mankind quietness, health, all agreeable diversions, all agreeable pleasures were blessings attending the middle station of life; that this way men went silently and smoothly thro' the world . . .

The large expansion in developed countries of the "middle part of mankind" and their exposure, for example, to the noise and hazards of jet aircraft, the stress-induced diseases and the crowding of holiday places has changed all that.

The history of British attempts to control air pollution could be interpreted in many different ways and we now turn to a brief consideration of this experience.

Air pollution in Great Britain: a short history

The earliest known record of an attempt to prevent air pollution in England dates back to 1273 when an ordinance was issued, prohibiting the use of coal in London as being "prejudicial to health". In 1306 a royal proclamation prohibited the use of coal by artificers in their furnaces. Penalties were exacted (records exist of the execution of one offender), but the proclamation was apparently of little effect and the following year a commission was appointed with instructions to "inquire of all such who burnt sea-coal in the city or parts adjoining and to punish them for the first offence with great fines and ransoms and upon the second offence to demolish their furnaces". However, trade and manufacturing increased and so fuel was used in greater quantities. Local wood had once been the main source of fuel but as supplies dwindled greater use was made of coal transported by sea from Newcastle. In consequence smoke inconveniences increased.

By Elizabeth I's reign the situation in London had worsened considerably and she is reported to have complained that smoke issuing from breweries in the vicinity of the palace caused her "grievous annoyance" and towards the end of her reign the use of coal was prohibited in London while Parliament was sitting.

Complaints against smoke continued but agitation was sporadic and individual. Probably the earliest reasoned case against smoke was put by the diarist John Evelyn in 1661. He was prompted to write a pamphlet on the subject, *Fumifugium*, which he presented to Charles II. Evelyn believed the main offenders to be, not the "culinary fires", whose modern equivalent, the domestic fire, has been shown to be one of the major sources of pollution, but the furnaces of "brewers, dyers, lime burners, salt and sope boylers . . . one of whose spiracles alone does manifestly infect the Aer more than all the chimneys of London put together besides". Apart from long descriptions of the evils of smoke, *Fumifugium* contained three rational, if not radical or far sighted, suggestions for its abatement. First, London should be supplied with large quantities of wood to be sold at cheap rates thereby decreasing the quantities of coal used. Secondly, all industries in central London should be moved down the Thames to Greenwich, thus decreasing the concentration of smoke in the central areas, and finally that central London should be surrounded by an area planted with trees and sweet smelling flowers which would disguise any remaining evil fumes.

Centuries later all three of these approaches were to be attempted: substitution of smokeless fuels, zoning of industry and the Green Belt concept. This was, however, only after things had got far worse in the period of the Industrial Revolution. The aggravation, in intensity and comprehensiveness, of this pollution by the Industrial Revolution may be gauged from many contemporary accounts. The Midlands and the North suffered far more than London. Manchester was notorious and probably typical of many Northern cities. One account reads:

A sort of black smoke covers the city. The sun seen through it is a disc without rays. Under this half-daylight 300 000 human beings are ceaselessly at work. A thousand noises disturb this dark, damp labyrinth, but they are not at all the ordinary sounds one hears in great cities.

The footsteps of a busy crowd, the crunching wheels of machinery, the shriek of steam from boilers, the regular beat of the looms, the heavy rumble of carts, those are the noises from which you can never escape in the sombre half-light of these streets.[21]

The environs of the Tyne and Mersey estuaries were little better. New residents of Newcastle "looked from that great high level bridge in the Tyne and cried in a kind of despair . . . as they observed a canopy of black smoke almost everywhere". While people visiting Widnes for the first time entered that town with a certain awe and wondered if life could be sustained there.

The 1819 Select Committee on Steam Engines was the first of its kind to investigate air pollution and it established precedents for the many committees that were to follow. The members were all experts in the field; either engineers, physicians, proprietors and users of steam engines or men who had served as commissioners of nuisances. No scientific evidence was available, however, and the committee's report was based on the memories of witnesses who testified among other things how views had been obliterated by rising factory chimneys.

The Committee was unanimous in its conclusion that the volume of smoke and the nuisance caused by smoke had increased over the past 30 years, but were optimistic that the smoke might be "considerably diminished or need be altogether removed".

That manufacturers were unwilling to take measures to prevent smoke nuisances is supported by the small use made of existing abatement devices. An adequate smoke consuming device for steam engines had been perfected in 1789 by John Wakefield but it required extra coal and was not widely used. Thus technical attempts to reduce air pollution foundered on the economic arrangements, as they frequently do today.

Despite the unpleasantness caused by dirty air, it was only when it was suspected of being a factor in the increasing frequency of epidemic diseases and in rising mortality rates that it gave any cause for either alarm or action on the part of the government.

The Committee estimated that the cost of prevention measures would not be excessive to manufacturers and that prevention devices would not unduly hamper industrial processes. The United States Environmental Protection Agency came to similar conclusions 150 years later.[22]

The Committee was well aware of the sorry state of local acts to combat smoke and emphasised that legislation should be national in scope. Parliament should introduce the necessary legislation. They showed foresight too in anticipating a steadily worsening situation if no action were taken. As to whether their recommendations would be heeded the committee was optimistic. They anticipated "cordial aid and co-operation, on the part of the proprietors of factories in accomplishing an object so essential to the comfort and well-being of the surrounding country and population". Apparently the problem was greater than anticipated, for a supplementary committee was appointed in 1845.

Difficulties were justifiably foreseen. Would manufacturers be prepared to adopt a plan which involved them in extra costs, even if they realised these expenses would be slight? Would they be prepared to regard smoke prevention measures as an investment with long range advantages? Witnesses who gave opinions on this aspect were very pessimistic; they felt that ignorance and unwillingness to bear extra costs, however small, would prevail.

De la Beche and Playfair, investigating in 1846, discovered several reasons for the ineffectiveness of local Acts. In the first place, the Acts lacked precision in wording and failed to define clearly the concept of nuisance. Secondly, where smoke inspectors existed they had to prove that smoke was issuing from the offending furnace when they imposed the fines. Very often no smoke inspectors existed but local authorities had power to take court proceedings against smoke offenders on registry of a nuisance caused. Local authorities were often hesitant in taking cases to court. Even when the guilt of an offender had been proven, magistrates, often with vested interests in the town's manufacturing, hesitated to impose fines. It was possible for individuals to take proceedings against a manufacturer but this needed capital and time, and very often the complainer had neither.

By 1862 the problem of air pollution had acquired a new aspect; attention turned from the long-standing problem of smoke to more lethal pollutants, which killed both plant and animal life, reducing countryside to unrecognisable waste land.

The various Acts and committees had little general effect, certainly prior to the 1863 Alkali Acts. These Acts were some of the first really effective pieces of anti-pollution legislation. An extremely important feature was the social innovation of a professional government inspectorate and the systematic use of scientific expertise in regulating the increased pollution from the chemical industry. In spite of manufacturers' concern about the effects of the first Act on competitiveness, its introduction led to at least one spectacular improvement. In the manufacture of alkali, "almost overnight, the evolution of (hydrochloric) acid was reduced from 13 000 tons to 43 tons *per annum* .. ". [23] Manufacturers came to accept and even welcome the work of the inspectorate but, as MacLeod notes: "The conditions in chemical works of the time, and the nature of the Leblanc industry itself, while it lasted, put a total solution of the problem beyond reach."[24] A more complete solution depended on further scientific progress and invention.

Even more effective than the Alkali Acts was the Clean Air Act of 1956.[25] Almost all observers are agreed that East London and the industrial towns of the North are almost unrecognisable as a result of the successful reduction of smoke pollution from domestic and industrial sources. Central London smoke concentrations have decreased by 80% since 1958, sulphur dioxide concentrations have decreased by 40% and December sunshine has been increased by 70%. The air of Bradford, Leeds and Sheffield has been sufficiently cleaned to allow those monuments to 19th century industrialism, the Town Halls, to be returned to their pristine and eccentric glory.

This account has dealt very briefly with some limited aspects of air pollution in Britain. Clearly several different interpretations are possible. On one interpretation, mechanisms of social control have always been inadequate

and introduced long after the population was already exposed to dangerous hazards. Technology and industrialisation as such are inevitably polluting and largely outside intelligent social control. This is the interpretation adopted by the MIT group and extrapolated indefinitely into the future.

Another possible interpretation is that the unbridled pursuit of private gain rather than industry and technology *per se* has been the main problem. In this case alternative institutional arrangements might be expected to resolve some of the problems. That amelioration is sometimes possible is suggested not only by the experience of the Alkali Acts and the Clean Air Acts but also from the history of Public Health legislation and control over the quality of foods and drugs in many countries. Those who are concerned about the quality of our food and drink today might ponder over this description from Smollett's *The Expedition of Humphry Clinker* of London's milk supplies in the 18th century:

I need not dwell upon the pallid, contaminated mash, which they call strawberries; soiled and tossed by greasy paws through twenty baskets crusted with dirt; and then presented with the worst milk, thickened with the worst flour, into a bad likeness of cream; but the milk itself should not pass unanalysed, the produce of faded cabbage-leaves and sour draff, lowered with hot water, frothed with bruised snails, carried through the streets in open pails, exposed to foul rinsings, discharged from doors and windows, spittle, snot, and tobacco-quids from foot-passengers, overflowings from mud-carts, spatterings from coach-wheels, dirt and trash chucked into it by roguish boys for the joke's sake, the spewings of infants, who have slabbered in the tin-measure, which is thrown back in that condition among the milk, for the benefit of the next customer; and, finally, the vermin that drops from the rags of the nasty drab that vends this previous mixture, under the respectable denomination of milk-maid.

Conclusions

The fundamental question of whether increases in material output are necessarily linked with equal or greater increases in pollution remains unanswered. The arguments for and against the proposition remain largely qualitative. The mixture of rises in physically measurable pollution with rises in other dis-amenities allow the discussion to be conducted on shifting ground. The allowance that must be made for social and personal value changes seems to ensure that this position will remain for some time. Early forecasts seldom, if ever, were cast in quantifiable terms. The difficulties this presents for the pollution sub-system became clear in chapter 7.

The MIT models have attempted to state the problem in quantitative terms though adequate statistical data necessary for this quantification do not yet exist. The MIT group has therefore made assumptions about future trends in pollution levels which are quite intelligible in the context of the USA environmentalist concern but are by no means the only possible scenario for a world future.

It is clear that social and administrative controls and technical improvements can be utilised to reduce the pollution burden. See, for example, reports of lake eutrophication.[26] This is a phenomenon which is often announced by the environmental lobby as being symbolic of wider decay. It is also apparent that

existing and available technical capabilities for improvement are often not used because of economic considerations, narrowly defined. It might therefore be argued that the model builders are correct, particularly if their purposes are polemical rather than scientific, in neglecting in the first instance the possibilities of the social implementation of improved abatement techniques. Moreover, it is clear from economic analysis of pollution control that, assuming that pollution grows at the same rate (or faster) as consumption per head, economic growth must always lead to a diminution in social welfare after some point of maximum social welfare is reached, provided that some residual pollution exists.[27] Thus, with permanent damage to the environment there will be conflict between short-run and long-run welfare maximisation. The difficulties of a scientific debate lie in the uncertainties of forecasting and anticipating levels of disamenity.

The discussion above on carbon dioxide levels may be used again to illustrate some limits of the scientific forecast at the higher effects level of impact (Classes 3 and 4). Currently, concentration is 320 ppm and fuel combustion produces another 2 ppm annually, of which 50% remains airborne. An authoritative study[28] assumes a 4% annual growth in fossil fuel combustion (the trend extrapolated by the UN) and the same proportions of fuel type as previously to give a level of 379 ppm by the year 2000. While the mathematical model from which these numbers are derived is relatively simple, the calculation of possible consequent climatic changes is considerably less so. Other pollutants, such as dust particles, man-made or from natural events, such as the Krakatoa eruption referred to above, the Mount Tambura (1815) or the Mount Agung (1936), may affect the resultant temperature changes. The difficulties of statistical inference even in a field where social and economic considerations can be excluded such as meteorology can be demonstrated from the use made by the environmentalist lobby of this data. The rise in both CO_2 and average world temperature over a number of years was taken as evidence of a causal relationship. With a reversal of the temperature change it became necessary for the environmentalists to posit increasing dust in the atmosphere as the cause. The physical bases of these mechanisms are well known. The correlation is quite impossible to prove although the idea was scientifically propounded as early as 1863.[29] How much more difficult, then, to use a world model to understand cause and effect relationships where the complex social and political interactions are subsumed or unknown.

Modification of high level cloud formation by SST operation is yet another example where speculation can produce disastrous predictions and where scientific rebuttal is impossible. The Report of the Study of Man's Impact on Climate (SMIC)[30] remarks:

Whereas we do have a rudimentary theory of climate and a good deal of knowledge about how things behave in the physical world, when we turn to a forecast of man's behaviour we must resort to simple extrapolation of present trends with only slight shadings to take account of the more obvious interactions that we can foresee. There are no laws that we know of, or mathematical models, that will allow us to predict the future course of human affairs better than such extrapolations. Therefore, we can in the end only forecast what *could* happen *if* mankind proceeds to act in a certain way, more or less as he is acting now.

Thus even modern forecasting methods and scientific knowledge can be used only as very approximate guides to future levels of pollutant (see the examples given in chapter 7). A countervailing effect to this is often the existence of unexploited abatement techniques which social pressures can bring into play. A recent, thorough forecast[31] of plastics waste and litter neatly balanced the technological problems with the social. It surveyed the problem till the year 1980 in the UK and assumed growth rates of plastic packaging of 20% *per annum* and 12% *per annum*. "There is", it states, "insufficient past accumulation of data to allow trend analysis ... the figures are based on opinions, experiences and the responses of those who are involved in the processes of manufacturing, packaging and retailing." Thus subjective elements must be present. By 1980, 4·5–6·5% of waste will be plastics; however, modern (ie, existing) methods of incineration "can successfully cope with wastes containing plastics in larger amounts than are likely to occur within the next 20 years". Chlorine corrosion can be prevented, HCl in the effluent gas is lower than theory predicts and can be dealt with by wet-scrubbers, large scale high pressure compaction and the economics and technology of baling are attractive. However, old incinerators and low stacks will cause trouble and the litter problem remains. The problem thus appears one of implementing best technical practice on the one hand, and of educating public behaviour on the other. Where existing techniques and knowledge are not sufficient, a fruitful area exists for the reallocation of research and development effort towards anti-pollution, or in general, welfare ends.[32]

This review of previous situations has demonstrated the capability of the technological system to respond to social and administrative pressures effectively applied. It is clear that this response has varied in the past and from country to country. It suggests that further effort is required both to measure objectively the extent of pollution and to develop adequate social control mechanisms. It is clear, too, that considerable unification of governmental and industrial policy towards both pollution and amenities is required if some major loss of life quality is to be avoided. Vigorous campaigning by informal pressure groups in local situations can produce official responses and force more rigorous and extensive monitoring.[33] What is questionable is that wide aggregation and simple trend extrapolation will produce other than the kind of crisis response that leads to irrational use of resources or provoke the more damaging attitudes of cynicism or despair.

The rejection of sweeping pessimism could well lead to the error of complacency. This can take two forms, a simple Pollyanna-like attitude of believing everything will turn out for the best, or the more jejune and cynical idea that it has all happened before. Instances of the Roman laws controlling street traffic are offered in support of the latter case, but neither this nor the theory that lead poisoning from the plumbing system caused the collapse of the Roman Empire can really be taken as relevant to the present situation. Today's problems are different in nature and extent, too different to allow them to be collected into a single term. Too little is known about their nature, the risk levels are too uncertain, and the extent of their effects too diffusely presented to allow such aggregation. The history of past threats to human life points both to the strong need for the design of social controls and to the possibility of their successful implementation.

The problem of obtaining a rational and balanced viewpoint on future pollution levels is one of balancing risks and benefits, of weighting likelihoods and of assessing possibilities. It is thus one of deciding what levels are acceptable and tolerable by adapting technological opportunities to informed and participating social demand.

References

1. H. E. Daly, "Towards a stationary state economy", in Hart and Socolow, *Patient F* (New York, Hart Rinehart and Winston, 1971)
2. E. Goldsmith, ed, *Can Britain Survive?* (London, Sphere, 1971)
3. Sir Eric Ashby, Chairman, *Royal Commission on Environmental Pollution*, Cmnd 4585 (London, HMSO, 1971)
4. L. B. Lave and E. P. Seskin, "Air pollution and human health", *Science*, vol. 169, No. 3947, 1970, pages 723–733
5. S. de Beauvoir, *Les Belles Images* (Harmondsworth, Penguin, 1969)
6. R. England and B. Bluestone, "Ecology and class conflicts", in Allan and Hansow, eds, *Ecology, Society and Man* (California, Wadsworth, 1971)
7. G. Schwab, *Dance with the Devil* (London, Bles, 1963)
8. J. Platt, "What we must do", *Science*, Vol. 166, No. 3909, 1969, pages 1115–1121
9. H. Frederikson, "Feedbacks in economic and demographic transition", *Science*, Vol. 166, No. 3907, 1969, pages 837–847
10. Report of the study of critical environmental problems (SCEP), *Man's Impact on the Global Environment* (Cambridge, MIT Press, 1970)
11. K. Boulding, "The economics of the spaceship Earth", in H. Jarrett, ed, *Environmental Quality in a Growing Economy* (Baltimore, Johns Hopkins Press, 1966)
12. T. C. Sinclair, "Technology assessment in the UK", *Technology Assessment*, Vol. 1, No. 2, 1973
13. H. Selye, *The Stress of Life* (New York, McGraw-Hill, 1956)
14. Donella Meadows, personal communication
15. E. Mishan, *Technology and Growth, the Price We Pay* (New York, Praeger, 1969)
16. D. Fleming, "The roots of the new conservation movement" in D. Fleming and D. Bailyn, eds, *Perspectives in American History* (Harvard University Press, 1973)
17. I. F. Stone, "Con games" in *Earth Day—The Beginnings* (New York, Bantam Books, 1970)
18. D. A. Dillman and J. A. Christenson, "The public value for pollution control", in W. R. Birch, N. H. Cheek and L. Taylor, eds, *Social Behaviour, Natural Resources and the Environment* (New York, Harper and Row, 1972)
19. N. Podhoretz, "Reflections on Earth Day", *Commentary*, Vol. 49, pages 26–28, 1970
20. Editorial, *Scientific American*, January 1872
21. *Industrialisation and Culture 1830–1914* (Oxford University Press, 1970)
22. US Department of Commerce, *The Economic Impact of Pollution Control* (Washington, DC, Environment Protection Agency, March 1972)
23. R. MacLeod, "The Alkali Acts Administration, 1863–84: the emergence of the civil scientist", *Victorian Studies*, Vol. 9, No. 2, December 1965, pages 85–112
24. R. MacLeod, *Ibid*, page 87
25. Sir Eric Ashby, Chairman, *Royal Commission on Environmental Pollution*, Cmnd 4585 (London, HMSO, 1971) Figures 1–5
26. P. McGaukey *et al*, *Eutrophication of Surface Waters—Lake Tahoe—Indian Creek Reservoir*, Series No. 16010 DNY (Washington, DC, US Environment Protection Agency, 1971)
27. L. Laudadio, "On the dynamics of air pollution: a correct interpretation", *Canadian Journal of Economics*, Vol. 3, 1970, pages 563–571
28. SCEP, *op cit*, page 55
29. J. Tyndall, "On radiation through the earth's atmosphere", *Phil. Mag.*, 25, Fourth Series, 1863
30. Report of the Study of Man's Impact on Climate, *Inadvertent Climate Modification* (Cambridge, MIT Press, 1971)
31. J. J. P. Staudinger, *Disposal of Plastics Wastes and Litter* (London, Society of Chemical Industries, 1970)
32. C. Freeman *et al*, "The goal of R & D in the 1970's", *Science Studies*, Vol. 1, No. 4, pages 357–406, 1971
33. A. Wildavsky, "Aesthetic power or the triumph of the sensitive minority over the vulgar mass; a political analysis of the new economics", *Daedalus*, Fall, 1967

13. SYSTEM DYNAMICS AND TECHNOCRACY

Harvey Simmons

The similarities and differences between the 1930's technocracy movement in the USA and the approach of Professors Forrester and Meadows are examined. The values and assumptions implicit in the MIT applications of system dynamics are identified, as are those of the Club of Rome. Some possible explanations of the huge impact of the MIT work are put forward.

FOR a short time during the 1930's a movement known as Technocracy flourished in the United States. Headed by a Mr Howard Scott, the group included a number of engineers and economists, among the latter some disciples of Thorstein Veblen. In 1932 the group entered into contact with certain important members of the American business community and a meeting was held at the exclusive Metropolitan Club in New York City. Among those present were the president of E. R. Squibb and Company; Colonel J. W. McCormick, president of Fiduciary Company; Henry R. Luce, editor of *Time* and *Fortune* magazines, and others. Soon afterwards, rumours began to circulate that the Technocracy group was about to initiate a new design for the social and industrial organisation of the American economy. Intended to meet the serious problems then posed by the Depression, it was based on Scott's idea that only by making use of the rational and scientific methods so familiar to engineers could the crisis be solved. One of Scott's associates, Dr Walter Rautenstrauch, Professor of Industrial Engineering at Columbia University, tried to explain the scheme by comparing society to an electric power system where the units have to operate in combination to generate current at varying load demands. This meant the units had to be integrated and controlled by scientifically designed devices. According to Rautenstrauch, only scientifically designed controls and regulatory systems could stabilise the erratic economy. The ultimate results would be, as Scott suggested, that "man, for the first time in history, finds himself occupying a position in which a complete utilisation of his knowledge would assure the arrival of certainty in a continental social mechanism". The main problem would be to remove the "riff-raff of social institutions" that blocked the way to the more productive use of American, and eventually world resources. With the engineers at the helm, the voyage to

utopia could finally begin. Unfortunately the Technocracy crew soon fell to quarrelling, the rather murky background of Mr Scott attracted journalists who found his biography to be quite different from that attributed to him, and the movement ultimately died out.[1]

The brief success of the movement did popularise the name and the notion of Technocracy and, if this particular group failed, since the 1930's the political and social influence of engineers, economists and scientists has grown enormously. Now, some four decades later, supported by a group of European managers and researchers, another group of scientists has burst on the scene, this time warning us that only through the use of computer technology and the application of certain statistical techniques will we learn how to avoid ultimate world disaster. If they do not promise to lead us to utopia, they do claim that their techniques are well suited to save us from sliding into dystopia.

The dissimilarities between the Technocracy group of the 1930's and the system dynamics group of today should be stressed. Whereas Scott had evidently faked an academic background in engineering, the leader of the new movement, Jay W. Forrester, has impeccable academic credentials. Whereas Scott managed to attach himself to Columbia University for a brief period, Forrester and his associates are part and parcel of the Massachusetts Institute of Technology. Whereas Technocracy claimed the economic problems of the United States could be solved through the use of scientific and engineering techniques, that political institutions alone stood in the way of maximising the enormous amount of untapped energy in the USA, Forrester and his men take the completely opposite view, stressing that political solutions will be needed to prevent world disaster.

Yet, despite these key differences, there are certain important similarities. First, there is the belief that engineering techniques can be used to indicate both the source of our problems and some possible solutions. Second, there is a shared scepticism about the ability of the citizen to understand through ordinary processes both the nature and possible resolution of these problems. Third, there is the link between scientists and a disinterested but prominent and influential elite. In the case of Technocracy, this elite was composed of businessmen; in the case of the system dynamics group, and appropriately enough in the 1970's, this elite is composed of men who are at the top of various knowledge institutions: research institutes, foundations or management consulting firms. Fourth, there is an immense, and therefore, dramatic simplicity of analysis. Fifth, since both groups share certain messianic qualities—a common faith, shared objectives within the group, and even a desire to proselytise—they can easily be viewed as movements.

Indeed, Forrester is quite convinced of the desirability of educating more and more people to accept the system dynamics approach. This follows logically from his view that most people cannot accept short-term deprivation in the interest of long-term effectiveness. His solution, in keeping with the simplicity of his view of social systems, is to educate people in system dynamics. He has stated that "fundamental, deepseated, sweeping changes cannot occur until there is a widespread public understanding and awareness, until some of the results of systems research have been conveyed more widely, until there are textbooks within the reach of high school and secondary students, and until

there are professional programmes in dynamics of systems in universities".[2] Given the fact that Forrester has estimated it might take 10 to 20 years for the system dynamics scheme to be accepted by the academic community and to begin turning out people qualified in its use, and adding that to his estimate that the long run effects of policies inspired by his approach would not make their effects felt until at least ten years after their inception (in the urban system), it would appear that a minimum of perhaps 20 years will have to elapse before the system dynamics approach and the policies derived from it have a real impact on political life. Of course, intuition tells us that this is an unlikely course of events. On the other hand, one should not underestimate the confidence of men like Forrester who himself has written: "The convergence of two areas of MIT pioneering—feedback theory and computers—may produce far greater impact on society than more popularised developments like atomic energy and space flight".[3]

Although control engineers and econometricians had used other types of mathematical simulation of complex systems, the specific system dynamics approach was invented by Forrester, who is Professor of Management at the Alfred P. Sloan School of Management of MIT. Born in 1918, Forrester received a Bachelor of Science degree from the University of Nebraska in 1939 and an SM degree from MIT in 1945. He received honorary doctorates from both Nebraska and Boston University. From 1939 until the end of the war he worked on servo-mechanisms at MIT, then on digital computers. From 1951 to 1955 he was head of the Lincoln Laboratory for Air Defense at MIT, and from 1956 a professor of industrial management. His achievements as a technical inventor in servo-mechanisms, digital information storage and industrial control are considerable. In 1968, he received the Inventor of the Year award from George Washington University and the Valdemar Poulsen Gold Medal from the Danish Academy of Technical Sciences. His book *Urban Dynamics*, was chosen as the best publication in 1970 by the Organization Development Council. His first major published work applying system dynamics was *Industrial Dynamics*, 1961. *World Dynamics* was published in 1971.

Forrester first developed system dynamics as a means of helping to solve management problems in industrial firms, but he claims—and both his work and the work of his former graduate student and now associate Dennis L. Meadows, try to demonstrate—that system dynamics can be applied to any kind of system, industrial, political or social. After completing *Industrial Dynamics*, Forrester made the acquaintance of the former mayor of Boston, John F. Collins. Collins had been appointed to a professorship at MIT after retiring from public office in 1967 and was given an office next door to Forrester. Forrester's interest in applying his scheme to urban problems was awakened, he wrote a simulation model of the urban system, and completed *Urban Dynamics* soon after.

The genesis of world dynamics occurred in the following way. Professor Carroll Wilson of MIT, a member of the Club of Rome, suggested to the Club that they might like to hear a presentation by Forrester of his system dynamics scheme. At that time the Club was looking for a suitable methodology for a project on "the predicament of mankind". Forrester was invited to Bern, Switzerland, where the Club of Rome was holding a meeting on 29–30 June

1970. Forrester gave his presentation and then, on the flight home on 1 July 1970 began to work on the equations for a world dynamics model.[4]Members of the Club of Rome, on Forrester's invitation, then came to Cambridge for a ten day conference from 20 July to 31 July for further discussion of system dynamics and the world model. The result was that the Club agreed to try to obtain funds for Forrester's associate Dennis L. Meadows for a project on the predicament of mankind. In the event, $250 000 was obtained from the Volkswagen Foundation to support Meadows' project which recently led to the publication of his book, *The Limits to Growth*. In the meantime, in 1971, Forrester published his own sketch of the world system as *World Dynamics*, a short book of 142 pages including appendices. Since the theory is basically Forrester's, it is important to understand how he thinks system dynamics can help us understand social systems.

According to Forrester, "mental models" and "computer models" are pretty much the same thing, the difference being that computer models are more "explicit". Moreover, computer models can do something mental models cannot: they can show the "dynamic consequences of interactions between components of the system". That is, they can look at and analyse the interaction among a number of variables over time with a high degree of accuracy. When we try to think ahead about the consequences of certain kinds of actions using mental models we are "usually wrong" in our conclusions. As Forrester puts it, "our intuition is unreliable. It is worse than random because it is wrong more often than not when faced with the dynamics of complex systems." The reason for this is that we tend to think in terms of "uni-directional cause and effect linkages rather than the feedback loop structure that actually exists. For example, we think of the faucet controlling the water in the glass, but do not think of the faucet at the same time being controlled (through our sight and action) by the water in the glass." This leads us to misunderstand complex systems and to think of them in simple causal terms rather than in terms of complicated feedback loops. "Complex systems are diabolical. In fact, the 'obvious' correction exerted on the apparent cause will often make matters worse."[3]

At this point we might ask whether Forrester is not misusing words. For one thing he constantly contrasts "intuitive" policies with "counter-intuitive" ones. But "intuitive" means immediate apprehension, immediate insight. Some people may claim intuitive understanding of a social system or hold that policy-makers should use only intuition in designing policies. Other people like to think they use reason in analysing or dealing with social systems. Because they make mistakes this does not necessarily mean they have been too dependent on intuition, although this certainly may happen. But they may also have had poor information, or their reasoning may have been incorrect, or they may simply have misjudged what they were looking at. Social systems are extraordinarily complicated and in trying to work out policies for them, despite the fact that we try to calculate the possible consequences of our policies in advance, we are frequently deceived. If our information and assumptions are right, a computer can enable us to work through the consequences or the preconditions for a range of events, some of which might not be detected or predicted by the naked, uncomputerised eye. But if our assumptions are wrong, then we shall be just as wrong with a computer model as without one.

There is another reason for questioning Forrester's use of the notion of intuition and counter-intuition. In social systems, when policy makers elaborate policies, they may fail to achieve the results intended not because they have misperceived the situation, not because their analysis was incorrect—and certainly not because they used their intuition only to find that the system is counter-intuitive—but rather because of the very nature of the political process. Politics is the art of compromise, and every politician knows that half-hearted, watered-down policies often are the necessary result of going through that process. In addition, most political systems are still not good at responding adequately and equitably to the whole range of societal interests and aspirations.

When Forrester contrasts the counter-intuitive behaviour of complex social systems with the rather simple intuitive process of mental modelling, he is not only using language incorrectly but deliberately preparing the ground for his surprising policy statements. For having completed his analysis, he will defend his policies by admitting that, although they are counter-intuitive, they are appropriate to the situation.

Urban and world dynamics: the approach

The way in which Forrester goes about elaborating and defending policy suggestions can best be understood by looking briefly at the conclusions of *Urban Dynamics* and *World Dynamics*.

According to Forrester, *Urban Dynamics* is "about the growth process of urban areas", and while he is obviously talking about a model of an urban system, he frequently refers to "urban areas" thus giving the impression his book is about a real urban system, rather than the extremely simplified model he has constructed. In any case, *Urban Dynamics* analyses the reasons why urban areas rise or decline by constructing a model whose three principal sub-systems are business, housing and population. As in the world model, the simulation is constructed on the basis of data on how each of the variables in the model affects the other. How do changes in the tax rate, for example, affect the rate of construction of low cost housing, or the immigration of new workers to the city? Equations are worked out for the manner in which each of these variables interacts with others, the model is then processed by the computer which determines how the system might work given different changes in the variables. One of the problems with Forrester's work here—and this is true of his world model as well—is that he supplies virtually no evidence for the basis of his equations. Forrester admits he has been criticised for constructing a model of an urban system without any apparent acquaintance with the literature on urban systems but he excuses this by claiming that "the book comes from a different body of knowledge, from the insights of those who know the urban scene first hand, from my own reading in the public and business press, and from the literature on the dynamics of social systems for which references are given".[5] (The "literature on the dynamics of social systems" consists of six references, all to publications by Jay W. Forrester. They are the only references in the entire book).

According to Forrester a declining or stagnating city has a high number of

underemployed workers, declining industry and high taxes. The result is slum areas, high tax rates, flight of industry to the suburbs and high welfare rolls. A healthy city has the reverse symptoms, ie, high employment, rising industry, etc. The question Forrester poses is, in terms of the sub-systems in the model, how does a city move from conditions of decline towards revival? Forrester then alters a number of variables in his model to stimulate a series of traditional urban programmes: creating jobs for the underemployed, job training programmes, tax subsidies, and low-cost housing programmes. Each of these, it appears, only degrades the system after an initial, brief period of improvement. In the end, Forrester concludes, certain unexpected policies are called for if the system is to revive. "The problem of the stagnant area is one of too much housing compared to employment opportunities and too much old industry and housing compared to new". Thus, "urban revival requires demolition of slum housing and replacement with new business enterprise". According to Forrester, the "surprising" finding is that traditional "humanitarian" motivated programmes such as job training, etc, only make the urban situation worse, whereas the "counter-intuitive" proposal of demolishing slum housing and helping new enterprises to get started leads to an improved urban situation.[6]

World Dynamics is system dynamics applied to the world, only the variables have been changed. The major sub-systems here are: population, capital investment, natural resources, pollution and quality of life. Here again Forrester plays with each variable in turn, trying to determine what effect changes in one, or in combinations of variables have on the system. He concludes that an increase in capital investment, that is in industrialisation of the developing countries, only increases pollution to disastrous proportions. Slowing the population growth through birth control leads to a temporary improvement but if capital investment is not limited, the pollution problem again becomes a serious danger to life and so also does the depletion of natural resources. The only solution, according to the model, is to reduce the birth rate drastically, to limit food production and industrialisation. Only then can pollution be mastered; only then will none of the other variables go out of control. A coordinated, integrated and total approach to the world system seems to be indicated.

Its limitations

In both *Urban Dynamics* and *World Dynamics* Forrester emphasises that the solutions to the problems posed in the urban and world systems are surprising and "counter-intuitive". They run against "short-term humanitarian" assumptions, and Forrester is quite frequently sceptical of "humanitarian" motives as a basis for elaborating policies.[2] Is it true, however, that the policy suggestions Forrester derives from his model are really surprising? The simplest way to answer these questions is to point out that one gets out of computer models what one puts in. If Forrester has defined a sick city in terms of a declining economy, increasing numbers of underemployed and high taxes, then it is obvious that a healthy city will simply manifest the reverse symptoms. Now one way to move from the sick to the healthy situation is to stipulate arbitrarily that one is going to improve the economy by attracting new business, by keeping

the numbers of underemployed low and by keeping down taxes. The urban dynamics model stops here, it cannot indicate the policies to be used in reaching these ends, although clearly these are the goals indicated. Keeping the underemployed out of the city, however, would certainly lead industry to soak up available labour. Then the quality of urban life would improve, the demands on taxes diminish because of the decline in large numbers of demoralised, discontented workers and the economy would begin to recover. There is certainly nothing surprising in this, although the proposal that underemployed workers be kept out of the city might well be shocking and the proposed "solution" begs most of the difficult socio-economic questions. On the other hand, the reason why urban systems may develop low cost housing projects where there are few jobs available in cities, or train workers for non-existent jobs, or create public service jobs which attract underemployed people to the city has little to do with intuition or the lack thereof.

If we turn to the world dynamics model, much the same point can be made. If one starts, as Forrester does, with fixed assumptions about exponential growth, it is apparent that the world is headed for imminent disaster from overcrowding, pollution or exhaustion of natural resources. Moreover, the notion that the only way to stabilise the system is to limit industrialisation, given the premise that pollution and exhaustion of resources are both made directly dependent on industrialisation, is not surprising. In fact there is nothing at all surprising in Forrester's conclusions given his assumptions. The model has only to be stood on its head for the solution to appear.

The difficulties inevitably encountered in trying to analyse and then design policies for real complex social systems play a large role in Forrester's books. He spends some time describing what he considers to be the characteristics of complex social systems so that in the end we have a picture of their apparently innate qualities. Indeed, after a while, they seem to take on not only certain characteristic qualities but even a personality. Forrester, at one point, refers to the "traps" set by the character of social systems for "intuitively obvious solutions to social problems". These are: "first, an attempt to relieve one set of symptoms may only create a new mode of system behaviour that also has unpleasant consequences. Second, the attempt to produce short-term improvement often sets the stage for long-term degradation. Third, the local goals of a part of a system often conflict with the objectives of the larger system. Fourth, people are often led to intervene at points in a system where little leverage exists and where effort and money have but light effect". But could it not be misleading to speak of "traps" set by social systems as if they were sentient beings motivated by evil considerations?[7] Forrester does speak of the "diabolical" nature of social systems, but this tendency to reify social systems could hide the fact that it is not necessarily the system which is tricking the observer but rather the observer who is either making mistakes or is having difficulty in trying to deal with a very complex phenomenon. Most of the "traps" mentioned by Forrester occur not because of the peculiar nature of systems but because our political values and preferences structure the way in which we deal with the system. Given different political values, these "traps" might disappear. The problem is not only a theoretical one of "system dynamics" but more a practical one of politics.

Certainly, the first of the traps (namely, the inability to distinguish cause and effect) could be avoided with the aid of system dynamics or other forms of analysis, in so far as any analysis is able to represent social reality effectively. The same cannot be said for the second trap: namely, the differences between short-term and long-term policies in complex social systems. Forrester stresses time and again that "social systems usually exhibit fundamental conflict between short-term and long-term consequences of policy changes. A policy which produces improvement in the short run is usually one which degrades the system in the long run". And, it should be added, Forrester would also claim the reverse—long-term improvement often means short-term decline. Forrester defines the short run in urban and national affairs as a decade, while the long run might be 90 years or more. In world systems the short run is several decades and the long run is fifty years and up.

But what explains the appearance of these "traps"? Exactly whether all social systems, or just some, are open to pressure from the "people" (Forrester rarely refers to "voters" or the "electorate") is not made explicit, although it is quite clear that Forrester is referring to parliamentary political systems. Forrester has said: "The short tenure of men in political office favours decisions which produce results very quickly. These are often the very actions that eventually drive the system to ever-worsening performance". He also makes it quite clear in *Urban Dynamics* that the impatience of the underemployed or as he puts it, of the "downward" forces, may make it politically impossible for political leaders to put through necessary long-term policies.[8]

It has now become clear that it is not the inherent nature of complex systems which creates the problem but rather certain political arrangements. After all, if one were dealing with a system where the political leaders were unresponsive to the demands of the "downward forces", then long-term policies could be carried through without worrying about the adverse reactions of certain people. As we have seen, however, in the urban system the "downward" forces might have to wait only 10 years for long-term policies to be fully effective, while in the world system their patience might be tried by the necessary 30 years' wait. Thus, it is not the system itself but rather the political process by which the system operates that is at fault, and it is quite evident that one of the problems Forrester attributes to the system comes from the responsiveness of parliamentary political systems to pressure from people who are unwilling to wait for the long-term effects of policies to make themselves felt. Forrester's impatience with democracy is frequently apparent.[9]

The third "trap" set by the system, conflict between local and "larger" goals of a system, could be translated as the conflict between local and national interests. It is true that all political systems confront this problem, but the way in which it is defined and the wide variety of methods for dealing with it are determined by the values of the people in that system. Here again, Forrester has imputed to the social system itself certain qualities which appear only because people in certain systems hold values which make it difficult to choose between local and national interests.

The fourth "trap" relates to another crucial point in Forrester's characterisation of social systems. This is that complex systems "seem to have sensitive influence points through which the systems can be improved . . . however,

these influence points are usually not in the location where most people expect them to be". This is why people often try to alter parameters which have little or no effect on the system. Clearly, in Forrester's view, only the use of system dynamics can help identify the hidden but crucial parameters whereby the system can be altered in a serious way.

Is it some property of the system, or is it rather that all policies are designed within a certain political context, which frequently leads policy makers to elaborate ineffective policies? Often it is not their expectations of the system which "lead" policy makers to intervene at such and such a point but rather the political structure which *allows* or *permits* intervention at those points. The reason why, as Forrester observes, some policies have "little effect" is often because other, possibly more effective, options are simply closed, either because support cannot be marshalled for the necessary policies, because the power structure would make such policies impossible to implement, or because other, more important values would have to be sacrificed.

That Forrester himself implicitly assumes the existence of a certain set of political values and power structures constraining policy choices can be illustrated by one example from *Urban Dynamics* and one from *World Dynamics*.

In his urban model, Forrester contends that the urban system will move from a position of stagnation to one of recovery if the climate for industry is improved through such things as tax concessions, favourable administrative regulations and zoning practices, and if the amount of space given over to low cost housing is reduced. This seems a drastic solution, one which, Forrester admits, might seem to "give superficial appearance of favouring upper income groups and industry at the expense of the underemployed".[10] But, he contends, it is the only solution indicated by the model. Forrester does go into some detail about how these two goals might realistically be achieved in cities, although he is well aware that underemployed people would make it politically difficult to carry through any programmes designed to limit or reduce low cost housing. It is the resistance likely to be offered by the "downward forces" that leads Forrester to elaborate on his theme of the difficulties of trying to get long-term policies accepted in complex social systems.

But while Forrester does not hesitate to suggest that low cost housing be discouraged and even reduced, he is very careful to avoid suggesting that the problem might be approached by imposing certain restrictions on industry. For example, according to Forrester, underemployed workers are drawn to a city where there is excess low cost housing, but they put such heavy demands on the city's tax structure that the attractiveness of the city decreases, while crime rates and degradation of the environment drive industry away. The notion that taxes needed to accommodate the underemployed or increase the city's attractiveness might be obtained from heavy taxation of industry is rejected. The reason is that "industry is not without retaliatory power. It can leave, and it does". Moreover, "it may not be possible or politically practical to assess the full amount of tax which is computed according to needs of the population".[11]

Thus policies, such as putting restrictions on the movement of industry fleeing an area with high taxes through forceful regional policies, or the operation of a system of central government subsidies for low-cost housing or indus-

trial investment, are not contemplated, while the admittedly difficult task of reducing low cost housing is. But is it the system which has suggested these policies? Or is it Forrester? And is it the complex nature of the social system which has led to such policies as job training programmes, tax subsidies, etc, or is it the American political context and the particular pressures generated therein? The answer is obvious. Although system dynamics would seem to indicate that all variables are free, in fact, some variables are freer than others. System dynamics can no more transcend the problems of value and choice in the social sciences than any other approach.

The same admixture of personal preference and political values conditioning the interpretation of the model is at work in Forrester's analysis of the world model. Here the world system seems to be degrading. No matter how Forrester manipulates the variables nothing much seems to stem the decline. Two of the main sources of danger are the rate of industrialisation which threatens to raise pollution to murderous levels and to exhaust natural resources and the growth in population which threatens the food supply. Our "intuitive" notion that a worldwide system of birth control might stabilise the system is rejected. Forrester claims that even a 50% reduction in the birth rate only temporarily staves off disaster since the increasing "quality of life" thereafter only provokes another rise in population.

But Forrester is ambiguous about the case of birth control. He doubts, for example, whether even after a 50% reduction in births people would be able to maintain the "discipline" necessary to keep the rate down. Rather, he interprets his model in such a way that only through drastic reductions in health services, food supplies and limits on industrialisation will the world system be saved from disaster. That this implies condemning millions of people to death in the developing countries seems to be a necessary, although unfortunate concomitant of the model. The disasters which would come later would otherwise be even greater in his view. Moreover, "forcible imposition of population control would be seen by most people as a sufficiently unfavourable change in the social environment that they might prefer that the forces take the tangible forms of lower material standard of living and reduced food supply".[12]

Just which people Forrester is talking about in the world system is not entirely clear but it is clear that he believes that the developing countries must stay poor. His willingness to suggest what choice "most people" would be willing to make would seem to be based on intuition more than anything else. After all, for people in the developed countries, the choice might well be between birth control or a lower standard of living. For those in developing countries, the choice would be between birth control or death—the standard of living cannot fall much lower. The choices that those in the developing areas might prefer to make might be different from those in the developed areas but Forrester's world model does not deal with this question. Not surprisingly, there was an extremely adverse reaction among intellectuals in developing countries when they first became acquainted with Forrester's book. Partly because of discussions with Latin American scientists and sociologists, Meadows approaches the problem of developing countries with far more sympathy and imagination. But since he accepts the fundamental assumptions of Forrester's model and the goal of zero growth, he cannot offer much hope to the third

world except a rather vague declaration of the desirability of world-wide egalitarian levelling.

It is seriously misleading for Forrester to claim that it is in the nature of complex social systems to pose riddles for mankind, rather than man who has to interpret the riddles he sets for himself. There is an even more serious problem in Forrester's approach, and indeed, in the world dynamics model in general.

The variables that go into the model are calculated on the basis of information derived from the behaviour of real men and real things in the real world.[13] That one must pick and choose among these statistics, that these statistics may be unreliable—especially when aggregated on a world scale—that they may vary widely or give inaccurate pictures of real behaviour only adds to the ultimate abstraction of the world model. (A full treatment of these problems is given in chapters 2 and 9). But the whole drama of the world dynamics model takes place when it extrapolates into the future. Once it takes off from its historical base it starts to operate, despite the sophisticated feedback system, on the basis of information gathered about society during a particular historical period. Yet one of the most obvious features of human society is that values are constantly changing and values affect behaviour. Indeed, it is arguable whether social and political systems can be profitably viewed as multiloop non-linear feedback systems. For example, the problem of short-term versus long-term policies that seems to bother both Forrester and Meadows is due to the fact that the feedback system in politics between electorate and politician carries information about changing goals, values and priorities. It is not a question in the political system of bigger or smaller, or less or more, all within the context of an explicit goal. It is rather a question of good or bad, better or worse, all within a context where goals and objectives are constantly shifting, where values are frequently in conflict, being called into question, or even inarticulate.

Thus, Forrester is mistaken about a number of things. He is mistaken in trying to reify systems so that we attribute to the characteristics of the systems themselves problems that are inherent in the political process. He is wrong in describing social systems as setting traps when in fact there are conflicts of interest and political systems find it difficult to reconcile sometimes incompatible demands. He is wrong when he claims that computer models are necessarily more explicit than mental models, especially in view of the paucity of data he himself supplies about the basis on which he has calculated his equations, and, even more importantly, when his computer models ignore the real world of social, political and cultural values while making implicit assumptions about these values. He is wrong when he says that policies go wrong because systems are "counter-intuitive" when in fact bad policies result from many factors, only some of which relate to the complicated nature of the social system itself and to the inability of "intuition" to comprehend it.

The main difference between *World Dynamics* and *The Limits to Growth* is that Dennis Meadows says very little about the political process, leaving the policy implications to the Club of Rome's commentary at the end of the book. Thus, the model is presented in a clear and concise fashion as a technical study of the variables at hand. But despite his caution about policy, Meadows reaches pretty much the same apocalyptic conclusion.

Its public appeal

One of the more interesting aspects of the Forrester/Meadows argument is its popularity. Surely one might have expected people to be sceptical about such an apocalyptic thesis and to have asked for a much more serious examination of the data and the premises on which the model is built before reaching any conclusions about its soundness. Yet this has not been the case. Why is it that a group of computer engineers and systems analysts who have frankly admitted the tentative nature of their findings, have found such a ready audience? ("It (the world model) perhaps contains the tenth part of 1% of what we should know about the real world if we want to make long-term statements . . .")[14] There are a number of reasons for this, some of them may be more tentative than others, but all of them may tell us something about the intellectual mood of our era.

For some time now, especially in the USA, but increasingly in Western Europe, there has grown the belief that we are in the midst of a profound environmental crisis. People are now concerned about issues that, a few years ago, would scarcely have provoked a raised eyebrow except from the most concerned citizens. We have already seen that there have been earlier periods of "environmental pessimism". This new pessimism, however, is connected with the fact that people are sceptical of the idea that the Western capitalist cornucopia will eternally overflow with wealth that must eventually trickle down to even the most deprived elements of the population. Many people are firmly convinced that, on the contrary, the overflow will eventually clog the sewers and pollute lakes and rivers. In a recent lecture, Robert Heilbroner has illuminated this change in attitude with a particularly apt analogy. Suppose, he says, that if in 1930 "someone had been told that the United States GNP in the 1970's would surpass a trillion dollars effectively doubling the real *per capita* income within the life span of the majority of the population then alive— I am sure he would have felt safe in predicting an era of unprecedented social peace and goodwill, particularly if he had also been informed that the distribution of income in 1970 would not be significantly less unequal than in the 1930's . . . Yet . . . social harmony has not resulted".[15]

This disillusion with the healing properties of capitalism has combined with a generalised and widespread feeling of despair at the apparent breakdown of certain societal values. Concern over rising crime rates, decline in the environment, changing family structure and relationships have all contributed to a general feeling of unease. It is as if society was on the verge of, or perhaps even in the first phase of, some kind of vast social or cultural revolution whose exact nature has not yet been understood but of which people see premonitions all around them. Strangely enough, these feelings of pessimism and despair are felt even in societies where it is probably easier to argue that, in fact, things have been getting better and better all the time. For everyone who criticises the cost to the environment of industrial pollution, there is someone else who will use the rising standard of living in the west as proof that for certain costs, ie, pollution, there are even greater benefits. What we are witnessing then, and what the widespread acceptance of the pessimistic argument indicates, is a gradual change in our cultural attitudes.

Values are now changing and the notion that quality of life (however vaguely defined) is more important than such things as increased material goods is the cause of the unresolvable argument between those whose hierarchies rank cars and clean air at different levels of goodness. The pessimistic ecologist's case fits well with this change in outlook since it confirms the suspicion so many people have of the negative effects of unrestrained growth. Moreover, unlike past arguments for caution in utilising environmental resources, the pessimists argue that the result of carelessness will not be merely a loss of certain amenities in life but disaster on a global scale.

There is another apparent reason for the widespread acceptance of the pessimist's case, and this has to do with the anti-political overtones of its message. We have seen how Forrester in particular expresses pessimism about the ability of politicians to solve the major problems posed by the world dynamics model. And although Meadows is, characteristically, more cautious than Forrester, he is also sceptical of political systems which are unable, supposedly for electoral reasons, to plan for more than five years ahead.

Once again, it should be emphasised that it is not necessarily the political process that is irrational, rather, politicians may be responsive to an electorate and to interest groups that do not share the values of its critics. The irrationality that certain industrialists or scientists in particular sometimes perceive as inherent in the process of policy-making is sometimes nothing more than their unexpressed dissatisfaction with the goals and values of the polity at a given moment of time. Given a certain amount of consensus, however, there is no reason why even the most democratic political system could not formulate long-term measures extending from 5 to 50 years—and indeed, many of the decisions being made now, to construct atomic power plants, to construct dams, to build nursery schools, or to use natural gas as opposed to oil—all have long-term implications. Thus, the suspicion the pessimists and their supporters have of the political process is based to a great extent on disagreement over what should be the primary goals pursued by the political system. After all, not everyone believes that industrial growth should be stopped. What evidence is available suggests that, although they may well be concerned to devote greater resources to combat some types of pollution, the great majority of people in all countries do not share this view. It is natural, however, that the discontent many people feel about the apparent unwillingness of politicians to press for limitations on pollution, etc, fits in well with the abstract nature of the system dynamics approach which attributes to the political system itself defects which are integral to any situation, where conflict over values must be resolved by reaching political concensus. Moreover, belief that the world dynamics model is somehow above politics lends to it a spurious aura of clarity and precision which, in turn, leads to the conclusion that it is only the obdurate and inexplicable irrationality of politicians that prevents men of good will from rapidly developing a programme to achieve the ends so clearly indicated by the world model.

The Forrester/Meadows view of the nature of the social system is both simple and well within a certain kind of tradition. Impatience with the vagaries of the political process has been a characteristic trait of certain groups in society for a long time, and it has existed among certain groups of scientists

whose conceptions of rationality are often severely tested by the necessary compromises and halfway measures characteristic of the democratic political process.[16] For these groups the solution to social problems is clear and evident and it is not unusual in history to find them banding together in the hope of convincing rational and intelligent people, like themselves, to exert pressure on politicians to be less devious.

It is in this context that the links between world dynamics and the Club of Rome can be clarified. The executive members of the Club are all leading members of "knowledge institutions". Aurelio Peccei is head of an Italian management consulting firm, Hugo Thiemann is head of the Battelle Institute in Geneva, Alexander King is head of Scientific Affairs for OECD, Saburo Okita heads the Japan Economic Research Center in Tokyo, Eduard Pestel is from the Technical University in Hanover and is a member of the Volkswagen Foundation, Carroll Wilson is from MIT as are Forrester and his associates.

The Club of Rome came about in the following way. In 1969, Aurelio Peccei, head of Italconsult, an Italian management consultant firm which is a subsidiary of Montecatini Edison, published a book *The Chasm Ahead*. In a rather discursive discourse on some of the world's major problems, including pollution, population and development, Peccei devoted much of the book to the growing technological gap between America and Western Europe— whence the title. He was struck by the fact that problems international and global in scope could not be solved through national efforts. The reason, he wrote early in the book, was that "the outdated and inefficient socio-political organization is patently incapable of coping with the new pattern of forces which have emerged in the modern age". Ironically, at the time of writing, Peccei was convinced that "*sustained development of the industrial countries* is a prerequisite to attack the array of future problems . . ." (his italics). Evidently acquaintance with the results of the world dynamics model since then has convinced him otherwise.

In any case, Peccei seems to have concluded as early as 1966 that a study of world problems should be initiated and he called the proposed study "Project 1969". He writes that from 1966 on he travelled widely in Europe, America and the Soviet Union trying to interest people in sponsoring his project, meeting with little more than polite interest. But in 1968 he evidently decided to take the initiative and after consulting Alexander King and Erich Jantsch, who has written on technological forecasting for the OECD, Peccei obtained the sponsorship of the Giovanni Agnelli Foundation (Agnelli is on the Board of Directors of Montecatini). A meeting was held in Rome in April, 1968 and to it were invited "economists, planners, geneticists, sociologists, politologues and managers". The results were not particularly encouraging since it appears most of the guests did not think in terms of a global analysis. But Peccei persevered and, with the support of the five executive members of the Club, founded the Club of Rome in April 1968. Its secretariat is located in Rome, and it has offices in Geneva and Tokyo. In an interview published in *La Recherche*, No. 9, February 1971, Peccei also stated that the Club relies for financial support for its activities on the Battelle Memorial Institute and Italian businesses.

As a group the Club of Rome is peculiarly representative of what Daniel

Bell calls the "intellectual technologists" of post-industrial society. In explaining this phrase Bell has written: "If technology is defined not just as machines, but as a rationalistic attempt at problem solving using machines, then the new intellectual technology—systems analysis, simulation, decision theory, linear programming, stochastic models—based on the computer will become increasingly important in the analysis of problems and the laying down of alternative solutions".[17] Moreover, as Meadows has stressed, the members of the Club of Rome do not hold public office, nor "does the group seek to express any single ideological, political or national point of view". In a phrase vaguely reminiscent of H. G. Well's famous "Open Conspiracy", Meadows refers to the Club as an "invisible college"[18] (the expression coined by Derek Price to describe scientific networks).

Having abjured any particular political or ideological viewpoint, carefully dissociating themselves from politicians (despite the rather important positions some of its members hold in semi-public bureaucracies) it is quite clear how anxious they are to appear to be above politics. They are open to the most radical kinds of proposals as long as the techniques used to arrive at them are well within contemporary canons of what constitutes an acceptable scientific-technological approach, and they are supporting a number of research programmes of model-building outside MIT and the USA. It is precisely because the world dynamics model says nothing about the means necessary to achieve the stable system that seems indicated by its conclusions, that it appeals to the "intellectual technologists" of the Club of Rome as well as to ordinary citizens. That this apolitical attitude is also dictated by their desire to appeal to decision-makers from diverse political systems and holding sometimes contradictory values does not vitiate the fact that, as has been noted above, certain political choices are logically inherent in the world dynamics model and in the notion of reaching a stable state.

There is a further reason why the MIT model may have such an immediate and intense appeal for certain elements of the population in the west. As we have seen, those who support the notion of a limit to growth and who share the model's pessimism almost always articulate a pessimistic view about the current state of society. Now it is generally agreed that one of the major causes of civil and criminal conflict today is that some people feel society has not given them their due, that financial, cultural, social or prestige rewards have not been allocated in a just fashion. The almost universal belief in progress implied that in one way or another everyone would benefit from the increased productivity of advanced capitalist society. But even though in absolute terms the standard of living has risen for almost everybody in the west, conflict today often arises because deprived groups are irritated by the gap between what they think they ought to have and what they actually receive. Moreover, expectations of what is their due are constantly raised by the vast array of goods that are produced in capitalist societies.

In the stable state, however, all this would change and people would have to adjust to a system where growth was limited and the infinite accumulation of goods would finally end. What kind of society would this be? A world-wide radical egalitarian levelling of incomes and property could be taken as a necessary implication of a stationary state and Meadows himself sometimes

appears to adopt this view. He approvingly quotes Dr Herman E. Daly who has written:

For several reasons the important issue of the stationary state will be distribution not production. The problem of relative shares can no longer be avoided by appeals to growth. The argument that everyone should be happy as long as his absolute share of wealth increases regardless of his relative state will no longer be viable . . . The stationary state would make fewer demands on our environmental resources, but much greater demands on our moral resources.[19]

The widespread appeal of the stable state does not necessarily grow out of a desire for an egalitarian society. It could also promise a society where there will be a clear diminution of the kind of conflict that offends certain people today. They would have to accept the fact that the supply of goods was limited and that, within the western system at least, some people might deserve more than others. The frustration that comes from one's inability to obtain as much as everyone else of the seemingly endless riches of capitalist society would disappear in the stable society. Unless there was a radical move towards levelling of an unprecedented kind in the stable state, social and economic hierarchies would continue to exist. But differential rewards would be more easily justified within the context of an economic and social system where there was a finite limit to the rewards to be distributed and where the illusions of achieving ultimate equality through production would have vanished.

Finally, for the audience that tends to support a pessimistic interpretation of environmental problems, Meadows' sketch of the kinds of activities in which people will indulge in the stable state must be very appealing indeed. He writes: "In particular, those pursuits that many people would list as the most desirable and satisfying activities of man—education, art, music, religion, basic scientific research, athletics and social interactions—could flourish".[20]

It is now apparent that the vision offered by some of the ecodoomsters is not at all one of world disaster and conflict. Despite the moralistic tone injected into Meadows' book by the quotation from Dr Daly, the real thrust of the message is clear. Once the stable state has been achieved all the anxieties, frustrations and conflict engendered by the frantic endeavour to accumulate goods will have disappeared. Man will be able to realise the spiritual side of his nature. Rivers and lakes will be clean, population controlled, urban problems resolved. The golden age would begin.[21]

In common with other chiliasts, the new scientific chiliasts are utopians at heart. Like the great prophet of world salvation through world breakdown, Karl Marx, their apocalyptic visions of the immediate future are tempered by the glittering image of utopia barely discernible through the fire and brimstone that rages in the historical foreground. This is not to denigrate the beliefs of the Forrester/Meadows school in any sense; rather, it is to suggest that they too, despite the surface appearance of scientific neutrality and objectivity, bring us a message which can only be fully understood in the context of their own beliefs, values, assumptions and goals.

References
1. Henry Elsner, *The Technocrats* (Syracuse University Press, 1967)
2. Forrester's testimony before the United States Congress, House of Representatives, *Ad Hoc* Subcommittee on Urban Growth of the Committee on Banking and Currency,

Hearings on Industrial Location Policy, 7 October 1970, pages 205–238; *Urban Dynamics*, (Cambridge, MIT Press, 1969) pages 10, 123, and *World Dynamics*, pages 80, 97 and 124

3. Jay W. Forrester, "A deeper knowledge of social systems", *Technology Review*, Vol. 71, No. 6, pages 21–32
4. Interview with Forrester in *Le Monde*, 1 August 1972
5. *Urban Dynamics, op cit*, page x
6. *Urban Dynamics, op cit*, page 109
7. *World Dynamics*, pages 93–95
8. *Urban Dynamics, op cit*, pages 121, 123
9. See, for example, Forrester's comments on equality, in *Le Monde, op cit*
10. *Urban Dynamics, op cit*, page 121
11. *Ibid*, pages 124, 203
12. *World Dynamics*, page 122
13. Exactly how the data that go into the various systems dynamics models are calculated is hard to say. Indeed, according to Dennis L. Meadows "in *World Dynamics* . . . there is no attempt to incorporate formal data . . . all the relationships are intuitive", Meadows, speaking before invited guests of the British Petroleum Company, *Report of the Proceedings of the Dynamar Clearing House*, 19 November 1971, Strand Palace Hotel, London, page 7. The method of constructing the model seems, therefore, to be based on using intuitive ideas about the relations among the variables, running the model to see if it replicates historical reality, and then, if it does, running it into the future.
14. *Ibid*, page 6
15. Robert Heilbroner, "Has capitalism a future", Speech for the Internationale Arbeitsagung der Industriegewerkschaft Metall für die Bundesrepublik Deutschland, Oberhausen, 11–14 April 1972, mimeo
16. W. Armytage, *The Rise of the Technocrats: A Social History* (London, Routledge and Kegan Paul, 1965); and *Yesterdays Tomorrows: A Historical Survey of Future Societies* (London, Routledge and Kegan Paul, 1968)
17. Daniel Bell, "The balance of knowledge and power", *Technology Review*, Vol. 71, No. 8, June, 1969, pages 38–47
18. *The Limits to Growth*, page 9
19. *Ibid*, page 179
20. *Ibid*, page 175
21. I do not choose the phrase "golden age" arbitrarily. It occurs in an article published by Jørgen Randers and Donella Meadows in "The carrying capacity of the globe", *Sloan Management Review*, Winter, 1972, Vol. 13, No. 2, pages 11–27. The article is quite similar to certain sections of *The Limits to Growth* but evidently the paragraph in the paper headed "A golden age" was omitted from the book. It began, "An equilibrium could permit the development of an unprecedented golden age for humanity. Freedom from ever-increasing numbers of people will make it possible to put substantial effort into the self-realisation and development of the individual".

Forrester is more pessimistic. He thinks that we may already be living in the golden age and that society will never again be able to achieve such a high standard of living as we now enjoy.

14. POSTSCRIPT ON SOCIAL CHANGE

Marie Jahoda

The major weakness of the world dynamics models is that they illustrate the pessimistic consequences of exponential growth in a finite world without taking account of politics, social structure, and human needs and wants. The introduction of an extra variable—man—into thinking about the world and its future may entirely change the structure of the debate which these models have so far limited to physical properties.

THE preceding chapters have examined the validity of a bold and imaginative effort to describe the predicament of mankind and to foretell its future. In the hands of Forrester and Meadows a relatively new and sophisticated method—computerised system dynamics—yielded results that showed disaster occurring within 100 years. Notwithstanding the differences in detail between these two prophets of doom, they largely agree on the outcome: the physical properties of the world in which we live are, according to them, such that total collapse is unavoidable unless severe limits to economic and population growth are immediately imposed on an international scale.

Both *World Dynamics* and *The Limits to Growth* have had widespread repercussions in government circles, among administrators and among many concerned persons in many countries. Since their appearance a public debate has been in progress in which support and attack appear equally matched and which as yet shows no sign of abating. This in itself is one unquestioned value of Forrester's and Meadows' work. But it is in the nature of public debates, particularly when carried on through the mass media, that convictions often replace critique and arguments are made out of context and over-simplified. Unfortunately, Forrester and Meadows have contributed their share to confusion; they do talk different languages in different contexts and can be quoted both for and against the firmness of their conclusions. While they speak in some places of the tentative nature of their work and the need to alter, expand and improve their technique, assumptions and data, they also assert elsewhere that they do not expect that anything will drastically change their conclusions. In Meadows' work, for example, the following statements occur: "The limits to growth on this planet will be reached in the next one hundred years" (page 23), "the basic behaviour mode of the world system [is the same] even if we assume any number of technological changes in the system" (page 142), "even the

most optimistic estimates of the benefits of technology in the model did not prevent the ultimate decline of population and industry or in fact did not in any case postpone the collapse beyond the year 2100" (page 145).

The aim of these papers is to scrutinise such assertions in technical detail and thus add to the growing number of informed criticisms which have already appeared.[1] This last chapter attempts an overall evaluation in the light of the preceding technical analysis and of the facts and arguments that balance them. Going beyond this it will consider some basic aspects of their approach.

Notwithstanding differences in values between the authors of this volume, between them and the two world-modellers, and even between Forrester and Meadows themselves, we share with them one major conviction: there is no room for complacency. The world does face a problem of energy production and consumption, some urban areas on the planet do suffer from pollution, the green revolution does create many problems even as it solves others. Demonstrating, therefore, that Forrester and Meadows have gone wrong must not lead to the conclusion that we can sit back and relax in the best of all possible worlds. By common scientific standards their method, assumptions, data and resulting predictions have been shown in this book to have faults, often severe ones; their model of the world does not adequately reflect reality. Yet it is inevitable that a critical exercise such as we have undertaken can only refute. We cannot, not yet at least, substitute for their effort a more realistic model, let alone suggest policies to cure the ills of the world. All we could do on that level is to show that policy recommendations, such as Meadows implies when he says that catastrophe can be avoided if by 1975 population growth is cut to a maintenance rate of two children per family and economic growth deliberately prevented, are a counsel of despair impossible to implement and not based on sound premises.

Can Forrester's and Meadows' faults be corrected or is the very essence of their approach in doubt?

Central to their entire argument is the idea of exponential growth which, in a finite world, must lead sooner or later to disaster. It is well worth re-examining this elegant mathematical invention in its application to human affairs. Meadows devotes his first chapter to a simple and clear exposition of the nature of exponential growth and of positive and negative feedback loops which enhance or reduce such growth. It does not require a sophisticated computer analysis to realise that if the assumption is made that threatening trends increase exponentially while negative feedback loops increase only arithmetically catastrophe must occur at some point. If this assumption is wrong, however, radical changes in the world may occur without famine because no more arable land is available, without asphyxiation because there is no air to breathe and without all physical resources being exhausted. The argument then stands or falls depending on what negative feedback loops are introduced into system dynamics and with what power. It is on this crucial point that Forrester's and Meadows' approach breaks down.

Let us consider first the nature of the negative feedbacks introduced by them. The flow diagram of the relations they present is so complex that it cannot easily be grasped by the naked eye, a point which seems to lend support to the need for computer analysis. Exponential growth for population, for example,

is less and less counteracted by the death rate as people have longer and longer life expectancy. Yet previous forecasters of exponential population growth of this kind have already been proved wrong. If the Malthusian formula is applied to Britain, for instance, the country should now have well over 400 million inhabitants. Individual human beings have prevented this by taking deliberate actions to keep family size down. How they have done it we do not know exactly but there can be no doubt that it was deliberately done, motivated perhaps by the wish for an easier life for women, better chances for the children, more material goods or some other attitude to living. We do not yet have a population theory which encompasses such factors. Judging by results, however, if people want to have fewer children they achieve their ends.

Meadows recognises this fact by having a negative feedback loop—desired total fertility. He does not recognise, however, that this factor influences the effectiveness of birth control, thus strengthening the power of the negative feedback. The point is not to attack the population sub-system which is the most thoroughly considered of all sectors, nor to deny that the world faces a population problem, but to highlight a conception of man in world dynamics which seems to have led in all areas considered to an underestimation of negative feedback loops that bend the imaginary exponential growth curves to gentler slopes than "overshoot and collapse". Man is not pushed by a unified system mechanistically into intolerable conditions but assesses the circumstances around him and responds actively by adapting his goals and values whether in the intimacy of his sexual life, in the public sphere through the political process and economic adaptation, or in the change of customs and norms. Such adaptations occur as a persistent process when the strains of life are experienced. Man's fate is shaped not only by what happens to him but also by what he does, and he acts not just when faced with catastrophe but daily and continuously. To present a model of the world as if this driving force in world events did not consistently assert its effectiveness amounts to an intriguing intellectual exercise rather than to modelling of the real world. Meadows frequently talks of the difficulty in changing social values, a difficulty which interferes with the applications of birth control, for example. He is right, but only half so and thereby misleading. Men's values are only partly a delaying mechanism; partly they are the major source of interference with the exponential growth of the physical properties of the world.

To take another example: Meadows explains the nature of exponential growth by a beautifully simple child's guide to compound interest. Yet there must be many people who can testify that their assumption of turning $100 in 40 years into $800 has not come true. The mathematics is correct but currencies change and inflation or devaluation may have left them with little of the meaning of the original $800. Once again political and economic actions have interfered with a prediction based on factors which did not include certain human actions.

A third example demonstrating the existence of non-physical factors in preventing exponential growth is illustrated by the well-documented fact that the number of scientists has for a period grown faster than the population. Derek Price[2] has formulated this particular predicament by calculating that in the not too distant future there would be "two scientists for every man,

woman, child and dog in the population, and we should spend on them twice as much money as we had". This particular disaster of exponential growth is already in the process of being averted, not just through the personal crisis of unemployment for some scientists in the USA and elsewhere but through congruent individual choices made by the young generation in many countries of the developed world. Students are turning away from the natural sciences. Notwithstanding the growing demand for higher education, places in the natural sciences often remain unfilled. This is not because a system pushes students away from science—if anything, many systems still try to push in the other direction—but rather because students make deliberate choices, appraise the world around them, discover the enormous effort which during the past 50 years has gone into science, note that this has not always improved the quality of living and are ready to experiment with other concerns than a career in science.

What these examples highlight has been hinted at in several of the preceding chapters, most explicitly so in Simmons' attack on the usefulness of building a system of the world which deliberately ignores the political process. The major limitation of Forrester's and Meadows' approach is, then, that they have chosen to be unconcerned with politics, unconcerned with social structure, unconcerned with human needs and wants. If we have learned anything from history it is that men make it as much as they are made by it. If we have learned anything from the study of politics it is that politics is concerned with the management of resources for the purpose of meeting human needs and wants. If these could be ignored, economic growth could of course stop immediately. But they cannot. Economic growth should never be a goal but a means to the end of fulfilling human needs. Unless the processes are understood which translate human needs into economic policies, which support or counteract the *status quo* in the distribution of income within and between countries, which lead to the compromises that are the essence of the political process whatever the nature of a particular régime, no satisfactory model of the state of the world can be designed.

It is their deliberate self-restriction to physical properties of the world which leads one to reject Forrester's almost Swiftean "modest proposal"[3] and to question Meadows' competence as a guide to the formation of world policies. For however justified the authors may be in stating that population growth must have physical limits, saying this without at the same time considering fundamental human values could have catastrophic consequences much sooner than Forrester and Meadows think. This, at least, I take as the implication of a recent study summarised in the Proceedings of the 1969 International Congress of Psychology (page 127): "Five hundred and seventy S's (subjects) were informed that the emotionally and mentally unfit, and others belonging to minority groups, were proliferating faster than the fit and educated and that 'we the fit' would be in danger unless there was a scientific application of the 'final solution'. Subjects in four conditions received different information as to the nature of the victims, the urgency of the threat, and the means of killing. The main findings were that two-thirds of S's endorsed the 'scientific application of the final solution', and the more immediate the threat, the greater the endorsement. It was concluded that genocidal attitudes became salient when 'acceptable' justifications are presented." (Justifying the final solution, by

Helge H. Mansson, University of Hawaii.) Outside their models, the authors recognise the importance of non-physical properties. Otherwise Meadows could hardly say "the model described here is already sufficiently developed to be of some use to decision-makers . . . we do not expect our broad conclusions to be substantially altered by further revisions" (page 22). In other words, he knows as well as we that exponential growth can be influenced by action. But he has not built this knowledge into his model, nor shown that he understands the continuous process by which scarcities lead to substitutions, new inventions and changing ways of life which, in turn, change the physical properties with which the model deals. It is possible that he and Forrester would justify their enterprise as a clarion call to action, influenced as they must be by the malaise of the second half of the 20th century which is undoubtedly most visible in the USA. As an effort to make propaganda for action, its virtual hopelessness in outlook may well backfire in two ways. First, there is some psychological evidence to show that overwhelming threat leads to looking away from a problem rather than tackling it;[4] and second, a call to action which cannot be implemented may inadvertently undermine the credibility of scientists to help in solving the problems of the world.[5]

Those familiar with the current state of the social sciences and particularly with the heroic but futile struggle to explain action and purposeful adaptation in mechanistic terms will not underestimate the difficulty involved in introducing the human factor as a sixth variable into world models. But unless the preceding argument is entirely wrong, nothing short of this could claim to guide world policy for a century in advance. This does by no means imply that systematic work on possible futures is useless nor that the study of physical properties alone is without value in such efforts. They will be more tenable and more useful, however, if limited to shorter periods and including adaptive negative feedbacks rather than exhortations to a change of hearts.

At first glance other criticisms of the feedback loops appear puny compared to this major problem. In the technical critique they have been discussed in order to see whether within their own language and limitations the two models are based on the best possible assumptions, and they have been found wanting on several occasions. But one of these criticisms is related to the major fault discussed here. It has been shown that while the model of World 2 yields sometimes identical catastrophic predictions if certain factors are changed by considerable amounts—a birthrate decrease of 20% does not significantly affect the major results—much smaller changes in parameters if applied simultaneously do indeed avert disaster. Now these combined changes are in the nature of purposeful adaptive processes which continuously occur in the real world through political, social, economic and technological actions. Forrester and Meadows characteristically ignored testing their model in this fashion.

Another major point of a different kind but relevant to the claims of the authors needs to be raised, and that is the assertion that the interrelated problems of the world are here made clear for everyone to see, that the computer output has made the predicament transparent for everyone. This is dangerously misleading. We know from our own experience in studying Forrester's and Meadows' work that it took a group of highly trained experts in a variety of

fields many months of hard effort to grasp fully the technique, the assumptions and the shortcomings of world dynamics. Even now some of the feedback loops are not fully understood, nor fully tested. Only after this period of work could all contributors agree on our final verdict: not good enough. Originally after the first reading of *World Dynamics* opinion had differed widely on this point. What Forrester and Meadows regard as transparent appeared to us opaque and mystifying. However clear the computer print-out of the doomsday curves—or perhaps just because of their clarity produced by a man-made machine of unquestioned value—the claim to transparency is all too easily believed; given that the stakes are high if the computer print-out is taken as established scientific truth, the MIT appeal to the intelligent layman to do just this, while the complex technical report is available only to a few, is dangerous indeed.

But it would be wrong to explain the very great impact which world dynamics has already had, largely by the belief—as widespread as it is naive— that unless a computer can be technically faulted its clearly printed results must be trusted. Whether or not Forrester and Meadows were right to aim at so large an audience, and quite apart from the faulty transparency argument, the impact of an intellectual effort is never just the result of its own qualities nor of its claims. To a very large extent it stems from the climate of thought within which it is presented and the state of the minds of those who come to grips with it. It would be presumptuous to attempt here an analysis of these two overwhelmingly important but elusive factors. All one can do is to mention them as an area of study which needs much more thought and research than it has so far received and to offer one or two hints in this direction.

It would be useful to discover through systematic content analysis, to which values and concerns the non-technical critique of the MIT work that has appeared in many publications appealed, and who the protagonists on either side were in terms of their expert knowledge, their position in society and their political outlook. This is not to encourage the simple view that the content of our thought is completely determined by our outlook and social position. It is not. But since non-technical comment has inevitably concentrated on the possible consequences for this and future generations of implementing or ignoring the MIT policy suggestions, such a study would reveal the dilemmas and confusions in the social values and goals of our times. It would be equally useful to discover how far the debate has penetrated into the minds of the people in general and, if one's impression that it has not gone very far outside professional circles is correct, to go beyond this and enquire not about knowledge of the MIT work but rather about whether the message it contains has a resonance in what people all over the world wish or fear. It is possible, even if it is nothing but a first guess, that the debate has been joined with such vigour and passion because of a widespread millennial mood, a sense that the. advanced societies have over-reached themselves and unleashed forces which can no longer be controlled. This is the mood which permeates Forrester's and Meadows' writings, a mood which may be responsible for having biased their assumptions in the direction of profound pessimism. But in addition to pessimism, there may be an even more dangerous sequel to their work if it remained unchallenged. In their exclusive concentration on the physical limits to growth and

on possible disasters in a century, they may help to divert attention from what can be done here and now on the urgent current problems of the world, including physical attributes but certainly not limited to them. In other words, they may encourage escapism. It is all very well to worry about the possible exhaustion of natural resources in the year 2100—in its proper place. If this became a substitute for worrying about the distribution of resources now between the rich and the poor on a national and international scale, it would amount to escapism, notwithstanding Meadows' concern with equality in the distant stable state. It would restrict, not to say paralyse, decision makers now in taking actions on current urgent problems, actions which in their total impact may well contribute the most powerful negative feedback loop to falsify the doomsday curves.

Would the danger of appealing to an irrational millennial mood and of encouraging escapism remain had their work been technically faultless? Even if this is a hypothetical question it must be faced, for there is little doubt that the technical aspects can and will be improved. The answer to this question is yes, *unless* the entire approach to forecasting the future is changed to include nonphysical factors and a more realistic conception of how the present changes imperceptibly into the future through the continuous responses and actions of men in their adaptation to an ever changing physical and social world.

The introduction of this sixth variable—man—into thinking about the world and its future may entirely change the nature of the debate which Forrester and Meadows have tried to limit to physical properties. It may show that, while gradual adaptations are the rule, they are not without exceptions. For it is in the realm of human actions that major discontinuities have occurred in the past and may occur again, while man's history provides not one single example for a sudden discontinuity in physical attributes of the world. It is in the nature of purposeful adaptation that the course of events can be changed dramatically if social constraints are experienced as intolerable, if aspirations remain unfulfilled and if confidence in the ruling political powers disintegrates. It makes no sense in this context to talk of exponential growth in a finite world. Man's inventiveness in changing social arrangements is without limits, even if not without hazards.[5]

What, then, remains of Forrester's and Meadows' efforts? Nothing, it seems to us, that can be immediately used for policy formation by decision makers; a technique, one among several—system dynamics—of promise which needs improvement; but above all a challenge to all concerned with man's future to do better.

References

1. See, for example, the editorials, articles, comments and letters published in *Nature* between March and September 1972, in particular Jeremy Bray's review of *The Limits to Growth*, No. 5359; *Science* for the same period; *New Scientist* between April and July 1972; Dennis Gabor, "The new responsibilities of science", in *Science Policy*, Vol. 1, No. 3, May/June 1972
2. Derek de Solla Price, *Little Science, Big Science* (New York, Columbia UP, 1963)
3. See, for example, the interview with J. Forrester in *Le Monde*, 1 August 1972, where he advocates the elimination of "shibboleths" like equality
4. I. L. Janis and S. Feshbach, "Effects of fear-arousing communications", *Journal of Abnormal Social Psychology*, No. 48, 1953, pages 78–92
5. Carl Kaysen, "The computer that printed out WOLF", *Foreign Affairs*, Vol. 50, No. 4, July 1972

INDEX